FANATICS!

Power, identity and fandom in football

Edited by Adam Brown

London and New York

First published 1998
by Routledge
11 New Fetter Lane, London EC4P 4EE

Simultaneously published in the USA and Canada
by Routledge
29 West 35th Street, New York, NY 10001

Typeset in Bembo by Routledge
Printed and bound in Great Britain by Biddles Ltd, Guildford and King's Lynn

British Library Cataloguing in Publication Data
A catalogue record for this book is available from the British Library

Library of Congress Cataloguing in Publication Data
Fanatics: power, identity, and fandom in football / [edited by] Adam Brown.
p. cm.
Includes bibliographical references and index.
1. Soccer fans – Europe. 2. Soccer – Social aspects – Europe.
I. Brown, Adam, 1967–
GV943.9.F35F36 1998
303.6'2–dc21 98–14911
CIP

ISBN 0–415–18103–8 (hbk)
ISBN 0–415–18104–6 (pbk)

For Mum and Dad,
Jane and Richard Brown,
and for football fans everywhere

CONTENTS

CONTENTS

CONTENTS

ILLUSTRATIONS

Figures

Tables

CONTRIBUTORS

Torbjörn Andersson is a lecturer in the Department of History at the University of Lund, Sweden. He has written a number of articles about the history of Swedish football and is co-author of the book, *Fran Gentleman till Huligan* (From Gentleman to Hooligan) due to be published by Symposion.

Les Back is a lecturer in sociology at Goldsmiths College. His books include *New Ethnicities and Urban Culture* (UCL Press 1996), *Race, Politics and Social Change* (with John Solomos, Routledge 1995) and *Racism and Society* (with John Solomos, Macmillan 1996). He is a Millwall fan.

John Bale is Reader in Education and Geography at Keele University. He has pioneered the geographical study of sports and among his many publications are *Sport, Space and the City* (Routledge 1992) and *Landscapes of Modern Sport* (Leicester University Press).

Carlo Balestri and **Carlo Podaliri** are heads of the Archivio sul Tifo Calcistico, Progetto Ultrà of the UISP (Archive on Football Support in Europe at the Ultrà Project, Italian Association of Sport for All), a project based in Bologna and financed by the European Commission's DG V. The project is to prevent violent and racist behaviour in football stadiums. They have also edited the bibliography of Dario Colombo and D. De Luca, *Fanatici: voci, documenti e materiali del movimento ultrà* (1997) and have written for various publications on Italian fans. Carlo Podaliri is a Rome fan, but is unable to contain an unhealthy passion for Bologna; Carlo Balestri is a Bologna fan though he was, in the pre-Berlusconi period, a fiery supporter of AC Milan.

Joseph M. Bradley has published a number of articles, papers and books since 1995 on Irish and Scottish identities, politics and societies. His research has also produced a number of works on the sociological and political aspects of modern sport.

Adam Brown is a Research Fellow at the Manchester Institute for Popular

Culture at Manchester Metropolitan University. He has researched and written extensively on the cultural industries, especially football and music. He is a National Committee member of the Football Supporters' Association and a member of the British Government's Football Task Force as well as being a lifelong Manchester United fan, supporting them home and away.

Ben Carrington is a lecturer in sociology at the Chelsea School, University of Brighton. His research interests and publications concern issues relating to 'race', cultural identities and popular culture, and is co-author of two important studies on racism in rugby (Commission for Racial Equality 1995) and local league cricket (Leeds Metropolitan University). When not scoring goals for various semi-professional football clubs he dreams of John Barnes returning to Anfield as manager to reclaim Liverpool's rightful place as the pre-eminent football club in England.

João Nuno Coelho graduated in sociology from the University of Coimbra (Portugal) in 1995. Since 1996 he has been working on his Masters thesis on the symbolic construction of Portuguese national identity in football as well as on a private project, to edit a collection of texts about the common experience of being an FC Porto fan – his beloved team and everlasting passion, along with watching and playing football.

Tim Crabbe is a freelance writer and Visiting Research Fellow at the Centre for Urban and Community Research, Goldsmiths College, where he is conducting research into racism, identity and sport and relationships between sport and drugs. He is former National Chair of the Football Supporters Association and is a Crystal Palace fan.

Liz Crolley is Senior Lecturer in Spanish at the Department of Languages at the Manchester Metropolitan University. Her research interests include examining the political aspects of football structures, organisation and culture, with particular reference to women's role in football. She has produced several articles on various aspects of football in Spain, Argentina and England and is co-author, with Vic Duke, of *Football, Nationality and the State* (Addison Wesley Longman 1996). She suffers from an addiction to Liverpool FC and supports them home and away.

Paul Darby has been researching into FIFA and its relationship with African football for his doctoral project in the Faculty of Humanities, University of Ulster. He is a lecturer at Liverpool Hope University College.

Paul Dimeo is currently researching for his doctorate at the University of Strathclyde. His main fields of interest are racism in football, and the history of football in the Indian subcontinent.

Gerry P.T. Finn is Reader in the Department of Educational Studies. Intergroup prejudice is a main research interest. He played for his home town club, Cumnock Juniors, but still dreams of what would be a truly senior Scotland cap.

Marcus Free teaches Media and Cultural Studies at Wolverhampton University. He is currently engaged in ethnographic research on constructions of Irish identity in Birmingham. He has been a Republic of Ireland fan from 'a time when it was neither profitable nor popular' (Myles na Gopaleen: Catechism of Cliché).

Simon Gardiner is Director of the Anglia Sports Law Research Centre and Senior Research Fellow in Sports Law at the Anglia Polytechnic University School of Law. He is currently researching in the area of sports violence and the construction of national identity in sport. He has published extensively on a number of sports law and social issues. He is a life-long Leeds United supporter.

Richard Giulianotti is Lecturer in Sociology at the University of Aberdeen, and has published numerous articles on football culture. He is co-editor of *Football, Violence and Social Identity* (Routledge 1994), *Game without Frontiers* (Arena 1994), and *Entering the Field* (Berg 1997), and is completing a book on football for Polity Press.

Steve Greenfield is co-director of the Centre for the Study of Law, Society and Popular Culture at the University of Westminster, London. He would like to be a season ticket holder at Manchester United and a member of FC Barcelona.

David Hand is Senior Lecturer in French at the Department of Languages at the Manchester Metropolitan University. His research interests include an analysis of French nationalist discourse with particular reference to football culture. He has given conference papers on the French Higher Education system and has had articles published in *Modern and Contemporary France* and *French Studies* (Bulletin). Relishing a challenge, he supports Manchester City, as well as following the French national team.

Ralf Jeutter was born in northern Germany in 1962 and educated in Bamberg, Tübingen and Norwich, where he received his PhD. He has published on German/Austrian literature, was co-editor of a bilingual German–English literary magazine and was an active footballer from the ages 5–20 at county level. He supports Werder Bremen in Germany and Moss Side Amateurs in Manchester, England.

Simon Lee is a lecturer in the Department of Politics at Hull University. He has researched and written extensively on the political economy of football and is author of *The Politics of Social Policy in Europe* (Edward Elgar). He is a diehard Manchester United fan.

Guy Osborn is co-director of the Centre for the Study of Law, Society and Popular Culture at the University of Westminster, London. A Birmingham City fan exiled to London, he also follows their kindred spirits Tottenham Hotspur from his London abode.

Aage Radmann is a lecturer in the Department of Sociology and is a member of The Centre for Sports Research at the University of Lund, Sweden. His research areas include football, fans and youth cultures in Scandinavia. He is co-author of *Fran Gentleman till Huligan*.

John Solomos is Professor of Sociology and Social Policy at Southampton University. He has previously worked for the Centre for Research in Ethnic Relations, University of Warwick and Birkbeck College, University of London. Among his publications are *Black Youth, Racism and the State* (1988), *Race and Racism in Britain* (1993), *Race, Politics and Social Change* (with Les Back 1995) and *Racism in Society* (with Les Back 1996).

John Sugden and **Alan Tomlinson** are lecturers at the Chelsea School, University of Brighton and have written extensively about football. Their study of the politics and culture of FIFA and world football, *FIFA and the Contest for World Football – Who Rules the People's Game?*, is published by Polity Press, Cambridge, in 1998.

PREFACE

This collection was first conceived of at a conference organised by Adam Brown to coincide with the Euro 96 European Football Championships in England in 1996. The conference, 'Fanatics! Football and Popular Culture in Europe', was held at the Manchester Institute for Popular Culture, Manchester Metropolitan University from 11–13 June 1996 and involved leading football academics from around the world.

Whilst naturally much of the attention at the time was focused on the championships, the 'on-field play' at the conference put football fans centre stage, with over forty papers looking at the modern game. Selecting the most appropriate of these to be revised and included in this collection was not easy and it should not be a reflection on the quality of those not chosen. However, the book has developed into much more than a collection of conference papers with major revisions, updating of all chapters and the inclusion of much previously unavailable research material. As such it is hoped that it provides a unique and informative collection of the most recent football-related research available.

ACKNOWLEDGEMENTS

This book is the product of many people's work. As editor I would like to thank all the contributors for their help and patience in writing and delivering their work. I would also like to take this opportunity to thank all those who participated as delegates and speakers at the 'Fanatics!' conference and those who helped to stage it. Not least amongst these are the staff of the Manchester Institute for Popular Culture and Manchester Metropolitan University Faculty of Humanities who supported the conference and helped ensure that it ran smoothly (well, smoothish!), including Maggy Taylor, Alex Forrester and Lyn Fentem. I would also like to thank Nichola Richards at MIPC who read and commented on some (including the editor's) sections and Rebecca Barden at Routledge for her faith and support in this project and all involved in its publication.

Finally I'd like to acknowledge the constant inspiration which football, and most importantly its often maligned fans, provide. Primary in these, of course, are the supporters, home and away, of my beloved Manchester United – you are fanatics one and all.

INTRODUCTION

Adam Brown

Football is changing and changing fast. The months during the preparation of this book have been testament to this. On a global level, we have seen the finalising of fixtures for the 1998 World Cup, to be staged in France, and fierce debate on the location of the 2006 tournament. Within Europe there has been the (seemingly annual) re-invention of the Champions League and the other European club competitions, as well as the on-going debates about the formation of a European Super League, driven both by the insatiable appetite of satellite television for football and the desire of clubs for more money to finance the spiralling, post-Bosman transfer market. In the UK, where this book has been compiled, there has been a massive influx of foreign 'stars' and the continuing dominance of the richest and most successful club – Manchester United – put into sharp relief by the struggle for survival of lower division clubs such as Brighton and Hove Albion and Doncaster Rovers; whilst in Scotland the top clubs have been attempting to form a break-away Premier Division prompted by the 'success' of its equivalent south of the border.

Supporters are centrally affected by all these processes and at all levels. At the international level, English fans have campaigned against vicious (and possibly illegal) treatment at the hands of other European police forces whilst also beginning the scramble for World Cup tickets almost as soon as the teams were drawn. At the national level fans of clubs in the all-seated Premier League are finding that the 'whole new ball game' of 1990s football (complete with cheerful, painted faces of children) is very different from that they have loved, as they suffer massive price hikes and draconian punishment of their traditional self-expression within stadia. At the other end of this scale, however, supporters of teams such as Brighton have had to fight acrimonious nation-wide campaigns in order to save their clubs from extinction, and on the continent, fans in Germany, Italy and elsewhere have joined the fight against racism. For many football supporters, the 1990s have been traumatic, with their very participation in the game jeopardised as football the world over rushes headlong into television-driven commercialism.

1

It is also a time of great contradictions in the game. National boundaries are swept aside by European Court rulings on the transfer of players, yet fans are prevented from enjoying the same freedom of movement and the press continues to peddle bellicose nationalisms. Money pours into European football in greater amounts than ever before, yet football at the grass roots struggles to survive and supporters are asked to pay more than ever. Also, whilst the game becomes more and more genuinely global, racism, intolerance and xenophobia exist (and are challenged) at all levels. Such a context is uniquely interesting and one in which *Fanatics!* has been written and compiled. It aims to analyse not only the processes and power-broking in motion but the complex and shifting identities associated with football and the impact of developments on fans. Given the breadth of change in the game and the diverse concerns it contains, this collection is deliberately multi-disciplinary, combining sociology, cultural and media studies, political economy, history, the study of language, law and cultural geography.

The publication is organised into five distinct but clearly inter-related areas of study: power in football; racism; continental football identities; football as Britain's 'national' sport; and the regulation and 'space' for fandom. In many ways these themes all concern the issue of ownership of football – whether actual control of the game, notions of participation, identity or exclusion. Certainly, the idea that football is the 'people's game' has never been more challenged as it is today: issues of power and control in football, the impact of television and new technology, racism and battles against it, changing notions of both national and local identities and the increasing interjection of the law into football have all raised questions about the position of the game in society, and especially the nature of contemporary football fandom. Crucially, these changes have challenged football – and football fandom – to meet its *own* rhetoric about being a popular participatory culture, about notions of common ownership of the game, about football's position in, and reflection of, national, regional and ethnic identity.

Certainly in England, such concerns have had a massive effect. They have driven fans' organisations from club level to national level to challenge increased ticket prices, racism in grounds and most recently to call for an abandonment of the consensus for all-seater football stadia. However, the all-pervasive 1990s game has also motivated 'outside' agencies such as the Commission for Racial Equality – who began the Kick Racism Out of Football campaign (now called Kick It Out) – to challenge the exclusion of communities in football, something which has also been taken up in Germany and Italy amongst others. Even government has not remained untouched, with the Blair-led British government's Football Task Force headed by ex-Conservative MP and media pundit, David Mellor, to investigate the role of fans in the modernised, commercially-driven game, as well as issues of racism and disabled access.

Whereas a decade and more ago, academic literature was almost exclusively driven by concerns with law and order and the 'hooligan problem', the study of football and its fans has now embraced much wider questions of identity and participation in the game. The reduction in violent confrontations between rival supporters in Europe has naturally been one cause; but a concern to go beyond the media-defined, moral panic of 'hooliganism' to consider other aspects of fandom, as well as a concern to broaden our understanding of football in the rapidly changing contemporary Europe, has rightly come to the fore. Naturally, violence in football is still a concern – some of the more optimistic treatises about the death of the hooligan have proved to be premature – and this volume reflects that. But *Fanatics!* is much more about contemporary fandom in all its facets, the context within which that fandom is developing and the key questions of ownership, participation, racial and national identities.

Fanatics! will look first at attempts to control or influence the running of the game and this is considered from the 'top' to the 'bottom' of football's hierarchy. Sugden, Tomlinson and Darby outline the battle – between the South American incumbent, Havelange, and the European pretender, Johansson – for control of FIFA, the world football's governing body. Setting it in its historical context, the chapter outlines the key role with which emerging footballing regions – crucially Asia and Africa – are defining the lines of debate and the context for the struggle for power. The chapter places the historical specifics of money, individuals and participation centrally in the equation of the 'democratic' process within FIFA.

Lee then tackles the topical question of control over domestic club football and critically examines the trend of clubs in England to float on the London Stock Exchange. Using Manchester United as the most celebrated example, this process, he argues, has not only raised the stakes in financial terms – and it has certainly done that with more money flowing in (and out) of the game than ever before – but has also raised questions over ownership of the game at club level. Setting this development in the context of the political economy of 1990s Britain, Lee poses the question that if clubs' primary and legal obligation is to maximise profit for shareholders, where does that leave fans and what rights and involvement can they expect? The conclusion is not optimistic.

The editor then attempts to look at the problems for fans' organisations by considering the reaction of supporters to the implementation of the Taylor Report and crucially the rebuilding of English football stadia. By first outlining the scope of fans' organisations and the main issues around which supporters in England have organised, and then by examining two case studies – at Arsenal and Manchester United – the chapter attempts to raise some questions over the feasibility of, and obstacles to, such a project. What is undoubtable is that supporters in Britain and elsewhere have made great strides and posed difficult questions about democratisation of the game, and it

is hoped that this look at a grass roots level will act as a useful counter-balance to the overwhelming power described in the first two chapters. Whilst on one hand football is being modernised in the context of the global battle for control of FIFA and the commercial might of the Stock Market, on the other the emergence of football fan organisations with clear political and democratic ambitions at club and national level has certainly challenged the cosy and authoritarian running of football.

We then move on to devote a considerable amount of space in Part II to the issue of racism in football as perhaps one of most basic means by which sections of society are excluded from the 'people's game'. Whilst the issue has been highlighted by both national and international campaigns (1997 was the European Union's anti-racist year and included a star-studded anti-racist football match in Madrid), much of the literature has failed until now to move beyond simple stereotypes. The section begins, therefore, with Back, Crabbe and Solomos' challenge to the simplistic notion of the 'hooligan racist', moving beyond such clichés to examine the complex nature of the expression of racism, its vernacular and cultural specificity. Originating in one of the biggest research projects to tackle the issue, this chapter signifies a major moving forward of the debate and outlines a context in which future work will take place.

Podaliri and Balestri outline the birth of organised racism in Italian football as inextricably linked to the development of the *ultrà* in Italian fandom. Arguing that the *ultrà* 'movement', if it can be called that, has been traditionally tied to political developments, this chronological study highlights key moments in the development of violent, racist fan organisations in Italian football, their left-wing rivals, the generational changes which have occurred and the challenges which have been made to racism. Amongst these challenges has been the Progetto Ultrà, a project run by the two authors in Bologna, which seeks to work toward an end to violence and racism.

Carrington then moves the debate back to England and makes a forceful and polemic attack on the cultural representations involved in the Euro 96 European Championship Finals held in June 1996. His argument not only raises accusations of racism and exclusion from the game, but crucially sets this within a wider context of popular culture and accuses participants in television, press and popular music of aiding the exclusion of large sections of society from the tournament. With English football still congratulating itself on the success of Euro 96 (and bidding for the World Cup Finals in 2006) it is a timely interjection that much still needs to be done if such a sporting event is to be truly international, representative and inclusive.

In the final chapter of this section, Dimeo and Finn turn the attention to Scotland, which, as they illustrate, has a constructed self-image of not suffering the kind of racism seen in England (and elsewhere). However, in their case study of Partick Thistle – one of the smaller Glasgow teams – they examine the expression of anti-Asian racism which accompanied an attempt by an

'Asian' business consortium to buy the club. The crucial role of the media in racial stereotyping is highlighted as they argue that far from being multi-cultural, Scotland can be seen through this particular football event to be highly racialised and divided.

Having looked at the role of racial identities in football, we then broaden this into continental Europe to raise important questions of national identities as mediated through football, in Part III. Andersson and Radmann set the nature of football fandom in Scandinavia in its historical context, contrasting its development with that in the UK which has been a major influence on Scandinavian football. They highlight two crucial periods – from 1900 to 1930 and from 1970 to the present – in the formation of Scandinavian fandom. From the 'Fast Painters' of Denmark to the 'Blue Saints' of Sweden they analyse aspects of north European supporter culture about which little is known and assess the roles which participation and violence have played.

Moving from one end of the continent to the other, Coelho tackles the problematic issue of Portuguese national identity as seen through its rich football history. Long in the shadow of great rivals Spain, and situated on the edge of Europe, Coelho describes Portuguese national identity as involving a 'centre imagination' (its position as a western European nation) and a 'periphery trauma' (the fear of being peripheral, close to Africa and 'inferior'). This, he says, is reflected in the imagined identities associated with the fluctuating fortunes of Portuguese football. He argues that following the increased success of club and national football, the country must take advantage of its semiperipheral position – rather than be fearful of it – and the multi-cultural opportunities which that offers, 'in life as in football'.

Crolley, Hand and Jeutter take a comparative approach to the role of the media in expressing national identities through football. Focusing on print media in France, Germany and Spain, they highlight the use of military, religious and even health metaphors which, they argue, display distinct national characteristics which are historically and culturally specific. Situating their debate in the context of the bellicose language of the British tabloid press, they contend that whilst these case studies may illustrate a difference of style and degree, they also, in fact, illustrate a similarity in terms of football's relationship to society and its ever-increasing mediation through the press.

Part IV then devotes considerable attention to identities of football fans in Britain, where football has long been described as the 'national game' but with little understanding of the complexities that involves. Finn and Giulianotti explore the expressions of a distinct, carnivalesque Scottish identity of fans who follow the Scottish national team – an identity forged in opposition to the negative one constructed of English fans. Based on a case study of Scottish fan experiences at Euro 96, and their first match against the 'auld enemy' since 1989 which took place during that tournament, they argue that there is still some way to go before there is a less *anti-English* and a more *positively Scottish* identity. Whilst football has undoubtedly been a major focus

for the international expression of Scottishness, this chapter says that Scottishness is still influenced by (in being defined against) their southern rivals. Recent political developments toward devolution, they argue, may impact positively on the identity of Scottish football fans.

Bradley, whilst still concentrating on Scotland, explores the sectarian division of identity between the two overwhelmingly dominant clubs, Glasgow Celtic and Glasgow Rangers. This he does by examining the popular songs, stories and traditions which are traded across the Irish-Catholic/Unionist-Protestant divide. Again historically located, Bradley surveys the varying support for the national team, political allegiances and the drastically opposing views on the Northern Ireland question. He argues that songs sung at football matches are important communicators of these differing identities and crucial to the collective construction of identity.

In the last chapter of this section, Free considers the question of the Irish diaspora and the problematic nature of travelling Republic of Ireland supporters born and/or resident in mainland Britain. Whilst the success of the Irish national team has certainly brought into sharp relief the 'imagined' nature of the Irish community, it has, he argues, also exacerbated the conflicts between those resident in Ireland and the so-called 'plastic Paddies' in Britain. Again the specific (post-colonial) context in which this takes place is crucial to our understanding, but so too, says Free, is the romantic and playful expression of Irish football fans in defying the dominant English *and* 'insular' Irish definitions of their identity.

The final section of this collection concerns the limits which are being imposed on the expression of fans in both a practical and theoretical manner, and as such returns to the questions of control considered in Part I. Greenfield and Osborn develop the increasing volume of work in the legal field regarding football and analyse the recent legislative attempts in Britain to control supporters. Outlining the various legislative projects of the Conservative governments, they consider the efficacy of legislation and its impact on the civil liberties of football fans. The most recent significant legislative measure – the Criminal Justice and Public Order Act 1994 – is looked at in some detail, including its rather arbitrary impact on fans. Such legislation, they argue, has sought to 'stigmatise and suffocate' fans' involvement in the game, but (returning to the theme of Chapter 3) is being resisted by sections of British fandom.

The penultimate chapter takes its cue from one of the most infamous and celebrated events in recent football – the xenophobic abuse of, and kung fu kick attack by, Manchester United's Eric Cantona on a Crystal Palace supporter. Gardiner considers this event from two angles: one is the construction by both Cantona and the media of his identity and his 'otherness'; and the other is the impact of the law in such instances in its attempt to control fans. In the former of these he argues that Cantona's time in English football illustrates the 'fear of the "other"' in English society (and the racism and

xenophobia that entails); and in the latter he echoes some of the concerns in Part II, as well as the preceding chapter, in the usefulness of the law in dealing with 'hate speech' and racially motivated crimes.

Bale's concluding piece continues his pioneering of the field of cultural geography by considering the dual roles of 'space' and 'place' in developing a geographical theory of football. In this he argues that football *ought* to be placeless: that in the interests of 'fair play' and 'achievement', sporting events (football matches) ought, logically, to take place in as similar surroundings as possible. Whilst arguing that football has become increasingly placeless (something reflected in postmodern descriptions of the game), he highlights the position of supporters as being particularly problematic, infringing as they do, on both the 'place' and the 'space' of football. The negative implications of this are clear for the participation of fans and the kind of distinct identities described in this volume. But Bale, somewhat controversially, uses the example of the 1992 European Championship Final to point to a 'futurescape' of fandom where communal televisual consumption 'satisfies' both fan and the need for placelessness. One could argue that the expression of fandom(s) on issues of democratisation, racial exclusion and national and local identities outlined throughout this publication, will be central to determining the success of the process Bale describes.

It is necessary to record that although there have been key developments around the issue of gender in football – increasing numbers of females attending games in the UK, participation of women in Italian *ultrà* groups, the increased marketing of the game to young women – this is not reflected in academic literature and research. In a volume which seeks to consider processes of exclusion and participation in football, the lack of work on this topic is recognised as an omission by the editor, and perhaps points the way for some future research. Having said that, this diverse collection of football writing represents both a unique collection of new research as well as a challenge to some of the key, accepted discourses about football supporters. It also brings together a range of distinct yet inter-related disciplines and topics which form a complimentary and we hope, valuable, body of work.

Whilst those who run football are determined to pursue the (literally and metaphorically) stratospheric trajectory demanded by satellite television and its sponsors, football – as a spectacle, as a popular culture, as a European social institution – still relies heavily on the loyalty and fanaticism of its followers. It is with the issues of power, race and identity which will determine the character of this inter-relationship, that *Fanatics!* is concerned.

Part I

POWER IN FOOTBALL
The 'people's game'?

1

FIFA VERSUS UEFA IN THE STRUGGLE FOR THE CONTROL OF WORLD FOOTBALL

John Sugden, Alan Tomlinson and Paul Darby

Introduction: FIFA's crisis

In 1997, FIFA President, João Havelange, estimated football's annual global financial turnover to be in excess of US$250 billion – more than multinational corporations such as General Motors, and considerably more than the GNPs of the vast majority of FIFA's 200-plus member nations (authors' interview with Havelange, Cairo, 3 September 1997). As over the last quarter of a century the riches and the status rewards attending the governance of international football have increased, so too have struggles to control the world's most popular game reached new heights. (The struggle at a more grassroots or local/national level will be considered in the next chapter.) The contest for the control of world football has been particularly keen between the incumbent FIFA administration and representatives of the most potent continental confederation, UEFA. In this chapter we explore the roots of this contest and review some of its more contemporary manifestations before placing this personal and institutional power struggle in a broader theoretical setting.

FIFA and UEFA in the 1950s and 1960s

After the Second World War, membership of FIFA began to expand to the extent that there was perceived to be a need for a degree of regionalisation and decentralisation of administrative functions. Jules Rimet, then FIFA President, was against the idea because it ran contrary to his notion of FIFA as a single 'family'. However, his contemporaries in the European federations, who were concerned that they were being politically out-manoeuvred by the Latin Americans, were all for it. As early as 1952, José Crahay, the Belgian FA's

11

delegate, was warning his European colleagues of the threat posed by what he viewed as a growing Latin American cabal. His recollections of the FIFA Congress in Helsinki that year are worth quoting at some length:

> One of the South American delegates had something general to say on each and every item on the agenda. We saw very clearly that each point had been carefully studied in advance and that the South American delegates had apparently been nominated to defend a certain standpoint which seldom corresponded with that of the FIFA Executive Committee (then dominated by Europeans). The FIFA General Secretary of the time, Kurt Gassmann, fought back as well as he could, and all the major issues were deferred until the next Congress. But when it came to voting the European Associations each went their own way with no preconceived policy: the result was that we came close to committing a number of errors which would have done irreparable damage. May it be emphasised that our aim never was, and never shall be, to override anyone else; Europe's only aim was to defend its own interests.
>
> (Crahay quoted in Rothenbühler 1979: 76)

The mounting awareness, within the European associations, of the emerging threat to their privileged position within world football's power structures, was the motivating factor behind UEFA's formation. In terms of the organisation of national football associations, Europe had been particularly fragmented prior to the 1950s. There had always been small, insular regional groupings within Europe, such as the separate British, Scandinavian and former Eastern Bloc associations. In the 1950s when Europe began to take seriously the notion of association football as a world game, this was in many respects a response to a growing concern that the South American consortium of national associations, which had been formed as early as 1916, gave that continent a uniform and collective voice within FIFA. Billy Drennan, the former secretary of the IFA (Irish Football Association), was present at the 1954 meeting in Basle, Switzerland at which UEFA was formed. Worried about being outmanoeuvred, Europe's 'divided house' was forced to reconsider its own position:

> At the actual [FIFA] Congress, the South American Associations' votes are in reality a 'block vote'. With no similar group of Associations in Europe, the various [European] Associations, with no previous study of FIFA matters and agendas, has not been able to vote solidly in the best interests of European football. . . . In view of all this a definite effort has now been made to form a European group.
>
> (IFA (1954) *Council minutes* 29 June)

Thus, the distribution of power in world football was the inspiration behind UEFA's formation in 1954. The establishment of UEFA gave Europe a collective voice within the world governing body and eased the emergence of two Englishmen, Arthur Drewry and Stanley Rous, who held the reins of FIFA from 1956 until the mid-1970s. These related developments assured that Europe would have a leading say in the pace and direction of world soccer development in the immediate post-war period (Tomlinson 1994). In general terms, however, the patronising, Eurocentric and neo-imperialistic style which characterised FIFA's relations with its constituents at this time became under-mined by the successful spread of the game into the Third World.

In FIFA's regional committee structure, countries which were otherwise politically invisible, discovered a political platform for focusing and asserting often newly acquired independence and national identities. However, in considering the reform of FIFA from the mid-1970s onwards, while there was a degree of 'push' from these new national and regional governing bodies, in equal measure there was the 'pull' of those with vested interests in diminishing European influence and it was a combination of both forces which was to lead to the election of the first non-European President of FIFA in 1974.

The Third World struggle for global equity and FIFA in the 1970s

One of FIFA's long-standing objectives has been to develop soccer world-wide and this has had important, if unintended, political consequences. The more successful this policy became the more pressure the organisation felt to adopt more and more national associations into the 'FIFA family'. However, FIFA's electoral franchise operated on the principle of one nation one vote, and this meant that, irrespective of their soccer tradition and playing ability, as each new member was admitted the Third World's power base grew. Alarm bells began to ring in the established football nations, particularly in Europe. Thus spoke the UEFA President, Artemio Franchi:

> With ever more states gaining their independence, and with existing countries splitting up into separate states – processes which are to be observed above all in the so called third world – the number of national football associations inevitably continues to grow. And there is nothing to stop these emerging football countries from joining the enlarged FIFA family. This is the uncomfortable truth.
> (Franchi (1979) *Official Bulletin of UEFA* 87 (June): 21)

The emergence of the Third World as an effective political force within FIFA began to drive a wedge between UEFA and South American soccer. At the 1970 FIFA Congress in Mexico the new member nations of Africa and Asia and the South Americans voted together, resulting in Europe losing its

majority representation on the World Cup and Olympic Tournament committees (FIFA (1970) *Congress minutes*). UEFA officials were outraged and the association called its members together for an extraordinary congress in Monte Carlo in June 1971. Louis Wouters, the Belgian delegate, voiced the concerns of all:

> It is not the competence of the European representatives in the FIFA Executive which is at stake but rather the future of Europe in world football . . . at the FIFA Congress in Mexico, political questions were given precedence over questions of sport and a clearly anti-European attitude had been exhibited there.
>
> (*UEFA minutes* (1971) IV Extraordinary Congress, Monte Carlo,
> June)

UEFA was particularly worried that its diminished influence on FIFA's most important committees would adversely affect its members' chances of hosting and qualifying for future World Cup Finals. Gustav Wiederkehr, the President of UEFA at that time, thought that the situation was a critical one: 'The reduction of the European influence within the competent Committees, which was recently decided by the President of FIFA and approved by its Executive Committee, is . . . not acceptable' (*Official Bulletin of UEFA* (1971) 55 (June): 814). Although the UEFA President ensured that the views of European nations on these matters would continue to be considered by the world governing body, the Europeans' exasperation with FIFA increased, caused in no small measure by the fact that they felt Europe was generating an increasing amount of FIFA's wealth while at the same time losing political control. By 1975 Wiederkehr's successor as UEFA President, Artemio Franchi, was making the European case in strong and unambiguous terms:

> UEFA represents within FIFA 74.61% of all affiliated clubs, 68.03% of the teams taking part in international competitions, 68.10% of the players and 85.27% of the referees. On the other hand, Europe with its 34 member associations only represents 23.57% of the actual affiliation, and this percentage continuously goes down whenever new countries become independent and then join FIFA. . . . As shown by these figures, Europe still represents the core of world football as far as technical matters are concerned, whereas from the political viewpoint, our continent forms a small minority.
>
> (*Official Bulletin of UEFA* (1975) 71 (June): 18)

Nevertheless, as these tensions stirred and recurred throughout the first two decades of UEFA's existence, so long as the Englishman, Rous, remained as President of FIFA, Europe felt that its interests would be protected. At the Monte Carlo UEFA meeting, Wiederkehr had seen trouble coming when he

said that he 'feared a further blow for Europe when Sir Stanley Rous would one day withdraw from the Presidency' (*UEFA minutes* (1971) IV Extraordinary Congress, Monte Carlo, June). The fact that within three years of the Monte Carlo meeting, Rous had not withdrawn but had been forced out of office – through a power-play led by Brazilian, João Havelange, and involving the political muscle of the under-developed world – spelled even more trouble for UEFA. Havelange's meteoric rise has to be understood in the context of broader First World–Third World political and economic tensions.

Round one: Rous versus Havelange

An understanding of the events surrounding the 1974 FIFA congress in Frankfurt and the election of Havelange as the organisation's supremo is critical to any interpretation of FIFA today. Havelange, a former double Olympian (swimming and water polo) for Brazil, and said to be an independently wealthy businessman, recognised in the Third World's problems with FIFA an opportunity for him to gain control of that organisation. Rous, who was of the old school and had a naïve view of the relationship between sport and politics, was a relatively easy target for Havelange, who, much to the chagrin of Europe, set about campaigning vigorously for support among FIFA delegates world-wide. He visited a total of eighty-six member countries, most of which had never participated in a World Cup Final and as things stood, were never likely to. Under such circumstances, Havelange had little trouble galvanising support for his bid for power. The journalist Malcolm Brodie covered the 1974 FIFA congress at which Havelange challenged Rous for the Presidency:

> At that time, a lot of people in world football, Europe included, felt that Sir Stanley Rous was much too autocratic and too dictatorial . . . the South American nations and a lot of the African and Asian nations were called in by Havelange to defeat Stanley Rous.
> (Brodie, M. (1995) interview with author, March)

In terms of global political relations the status of South America has always been ambivalent. It had been subjected to colonial exploitation, but had been mostly independent for the greater part of the twentieth century. Most South American countries had achieved levels of economic development which set them apart from the Third World, but which did not put them on a par with North America and Europe. Furthermore, there has been a tradition of South America taking a lead in the global political and economic relations among 'non-aligned' nations. It is not surprising, therefore, that the Third World challenge to FIFA was championed by a Latin American.

Patrick Nally, was closely involved with the business activities of FIFA at

this time and took a corresponding interest in the organisation's political affairs:

> It was such a radical change to suddenly have this dynamic, glamorous South American character, brimming with bonhomie, travelling the world with his wife, meeting people, pressing the flesh, bringing over the Brazilian team, travelling with the likes of Pelé. It was Brazilian carnival time. Havelange had spent a fortune going around the world with the Brazilian team and had canvassed every single member of FIFA. It was unheard of. No sports president had ever gone round the world glad handing and campaigning.
>
> (Nally, quoted in Simson and Jennings 1992: 39–40)

Havelange's platform was unashamedly based on increasing opportunities for the Third World. He pledged to increase World Cup Final places from 16 to 24 and promised to establish an International Academy committed to the development of soccer in the Third World; proposed an international Youth Championship to be hosted regularly by developing nations; and committed himself to cash subsidies for the construction of stadia and facilities and for the provision of top-class coaching, as well as support for more club competitions throughout Africa and Asia (Tomlinson 1986, 1994). As Nally argues, it was clear from the outset what Havelange's electoral strategy was:

> Havelange had obviously made lots of promises to the Asians and the Africans. One of his devout statements was that he was going to spread the message of soccer, to take away the domination of Europe and parts of South America. . . . All the pandering to the Asians and Africans was because obviously they had lots of votes.
>
> (Nally 1991)

While Havelange canvassed the world, a combination of circumstances conspired to undermine Rous' position. To begin with there was his own political *naïveté*. It is an enduring source of amazement that so many leading sports administrators are able to claim that sport and politics are separate spheres when so much of their time is taken up with political manoeuvring and mediation. Rhetorically, Rous made his position clear by arguing that, 'the tangles of world politics are best left to the United Nations, while FIFA concerns itself with world football and jealously guards its constitution' (Rous 1978: 171). In effect, as the following examples will illustrate, this view allowed him to claim apolitical status while at the same time buttressing the challenged political and cultural hegemony of the West in the cold war era.

As the 1974 congress approached, Rous found himself confronting three simultaneous political crises. China had left FIFA in 1958 because FIFA continued to recognise the Association from Chaing Kai-shek's Taiwan. The

communist Chinese were particularly offended by the fact that FIFA allowed Taiwan to operate under the name it used within the United Nations: National China. As the influence of communist China spread, particularly throughout Asia and Africa, in the early 1970s there was a growing lobby outside of Europe and South America, which held the view that not only should China be readmitted, but that Taiwan should be expelled. Rous argued that while it was perfectly acceptable to readmit China, this could not be done at the expense of Taiwan as this would be contrary to FIFA's constitutional position which stated that, 'so long as a country was internationally recognised to exist [i.e. was a member of the United Nations] and had a reputable national Association . . . FIFA's rules required us to give recognition' (ibid.: 168).

Rous realised that by taking such a stand he may have alienated potential voters from the Third World and the communist bloc, but still he chose to hide behind his cherished, philosophical belief in the separation of sport and politics. 'It was made clear to me that some delegates would vote against me unless Taiwan was expelled, but I was not amenable to that sort of pressure' (ibid.: 201).

His relations with the communists were further damaged through the position he adopted over the World Cup qualifying match between Chile and the Soviet Union, scheduled to be played on 21 November 1973 in the National Stadium in Chile's capital, Santiago. At that time Chile was governed by a military junta headed by General Pinochet which had overthrown the democratically elected Marxist government of Salvador Allende in the September of that year. This regime had brutally eliminated political opposition and there was considerable evidence to suggest that the National Stadium had been used as both an internment camp and as a venue for the torture and execution of left-wing dissidents (Amnesty International 1993). The Soviets argued that under these circumstances, the game should be played in a neutral country. Once more Rous invoked FIFA's constitutional position in preservation of the *status quo*, and prepared to face the consequences through the ballot box:

> The Russian attitude may well have repercussions outside Europe, since their political muscle extends wide. And while a sitting President has certain advantages there were several 'political' issues militating against me, because I was not prepared to connive at FIFA ignoring its own statutes.
>
> (Rous 1978: 201)

Perhaps Rous' gravest mistake, however, was that, in concentrating on these political controversies in the East, he took his eye off the ball in Africa where Havelange was concentrating most of his pre-election efforts. The details of Havelange's Africa campaign and Rous' poor response to it are detailed

elsewhere (Sugden and Tomlinson 1997). To summarise, Havelange realised the huge significance for black Africa of the exclusion of South Africa from world football and was prepared to guarantee a South African embargo should he be elected to the Presidency. Rous, on the other hand, was less attuned to the black African position and was viewed by many as pro-'white South Africa', a perspective which alienated the black African constituency.

Right up to the vote in Frankfurt, just prior to the 1974 Finals in West Germany, the Europeans did not realise that they had been outmanoeuvred, and remained confident that Havelange's challenge would fail. Rous' political *naïveté* comes across in the words he used to close the address he gave to the Frankfurt Congress prior to the vote:

> I can offer no special inducements to obtain support in my re-election, nor have I canvassed for votes except through this communication. I prefer to let the record speak for itself.
>
> (Rous 1978: 202)

A combination of UEFA's complacency and Rous' *naïveté* would cost European football dear. Ali (1984) summarises this view well from the perspective of the African delegates at the meeting:

> Africa went to the FIFA congress with 37 votes. The 79 year old Sir Stanley Rous put his twelve year tenure of office and Europe's monopoly of the world body in the hands of 122 delegates. The balance of power was held by the AFC [CAF] bloc. In the vote it became clear that the battle was between the old guard and the third world with Africa playing a decisive role. The AFC's candidate, Dr. J. Havelange won the second vote with a clear majority.
>
> (Ali 1984: 10)

According to Brazilian, Peter Pullen, a senior FIFA official (Advisor for Special Duties) and a long time associate of Havelange, there was a hidden irony in this result. Some time before he launched his own campaign for the Presidency of FIFA, Havelange, in his capacity as President of the Brazilian Sports/Football Federation, had warned Rous of the increasing power of the Third World. Havelange counselled that Rous should consider changing FIFA's constitution in such a way that the votes of the more established nations of Europe and Latin America would weigh more than those of the newer members from Africa and Asia. Pullen believes that :

> Rous, thinking that he had the votes of the British Commonwealth nations in the palm of his hand, turned down Havelange's proposal – a decision that was to haunt him after the Frankfurt congress.
>
> (Pullen (1995) interview with author, 4 September)

This result shattered Rous and stunned his European colleagues. It signalled a sea-change in the affairs of FIFA as the balance of power shifted from the northern to the southern hemisphere. Havelange himself draws upon a generational metaphor when recalling his triumph, referring to Rous as the grandfather out of touch with the needs and the realities of the world of the grandson: a metaphor which has clear resonances in First World–Third World dynamics (Mellor 1996). According to Simson and Jennings, along with the rise to power of the Spaniard, Juan Antonio Samaranch within the Olympic movement and the ascendancy of Primo Nebiolo in the IAAF (International Amateur Athletics Federation) Havelange's victory, 'marked the beginning of a new Latin dominance in the running of world sport; of a dramatic shift away from its former Anglo-Saxon control' (1992: 37). With regard to the Third World's position within FIFA, Ali clearly views Havelange's succession as a victory for those who formerly had been scorned:

> By ousting Sir Stanley, Africa and the rest of the third world would have struck a resounding blow for a more equitable distribution of sporting power and influence in the world . . . it [Africa] has brought its influence to bear on a number of issues and has succeeded in breaking Europe's monopoly of world football.
>
> (Ali 1984: 10)

Havelange had campaigned on promises which would be expensive to keep and had inherited an organisation which was virtually bankrupt. His first task upon assuming office was to set about securing FIFA's financial future. With considerable help from Adidas' Horst Dassler, he did this by bringing together the big television companies with Coca-Cola and a number of other big name multi-national sponsors. This gave Havelange the financial base within which to deeply root his Presidency and, as Simson and Jennings put it, 'since the Coke money tap was turned on . . . he has remained the unchallenged President of FIFA' (1992: 47).

Round two: Havelange versus Johansson

It was, however, inevitable that eventually Havelange's authority would be challenged. There is irony in the fact that the man who so successfully exploited FIFA's democratic structure in securing his power base, became increasingly high-handed and dictatorial in his dealings with the regional associations. The Europeans woke up to the fact that unless they challenged him on his own terms, Havelange would continue to steer FIFA in directions which ran counter to UEFA's interests. By 1995 the Europeans made it clear that, if he stood again, they would challenge Havelange's re-election in 1998. In December 1996, Havelange surprised many people when he announced that he did not intend to stand for re-election, pointing to the fact that by the

time of the vote he would be 82 years old. However, while age may have been a contributory factor to his decision, it is equally likely that he began to have doubts about whether or not he continued to have sufficient support in the FIFA congress to fend off a strong European candidate. Before Havelange took his decision to retire, he entered the lists once more in Africa, but unlike in the case of Sir Stanley Rous, he realised that this time he was up against a more formidable and politically astute opponent.

The champion of UEFA's cause was the organisation's Swedish President, Lennart Johansson (Figure 1.1). Once more, because of the number of votes vested in that continent, Africa became a critical theatre in the campaigning of both men. Oroc Oyo compares the situation to the period leading up to the 1974 elections:

> We are faced with a similar situation now . . . Africa is now like the bride whose hand everyone is seeking. Johansson was here during the Congress [CAF, Johannesburg 1996], so too was Havelange and each of them at every turn of the road was trying to make his case for the Presidency. In every speech I was reading campaign strategies.
> (Oroc Oyo (1996) interview with author, Johannesburg, 2 January)

There were two main planks to Johansson's strategy to woo the African vote, encapsulated by the 'Visions' proposals (One and Two) presented by UEFA in 1996. In summary 'Visions One' suggested reducing the number of confederations from six to four and rotating both the FIFA Presidency and the World Cup Finals around the four confederations every four years. Cajoled by Havelange, the FIFA Executive diluted 'Vision One', accepting rotation in principle, but not committing FIFA to any short-term practical intervention. Rotation had an obvious appeal to the peripheral confederations, particularly CAF. In fact, according to Emmanuel Maradas, editor of *African Soccer*, 'Johansson's Visions proposals were originally a CAF initiative which, characteristically, were not taken seriously until the Europeans became interested' (Maradas (1996) interview with author, 20 January).

'Visions Two' was a series of proposals designed to alter the financial structure of FIFA, making it more profitable, more accountable and allowing greater freedom for regional and local management of resources. As part of this package, Johansson championed a scheme through which any country which participates in World Cup qualification will receive significant financial assistance *in advance* from FIFA (in Swiss Francs: one million for first round participants; six million for those qualifying for the final round; and twenty million for the finalists). This aspect of 'Visions Two' has great appeal for less economically developed countries, particularly the Africans.

Along with political interference, extreme poverty is one of the most serious obstacles to the development of football in Africa. Regularly countries are forced to withdraw from international competitions because national

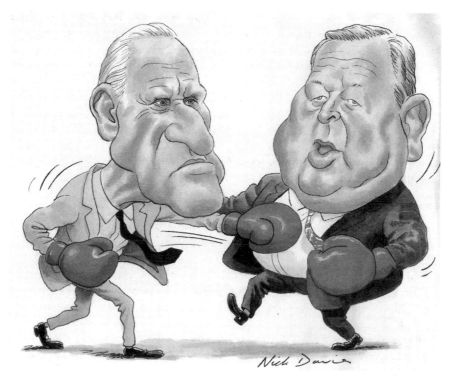

Figure 1.1 Havelange (left) and Johansson square up for battle

Source: Printed courtesy of *World Soccer Magazine*.

federations do not have the money to send their teams abroad. For instance, in the qualification series of the 1996 African Cup of Nations a combination of civil war and lack of funds led to sixteen countries dropping out. For similar reasons, several African countries did not participate in the qualifying rounds for France 1998.

A combination of political instability and economic hardship has led to corruption becoming endemic to many African countries (Bayart 1996). As we have described elsewhere (Sugden and Tomlinson 1996), corruption is a huge problem in African football. Because of this it must be questioned whether or not Johansson's initiative will succeed in having the intended impact at the grass roots of the game there. There is a great danger that a size-able chunk of the one million francs per nation proposed under 'Visions Two' will be re-routed. As Maradas concludes:

Hopefully, the new money for development promised by FIFA will make the national FAs stronger and more autonomous, but there is an equal chance that this initiative will only lead to more corruption.

(Maradas (1996) interview with author, 20 January)

Either way, it was highly likely that Johansson's initiative would pay dividends for him on polling day in 1998, as those who stood most to gain from FIFA's European-inspired largesse were precisely those who would be voting on behalf of their national federations.

UEFA's increasingly close relationship with CAF was formalised in 1997 when Johansson and Issa Hayatou, the President of CAF, signed a co-operation agreement through which Europe pledged itself to providing financial, material and technical support to African football. On signing this agreement Hayatou proclaimed, 'From now on both Confederations are running on the freeway of international football development. They are the pillars of FIFA, the focal point of football on the planet' (Diakité 1997: 127). If this alliance held, and with it Africa delivered its fifty-one votes at the 1998 FIFA Congress, then so long as Johansson could manage to muster Europe's total support, he would be elected as the next FIFA president.

Before his retirement announcement, Havelange appeared to be doing all in his power to prevent this. In a repetition of his 1974 campaign, Havelange tirelessly travelled the African continent drumming up support for his re-election. His main strength was that he had delivered on his pre-1974 promises to develop the game in Africa and, as such, this time any promises he made were sure to carry considerable weight. Already, under his Presidency, African representation at the World Cup Finals had grown from one in 1974 to five in France in 1998. In this regard, Havelange continued to be viewed by many as a champion of the African cause, and, while by 1996 many Africans believed that he had reached an age when he should retire gracefully, if he were to have stood in 1998, they may have voted for him out of a sense of duty:

Africa may continue to support Havelange in 1998 – if only out of sentimentality and Africans are sentimental people. We are loyal to people who have helped us. Unfortunately, this is a trait that Havelange and many other individuals and groups are only too willing to exploit.

(Maradas (1996) interview with author, 20 January)

Never a man to leave anything to chance, Havelange attempted to boost his popularity in Africa by suggesting that an African nation should host the World Cup Finals in 2006. When he spoke of 2006, Havelange had South Africa in mind. Once more Havelange played the South African card, but in an ideological setting which was a mirror image to the one against which operated in 1974:

South Africa, with its superior infrastructure, modern transportation and telecommunications systems and beautiful facilities, has an important role to play in the future of African football in particular, and sport in general. The end of South Africa's isolation can only serve as a further boost to making Africa an even more powerful sporting force on the World stage. I have no doubt in my mind that with her resources, facilities and expertise, South Africa could stage the 2006 World Cup Finals.

(Havelange 1996: 7)

In part this was an attempt to win back some of the ground which he had lost through FIFA's rejection in 1992 of Morocco's bid to host the World Cup Finals – a decision for which many Africans, including the CAF President, held Havelange personally responsible (Majhoub 1997: 120). However, with Germany and England already preparing bids for the 2006 event, Havelange's intervention on behalf of Africa once more infuriated the Europeans who viewed his comments in Johannesburg as shameless vote-catching, and as part of his attempt to split the growing alliance between UEFA and CAF. Even after announcing his retirement, Havelange (at press conferences in Belfast and Cairo, in March and September 1997 respectively) repeated his personal support for South Africa's candidature for 2006.

While Havelange's backing for taking the World Cup to South Africa would have pleased Nelson Mandela, the way he handled FIFA's relations with Nigeria was viewed less favourably by the South African President, as it was by many others throughout the continent and, indeed, throughout the world. The Nigerian case offers a fascinating insight into how the international politics of FIFA can be caught up in the internecine political economics of post-colonial Africa and First World–Third World international relations.

In 1995 Nigeria had been scheduled to host the Under-20 World Cup Finals. In part this was a conciliatory gesture from FIFA to CAF over its decision to favour the USA over Morocco as the hosts for the 1994 World Cup finals. However, at the eleventh hour FIFA rescinded Nigeria's status as hosts and switched the Under-20 tournament to Qatar. FIFA argued that there were too many health risks in this part of West Africa and that European teams in particular had been unable to obtain health insurance for travelling teams. Some observers believe that there was more to this decision than the risk of illness and that it was the product of a neo-imperialist, anti-African arrangement between the West and the oil rich, Gulf Arabs (Quansha 1996; Mahjoub 1997).

Because the main thrust to take the competition away from Nigeria had come from the Europeans, Havelange saw an opportunity to exploit the situation and improve his standing in Africa at the expense of Johansson. In November 1995 Havelange visited Lagos and met with the leader of the

military dictatorship, General Sani Abacha, who feted him like an important foreign head of state. Amidst a liturgy of glowing compliments about his hosts, Havelange apologised for the 1995 withdrawal and pledged to hold the 1997 Under-20 World Cup Finals in Nigeria.

There were three huge problems associated with this promise. In the first place the 1997 tournament was already scheduled to be held in Malaysia. To say the least Havelange's pledge infuriated the Malaysian Federation and seriously damaged the ageing President's reputation throughout the Asian confederation. Second, decisions of this nature can only be taken by the full FIFA Executive and Havelange's *ex-officio* behaviour was a propaganda coup for Johansson and his supporters who were already campaigning on the grounds that Havelange was too dictatorial in the way he ruled FIFA. The affair reached crisis point in Paris on the eve of the 1998 World Cup Draw:

> What should have been a routine debate took on the dimensions of a crisis, as three and a half hours of acrimonious discussion failed to resolve the issue. For the first time Africa and Asia were forced to greet each other coldly. Europe and South America, those other long standing allies also found themselves on opposite sides of the table. The vote, when it was eventually taken, was split along straight regional lines: 11 in favour of Malaysia (eight European plus three Asian) against 9 in favour of Nigeria (three each from Africa and north/central and South America).
>
> (Maradas 1996: 19)

The third and biggest problem for Havelange was the appalling timing of his Nigerian visit. Just as he was busy helping to legitimise the Abacha regime in Lagos, the writer and poet, Ken Saro Wiwa, and eight other Ogoni dissidents were hanged at the General's behest. Saro Wiwa and his clansmen were executed by the Abacha regime for leading a group of activists who were fighting for the rights of the Ogoni people in the face of the exploitation of their traditional tribal homelands by Shell Oil, who in turn, were one of the main contributors to the coffers of the Abacha military government. An authoritative FIFA insider has described this, and is in no doubt that it has damaged Havelange's reputation:

> As if things weren't bad enough, as Havelange is being honoured in Lagos, elsewhere, the Nigerian Government are executing civil rights leaders! An absolute disaster for Havelange and another public relations nightmare.
>
> (interview with author (1996) London, 10 May)

The international outrage at these executions was led by South African President, Nelson Mandela. Previously Mandela had played a leading role in

using diplomacy in an attempt to bring Nigeria back into a more democratic, African fold. Now enraged, he made an emphatic call for oil sanctions against Nigeria and urged Shell to suspend its $4 billion liquefied natural gas project in Nigeria as a mark of protest, warning that 'we are going to take action against them in this country because we can't allow people to think in terms of their gains when the very lives of human beings are involved' (*Africa Today* 1996: 5).

One of the first things Mandela did was to persuade the South African Football Federation to withdraw an invitation to Nigeria to take part in a four nation tournament held in South Africa in December 1995 as a prelude to the African Cup of Nations. In related moves both The Netherlands and Israel refused to allow the Nigerian team to set up training camps and it was only through the personal intervention of Havelange (he threatened to call off the draw) that France was persuaded to allow Nigerian representatives to attend the World Cup draw in Paris on 12 December 1996. An almost inevitable consequence of these sanctions was that Nigeria, the 1994 African champions, withdrew at the last minute from the 1996 African Cup of Nations in South Africa. As a consequence of Nigeria's withdrawal, CAF suspended them from the following two (1998 and 2000) African Cup of Nations and fined the Federation £11,000.

Ironically, Shell Oil was one of the major sponsors of the African Nations Cup. During the final between South Africa and Tunisia a man in the crowd held aloft a placard with a picture of Ken Saro Wiwa on one side and Abacha on the other under the slogan, 'Abacha and Shell go to Hell!'. Meanwhile overhead, and in full view of Mr Mandela, a light aircraft circled Soccer City in Soweto towing a banner proclaiming 'Go Well *Bafana Bafana* Go Shell'.[1]

Whatever the impact of Sara Wiwa's execution on Shell Oil, Havelange's proximity to it certainly damaged his kudos throughout Africa. It is difficult to avoid the conclusion that this loss of face in such a critical constituency was a key factor in his decision not to stand again for the Presidency. FIFA's African affiliates, upon whom Havelange had relied so heavily during the 1974 congress, appeared to be growing disillusioned with the Brazilian's perceived insensitivity towards their needs and aspirations. For example, in response to Havelange's apparent indifference towards Africa's attempts to improve their allocation of places for the 1998 World Cup, Issa Hayatou warned that 'Africa would only work with its friends and that it would fight all those who considered attacking it' (*CAF News* 1996: 16).

As the 1998 Congress loomed closer, Havelange's efforts to canvass support for his ambition to lead the world body into the new millennium, reiterated on BBC Radio (Mellor 1996), were becoming increasingly conspicuous. This was clearly evidenced in the overtures he made to Nigeria, and in his stated support for a South African bid for the 2006 World Cup. However, in the first half of 1996, through his advocacy of Japan's bid to host the 2002 finals, Havelange concentrated his efforts on building support in the Asian continent. In the weeks preceding the hosting decision, though, Johansson had

successfully engineered broad support, from within the FIFA executive, for the proposal that Japan and South Korea co-host the event. Havelange stood firm, intimating that he saw support for Japan's bid as backing for his continued role at the helm of world football (Calvin 1996: 13). The decision to formally ratify the compromise agreement put forward by Johansson clearly had more to do with FIFA's internal politics than with the respective merits of the rivals' bidding packages:

> Nobody doubted that this was anything more than a double defeat for the man who had ruled world football with an iron hand for more than two decades. . . . The European camp, led by the ambitious UEFA chief, Lennart Johansson, had quite simply turned the 2002 attribution into a confidence vote in the old régime.
>
> (ibid.)

Havelange's decision to stand down undoubtedly strengthened Johansson's position, as the only declared candidate for the 1998 election. The Swede and UEFA took nothing for granted, and consolidated alliances central to the campaign strategy – primarily in initiatives to confirm the European co-operation with the African confederation. However, in November 1996 the relationship between Europe and Africa was threatened when Johansson provoked a storm of protest over remarks that he had made during a tape-recorded interview with a journalist, extracts of which were published in the Swedish daily newspaper *Aftonbladet*. In the interview, the UEFA President recalled a visit to South Africa, commenting in what he believed was an informal and light-hearted tone: 'When I got to South Africa the whole hall was full of blackies and it looks hellishly dark when they all sit down together' (*African Soccer* 1997: 38). Johansson's injudicious remarks naturally evoked considerable outrage from the African press over what it saw as an overt display of racism. Sensing a potential and fatal undermining of his position within the African continent, Johansson immediately took steps to underline his anti-racist credentials by commenting that he had 'many black friends', and apologising for any offence that had unwittingly been caused (Radnege 1997: 6):

> I will make an apology to all concerned . . . to make them understand that this was supposed to be sort of a joke. This was a mistake. I hope that they [the Confederation of African Football] will accept my apology because it was not supposed to be connected to racism.
>
> (*Reuters Sports Report* 1996)

Although Johansson's *faux pas* in the Swedish press raised doubts over his appropriateness as a future FIFA president, much of the damage was soon limited by the co-operation agreement, signed in January 1997, between UEFA and CAF (Diakité 1997). Indeed, in view of the significant financial

assistance that this accord committed to the development of African football, it was highly unlikely that CAF would not sustain its relationship with UEFA up to and beyond the 1998 congress. Such a situation augured well for Johansson, as did the fact that no viable alternative candidate had emerged . The names of notable former international players, notably Pelé and Franz Beckenbauer, were discussed in the press. But at the heart of FIFA, in an era dominated by television and sponsorship deals, the claims of international football administrators such as FIFA's Blatter, or Asia's Peter Velappan, represented more credible and realistic challenges, if any further candidates were to join the fight.

Significantly, in the year prior to the succession, Havelange was still bringing his views, and his enduring influence, to bear upon the issue, and promoting speculation on his role in the process (*African Soccer* 1997: 39). At the beginning of the year it was reported that Havelange believed Franco Carraro, President of Italy's professional league, to be an ideal successor (Radnege 1997: 15). Probed at a press conference in Belfast on this issue, Havelange provided a glowing endorsement of the Italian, citing his national and international experience, and concluding that such a pedigree fitted Carraro for the demands of the Presidency (authors' tapes and field notes (1997) 1 March). Given the history of thinly disguised animosity that existed between the FIFA and UEFA leaders, the possibility remained that a 1998 election could be used as an arena in which to settle old scores. Although Johansson remained the sole candidate as the deadline approached, within the context of the restructuring and reordering of alliances and coalitions that characterised contemporary FIFA politics, the late emergence of a new challenger, to what could be classed as the vacant crown of world football, could not be completely ruled out. As Issa Hayatou of CAF declared in September 1997, whilst acknowledging that this was not the perfect moment for any candidature from him personally, 'nothing is certain in life' (interview with author (1997) Cairo, 4 September).

Conclusion: theorising world football

How can we make sense of the seemingly absurd situation through which the execution of a poet in Nigeria, and a decision over a football competition in the Far East, increased the chances of a Swedish football administrator getting a Brazilian's job in Zurich? The development of world football is rooted in the colonial experience. Jules Rimet's conception of FIFA as an extended family follows a paternal and neo-colonial view of world development: the radiation of economic and cultural hegemony from a 'modern' European centre to a 'premodern' Third World periphery. For figures like Jules Rimet, Arthur Drewry and Sir Stanley Rous, football, like Christianity, was viewed uncritically as something which was good for the savages and as such it was FIFA's mission to develop the game in the farthest flung corners of the globe. The success of this mission underpins FIFA's current crisis.

In the African case, football – unlike other sports of the British Empire, such as rugby and cricket – was, from its earliest introduction into the colonies, adopted by indigenous populations as the people's game. Furthermore, throughout Africa, football became a popular forum for the expression of republican aspirations during the struggle for independence. In the post-colonial era, in the absence of military might and economic power, in regions such as sub-Saharan Africa, football has been adopted as one of the most potent symbols for the assertion of national identity and peer recognition in the international arena. Similarly, football has acted as a forum for the assertion of new or resurrected nationalisms in Eastern Europe (Duke 1995; Edelman and Riordan 1994).

In this regard there is a clash between the apolitical, paternalism of a Euro-centric FIFA and the thrusting, politicised view of football which emanates from the organisation's newer members. The fact that the vote of each new member is equal to that of the longest established and most successful football nation led to a situation whereby this clash of interests could be exploited by the traditional enemies of Euro-centrism in world football, the Latin Americans and their champion, João Havelange. Moreover, since Havelange took the reins of power in 1974 the stakes have been multiplied considerably as world football has become a massive commercial market place.

This perspective offers an accurate and yet a relatively descriptive interpretation of the political economy of FIFA. However, some of the terms used (centre-periphery, modern, pre-modern, colonial, post-colonial) provide clues to the location of a more in-depth theorisation. For Wallerstein (1974; 1978), the world coheres around four interdependent sectors whose positions *vis-à-vis* the capitalist world economy have been determined through combinations of colonial history and economic power: the core (north-west Europe, North America and Japan); the semi-periphery (southern Europe and the Mediterranean region); the periphery (Eastern Europe, North Africa and parts of Asia); and the external arena (most of Africa, parts of Asia and the Indian sub-continent). While we may argue with the precision and contents of Wallerstein's sectors, it is hard to ignore the thrust of his argument that the world comprises interdependent clusters of political economies which relate to one another unequally according to the complex working out of their post-colonial heritage.

There are two main challenges facing us in trying to understand FIFA in terms of Wallerstein's model. First, while the six continental confederations of FIFA have some correspondence with Wallerstein's core-periphery typology, significantly they also cut across the model. Thus, while we may wish to consider UEFA as core and CAF as peripheral we also have to be aware that the former includes 'new' and relatively impoverished nations such as Azerbaijan and Georgia, whereas the latter contains economically strong nations such as Egypt and South Africa. Second, 'world systems theory' is essentially an economic model and while international football has a growing economic dimension it must also be theorised as a political and cultural product.

Given FIFA's democratic constitution, football can reveal itself, in terms of international relations, as a powerful political tool, even for countries which are economically and militarily impotent. For such nations, as well as for advanced and traditionally privileged nations, the confederations can offer some potential for operating in the sphere of what Sklair has called 'cultural-ideological transnational practice' (Sklair 1991: 6). At the same time, emergent and assertive nationalisms chant no simple or homogeneous anthem. As Gellner, rooted in the sensitive insights of a comparative political anthropology, reminds us:

> nationalism is not the awakening and assertion of . . . mythical, supposedly natural and given units. It is, on the contrary, the crystal-lization of new units, suitable for the conditions now prevailing, though admittedly using as their raw material the cultural, historical and other inheritances from the pre-nationalist world.
>
> (Gellner 1983: 49)

Add to this the impact of supra-national units such as FIFA and the continental federations, and the alliances between them, and the overall picture is rendered still more complex.

The politics and cultures of world football are not reducible to some cultural dimension of any simple economic model; nor are they to be accounted for in any glib framework of globalisation. We must learn to understand world football and FIFA's role within it in terms of the historically specific contexts within which the game is played and watched as well as in terms of the complex relations of dependency and counter-dependency which impress upon the world's most popular sport. Finally, and critically, to this we must add the dialectics of power and control through which key actors work with the raw material of history to personally influence the shape and direction of institutional development. It is only in this, the fullest context, that we are able to make sense of the political dimension of a trans-national organisation such as FIFA.

Glossary

ACN	African Cup of Nations
AFC (CAF)	African Football Confederation (Confédération Africaine de Football)
FIFA	Fédération Internationale de Football Association
IFA	Irish Football Association Ltd. (Northern Ireland)
UEFA	Union des associations européennes de football (European Football Union)

Note

1 *Bafana Bafana* is the African nickname for the South African national team, and means 'boys, boys'.

Bibliography

African Soccer (1997) 'Havelange steps down, but Johansson blunders', 21, January/February: 38–9.

Africa Today (1996) 'A nation in quarantine', 2, 1 (January/February): 5–6.

Ali, R. (1984) *In the Big League; The Rise of African Football*, London: Festac (a division of Afropress Executive Ltd).

Amnesty International (1993) *Annual Report*, London: Amnesty International Publications.

Bayart, J.-F. (1996) *The State in Africa: The Politics of the Belly*, London and New York: Longman.

CAF News (1996) 'Issa Hayatou: the Cup of Nations will never change', September: 11–16.

Calvin, M. (1996) 'House of Havelange on verge of collapse', *Daily Telegraph*, 31 May.

Darby, P. (1997) *Sport, Politics and International Relations: Africa's Place in FIFA's Global Order*, unpublished D.Phil. thesis, Faculty of Humanities, University of Ulster.

Diakité, A. (1997) 'CAF and UEFA. The Convention of Lisbon', in F. Mahjoub (ed.) *Confédération Africaine De Football 1957–1997*, Cairo: CAF: 124–7.

Duke, V. (1995) 'Going to market. Football in the societies of Eastern Europe', in S. Wagg (ed.) *Giving the Game Away. Football, Politics and Culture on Five Continents*, Leicester: Leicester University Press, pp. 88–102.

Edelman, R. and Riordan, J, (1994) 'The USSR and the World Cup: come on you reds!', in J. Sugden and A. Tomlinson (eds) *Hosts and Champions: Soccer Cultures, National Identities and the USA World Cup*, Aldershot: Arena/Ashgate, pp. 253–78.

Gellner, E. (1983) *Nations and Nationalism*, Oxford: Basil Blackwell.

Havelange, J. (1996) 'Opening remarks', in *CAF/Coca-Cola African Cup of Nations, Official Souvenir Book*, January, p. 7.

Mahjoub, F. (ed.) (1997) *Confédération Africaine de Football 1957–1997*, Cairo: CAF.

Maradas, E. (1996) 'France 1998, World Cup Draw', *African Soccer Magazine* 15, January/February: 18–19.

Mellor, D. (1996) 'The Moguls' – feature on Havelange, *BBC Radio 5 Live*, 11 June.

Nally, P. (1991) Interview transcript (by Simson and Jennings).

Quansha, E. (1996) 'The cup to surpass all cups', in *Africa Today* 2, 1 (January/February): 22–8.

Radnege, K. (1997) 'Black marks mar Johansson's campaign', in *World Soccer*, January: 6–7.

Reuters Sports Report (1996) 'Johansson admits stupidity of racist "joke"', Wire Service, 19 November.

Rothenbühler, U.R. (ed.) (1979) *25 Years of UEFA*, Berne: UEFA.

Rous, S. (1978) *Football Worlds: A Lifetime in Sport*, London: Faber & Faber.

Simson, V. and Jennings, A. (1992) *The Lords of the Rings – Power, Money and Drugs in the Modern Olympics*, London: Simon & Schuster.

Sklair, L. (1991) *Sociology of the Global System,* London: Harvester Wheatsheaf.

Sugden, J. and Tomlinson, A. (1996) 'The price of fame', *When Saturday Comes* 109 (March): 39.

—— (1997) 'Global power struggles in world football: FIFA and UEFA, 1954–74, and their legacy', *The International Journal of the History of Sport* 14, 2: 1–25.

Tomlinson, A. (1986) 'Going global: the FIFA Story', in A. Tomlinson and G. Whannel (eds) *Off the Ball: The Football World Cup*, London: Pluto, pp. 83–98.

—— (1994) 'FIFA and the World Cup', in J. Sugden and A. Tomlinson (eds) *Hosts and Champions: Soccer Cultures, National Identities and the USA World Cup*, Aldershot: Arena/Ashgate, pp. 13–34.

Wallerstein, I. (1974) *The Modern World System*, New York: Academic Press.

—— (1978) *The Capitalist World Economy*, Cambridge: Cambridge University Press.

Other sources:

Author interviews

Official Bulletin of UEFA

FIFA *Congress minutes*

Irish Football Association *Council minutes*

UEFA minutes

2

GREY SHIRTS
TO GREY SUITS[1]

The political economy of English football
in the 1990s

Simon Lee

Introduction

Superficially, all would appear well with the English game. In the late 1980s, English football was confronted with the depressing scenario of falling attendances, antiquated stadia populated by fighting fans off the pitch and declining playing standards on the pitch at both domestic and international levels, these latter trends accentuated by exile from European club competitions following the Heysel tragedy. Despite its declining fortunes, it was only the further trauma of Hillsborough and Lord Justice Taylor's inquiry into the events of the 15 April 1989 (Taylor, Lord Justice 1990) which ensured that a long overdue restructuring of the English game would be undertaken. Less than a decade later, after more than £400 million of investment in ground development and the spectacle of a succession of clubs seeking stock market flotations, the popular image of English football is of modernised, all-seater stadia filled to capacity with well-behaved supporters watching an unprecedented influx of expensive foreign stars. A not entirely unsuccessful return to European club competition by English teams, followed by heroic international failure of the English national side at home in the festival atmosphere of Euro 96, and an unexpected victory in a warm-up tournament for the 1998 World Cup (Le Tournoi, in France), would appear to signify a genuine recovery in English football.

This chapter seeks to challenge this popular image of football by demonstrating that the English game now displays all the symptoms of inequality, short-termism and greed, characteristic of society in general and the City of London's financial markets in particular (Hutton 1995; 1997). Indeed, as one study has suggested, 'Football in England shows all the signs of being a great market failure' because the free market has led to a 'lack of stability, to a

concentration of power among a few firms (clubs), to exploitation of the consumer (fan), to an over-emphasis on advertising, to increased homogeneity of product, and to the neglect of the 'collective' good (in the form of our leagues and our national game)' (Corry *et al.* 1993: 3–4). From the fans' perspective, the whole experience of being an English football supporter in the 1990s has become an increasingly expensive, passive and individualistic experience. Therefore the chapter considers how supporters might, and have responded to these developments before addressing the prospects for English football under the Blair government. The conclusion drawn is that the commercialisation of English football has not created but has merely served to accentuate and legitimise the inequalities that now exist between the richer Premier League clubs and the rest.

A game of two halves?

The popular image of unprecedented prosperity in English professional football disguises the reality for most clubs of ongoing and possibly unsustainable annual losses, cumulative indebtedness and rampant wage inflation. This has been vividly illustrated in the August 1997 *Deloitte and Touche Annual Review of Football Finance*, where the suggestion is that the English professional game's financial position is unsustainable, especially for the fourteen clubs whose wage bill currently exceeds their annual income. Deloitte and Touche have further contended that 'Collectively the game is far from proving that income growth can be converted into sustained profitability' (Boon 1997: 11, 31). Although its income during 1995–6 rose by 10 per cent to £517 million compared to the previous year, the English game also recorded an overall pre-tax loss of £98.3 million, thereby eliminating more than 40 per cent of its net assets in a single year's trading. Once transfer and interest charges are taken into account, the Premier League lost no less than £62.4 million. Premier League clubs would have lost an average of £4 million but for the profitability of Manchester United. One club, Newcastle United, lost an astonishing £23.6 million because of its net transfer spending of £27.6 million (Boon 1997: 21–3). As a consequence of the influx of foreign players, a trend accentuated by the deregulation of the labour market following the Bosman ruling, more than £93 million flowed out of the English game during 1995–6 compared with a net outflow of only £31 million during the previous year.

To finance their £61 million cashflow deficit in 1995–6, English clubs drew upon £58 million from the banks and £62 million from directors and shareholders (Boon 1997: 6–7). A substantial percentage of this finance was required to cover players' wages which rose by 22 per cent on average and by 25 per cent in the Premier League. Indeed, wage and salary costs now account for half the turnover of Premier League clubs and more than three quarters of the turnover of Football League clubs. For their part, supporters on low

incomes have found themselves excluded from possibly their most important and possibly *only* source of collective identity and sense of community. Indeed, an analysis of ticket prices for top clubs by the think tank, Case Associates, has found that prices rose by 222 per cent between 1985 and 1995, compared with a 52 per cent increase in the Retail Price Index during the same period. Increases were not confined to Premiership teams because ticket prices in the new First Division have risen by 169 per cent between 1985 and 1995, by 151 in the new Second Division, and even by 145 per cent in the Third Division (*The Times* 21 July 1997). The *Financial Times* reported that the overall cost of football to the supporter in England rose 16.5 per cent in the season 1996–7, easily four times the rate of inflation (*Financial Times* 16 September 1997).

The growing inequalities between the Premier League and the Football League are demonstrated by the fact that the average annual operating profit of Premiership clubs for 1995–6 was £3.8 million greater than that of Division One clubs (Boon 1997: 6). Deloitte and Touche have identified a growing funding 'gap' between Football League clubs' expenditure and revenue. The Football League collectively lost £42.1 million during 1995–6 and more than £89 million in its past four years of trading. This dire trading performance was not sufficient to discourage the Football League clubs spending more than £58 million on new players during 1995–6. With Premier League clubs increasingly recruiting star players from overseas, the net transfer of £25.2 million during 1995–6 from Premier League clubs to the Football League disguised a long-term decline in this income. In the lower divisions, Division Two and Three clubs sustained a loss of £15.2 million during 1995–6 despite a £5.5 million injection from transfer income which is unlikely to be repeated (Boon 1997: 19).

Furthermore, although the Football Trust has provided £139 million towards ground redevelopment, its revenues from the pools companies and spot-the-ball competitions have declined dramatically from £36.6 million in 1995–6 to £10 million during the financial year 1996–7 as a consequence of the National Lottery. Only the intervention of a £55 million funding package from the new Labour Government will enable the modernisation of League football grounds to be completed by March 2000. Despite their desperate financial plight, when Deloitte and Touche proposed a merger of the Third Division with the Vauxhall Conference and the creation of North and South Divisions to cut travelling costs and increased ticket revenues from more local derbies, the lower Division clubs rejected the proposals.

For much of the post-war period the Football League protected the interests of lower Division clubs by functioning as a mechanism for redistributing power and resources from the old First Division to smaller clubs. For example, it had actively prevented all the top players going to the biggest clubs through measures such as the 'retain and transfer' system and the 'maximum wage'. The League had also imposed a 4 per cent levy on gate receipts (3 per cent from

1986) to provide a further means of cross-subsidisation (Corry *et al.* 1993: 11, 20). However, the present inequalities within the Premier League and between it and the Football League can be traced back at least as far as the mid-1980s, when growing dissatisfaction with the distribution of revenue, especially television revenue, among the then 'Big Five' clubs (Manchester United, Liverpool, Everton, Tottenham Hotspur and Arsenal) led to a renewal of the TV contract in 1988. This gave the Big Five a greater share of the revenue but still provided a vital financial lifeline to the lower Division teams. Although the Football League remained committed to its principle of redistribution through cross-subsidy, in 1991 the Football Association (FA) published its own *Blueprint for Football*. In the wake of the trauma of Hillsborough and the recommendations of the Taylor Report, the FA sought to harness football's rapidly growing commercial potential and reconcile the top clubs' demands for a larger share of revenue with the interests of smaller clubs through the creation of an eighteen-team Premier League.

In the event, the effect of the creation of the, initially twenty-two-team (now twenty), Premier League was to provide the largest clubs with the opportunity to negotiate an exclusive five year, £304 million TV contract with the satellite station, British Sky Broadcasting (BSkyB), which merely whetted their individual and collective appetite for greater autonomy from the domestic game's traditional governing bodies. The principle and practice of cross-subsidy which under the old system had seen income generated from television rights being evenly distributed between English clubs, irrespective of their actual TV appearances or audience appeal, were soon discarded. From this juncture, TV would become the prime agency by which football's existing financial inequalities would be irreversibly widened during the 1990s.

Much attention has understandably been devoted to the sheer scale of modern TV contracts. Most recently, in 1996, BSkyB negotiated a four year deal with the Premiership for exclusive live coverage of Premier League games. The cost was £670 million. On top of this huge sum, the BBC was contracted to provide recorded highlights for an additional £73 million – a considerable sum to pay for the privilege of sustaining 'Match of the Day' as the BBC's sole established Saturday night institution. The gulf between rich and poor could become even wider given the potential dividend from pay-per-view TV after the expiry of the BSkyB deal in 2001. At a time when Leeds United has already become the first club to announce the launch by the end of 1997 of its own subscription channel (*Independent on Sunday* 3 August 1997), Case Associates has estimated that by pay-per-view may be worth as much as £2.3 billion to the Premier League (*The Times* 21 July 1997). The media consultancy firm, Oliver and Ohlbaum, has claimed that under the current £670 million contract BSkyB is paying clubs only half the real value of the rights to broadcast live matches (*Financial Times* 24 June 1997). The stockbroker, Greg Middleton, has estimated that Manchester United could earn £70 million or more per annum from its television rights

within three years of the introduction of pay-per-view (*Financial Times* 9 December 1996).

At the time of writing the Office of Fair Trading are investigating the Premier League for operating as a 'cartel'. Should they rule against the League it would not only make the BSkyB deal null and void – something which would cause its own crisis – but would allow clubs such as Manchester United to pursue their own, highly profitable pay-per-view deals without either having to negotiate with other clubs or share any of the profits with them.

Football comes to the market

The ground-breaking 1992 BSkyB TV contract opened up the possibility to Premier League clubs of entering a virtuous circle whereby their increased revenue would be invested in better players who would attract larger crowds in refurbished but markedly smaller all-seater stadia. The increased demand for tickets would enable clubs to charge a premium, thereby generating higher dividends for shareholders. Suddenly, English football began to appear very attractive to institutional investors. The process of football coming to the market had actually begun in September 1983 when Tottenham Hotspur became the first English football club to undertake a stock market flotation. The flotation's instant success not only raised almost £3.5 million for the club but also provided the club's principal shareholders with a rich and immediate dividend. However, it was not until the October 1989 flotation of Millwall that another English club took the stock market route to instant riches for its shareholders. During the 1990s, six clubs have been quoted on the main stock exchange and twice as many others have chosen to have their shares traded on the City's junior markets, i.e. the Alternative Investment Market (e.g. Celtic) and Ofex, the more loosely regulated 'matched bargain' share market (e.g. Arsenal, Glasgow Rangers and Manchester City).

Recent examples of investor and shareholder interest in English football are legion. During 1997 Charterhouse Development Capital has acquired a 36 per cent interest in Sheffield Wednesday for £16 million, Mosaic Investments has undertaken a £22 million reverse takeover of Bolton Wanderers and Electra Investment Trust has paid £10 million to acquire a 25 per cent stake in Derby County. Singer and Friedlander have launched a Football Fund whose initial £33 million of investors' funds are being half invested in football shares and half in football-related businesses (*Financial Times* 18 February 1997). Even AC Milan is reported to be considering a £500 million stock market flotation in 1998 (*Guardian* 25 February 1997).

Supporters, now seduced by the idea of share issues or full flotation as means of transforming the prospects of their club both on and off the field would do well to reflect not only on the wider economic and social consequences of the Thatcher governments' attempts to foster a share-owning,

property-owning 'popular capitalism' during the 1980s, but also on the kind of disciplines that financial markets have placed upon football clubs following their flotation. 'Popular capitalism', itself a retrospective justification for the redistribution of wealth in favour of the rich induced by privatisation of public utilities and financial deregulation, may have increased the number of small shareholders in Britain from 3 million to 9 million during the 1980s, but the proportion of shares held by individuals simultaneously declined from 28 per cent in 1981 to 20 per cent by 1988. By the same token, a cursory glance at the shares' register for major English clubs which have sought share market listings reveals that the number of shareholders has indeed multiplied but that the clubs remain under the control of the rich men most of whom who ran them before flotation, e.g. Martin Edwards (Manchester United), Sir John and Douglas Hall (Newcastle United), Doug Ellis (Aston Villa), and Alan Sugar (Tottenham Hotspur, although he was not in place before the share flotation of the club).

Popular capitalism as advanced by the Thatcher and Major governments has produced such inequalities in wealth in Britain that one eminent political commentator has suggested that 'Society is dividing before our eyes' into "The thirty, thirty, forty society"' (Hutton 1995: 106–8). Only 40 per cent of the population are held to be 'privileged' by affluence and secure full-time employment, while the remaining 60 per cent are either disadvantaged by unemployment or economic inactivity or marginalised and insecure because of their poorly paid employment. In English football, the distribution of wealth and benefits among clubs, players and supporters appears to be even more unequal than this wider societal distribution. The category of 'privileged' football clubs and players is nowhere near Hutton's 40 per cent category for society as a whole. Indeed, within the Premiership itself, there is a very strong case for arguing that it is only among the 'super-rich' elite of Manchester United, Newcastle United, Arsenal, Chelsea and Liverpool that realistic title winners can be found. For the moment, even some of those major English clubs which have embraced share markets in one form or another – notably Leeds United, Aston Villa and Tottenham Hotspur – appear to have been relegated to the status of frustrated spectators in the race for major domestic and European trophies. Leeds United supporters, for example, have seen their club's owners, the Caspian Group, concentrate on plans for expensive diversification into hosting other sports and pop concerts through ground rather than team redevelopment during the tenure of George Graham's management.

The volatility which flotation on the stock market can impart to English clubs was vividly illustrated during the 1996–7 season which kicked off with only six clubs quoted on the stock market, with a combined market capitalisation of £608 million, but concluded at the end of June with eighteen quoted clubs and a total capitalisation of £1,364 million. What these figures hide is a 29 per cent decline in the clubs' capitalisation during some volatile

spring trading (Boon 1997: 47). Accountants Coopers and Lybrand had warned in February that shares in football clubs were overvalued by about one third (*Guardian* 8 February 1997). The recent performance of individual football clubs' shares provides a salutary warning. For example, in January 1997, Millwall Holdings, the owners of only the second football club ever to secure full stock market flotation, called in the receivers in the face of debts estimated at £10 million. These had arisen both from moving the club from the Den to a new stadium with annual running costs of £3 million and from wage costs which had not taken into account two relegations since flotation. Millwall's fate followed shortly after the December 1996 flotation of Sunderland whose share offer was oversubscribed and whose chairman made an immediate paper profit of almost £19 million. However, Sunderland was relegated from the Premier League on the final day of the 1996–7 season so although flotation provided the finance for the new 41,600-seat 'Stadium of Light', it also left the club without the means to invest in a team worthy of that venue, Sunderland's supporters or an immediate return to the Premier League. In a similar vein, for much of the 1996–7 season, Nottingham Forest was the subject of protracted take-over activity before the acceptance of a £19 million offer. This postponed the major signings necessary to stave off relegation with the consequence that while its new owners now contemplate the large instant paper profits to be gained from a £32 million stock market flotation in October 1997 the club's supporters will simultaneously be enduring First Division football.

Manchester United: from FC to plc

Manchester United's most recent financial results give ample evidence that the club is in a different financial league to any other in England. During the six months trading to 31 January 1997, operating profits rose by 80 per cent to £15.4 million on a turnover up 68 per cent to £50.1 million – an operating margin of 31 per cent, a figure achieved by relatively few large UK corporations. Indeed, the scale of the growing inequalities within the Premier League is indicated by the fact that only four other clubs – Liverpool, Newcastle, Arsenal and Spurs – have an annual turnover larger than this profit figure. Merchandising income alone grew to £17.6 million (Boon 1997: 22). This astonishing financial transformation of a club whose June 1991 flotation saw it capitalised at only £38 million was helped by net transfer spending of only £1.3 million. Since 1993, and during the club's most successful period when it has won the Championship four times and the FA Cup twice, it has not had to dip into the transfer fund set aside to finance new players. Indeed, it spent a net £1.1 million on players during this period, one of the lowest investments by any Premiership club, and an insignificant sum when set against Newcastle United's net £39 million expenditure (Harverson 1997: 23). With its most recent financial results revealing net cash of £39 million,

the possibility that the directors may choose to distribute this revenue as a windfall to investors, or perhaps use it to finance further merchandising diversification rather than to strengthen United's footballing infrastructure, risks the further alienation of long-standing supporters.

Herein lies the paradox at Old Trafford. Accountants Deloitte and Touche have concluded that, in financial terms, United is the biggest club in Europe and quite probably the world (Boon 1997: 43). Indeed, the club's operating profit of £16.7 million for 1995–6 compares very favourably with AC Milan's £17.8 million loss. The problem is that this financial prowess is irrelevant to the majority of United's supporters as long as the club appears too conservative, risk averse and short-termist in its attitude towards further expansion of Old Trafford off the pitch and recruitment of world class players in central defence and attack on the pitch.

The club's directors refuse to contemplate an extension to the capacity of Old Trafford before the onset of pay-per-view television despite the overwhelming evidence that demand continues to vastly outstrip supply. For the 1996–7 season, United closed their membership at 120,000 despite the fact that the season had many months to run. With 40,000 season ticket holders (all paying for their tickets up front), no fewer than 2,000 seats allocated to sponsors, and 3,000 visiting supporters entitled to attend every home match, only 10,000 seats were left to be allocated to the club's membership. Given that club chief executive Martin Edwards had acknowledged that these latter supporters are the most likely to spend the most on the club's range of merchandise, the case for further redeveloping the Stretford End (or West Stand to give it its correct entertainment complex designation) and/or the ageing Sir Matt Busby Way end (East Stand, formerly K Stand) to raise capacity to around 70,000–75,000 would appear sound on both a footballing and a longer term commercial basis. The second area of manifest financial short-termism concerns the club's reluctance to join other major European clubs in being prepared to spend the millions necessary to attract world-class talent. The inadequacies of the United central defence when confronted with the increasing number of international strikers in the Premiership was vividly demonstrated in the 5–0 defeat at Newcastle and, more embarrassingly, in the subsequent 6–3 rout at Southampton in 1996. However, it was Manchester United's failure in the semi-final of the 1996–7 European Champions League to beat Borrussia Dortmund, the eventual winners, because of the absence of a world-class striker with sufficient composure to convert just a few of the string of chances created in the second leg of the semi-final at Old Trafford, which was to prove the most expensive consequence (in footballing terms) of financial short-termism.

During the summer of 1997, Martin Edwards asserted that United had made no fewer than five bids (sequentially rather than in combination) of £10 million or more in an attempt to strengthen the squad – but without success. The logic of the club's strategy to be content with the recruitment of

the 31 year old, £3.5 million, Teddy Sheringham rather than a younger and more expensive foreign alternative can only be fully appreciated when the financial consequences of such signings and victory in the Champions League are fully understood. Announcing the club's most recent financial results in April 1997, Edwards not only confirmed that the cost of the players' salaries had increased by £6 million but also stated that the players' bonuses which would have to be paid out if the Champions League was won would eliminate any financial benefits from being champions until the following financial year. Thus, the short-term financial benefits, in terms of TV, ticket and merchandising revenue, to be derived from a run to the semi-final rather than the final of any major European cup competition would appear to outweigh those to be derived from a victory in the final. Likewise, the repeated failure to sign more expensive players, whose arrival might both further inflate the club's salaries bill (principally through the knock-on impact it would have on the upgrading of other players' salaries which would be demanded by their agents) and exacerbate players' demands for a greater personal share of merchandising income, is financially prudent in the short-term. But it does mean that unless United's outstanding youth policy is able to generate world-class players to fill the weaknesses in central defence and attack, very clear limits have now been placed upon the European trophy winning capacity of England's biggest and now most successful team, especially given that many of its major continental European rivals remain willing to speculate in the transfer market to accumulate the top European trophies.

So dramatic has been the rise in United's financial and domestic trophy-winning fortunes during the 1990s, that financial analysts and glory-hunters too easily forget the barrenness of the late 1980s. Loyal supporters are not so easily party to selective amnesia. As early as the financial year 1983–4, the club had made record profits of £1.73 million. Indeed, in the wake of Tottenham Hotspur's successful October 1983 stock market flotation, Martin Edwards had been prepared to sell United to Robert Maxwell for a reported £15 million (Crick and Smith 1989: 184). For many supporters, the contemplation of this ultimately uncompleted transaction marked their transition from suspicion about Edwards' ultimate motives to an attitude of open hostility. What has caused such bitterness between Edwards and United's supporters has been the amount of money which he and other shareholders have raised from the club. Despite the club's spectacular lack of success in the late 1980s, by July 1989 Edwards had been paid £535,000 over the previous six and a half years (Crick and Smith 1989: 200). This was despite the fact that for the seasons 1987–8 to 1989–90, average Division One attendances at Old Trafford fell below 40,000 with the average of 36,247 for the 1988–9 season including the humiliation (for those, including this author [and editor!], in attendance) of only 23,238 for the end of season fixture versus Wimbledon. It was at this juncture that Edwards entered discussions with Michael Knighton for the sale of Edwards' 50.2 per cent controlling interest in the club for which Edwards

wanted £10 million. After the Knighton take-over fell through, Edwards offered to sell his stake to a fellow director, Ader Midani, for £15 million.

The failure of the Midani negotiation in December 1989 coincided with the turning point on the field for the team under Alex Ferguson's management. Victory in a difficult FA Cup tie at Nottingham Forest presaged a successful Cup run culminating in victory over Crystal Palace in an FA Cup Final replay. Despite the recovery on the field, Martin Edwards announced his intention to sell the club at the end of the season (Crick and Smith 1989: 300). However, the successful £13 million stock market flotation of lowly Millwall in October 1989 alerted United shareholders to the instant profits and richer dividends to be secured from stock market flotation These dividends duly began to flow in ever larger amounts following flotation in July 1991. In the subsequent period, United has spent £69 million to build up its business but it has been supporters rather than major shareholders who have financed United's expansion, primarily from much higher ticket prices and expensive merchandise. The £23.5 million to be spent over the next three years on further expansion can be easily financed given that the club is sitting on a bank balance of £21 million (Harverson 1997: 23). Only once has Manchester United gone to the market to raise revenue by a placement of equity. It is significant that in December 1996, when the club placed 3 million shares with City institutions thereby raising £16.7 million, it provided assurances that this additional capital would be used solely to finance the physical infrastructure of the club, namely the new North Stand and the construction of a new training ground. On no account would it be used to strengthen United on the football pitch.

The same directors who came so close to selling the club in the late 1980s have profited handsomely from the spectacular rise in the value of the club's shares. For example, by June 1997 Ader Midani had raised more than £10 million from United share sales in less than two years. However, it is Martin Edwards and his family who have been the principal beneficiaries. In March 1996, Edwards sold 1.6 million shares at 270 pence. Subsequently, the Edwards family sold a further 2.2 million shares in June 1996, reducing their stake in the club to 17.2 per cent of shares but raising £16.6 million in a single transaction. At this time, they were joined by finance director Robin Launders and club solicitor Maurice Watkins whose own share sales together netted a further £1.75 million. Had the directors been prepared to back Alex Ferguson with the cash needed to buy a world class centre forward or to part-finance Old Trafford's further expansion, no genuine United supporter could have begrudged the directors their dividend from an investment in the future growth of the club. What has inspired a 'love the team, hate the club' mentality in so many United supporters has been the contrast between the continual profit-taking of directors and the club's apparent hesitation over Alex Ferguson's new contract and subsequent refusal to pay Eric Cantona – the talisman and prime mover of so much of the footballing and

merchandising success at Old Trafford during the 1990s – an *ex-gratia* payment for services rendered to the club. Cantona's contract may have been honoured in full and he may have had no legal grounds for redress against United, but at a time when the club has spent £4 million to relocate its museum in the North Stand, the club's grinding commercial logic appeared inappropriate for an institution with pretensions to be regarded as the world's largest football club. At the very least, a 'testimonial' match could have been arranged at Old Trafford which would have provided not only the opportunity for Cantona to grace the turf at Old Trafford one final time and for supporters to say a proper farewell to their greatest modern hero, but also the revenue for the club to be seen to behave generously towards a unique talent without that gesture having to cost the shareholders a single penny.

Recapturing football?

The unequal struggle between club and supporter is vividly illustrated by events at Old Trafford in recent seasons. The example of the Independent Manchester United Supporters Association (IMUSA) is very instructive about both the potential for and the limitations of 'fan democracy' for influencing the activities of clubs, especially those that have chosen to embrace the financial disciplines resulting from flotation on London's share markets.

IMUSA was formed by supporters in April 1995 and soon became part of a growing national network of independent supporters associations throughout England created by supporters increasingly frustrated at their cavalier treatment by the clubs to whose teams they owed allegiance (see Brown, this volume). Aside from the services it has laid on for its members, IMUSA has campaigned vigorously on behalf of all United supporters. For example, IMUSA has established a share club to enable its members to purchase blocks of shares and thereby organise effectively at shareholders' meetings to articulate the viewpoint of ordinary supporters. Although the number of shares held by IMUSA members is extremely small, by asking pertinent questions at shareholders' meetings, IMUSA members have encouraged larger individual and institutional shareholders to adopt a less deferential attitude towards the United board. IMUSA had also submitted its own *Redprint for Change* to the United board. *Redprint for Change* primarily addressed various ticketing issues, not least the displacement (without consultation) of long-standing season ticket-holders from their normal seats due to expansion of corporate hospitality in the redeveloped North Stand, the loss of the famous Old Trafford atmosphere, the restrictions on the active participation and expression of fans inside the ground and the need for a regular dialogue between club and supporters. The club has stood steadfast against most of IMUSA's ideas, especially the need for dialogue.

IMUSA's greatest triumph came away from Old Trafford when it, alongside the Football Supporters Association (FSA) to which it is affiliated, leapt to

the defence of the United supporters falsely accused of starting trouble in Porto when they had in truth been victims of dangerous congestion and unprovoked assaults from the Portuguese police both inside and outside FC Porto's stadium (Brown 1997). Through collaborative and concerted action, and following a damning FSA report of the incident, IMUSA, the FSA and club representatives were able to clear the names of United supporters (believed to be the first time that UEFA have exonerated English fans for violence on the Continent) with the result that the subsequent UEFA Disciplinary Committee found FC Porto to blame, resulting in an admittedly derisory £40,000 fine.

Closer to home, IMUSA's greatest frustration has been its inability to persuade club officials to engage in a regular dialogue, especially over IMUSA's desire to establish designated 'singing/standing areas' inside Old Trafford, i.e. areas of the stadium where supporters would be able to stand up to express themselves in the traditional manner of English supporters without fear of retribution. The club has demonstrated an inconsistent attitude towards standing areas, oscillating between open hostility via ambivalence to tacit acknowledgement that this might be a constructive measure. For his part, following a pathetically quiet home crowd during a home defeat by Chelsea in October 1996, Alex Ferguson's programme notes identified 'the growing number of corporate hospitality packages' as the root cause of the lack of a vibrant atmosphere (Figure 2.1). However, Ferguson's public concerns were dismissed by other club officials. In correspondence with an IMUSA member, club secretary, Ken Merrett, commented 'it obviously cannot be said to have affected the team too much since they have completed the Double Double' (IMUSA 1997: 1). Another club official suggested in correspondence that while the manager had the 'right to express his own opinions . . . there might be others who do not always share his views' (IMUSA 1997: 1). The 'others' in this case were never specified.

The standing areas issue needs both urgent attention and resolution. The 1997/98 season began with the farce of members of the security firm employed by the club (Special Projects Security) being used to eject no fewer than forty-one United supporters from the opening home fixture against Southampton *not* for fighting, racist abuse or drunkenness but for the offences of standing up to support their side and/or seeking to gain a better view of the match. Spurious arguments have emanated from club sources concerning contravention of ground regulations and the threat of parts of the stadium being closed down by the local authorities. Even a cursory glance at any edition of 'Match of the Day' reveals that supporters at grounds throughout the Premier League regularly take to their feet – not least because of the poor alignment of seating. Furthermore, no complaints were heard from the club following the home Champions League fixture against FC Porto in 1996–7 or in the famous victory against Juventus a season later, when most of the crowd behind both goals spent the entire match on their feet. This provided

RedIssue

Stand up for the Champions

"I don't want a stadium that is inhibited and restricted. I want to see the crowd on its feet cheering the team on. That's passion and it's part of football. Football should be a release for people. If you don't let people stand and shout and encourage their team, they just bottle up their frustrations!"

Volume 9 Issue 5 December '96 **£1**

Figure 2.1 Red Issue supports Manchester United manager Alex Ferguson's calls for a better atmosphere at matches

Source: *Red Issue* 9, 5. Reprinted with kind permission of *Red Issue*.

the sort of atmosphere reminiscent of an earlier era, when terraces were still in place, which helped to inspire United's finest home performance since the 3–0 defeat of Barcelona in 1984 – the occasion of another memorable team performance driven by an atmosphere bordering on the riotous.

When the greatest threat of violence inside an English football stadium is between supporters of the home team and the security firm hired by their own club, it is evident that a better means of communication between clubs and supporters has to be found. The very need for supporters to campaign for the right to stand at football matches is an indictment of the modern English game. Further confusing the inconsistencies in approach, the problems at United were one of the causes promoting Martin Edwards to declare that he would like to see a change in government policy to allow a reintroduction of limited terracing at Old Trafford (*Channel 4 News* 2 October 1997) – something which would solve the conflict over standing in seated areas; would be supported by all fan groups; and, perhaps most significantly, would allow Manchester United to expand the ground capacity without recourse to costly rebuilding.

As a contribution to the debate about the governance of football, the Fabian Society has published *Football United* (Perryman 1997). Among Mark Perryman's many and diverse suggestions for closing the chasm between clubs and supporters are the establishment of weekly 'fan forums' and elected 'fan juries'; the creation of OffFOOT, a regulatory body to protect supporters' rights as consumers; and the launching of 'Football United', a single, united body to promote football financed by an agreed percentage levy on all sponsorship deals, broadcasting agreements, and transfer fees (Perryman 1997: 4–10). An earlier study by another left-wing think tank, the Institute for Public Policy Research had similarly suggested that the only means to address the growing inequalities within the English game was for the imposition of external constraints on the activities of the big clubs (Corry *et al.* 1993).

Given its origins from a think tank historically associated with a metropolitan, middle-class intellectual elite, and because its author's own business (Philosophy Football – producers of shirts celebrating the philosophy of football) is itself a symptom of the commercial invasion of football culture by expensive peripheral merchandise (how many Philosophy Football shirts are seen at St James Park or Old Trafford?), it would be easy to dismiss *Football United* as merely the latest attempt by the chattering classes to interfere in the people's game. This would be a mistake. *Football United* touches upon some of the key questions concerning not only the inequalities between the financial power of the top English clubs and increasingly distant lower Division clubs but also the remoteness of supporters from the players and clubs which they cherish. Perryman correctly acknowledges the difficulty confronting the Labour government's Football Task Force and the Minister for Sport given New Labour's tight control on the public spending. However, he further suggests that the issue is one of 'persuading the major investors in football –

the sponsors, the broadcasting companies, those individuals and companies who own the clubs – that the proposals are in their best interests' (Perryman 1997: 4). It is at this point that Perryman's argument addresses the critical issue, namely the willingness of the government to intervene to regulate the activities of commercially-driven Premier League clubs in the wider interests of the English game and to provide supporters with a genuine stake in their game's governance.

New Labour, new football?

The share-owning democracy promised by popular capitalism has not offered supporters a greater influence over English football. Does the idea, promoted by Tony Blair before his election as Prime Minister, of 'stakeholding' provide a more viable alternative for supporters? The attraction of stakeholding is that it recognises that in any business, it is not just the owners and or shareholders who have a legitimate interest or stake in the business's performance. Either directly, through market transactions, or indirectly through their exposure to external effects of the business's activities, individuals and the wider community are legitimate stakeholders in any business. However, while shareholders in a business have their interests protected by company and property law, other stakeholders can only safeguard their interest through laws relating to trade and employment, by contracts or by concessions granted at the discretion of business managers (Nuti 1997: 14). Beyond the point up to which stakeholders' interests are protected by voluntary action by the business's directors or management, it is only through public policy and the intervention of government legislation and regulation that stakeholder interests can be guaranteed.

The relevance of stakeholding for football supporters is immediate. In their hundreds of thousands, football supporters hold a stake in their clubs which is not normally based on any property or share ownership. Although their financial commitment to their club may be limited to the purchase of tickets and club merchandise (a percentage of their annual income often greater than that committed by major shareholders), supporters' stakeholding is based on something equally powerful and tangible, namely a long-term (possibly lifelong) allegiance to their club. The problem with stakeholding is that while it offers an attractive political design, 'it is indeterminate and ambiguous until it is articulated into detailed specific proposals' (Nuti 1997: 17). To impose a statutory obligation upon football clubs to take into account all their stakeholders' interests will remain an indeterminate objective, unless legislation clearly specifies which stakeholders' interests are to be taken into account and when, and which interests are to be accorded primacy, i.e. whether in particular circumstances supporters' interests are to be granted primacy over those of shareholders should a conflict arise. For the present, this debate will remain purely academic because, with the notable exception of the utilities' tax, the

Blair government appears to have hollowed out the concept of stakeholding in refusing to contemplate legislation which might alienate shareholders and investors by subordinating their financial interests to the longer term interest of the community.

It is the creation of the Football Task Force (FTF) which is most instructive about what football supporters and fans alike can expect from New Labour. The FTF, chaired by David Mellor QC was established in the summer of 1997 and comprised two bodies: a representative, fifteen-member 'main' Task Force group of all the key football organisations; and a 'Core Working Group' of eight individual appointees which has undertaken much of the research and information gathering, including regional 'fan forums'. This latter group includes Sir Roland Smith, Chair of Manchester United plc, as well as the Chief Executive of the Premier League, although the powerful club chairmen are notably absent from the main FTF body.

The Task Force has been given a wide-ranging remit to examine important issues in English football, such as racism, treatment of English fans abroad, ticketing and the relationship of fans to the commercial operations of clubs. Given that the FTF has no legislative powers, and given the reluctance of the Labour government to interfere in the affairs of private business, the FTF appears to be the political equivalent of the midfield player who does a lot of unselfish, off-the-ball running – a lot of energy expended but ultimately a minimal contribution to the game's overall shape and direction. At the time of writing it appears that in terms of addressing the issues of inequalities both of income among clubs and access to grounds for supporters, the FTF is unlikely to deliver anything stronger than a voluntarist Code of Conduct or Best Practice for clubs rather than statutory regulation to change their corporate governance.

Given its pretensions to be a business-friendly government, and Tony Blair's use of Marks and Spencer as an allegory for effective political management, it is highly unlikely that the Blair government will risk confrontation with football's financial interests when it has already declined to confront them in other sectors. Legislation is likely to be confined to the issues of racism and ticket touting – albeit that these will be highly commendable developments should they be enacted (see Osborn and Greenfield, this volume). It can only be a matter of time before the rhetoric of stakeholding and empowerment is applied to the English game. Football supporters will then acquire the label of 'stakeholders' to add to the unwanted appendages of 'investors' and 'consumers' given to them by City financiers and multinational merchandisers, but the powerful vested interests now driving English football will remain unchallenged as the concept of stakeholding is hollowed out for football supporters as it has been in other spheres by New Labour (Lee 1997).

Given that it is unlikely that the government will place fan-friendly economic conditions on the (considerable) amounts of public money provided to football, the FTF appears as yet another example of New Labour's

consumer-driven and media-friendly managerialism, which in its early breathless months has spawned a frantic succession of policy initiatives whose energy gives the impression of activity and direction but whose very number betrays an absence of strategy and substance.

Conclusion

During the 1990s, as English football has absorbed the impact of deregulation in financial and broadcasting markets to embrace the values of the entrepreneur-driven enterprise culture that the Thatcher governments set out to create during the 1980s, the ties of community which once created a bond between players and supporters have now been largely extinguished. The commercialisation of English football, at least at Premiership level, has both sanitised and anaesthetised the experience of being a football supporter. This, above all emotional, experience, which cannot be reduced to the level of individual consumption or a market transaction, has long provided people living in England with an important source of their collective, often civic, identity and pride. More recently, for many it has served as a vital source of community, identity and sanctuary from the selfish and materialist values of Thatcherism as it sought to dismantle so many other means by which the English could imagine themselves to be something more than the sum of increasingly isolated individuals. Because the Blair government's wider political agenda is working within rather than fundamentally challenging the terms of Thatcherite political economy, and indeed in some areas rolling its frontiers further forward, New Labour is unlikely to offer anything more substantial to supporters than a series of high profile, media driven photo opportunities. English football has long since overdosed on such drivel.

It may be unrealistic to imagine that supporters can challenge the overriding influence and corporate wealth of their clubs' institutional shareholders unless they are prepared to resort to forms of behaviour and tactics which will undermine investor confidence by destabilising clubs' share prices. Investors dislike uncertainty. Fortunately, it is their very numbers and huge potential market impact (when purchasing of merchandise is withdrawn) which offers English supporters a most potent weapon. Admittedly, the retort that will instantly emanate from club chairmen is that such activity merely reduces the cash available for purchasing new players or renewing existing contracts. No supporter-driven tactic will be without its cost but any collective activity will be beneficial which enables supporters to come together to defy the corporate merchandisers and artificial uniformity of all-seater stadia which itself would render passive and individual the modern experience of being a football supporter in England. Such activity will enable older supporters to rediscover that collective intensity, passion and camaraderie – in short, atmosphere – which makes football the greatest game to follow. Most importantly, it will demonstrate to younger supporters and recent middle-class converts,

that there is still more to being an English football supporter than the possession of a replica shirt and a satellite dish.

Note

1 This refers to Manchester United's use of a grey 'third' strip at a game at Southampton in the 1995–6 season which United were losing. The strip was infamously ditched half-way through the match on the grounds that the players could not distinguish one another properly. Alex Ferguson, referring to strip manufacturers Umbro's relentless issuing of new kits for the club (a major money-spinner), declared that 'enough is enough' ('Match of the Day' 13 April 1995).

Bibliography

Boon, G. (ed.) (1997) *Deloitte and Touche Annual Review of Football Finance*, Manchester: Deloitte and Touche.

Brown, A. (1997) *A Report Into Events at FC Porto v Manchester United, European Champions League Quarter-Final, March 19, 1997*, Manchester: Football Supporters Association.

Corry, D., Williamson, P. and Moore, S. (1993) *A Game Without Vision: The Crisis in English Football*, London: Institute for Public Policy Research.

Crick, M. and Smith, D. (1989) *Manchester United: The Betrayal of a Legend*, London: Pan Books.

Harverson, P. (1997) 'When size is the biggest asset', *Financial Times* 8 April: 23.

Hutton, W. (1995) *The State We're In*, London: Jonathan Cape.

—— (1997) *The State To Come*, London: Vintage.

IMUSA (1997) 'It's all about opinions Ken', *Red Print* 9, January/February: 1.

Lee, S. (1997) 'Competitiveness and the welfare state in Britain', in M. Mullard and S. Lee (eds) *The Politics of Social Policy in Europe*, Aldershot, Edward Elgar.

Nuti, D. (1997), 'Democracy and economy: what role for stakeholders?', *Business Strategy Review* 8, 2: 14–20.

Perryman, M. (1997), *Football United: New Labour, The Task Force and the Future of the Game*, London: Fabian Society in association with *When Saturday Comes*.

Taylor, Lord Justice (1990) *The Hillsborough Stadium Disaster (15 April 1989), Inquiry by the Rt Hon. Lord Justice Taylor, Final Report*, Cmd 962, London: HMSO.

3

UNITED WE STAND

Some problems with fan democracy

Adam Brown

[I]f that's the direction we're headed in, me and millions like me
will stop going. Because this is our game, this beautiful game –
it doesn't belong to Coca-Cola or JVC, or to Mars or
Gillette. . . . So keep your hands off, greedheads. It's a game of
two halves – and we like it that way.

(Davies 1991: 471)

The problem

This chapter is concerned with the issue of fan democracy in football and
focuses on recent developments in England. It considers the role of supporters
in the game and in particular their response to changes in the football
industry since the Taylor Report (Taylor, Lord Justice 1990). It raises questions
of regulation and control, but also of participation and exclusion, of the
organisation and operation of power in football. The chapter will outline the
main issues – should we be concerned with fan demands for participation in
the running of football?; what issues have mobilised fans? – and then will
move on to look in some detail at two ways in which groups of supporters
have responded to changes in the game since Taylor.

The last decade or more has seen a fairly concerted attempt by football
supporters to try and gain control or influence the game. There have been a
myriad of supporter protest groups formed – at club and national level, trying
to remove an unwanted chairman or board to resisting FA and government
policy – which have signified a qualitative and quantitative shift in the nature of
the consumption of football. There are now over forty independent supporters
organisations at club level in England, two national supporters bodies and a
host of other – some short lived – grass roots protest groups as well as hundreds
of fanzines (Haynes 1995). It is important, if we are to understand the balance
of power in football, to understand the phenomena of supporters' organisation
and their demands for the democratisation of football.

Fans' organisations in England in the 1990s[1]

There are two main national supporters bodies: the Football Supporters Association (FSA) and the National Federation of Football Supporters Clubs (NFFSC). In addition, there is the recently-formed National Association of Disabled Supporters Clubs as well as a number of very small-scale campaigns.

The oldest of these bodies – the NFFSC, formed in 1927 – is a federation of club-based supporters' organisations. It represents a somewhat 'official' aspect of football fandom: many of the supporters' clubs are tied to their clubs (often travel clubs rather than campaigning organisations) and have been involved in raising money for the club, facilitating relations between supporters and clubs, but rarely influencing the direction or decisions of the football industry.[2] However, it should be noted that the NFFSC has suffered badly from its own image – that of an older organisation, with lifetime presidencies and a lack of individual membership, little visible internal democracy, little awareness of its existence amongst fans and even its own members, lack of campaigning credentials and representing what many fans consider to be establishment values (Crabbe and Brown 1996). It has also suffered in terms of profile since the formation of the FSA, who have achieved a much higher media profile.

The FSA was formed in the wake of the Heysel Stadium tragedy in 1985, prompted, according to current Vice Chair and founding member Shiela Spiers, because 'it was felt that ten supporters from each team [Liverpool and Juventus] could have organised the event better' (conversation with author). However, the FSA was also a reaction against the establishment sympathies of the NFFSC and their inability to campaign effectively on supporters' behalf. The FSA is an individual membership-based organisation built around regional branches rather than clubs, and with branches, affiliates and individual members attending an annual conference to establish policies.

The FSA has been particularly successful in creating a media space for supporters, and raising supporters concerns on a national level. It has also campaigned very effectively on a number of issues: against the Thatcher governments' ID Cards scheme (Smyth 1990; Jary et al. 1991; Brown 1997a); against racism in football (it was central to the Kick Racism Out of Football Campaign (Back et al. 1996)); and for a better treatment of English supporters abroad (Brown 1994, 1996, 1997b; Pilling 1997; Lee this volume), including the running of 'fan embassies' at major international tournaments (Beauchampé 1996).

The FSA has a certain credibility amongst supporters which the NFFSC lacks, an independence from clubs and football authorities, a non-parochial perspective, and an established track record as both a campaigning organisation and as informed commentators with genuine links to supporter culture and groups. However, it has suffered due to its inability to create a mass membership base, which has threatened its representative role as well as its

financial stability, and has suffered due to its lack of membership structure at club level (Crabbe and Brown 1996; Brown 1997a).

Of more concern in this chapter, however, has been the development of 'Independent Supporters Associations' (ISAs) at club level in English football, which have informal, *ad hoc* links with each other, but no national structure. Indeed a number of ISAs are affiliated to the FSA and share concerns over the development of the game at a national level, whilst others have remained distinctly parochial.

What ISAs have illustrated is that the primary attachment of football fans (to their club) also translates into their likely primary activity in the realm of democratisation. ISAs have appealed to supporters of particular clubs in a way which the NFFSC (because of the organisation's nature) or the FSA (because of its national orientation) have been unable to. Some ISAs have established very effective and extremely popular campaigns, although attempts at broadening these to a national level (a merger with the FSA has been discussed) have not occurred and have highlighted divisions between different ISA approaches (Pinto 1997). A further weakness of ISAs is that they are often very transient affairs, which decline in numbers and activity once the immediate cause of concern has gone.

Furthermore, it would be remiss not to mention the several hundred football fanzines, which, whilst not the immediate focus of concern here (see Jary *et al.* 1991; Haynes 1995), have also played a crucial role in inspiring the formation of organisations, raising issues and acting as information disseminators and campaign publicisers. Perhaps more broadly, fanzines have been central in developing 'cultural contestation' (Jary *et al.* 1991) or a 'culture of dissent' (Brown 1997a) in contemporary football. Nation-wide campaigns run by the FSA, such as the ID Card campaign and the United Colours of Football anti-racism initiative, have utilised the fanzine network to mobilise supporters, although fanzines are not primarily campaign organisations.

Issues

It is now necessary to briefly outline the main motivations behind the formation of club-based supporter organisations. In this I will not be focusing on national campaigns or national organisations but on club-based ISAs. National bodies such as the FSA have been considered elsewhere (Jary *et al.* 1991; Redhead 1991; Brown 1994, 1997a) and it is with the particular mechanics of organisations at two clubs – Arsenal and Manchester United – on which I wish to dwell.

The Hillsborough disaster and subsequent Taylor Report have played a pivotal role in the development of football in England in recent years. The Taylor Report has, as Ian Taylor (1992) has argued, been one of the determining factors in the contemporary regulation and control of the football industry. For the fans it has proved a particular focus for attempts to democra-

tise the game: most importantly, the implementation of all-seater stadia is central to the fans' belief that they have as little influence over the industry as ever. Further, the Taylor Report has proved to be the single most important catalyst for the modernisation of the English game, its clubs and their commercial strategies which have formed the basis of many of the concerns of supporters (see also Lee, this volume).

It is perhaps notable that it is those developments which supporters feel have restricted their access to the live game and cut the 'space' within that live event for fans' expression and participation which have been the primary causes of supporter protest in recent years. The other main focus of fan campaigns has been the antagonisms caused by the actions of particular club chairmen, although it is important to note that many of these are not unconnected to the modernisation and commercialisation of football in the 1990s, either in a desire to compete with the richest clubs or in battles for survival.

Thus, it is important to note, for instance, those campaigns at Brighton and Hove Albion, Manchester City, Tottenham Hotspur, Glasgow Celtic, Queens Park Rangers and Ipswich Town (against club chairmen and boards of directors), and Southampton (against the then manager, Ian Branfoot) which illustrate ways in which supporters have attempted and sometimes achieved significant victories in determining the running of their clubs. What is important about these protests is that it is difficult to think of any other industry where those at the bottom of the hierarchy have been able to overturn the running and ownership of what are multi-million pound enterprises. It illustrates above all else the power that supporters *can* wield and represents a politicisation of football's fandom and an economic and ideological challenge to the *status quo*. However, it is with fans' reactions to the aftermath of Hillsborough on which I wish to concentrate as these seem to be more centrally concerned with access and participation in football nationally.

All-seater stadia were introduced in all grounds (bar a few special dispensations) by the end of the 1994 season. However, they have proved highly controversial for a number of reasons. As Lord Justice Taylor admitted, the requirement for all-seater grounds was opposed by fans organisations that gave evidence to the Inquiry (Taylor, Lord Justice 1990: para. 66–72). Furthermore, both the implementation as well as the lived experience of all-seater grounds has made many supporters unhappy due to reduced capacity, increased prices, bond schemes, a decline in atmosphere and greater regulation of their activities.

Despite the safety issue at the heart of the Taylor Report (and this has been challenged by fans and designers of safe standing areas)[3] for the clubs the Report represented an opportunity to modernise and revolutionise football, and football supporting. For some it represented a chance to change the social make-up of those attending (and thus provide a more attractive audience for advertisers); for others it represented a chance to charge more for entrance and thus generate more profit. Generally there was some combination of these motivations, but it seems fair to say that the general feeling amongst

football supporters is that safety is not the clubs' primary motivation, contrary to Lord Justice Taylor's intentions:

> As to cost, clubs may well want to charge somewhat more for seats than for standing but it should be possible to plan a price structure which suits the cheapest seats to the pockets of those presently paying to stand.
>
> (Taylor, Lord Justice 1990: para. 72)

It is certainly clear that with price increases of 350 per cent over five years (Crabbe 1996) and with the cost of football spiralling at a rate of 16.5 per cent in 1996–7 (*Financial Times* 16 September 1997), Taylor's wishes have been conveniently forgotten by most clubs.

At the end of the 1991–2 season, many clubs, faced with the requirement to make their grounds all-seater by the 1994–5 season, sought ways of raising the necessary capital for converting old terraced areas to new, all seated stands. I would like to look at two examples of how clubs approached this problem, and how supporters reacted to these plans. In particular reference to the supporters' reactions, I will concentrate on Arsenal and Manchester United.

A final general comment is that for many fans it appeared at this time that football was being 'taken away' from them. Perry Dyball, a Norwich City supporter, has illustrated supporters' feelings behind the changes and also highlights one key difficulty in organising fans' opposition:

> It is not just a club, it's mine. It's one of the most important things in my life . . . and they know that, they can play on that loyalty and get away with anything because they know that you're still going to turn up . . . I don't care whether my stand's got a roof over it. I don't care if I've got a nice comfy seat to sit on. I want to see the game.
>
> ('Shut Up and Sit Down', Open Space, BBC2 TV, March 1993)

The strength of football as a social institution, which has remained a central feature of British popular culture for over a century, and the passion and loyalty which club attachments produce, make it very difficult for fans to challenge the running of the game. This echoes Rogan Taylor's recognition of the supporters' position as, 'neither straight "consumers" of a leisure product, nor . . . legitimate participants in the game' (Taylor, R. 1992: 179).

Fans' responses

1–0 to the Arsenal: the Highbury case

Arsenal (and in a similar scheme, West Ham United) launched a 'bond scheme' at the end of the 1990/91 season. This was a means whereby

supporters could buy the 'right' to then buy a season ticket in the newly built stand, which would replace the North Bank terrace, the traditional 'home' end at Highbury. For Arsenal supporters, this meant that they had to spend between £1,100 and £1,500 to buy a bond which would guarantee them a season ticket for up to 150 years, but which they would still pay for seasonally. It was, argued the club, a means of raising much needed capital to finance the demolition of the North Bank and the building of the new stand.

Supporters reacted angrily to the proposal. Tony Willis, editor of Arsenal's *1–0 Down, 2–1 Up* fanzine argued that:

> The club is trying to enforce economic apartheid. The bonds will go to big business at the expense of ordinary fans. This is a kick in the teeth for the fans. A lot of people simply can't afford the money. Where will the next generation of Arsenal supporters come from?
>
> (*IASA News* 1)

The criticisms of the scheme were based on a number of points. First was simply the cost. Fans argued that to be able to find over £1,000 was beyond the scope of many supporters who had stood on the North Bank terrace. Second, this was a betrayal of the loyalty that these fans had shown over the years – they felt that they had already 'bought' the right to get a season ticket by dint of the fact that they had been spending money year in and year out, financing the club. To be asked to pay a one-off £1,500 was, argued the Independent Arsenal Supporters' Association (IASA), an insult. Third, as Willis stated, it obviously benefited those most able to pay and reduced the ability of the less well-off to participate in supporting their team. Furthermore, this would, argued the fans, mean that new generations of supporters would find it hard or impossible to attend matches given that they could afford neither the bond, nor the season ticket. It blocked the participation of young fans and also the casual supporter – both sources of long-term fans.

The long-term implications of this would be to reduce the loyal support in favour of an attendance based on corporate hospitality and wealthy 'fans' who view football as part of an 'integrated leisure experience' (Taylor, R. 1992: 159). The IASA's newsletter carried a cartoon of David Dein's (the Arsenal Vice Chair and main proponent of the scheme) 'vision of the future': it pictured a crowded terrace 'before the bond' and almost empty, seated stand 'after the bond'. Asking 'do you want to share in David Dein's vision of the future of the North Bank??', it epitomised the fear of many fans.

Another criticism was the way that the bond scheme was launched: there were accusations of Machiavellian tactics being used by Dein and the board based on the fact that, 'David Dein launched the bond scheme at the end of last season hoping that any opposition would founder in the summer months, when fans would find it more difficult to organise' (*IASA News* 1: 1). This was unsuccessful, however, and supporters launched a highly effective campaign

against the bond scheme. Despite initial panic-buying of bonds, by September 1991 the IASA campaign had started to make a mark. The IASA claimed that the sales figure had not in fact increased for three months after the 'first flush of enthusiasm . . . [and] the hysterical haste to secure their place at Highbury after the championship win' (*IASA News* 2: 2).

The use of the press in the campaign was crucial in opposing Arsenal's plans and was given a priority in their campaigning. In the IASA's first newsletter, they declared that: 'On Saturday 21st September prior to the Sheffield United game, the BBC are bringing cameras to Highbury to see IASA in action and to interview fans on their view of the bond and all its implications' (*IASA News* 1: 2).

To capitalise on this highly visible, media-friendly campaign, strategies were developed both to maximise the media interest as well as to display to the club, and David Dein in particular that the majority of supporters opposed the plans. Not only did supporters use their vocal power – chanting 'stuff the bond' etc. – but they combined support for the club in a carniva-lesque manner with attacks on Dein and the bond.

> For the European game, we shall also require people to distribute leaflets and balloons (the evening is a celebration of Arsenal's long awaited return to European football after all!!) and generally get a good party atmosphere going inside the ground: particularly focusing on the Clock End and of course the North Bank. The idea is to show David Dein that while we are going to have a good time in spite of him that support for our campaign is massive. Thousands of balloons floating around the ground with our Ban the Bond logo should let Mr Dein know exactly that, while also providing a good spectacle and a lot of fun for the fans.
>
> (*IASA News* 1: 3)

The strategy of self-consciously combining playful support for the team with hard-hitting messages was particularly effective, avoiding criticism from other fans that they weren't supporting the team and creating a spectacle that hammered home a message and provided the media with a focus. It was an appropriation of the gradually changing nature of football supporting that characterised the early 1990s (Redhead 1991; Giulianotti 1993a; 1993b) and humour was very much part of the campaign, making sure that it wasn't marginalised as a dour political activity.

This ability to celebrate and demonstrate at the same time was recognised by more than one commentator at the time. As Hunter Davies argued: 'Look at how fans' organisations are organising against those dopey bond schemes. Their action groups work creatively, not to destroy' (the *Independent* 12 February 1992). Fans effectively appropriated the media space of live televised football by chanting songs against the bond that television could not edit out,

and produced red cards with 'Stuff the Bond!' written on them. These were to 'give the bond the red card at corners and goal kicks', as supporters held them aloft around the ground.

The campaign undermined support for the bond and one angry Arsenal fan, Andrew Allerton, tore up his bond prospectus saying that he had informed the club that he was stopping his £42 monthly payments, even though this meant writing off the £126 he had already paid (*Independent On Sunday* 29 September 1991). Only a third of bonds were ever sold. With similar successful protests occurring at West Ham United, the IASA began pointing to wider achievements:

> Some good did come out of our efforts. We now have a network of independent supporters associations through which we can exchange information and help, and we will be able to campaign alongside others, and the FSA, on issues which affect fans nationally.

But they were fully aware of the limited nature of the success:

> Simon Inglis, author of *The Football Grounds of Britain*, has apparently said that it is thanks to IASA and GAAS (the Group for the alternative stand) that Arsenal will be getting a far superior stand to its original design. Thanks, Simon, but you miss the point – we didn't want a new stand, and if we are to have one, we don't want to be the ones to pay for it!
>
> (*IASA News* 4: 7)

Attention has since been focused at the other end of the ground – the Clock End. Not only was the installation of seating there opposed – 'why seat it a year early? What is the rush, especially if the fans do not want it?' (*IASA News* 5: 2) – but fans pressured the club to attempt a 'singing area' where fans would be less severely policed in an attempt to recreate some kind of atmosphere at Highbury.

It should be noted that West Ham United also attempted to introduce a bond scheme which they eventually had to abandon due to fan protests. After the bond scheme protests, fans were looking to the wider picture:

> A 'game fit for the 21st century' (as we are constantly being told is the aim) will never be achieved while those who control the game do so without the consideration of the views of the fans, or indeed the players and managers. A 21st century game run by a 19th century autocratic elite, more at home in the masons than on the terraces, does not seem like a recipe for success.
>
> (*IASA News* 5: 2)

Divided we sit: the Old Trafford experience

At Manchester United, the fans faced a different problem. Although similar in that changes were forced on the club by the Taylor recommendations and that protest focused on the rebuilding of the former 'popular', cheapest and most vocal end of the ground (the Stretford End), the issue here was not bonds but prices. The United board had witnessed experiments with bond schemes at Arsenal and West Ham and they chose instead to simply increase prices. This allowed them to cover both the cost of rebuilding and the loss of income from reduced attendances during building work, as United Chairman Martin Edwards outlined:

> We knew when the Stretford End was demolished we were losing something like 12 or 13 thousand spaces. We sat down with a calculator and a pencil and said: 'What do we need to make up that lost income? what do we need to charge?' And that is exactly how we arrived at the £14, £12 and £8 standing for this [1992–3] season.
> ('Shut Up and Sit Down', Open Space, BBC2 TV, March 1993)

Further, the club were not shy in making it explicit where money was to come from:

> Some time ago we rejected the idea of a bond or debenture scheme. Judging by the reception elsewhere it would seem that we chose the correct decision. . . . Who has to pay? In a nutshell – you – the supporter!
> ('Pricing and Visitor Policy, Season 1992–3', *United Review* (1992) 53, 21 (8 February))

The club had already floated on the stock market in 1991 to raise extra revenue but many fans were excluded from buying shares given the price (a minimum purchase of £194) and timing (just after expensive trips to the Cup Winners' Cup Final in Rotterdam). The links between commercialisation and the Taylor Report were seen clearly by many fans:

> The Taylor Report is now being cynically abused. It has provided certain club chairmen (one springs to mind immediately!) to redevelop grounds, send prices into outer orbit and at the same time bleat on about how the Taylor Report has left them with little or no alternative. . . . The changes at O.T. [Old Trafford] have nothing to do with Hillsborough, nothing to do with supporters' safety and very little to do with the Taylor Report.
> (*United We Stand* 18: 12)

The announcement of price increases for the following season came in February 1992. The Stretford End would be demolished in the close season, and rebuilding would take most of the following year. For those (like myself) who had stood at the Stretford End, the cost of a League Match Ticket Book (LMTB, equivalent to a season ticket) increased from £108 to £152. This came on top of the previous season's increase from £76 to £108, representing a 100 per cent increase in two years. The price of seating accommodation also increased for members from £8 to £12 for the cheapest seats and for a supporter going from standing to seating accommodation, the annual increase was huge, from £108 to between £228 and £266 (*United Review* (1992) 53, 29 (2 May)). At a time of economic recession and low inflation, this was a particularly steep increase for fans and, as with Arsenal, there were many people who were becoming priced out of participation in the game and their club.

Many supporters reacted angrily to these proposals. Andy Mitten, editor of *United We Stand* asked: 'Are they real or what? Fifteen quid to watch Brighton in the Coca-Cola Cup sums up the greedy attitude. Something has to be done to stop the rot which has already set in our national game' (*United We Stand* 20: 3). A group of season ticket holders, headed by two fans, Johnny Flacks and Peter Kenny, formed an organisation called HOSTAGE – a short hand for the rather cumbersome, Holders Of Season Tickets Against Gross Exploitation – in February 1992. In direct response to the announcement of increased admission prices, HOSTAGE sought to force a climb down by the club.

With considerable media attention, HOSTAGE held a public meeting on 18 February 1992, at Lancashire County Cricket Club with over 1,000 fans in attendance. A diverse range of speakers included representatives from the FSA and from the West Ham United Independent Supporters' Association.

Changing the name to the United Supporters' Association (as one speaker argued 'because of HOSTAGE's militant inference'!), the meeting itself was hugely successful. Of key importance was the involvement of the West Ham and Liverpool supporters at the meeting. Indeed, the representative from the West Ham group joked that it was a change to get a round of applause from Manchester United fans, rather than being chased along the road – a poignant example of the politicisation of football fandom.

The meeting declared its opposition to the price increases, the 'profiteering' of Manchester United, the stipulation of the Taylor Report on all-seater stadia, and the sense that football was being taken away from traditional supporters. One speaker said:

> Manchester United should have stood up against the Taylor Report. What gets to me is that this is the first time we are in with a chance of the championship for 25 years and the board is tearing this club apart.
>
> (Author's own records, and *Manchester Evening News* 19 February 1992: 52)

USA decided to: meet with Martin Edwards; take part in a day of action coinciding with the FSA's protest on 29 February; organise a petition; and generate media-friendly 'stunts'. The role of fanzines was again important in disseminating information and garnering support. In a mockery of the club's own 'Pricing and Visitor Policy', *United We Stand* ran its own 'United We Sit: Pricing and Readership Policy' declaring that it had to comply with the Taylor Report, 'on fanzine safety'. This included 'a limited number of fanzines available to visiting fans'; a dividend of £7 paid to editor and co-editor; and 'those young reds wishing to read the fanzine for the first time will be expected to pay up to 400% more than current prices' (*United We Stand* 18: 6).

However, despite the opposition that was evident from HOSTAGE/USA, Manchester United were not forced to change their pricing policy, and the success of the team in the 1992–3 season soon meant that thousands of fans were being turned away at every game – a situation which has continued. Although prices were pegged for the 1993–4 season, a 20 per cent increase (with inflation of 3 per cent) was announced at the end of that season. A £76 standing LMTB in 1990–1 cost £325 for an (unwanted) seat by 1997.

There are several reasons behind HOSTAGE's failure. First was that instead of building an active supporter campaign as at Arsenal and West Ham United, the organisation chose a strategy of seeking meetings with the club, and hoping to negotiate a price reduction. Neither the promised drafting of a constitution for the USA, the membership drive and committee elections, nor the day of action or campaign stunts ever materialised. Given that the organisers had 1,000 supporters, and likely many more willing to join, this seems a monumental mistake.

This failure is exacerbated by the fact that although the USA did meet Martin Edwards no concessions were obtained and no further meetings happened. In a statement, Edwards said: 'We do not propose to institute any regular forum with any one group as these are too numerous. We are guided by the views and demands of a wide divergence of opinion and statutory requirements, but the directors carry the responsibility for club policy' (*Manchester Evening News* 14 April 1992). They would, in other words, undertake any policy they wished.

The lack of a strong and active campaign was undoubtedly one of the reasons why Manchester United found it so easy to reject a change of policy. There was no public pressure on the club, as there had been at Arsenal and West Ham and the 'top-down' nature of the campaign group not only ensured that committed supporters felt isolated and uninformed, but also that they weren't participants in a living campaign.

What compounded these problems, uniquely to football, was that Manchester United were in strong contention to win their first League title in twenty-five years. Issues on the pitch took over. The struggle at the top of the First Division with arch rivals Leeds preoccupied those very supporters who would have been the most vociferous in any campaign. Resources were

spent, not in organising against price increases but in earnestly following the attempt to win the League. Emotional attachments to the team proved a strong impediment to the ability to campaign against the club's policies.

Within two months, the battle was lost. Initially this, combined with continued success on the pitch, bred disillusionment amongst Manchester United fans, as it was left to fanzines to articulate the dissatisfaction with the club. Nothing symbolises both the failure of the protest, 1990s commercialism and sanitisation in football more than the new West Stand (formerly the Stretford End). A 15,000 standing section, providing the cheapest access to the club, became a 4,000-seat McDonald's Family Stand, 864 Executive seats, several thousand expensive Club Class seats, a purpose built TV studio and a few thousand 'ordinary' seats at inflated prices. The Umbro advertising read: 'The end of the Stretford? No, just the beginning. We the sponsors, and you, Fergie's Red Army. United in one stand' (*United Review* 1993–4). *United We Stand* mocked this with: 'The end of the Stretford? No, just the singing. We, the sponsors. And you, the business clients. Quiet in one stand. Umbro – another kit coming soon, parents' (see Figure 3.1). The *Manchester Evening News* championed the new '£12m sitting room', but clearly had a poorer grip on irony, as many of those former Stretford Enders would only be able to see matches in *their* living rooms – provided they could afford the satellite subscription.

More recently, however, the mantle of protest has been taken up by the Independent Manchester United Supporters Association (IMUSA), formed in April 1995 with Flacks, many associated with the fanzines and some of those who had been first inspired by HOSTAGE. There is not space to discuss the detail of IMUSA here and it is covered elsewhere (Lee: this volume), but it is notable that it has been far more successful in providing a sustainable campaigning organisation. Affiliated to the FSA and with around 1,000 members, it has continually challenged the club on issues of pricing, distribution of tickets, regulation of fans and the treatment of fans when travelling abroad. IMUSA has pursued a strategy of holding regular open meetings, combining entertainment with campaign business, as well as maintaining a high media profile. IMUSA has developed an active, involved and committed membership, a democratic structure, and whilst the power of commercial interests in the club vastly out-gun the resources of IMUSA, the organisation remains a thorn in their side, as well as being one of the most successful ISAs in the country. The lessons of HOSTAGE/USA, it seems, have been learnt.

Conclusions: toward an understanding of fan campaigns

What, then, can we learn from the experience of fans' organisations about the problems for democratising the football industry? One of the key problems in confronting democracy in modern football is the justification of the issue

Figure 3.1 Manchester United fanzine, *United We Stand*, respond with cynical humour to the rebuilding of the Stretford End

Source: *United We Stand* 30: back page. Reproduced by permission of *United We Stand* (Umbro logo deleted).

itself. Why should a multi-million pound industry which increasingly sees itself as part of an 'integrated leisure sector' be concerned with football supporters, beyond being customers in their market? What rights can supporters, as paying visitors to football matches, expect from football and what problems do they face?

Although there is not space to fully explore this here, to Marxist analysis (especially Theodore Adorno (Bernstein 1991)), to free market economists, and to some of the more extreme theories of postmodernity,[4] the idea is something of anathema. In these approaches, supporters are either duped, turnstile-fodder; or they are 'mere' customers; or they live in a world of *purely* symbolic value where 'actors are not required' (Baudrillard 1993). None of these seem adequate to explain the experience and desire for democratisation by fans.

It may be that a much more flexible approach is needed to appreciate the issues of democratisation of football. Notions of political economy and hege-mony, ideas associated with the breaking of hierarchies in postmodernity and the importance of symbolic value to campaigning organisations may all be important. In this it is possible to use the notion of 'democratisation' in three, inter-linked, ways: as a way of looking at the relations of power in the produc-tion and consumption of popular culture; as a way to describe the content or character of popular culture; and as a way of describing both *institutional* and *non-institutional* aspects of control.

Thus, in the two cases outlined, we can see the operation of economic power to devastating effect: since the Taylor Report, clubs have almost had *carte blanche* to exploit the loyalties of their supporters in their commercial policies. The limits of this have only been exposed when the organisations of fans have been strong enough and imaginative enough to make those policies economically untenable (e.g. at Arsenal and West Ham United). Despite the weaknesses of approaches associated with Adorno, it does appear that processes in football's modernisation are leading toward precisely the commodification of the product he describes. The actions of fans organisa-tions are testimony against the success of this project.

As a means of describing the content of popular culture, democratisation also highlights a problem. The motivations behind many supporters' actions is precisely to protect a democratic ethic in football:[5] its role, in other words, as a participatory, 'people's' game. Whilst Rogan Taylor (1992) rightly highlights the historic marginalisation of fans in football, his description of football's marriage to the social fabric of (urban) Britain is instructive and illuminates an irony in the issue of democratisation of the game. Football's saleability as a *fin de siecle* cultural commodity – the prerequisite for the commercialisation we have witnessed in recent years – is based precisely on its *democratic appeal*. James Poole, former corporate director of Barclays Bank, a major football sponsor, said football, 'binds communities, it generates strong emotional commitment . . . it is genuinely a sport for everyman' (Poole 1992: 5). In this he was not only

outlining why football is so attractive for advertisers like Barclays, but also as a warning to those commercial interests that if they pursue strategies in the wrong way, they will lose football's broad appeal in the long-term.

This is precisely the argument of many fans' organisations: that corporatisation, commercialisation and blatant greed, carried through on the back of the Taylor Report have marginalised long-standing concerns of fans and brought about the exclusion of some constituencies in football. One could add to this the failure of football to adequately deal with issues of racism or in attracting female fans has prevented an opening up of football's democratic ethic. The appropriation of the Stretford End at Manchester United for corporate hospitality and 'family' sections has replaced the most accessible area of the ground with an exclusive one and remains a potent symbol of the squeezing of the democratic content of football.

Democratisation, and its negative correlation, can also be witnessed in 'institutional' and 'non-institutional' ways. The institutional drive to commercialise the product, and the institutional power that clubs enjoy over their fans is one example. The differing nature and capabilities of supporters' organisations to campaign against such moves is the correlation. However, there are also non-institutional powers at work: with HOSTAGE the love of team and game acted against democratisation, weakening campaigns and making the exercise of the ultimate fan action – that of a boycott – unlikely to succeed. This loyalty to the team (rather than the club) is highly problematic for all fan organisations.

Conversely, however, it is in the arena of the 'non-institutional' that fans have found space for their expression and success in their campaigns. The 'red card' protests, chants against the board or demonstrations which television cannot ignore, the (increasingly narrow) cultural space for expressions of fandom like the carnivalesque techniques of some organisations, and the new expressions of resistance visible in football fanzines are all examples of how fans have turned football's nature as a popular culture to their own advantage. Whilst of course the institutional power of commerce dominates, to ignore the power or space for fans' actions would be folly. Further, the alliances (formal and informal) of club-based organisations, national associations and fanzines can be seen as the expression of a 'culture of dissent' in the football world: their ability to turn their sub-cultural capital into meaningful change will be crucial to the future of football in Britain.

There are more 'practical' problems generated from the particular nature of football as well. One is representation: it is extremely difficult for any fans organisation to legitimately claim that they represent the views of a majority of a clubs' support. Part of this is definitional – almost anybody *can be* described as a football supporter and fandom contains different 'constituencies' of support. To be able to claim majority support for a campaign is therefore difficult and fan organisations are often dominated by an active minority.

Another problem for fans' groups is the charge of conservatism. This is levelled against fans by clubs and the football authorities for opposing 'modernising' changes such as stadia rebuilding (recent calls for a reintroduction of terracing have been described as 'backward').[6] Some academics have joined in – Ian Taylor (1992) argues that the defence of traditional terrace culture was in fact a constructed image, 'reactivated culturally by the fanzine movement during the 1980s'. What was being defended was a culture of 'rampant racism, crudely sexist banter, and of aggravation conducted by groups of young white males of little education and even less wit' (Taylor, I. 1992: 14–15; see also Wilson 1993).

Such a negative portrayal does little to help us understand what the 'culture of dissent' is about, relying on clichés about terraces and a misunderstanding of what fan organisations represent. Terrace culture contained many elements which are anti-democratic but so does the world of commercialism and television packaging of which Taylor is much less critical. The universality of his dismissal does little to recognise that what was being defended was the ability of some constituencies of fans to carry on attending and participating in football. What has been and is at stake is access to the game, the ability of 'young white males' (and others) to go to a stadium to watch live football. Taylor's analysis takes little account of how the quantitative shift in the political economy of football threatens its democratic elements. In fact, Ian Taylor's argument that fans' protests should not be 'traditionalist' but forward-looking and modernising (Taylor, I. 1992: 14) is *precisely* what many campaigns were. I would argue that they represented a fundamental regeneration of football fandom – politicised, sometimes carnivalesque, highly organised, uniquely popular.

Having said that, of course, there has not been victory for fans on a national (rather than club-specific) issue and football certainly has not been democratised. Local battles have and will continue to be fought and won, but a greater (inter)national co-operation between organisations is needed if such success is not to remain piecemeal. Such reasoning has been behind the FSA's attempts at closer co-operation with ISAs (author's own records).

Of course such problems as representation and charges of conservatism were exacerbated in some instances – with HOSTAGE, although not since with IMUSA – by organisational weaknesses. It is notable that those campaigns which were more successful – Arsenal and West Ham, IMUSA – are the ones which have *attempted* to be democratic and participatory, however much they may be dominated by the 'generally well educated' and activist elements.

None of this is to detract from the achievements of the supporters involved. The campaigns articulate a huge concern amongst supporters about the post-Hillsborough shape of the football industry, a concern that is still very much with us. They also exhibit a number of characteristics that are quite remarkable given the difficulty of organising football supporters into

any kind of action, and the hostility that they faced. Finally, the odds which fans were campaigning against mean that all achievements and compromises made by the football hierarchy should be viewed accordingly.

What is centrally important is that they confront the problem of democracy and popular culture on a number of levels. On one level issues are taken up where participation itself is threatened and the very meaning of 'football support' is at stake. Second, questions are raised about the ownership of culture and ownership of football's regeneration. Third, fan democratisation illustrates concerns with challenging control, where control is about the exercise of power and democracy is the check on that power. This is because, above all, such attempts at control or restructuring are really attempts to define the meaning of, and participation in, popular culture.

Notes

1 In this I must declare an interest: I have been a member of the Football Supporters Association for some years, am currently a National Committee member and a member of the present government's Football Task Force; I am also a member and former committee member of the Independent Manchester United Supporters' Association.
2 Rogan Taylor's (1992) informative account of football supporters' relations to the game prior to 1985 has dealt much more thoroughly with the Federation's (and supporter clubs') development than is possible here.
3 A company called NNC, based in Warrington has designed a computer-regulated Crowd Monitoring System which can record the pressure on crush barriers and therefore avoid disasters like Hillsborough.
4 See Fiske (1989) where the consumer is given almost total power to 'make over' meanings of cultural products; or Baudrillard (1993) where cultural images become almost meaningless.
5 For a discussion on the egalitarian nature of popular culture, see Stauth and Turner 1988; Fiske 1989.
6 Author's own records, Government Football Task Force meeting, 29 October 1997.

Bibliography

Back, L., Crabbe, T. and Solomos, J. (1996) *Alive and Still Kicking*, London: AGARI.

Baudrillard, J. (1993) *The Transparency of Evil*, London: Polity Press.

Beauchampé, S. (1996) *From Euro 96 to 2006*, Liverpool: FSA.

Bernstein, J.M. (ed.) (1991) *TW Adorno, the Culture Industry: Selected Essays on Mass Culture*, London: Routledge.

Brown, A. (1994) 'Football fans and civil liberties', *Journal of Sport and the Law* 1, 2 (July).

—— (1996) *A Report Into Events at Juventus v Manchester United*, Manchester: FSA.

—— (1997a) 'Let's all have a disco? Football, popular music and democratisation', in S. Redhead, (ed.) *The Clubcultures Reader: Readings in Popular Cultural Studies*, London: Blackwell, pp. 79–102.

—— (1997b) *FSA Initial Report: FC Porto v Manchester United*, March 1997, Manchester: FSA.

Buford, B. (1991) *Among the Thugs*, London: Secker.

Crabbe, T. (1996) *The Price Ain't Right: FSA Proposals for and Alternative Admission Pricing Strategy*, Manchester: FSA.

Crabbe, T. and Brown, A. (1996) *Involving Supporters in Football's Future*, Manchester: Unpublished discussion document.

Davies, P. (1991) *All Played Out: The Full Story of Italia '90*, London: Mandarin.

Fiske, J. (1989) *Understanding Popular Culture*, London: Unwin Hyman.

Giulianotti, R. (1993a) *A Model of the Carnivalesque? Scottish Football Fans at the 1992 European Championship Finals in Sweden*, Working Papers in Popular Cultural Studies, No. 6, Manchester: Manchester Institute for Popular Culture, Manchester Metropolitan University.

—— (1993b) 'Soccer casuals as cultural intermediaries: the politics of Scottish style', in S. Redhead (ed.) (1993) *The Passion and the Fashion*, Aldershot: Arena.

Hamilton, I. (1992) *Gazza: Agnostes*, London: Granta.

Haynes, R. (1995) *The Football Imagination*, Aldershot: Avebury.

Hornby, N. (1992) *Fever Pitch*, London: Victor Gollancz.

Jary, D., Horne, J. and Bucke, T. (1991) 'Football "Fanzines" and football culture: a case of successful "cultural contestation"', in *The Sociological Review* 39, 3 (August).

Pilling, A. (1997) *Italy v England 11 October 1997: An FSA Report*, Liverpool: FSA.

Pinto, T. (ed.) (1997) *ISA Network Newsletter* 1997.

Poole, J. (1992) *Better Off With Barclays?*, paper given at TVUK: The Television Debate, University College Salford, Old Trafford, Manchester, 8 July.

Redhead, S. (1991) *Football With Attitude*, Manchester: Wordsmith.

Smyth, C. (1990) *Football Identity Cards: The Beginning of the End for Civil Liberties?*, Belfast: University of Ulster unpublished paper.

Stauth, G. and Turner, B.S. (1988) 'Nostalgia, postmodernism and the critique of mass culture', in *Theory Culture and Society* 5, 2–3, London: Sage.

Taylor, I. (1992) 'English football in the 1990s: taking Hillsborough seriously?', in J. Williams and S. Wagg (eds) *British Football and Social Change: Getting into Europe*, Leicester: Leicester University Press.

—— (1993) *It's A Whole New Ball Game: Sports Television, the Cultural Industries and the Condition of Football in England in 1993*, paper presented to the Centre for the Study of Sport and Society, University of Leicester, 18 June.

Taylor, Lord Justice (1990) *The Hillsborough Stadium Disaster (15 April 1989), Inquiry by the Rt Hon. Lord Justice Taylor, Final Report*, Cmd 962, London: HMSO.

Taylor, R. (1992) *Football and Its Fans: Supporters and Their Relation with the Game, 1885–1985*, Leicester: Leicester University Press.

Wilson, P. (1993) 'Realities behind a dirty war', the *Observer: Sport* 5 December.

Part II

RACISM IN FOOTBALL
Identity and exclusion

4

RACISM IN FOOTBALL

Patterns of continuity and change[1]

Les Back, Tim Crabbe and John Solomos

Introduction

Football grounds have provided one of the largest public arenas in which racism can be openly expressed. It is against this background that the phenomenon of racism in football has led to widespread discussion during the past two decades within the media, amongst policy makers and in the wider football community. In turn this has led to the launch of a number of high profile campaigns against racism both within fan organisations and within football's institutions. Nevertheless, there remains, amid this flurry of activity, a lack of serious analysis of exactly how the cultural context of football grounds provides the platform upon which racism can be expressed and celebrated. Our concern in this chapter is to examine the way in which the problem has been understood within anti-racist campaigns, fan publications and wider public forums. Drawing on our research on cultures of racism in English football we want to question the degree of fit between the terms of the public debate and the contemporary patterns of racist practice and action within football?

A range of authors have provided important insights into football related racism (Williams 1992, 1994; Turner 1990; Holland 1992a, 1992b, 1995), yet there is little systematic current research on how these manifestations of racial conflict are being affected by the dramatic changes that have occurred within football culture in recent years. By drawing on empirical research gathered from an Economic and Social Research Council funded project conducted between 1995 to 1997, we want to suggest that there is an urgent need to re-shape the terms of the debate and move towards a more grounded approach to countering racism in football.

Given the focus of this volume, we will, in the main, concentrate on the patterns of racist behaviour amongst football fans. There are, however, some

important points to stress with regard to the limitations of only locating 'the problem' in the stands and what is left of the terraces. It has proven easy to talk about racism amongst fans precisely because, for football administrators, the issue of race can be readily added to a range of other forms of anti-social fan behaviour. Equally, stressing that racism is an extension of other forms of football violence and abuse means that attention can be deflected from difficult questions relating to the under-representation of black people and minority groups within the management and administration of the game. As John Williams has commented, fan racism has been more easily identifiable precisely because of its crass nature, while the more subtle forms of racial inequality inside the institutions of professional football have received little attention (Williams 1992). We are aware here of the dangers of uncritically reinforcing such a limited agenda. However, we want to argue that in order to open up these broader questions it is necessary to demonstrate the limitations of the current public debate through an exploration of the extent and quality of racism within contemporary football fan culture.

Our discussion is divided into three sections. The first examines the ways in which the issue of racism in football has been constructed within academic, media and political discourses. We argue that the issue of racism has been viewed as merely an extension of wider concerns about public order and anti-social fan behaviour. Second, we examine in detail some of the changing manifestations of racist activity within fan culture. Here we are concerned to avoid the trap of labelling particular clubs or supporters as racist, a tendency which is pervasive within the folk forms of knowledge that are generated within fan culture and the media. In the final section we will provide a general overview stressing the contextual complexity of the culture of racism in football. Before going on to discuss some of the findings of our research we want to examine critically the tendency to interpolate racism through the controversies surrounding football hooliganism.

The racist–hooligan couplet: racism, the media and Euro 96

There is a tendency within the football literature to deal with a whole range of issues related to supporter behaviour only in the context of wider research dealing with 'hooliganism'. Indeed, it is increasingly recognised that discourses surrounding the topic of 'hooliganism' have tended to establish the parameters of debate around and influence thinking about virtually every aspect of football culture (Duke 1991; Redhead 1991, Redhead *et al.* 1993; Giulianotti 1994; Haynes 1995). A consequence of this is that the 'hooligan' becomes the organising principle for understanding or knowing the social configuration of power, identity and autonomy within fan cultures. In the context of the politics of racism, the 'hooligan' becomes the exemplary archetype of the racist.

We suggest that this relationship produces a form of discourse which can be characterised as the racist–hooligan couplet.

There is an allure to this approach because it enables a difficult question like how to understand the forms of popular racism expressed in football to be reduced to a simple archetype. It becomes a useful shorthand way of: (a) understanding what racism in football is and (b) locating the problem outside of the institutions of football and into the shady interstices of quasi-criminal subcultures. In turn journalists focusing on sinister relationships between far right activity and football violence are able to use academic commentaries to substantiate their stories. This capacity has further contributed to the universality of the up-take of this archetype within media discourses, whether they be within the popular or serious press. The Euro 96 tournament staged in England during the summer of 1996 provided the ideal context for these constructions of racism to be deployed. What is interesting and important here is the consistency in use of this archetype regardless of whether one is looking at a broadsheet or tabloid newspaper.

The Times, on 12 May 1996, ran an article titled 'Police fear "Third World War" on terraces of Euro 96'. The piece invoked memories of the battle against fascism, predicting that neo-Nazi football fans and other rival gangs from across Europe would be fighting out a kind of replay of the Second World War during the tournament. On the 20 May, adopting a similar theme, the paper began a two part series speculating on the potential for spectator violence during Euro 96 with the headline 'Neo-fascists aim to stamp their mark on Euro 96'. Meanwhile on the 29 April 1996 the *Daily Sport* ran an illustrated story about a pitch invasion and protests during a match between Brighton and Hove Albion and York City and drew connections between the incident and the potential for further disturbances during Euro 96. The *Daily Sport* stated that members of the far right group Combat 18 were involved in these protests and claimed to have interviewed a member of the group:

> We will rule the European Championships with an iron fist to prove we are the hardest fans in Europe. Anybody that gets in our way will regret it and while we are not targeting players we won't hesitate in taking them out if that's what it comes to.
>
> (*Daily Sport* 29 April 1996: 7)

The beleaguered Brighton Chairman, Bill Archer – who didn't attend the match – was quoted as saying:

> I saw the scenes on television and I was horrified. There was clearly a rent-a-mob element present. There were people ripping down the goal posts who were skinheads with swastika tattoos . . . I don't think the majority of the rioters were Brighton fans.
>
> (*Daily Sport* 29 April 1996: 7)

73

Archer here put the hooligan–racist couplet to good effect. The mass protests had in fact been prompted by plummeting gates, the sale of the Goldstone Ground stadium despite the failure to secure alternative accommodation, the club's decline from their status as FA Cup finalists in 1983 to relegation to the Third Division of the Football League in 1996 and a precarious financial position. Archer's comments managed to deflect attention from the fan discontent and the mismanagement of the club by condemning the infiltration of the swastika tattooed skinhead, the folk demon behind all of football's ills, conveniently disregarded as not being Brighton fans at all.

This kind of miss–identification and name-substitution is rife not only within football reporting but also within other related institutions. A Football Intelligence Officer based in London offered an amusing example. The Brighton police had previously consulted him because of his experience in football matters as they were becoming alarmed following the recording of what they believed to be choruses of 'Sieg Heil' at the Goldstone Ground. So the officer made a special match day trip from his London patch only to find that the concerns of the local police about a groundswell of Nazi sympathy had been little more than misinterpretation. The Brighton fans were not in fact chanting 'Sieg Heil' but rather they were singing their traditional call to arms, 'Seagulls, Seagulls!' This is not to trivialise the importance and power of the assumptions that underscore such misunderstandings.

The fear of rival right-wing gangs clashing on the streets of London was a far cry from the reality of the Euro 96 tournament. In large part the competition passed off with little incident. Even the *Daily Mirror*'s attempts to whip up tabloid jingoism, particularly in the run up to the semi-final match between England and Germany, was on the whole out of step with the mood of English fans and the nation as a whole (see *Daily Mirror* 25–6 June 1996). It is important to be clear that we acknowledge that the national team in particular attracts some support from the far-right. There is little doubt that a small proportion of fans with ultra right-wing political leanings attempt to attach themselves to football culture. In the ethnographic work we have conducted with England fans we have found in a minority of fans a clear interconnection between English nationalism, Ulster Unionism and popular racism. However, this is quite different from making such relationships the defining framework for understanding racism in football culture. Also, relying on such crude archetypes means that complex negotiations between fans which might produce partial or temporary disruption of racially exclusive nationalism are ignored.

Vince, a black England fan, recounted a series of incidents he experienced during the tournament which suggested that small scale re-negotiations were occurring around issues of race, nation and belonging. Here he describes the atmosphere outside The Globe Pub, West London prior to the England versus Scotland game. This pub is a common point of assembly for fans on their way to Wembley:

Yeah, this year, Euro 96 – I wanted them [the England team] to win it so badly . . . And some mad incidents happened. The craziest one was England versus Scotland 'cause all the old firms came out. You went up the pub down the Marylebone Road, The Globe, and all the fucking criminals from yesteryear were there and like that, and they all clocked me and, you know, I remember there were only three other black guys out there – two – me. [One of the other black guys] turned up with like six of these white mates . . . and I turned up with two white mates – like no black guys turned up alone, they all came with white mates and all that. They [the black fans] weren't getting no stick, they were getting absolutely no stick. . . . Outside The Globe, yeah – all fucking credit to them, you know, and they were with their white mates in their white firms. And there was a West Ham geezer especially, 'cause he looked – he looked like a mean fuck as well, you know, and he just like: 'Yeah, yeah'. . . . You know, I just [got into] having one of those real quiet whispered criminal conversations – 'Yeah, sound – you get any trouble here today, we're going down with yer – you know that. We're standing over there so just give us the nod if anything, anything's happening.' I went: 'Yeah, sure, sweet'. It was fucking brilliant, that is so cool. And the Wolves lads, you know, 'cause they're like from Birmingham and they're not as cool as the London guys, they were just a bit more abrupt about it like [switching to a Midlands accent]: 'You all right, you all right – it must be a bit hard here being a black guy – well fuck it, any problems here we're with you, mate – fucking hell. Fucking black? Well it don't matter, ain't it, supporting England, ain't it?' You know what I mean? It was like really mad, it was really mad.

<div align="right">(interview with authors)</div>

The important thing about this testimony is the open recognition by some of the white England fans of the issue of racism and how it might affect Vince. Clearly, notions of race and nation were being negotiated in an explicit way. Perhaps this was only confined to a situation where there was a collective and shared adversary in the shape of England's old footballing enemy – Scotland (see Giulianotti and Finn, this volume). Nonetheless something was occurring here that is inconceivable in the terms defined by the form of discourse we have referred to as the racist–hooligan couplet.

The presence of black fans during the tournament forced a grudging acknowledgement even from politically committed extreme right-wing fans. Vince continues:

I was standing right by the pavement, on the pavement right by the road in front of The Globe – you know what I mean – and I saw the fans below, and I was on the pavement and there was Police standing

right in front of us, having a drink and all that sort of stuff, and the fucking atmosphere was electric, it was like: 'Fucking Scotland!' And then these group of boys were being herded along, given a Police escort, and they were, you could see they were about to walk right past us, and everyone went: 'Fucking hell, fucking hell – it's the Scots, it's the Scots!' And everyone started pushing to like get to where we were 'cause we were on, we were at the kerb, and they're like: 'No, no, no, no, it's not, it's not [the Scots]!' And it turned out it was C18 [a far right paramilitary cell] under Police escort being escorted away from the centre of town. So they walk, right, and I'm right on the kerb – this is mad – I'm right on the kerb and they're walking past, I'm with my mates and all that, and then they just walked past me. But one guy stopped and clocked me, it was the weirdest thing – total skinhead as well, it was really weird, and he just looked at me and like he nods – I've got a little rose, red rose lapel on and he looked at me, looked at my badge and just nods, and he just looks at me and goes: 'Yeah, right'. And I just held my own, it was just like eye contact and like: 'Today we're on the same team', it was just in the eyes, it was so fucking mad, it was just like, you know: 'Today we're on the same team, yeah, England. Any other day it'd be different, but today it's about the fucking Jocks.' And it was just our eyes, you know, he just looked at me and like well I'm their geezer, you know – fucking England, you know, you're just like – and it was the weirdest moment, and then the Police moved him on and everyone's just like looking around and I was like fuck, and it was so frightening! But he was just, it was one of those moments when you just had to hold your own, it was like, you know. It was an acknowledgement, it was just all in the eyes though, it was brilliant, it was, in a weird way, in a perverse way it was brilliant. It was all in the eyes, we had a conversation with the eyes in like two seconds, it's like oh God, you know, and it's just like he sort of approved of me and I sort of said: 'Well listen, I know you're a racist cunt, but nothing's gonna happen today, is it, 'cause it's about Scotland?'

(interview with authors)

We are not claiming that incidents like these should be read in a naïvely optimistic way. Such forms of acknowledgement and racial inclusion are temporary and contingent. It is entirely plausible that the inclusion of black fans like Vince can occur simultaneously with complexly articulated forms of racist culture.

Christopher Terrill captured football fans on film during the tournament, chanting monkey grunts and abusing black doormen in the central London district of Soho. His programme 'High Noon' for the 'Soho Stories' BBC series provided a fleeting but unique insight in to the forms of football related

racism and harassment that took place during Euro 96 (Terrill 1996). Additionally, England fans sang the complexly racialised chant 'I'd rather be a Paki than a Jock' during the match against Scotland. We will return to this later, but for now we want to stress the need to develop a sensitivity to such nuances in order to move beyond crude and distorting caricatures of fan racism. Equally, the dialogues described by Vince are couched within a shared, highly ritualised and class-coded form of masculine culture. All of these social features need to be taken into account if one is to develop an accurate picture of the unevenly developed nature of fan racism.

The problem with the current state of the debate is that it does little to move beyond the hooligan–racist model. This discourse is useful because it provides a caricature of racism against which practically everyone within the game can rally. What is more familiar and in some ways more challenging is the intermittent and often banal forms of racism practised within football culture. Our experience of racism amongst football supporters points to an expressive tradition which ranges from banal, individually spoken insults to sophisticated communal chanting built around an implicit collective identity which can cut across the full spectrum of the football supporting community. We do not have the space here to describe the full range of incidents and patterns uncovered by our research but the variety and complexity of racialised references within the football ground is something that is often missed by commentators who adhere to the simplistic association between hooliganism and racism. We will now go on to explore some of the ways in which particular expressions of fan culture are racialised, despite the general decline in racial abuse inside English grounds.

Continuity and change in the expression of racism in football

There is an overwhelming tendency for people involved in both the recreational and professional cultures of the game to play down the significance of racism in football and to speak, in very general terms, about the 'improvements' witnessed since the 1970s and 1980s. This approach, at once, ignores the uneven development of racism within the game and the complex means by which racialised notions can be expressed in contemporary fan culture. We would point to the twin processes of continuity and change which have historically characterised the development of racism within football.

Despite this assertion, the 1980s can certainly be cited as an era when the chanting of overtly racist taunts and associations was more commonplace, particularly amongst high status clubs. This can be illustrated by the Everton fans' reception of the black forward John Barnes during an appearance for Liverpool against Everton in 1987.

'Everton are white!': John Barnes, Merseyside and difference

At the end of October and beginning of November 1987 Everton played Liverpool at Anfield on two occasions within the space of four days, first in the Coca-Cola Cup and second in, the then, Barclays League Division One. The first of these games in particular has gone down in the folklore of Merseyside football (Hill 1989) and marked John Barnes' first appearance for Liverpool in a Merseyside derby. His appearance for Liverpool prompted some of the most widespread racialised chanting and barracking, by Everton supporters, ever witnessed in an English football ground. However, when we look more closely, even this celebrated example reveals a complex range of forces which are involved in expressions of racist sentiments and the instability of any notions of generic 'improvement'.

The patterns of chanting reveal the weakness of attempts to label particular clubs and groups of fans as monolithically racist. In the aftermath of this game much media attention was focused on the behaviour of Everton's fans and their displays of racism, so much so that BBC2's *Newsnight* even produced a special feature on the racial abuse directed at John Barnes. The subsequent failure of Everton to sign any black players until Daniel Amokachi in 1994, whilst Liverpool went on to sign several other black players, including Michael Thomas, Mark Walters and David James, led to a whole series of accusations that Everton was a 'racist club'. It was suggested that the attitude in the board room reflected that identified on the terraces during the derby match with Liverpool and that there was a policy of not signing black players. This was contrasted with the way Liverpool fans embraced John Barnes and the succession of black players who were later signed by the club.

However, it is clear from video recordings of both of the matches from 1987 that whilst John Barnes was the referent in each of the key chants, 'Everton are white' and 'Niggerpool', their targets were the predominantly white Liverpool supporters. Everton fans were making a statement about the perceived normative identity and racial preferences of Merseyside which could only work if those preferences were shared by the Liverpool supporters. The universal whiteness of the Everton team was being celebrated whilst the name of Liverpool was denigrated by reference to the introduction of a black player into the side. The intention was to 'wind up' the Liverpool supporters on the premise of a *shared* antipathy towards 'niggers' which is located within a common understanding of the racial characteristics associated with the Scouse identity. As Jimmy, an Everton fan in his forties, put it to us:

> I think it was an attack at the player and an attack at the football club and an attack at the fans. Suddenly Liverpool supporters who had been making racist comments about other players stop making racist comments because they . . . have John Barnes playing for Liverpool.
>
> (interview with authors)

Brian, an Everton fan of a similar age who was at both the Anfield games, argues that:

> They were no different from us, and as soon as Liverpool's black players went they'd be right back to where they were. You know, Liverpool fans did seem to have a holier than thou attitude because they had black players, therefore they weren't racist anymore, but that wasn't true.
>
> <div align="right">(interview with authors)</div>

Graham Ennis, editor of the Everton fanzine *When Skies Are Grey* developed the point:

> It's one of these things Liverpool fans will now sort of never admit to, but John Barnes, when it was widely reported that he was gonna come to Liverpool, one of his last games for Watford was at Anfield, and he was booed for 90 minutes. It's a fact. It happened. The same as the famous banana-throwing incident at Highbury (Liverpool fans were reported to have thrown bananas on the pitch during this match, which was Barnes' debut for Liverpool), it happened. I'm not saying it was representative of all Liverpool fans, but it happened.
>
> <div align="right">(interview with authors)</div>

In a moment we will show how these same normative racial preferences are utilised in the contemporary context by fans from outside of Liverpool to express a regional antipathy towards Merseyside. Before we move on though it is important that we understand the instability of the supporters' expressive traditions. Since whilst the racialised chanting at both games was clearly audible, on the second occasion, following much media criticism of the Everton fans' behaviour during the match the previous Wednesday, it was played down by the television commentators. The atmosphere was specifically compared favourably to the reception that Barnes had received during the first derby match, when dozens of bananas had been thrown at the player on the pitch and even a monkey stolen from a local zoo, which was later found sitting happily on top of a piano in the Clarence pub, with the intention that it would be let loose on the pitch. Jimmy Hill commented on BBC1 after the game:

> What we should be grateful for I think is that this was a real local derby with none of the nastiness really of last Wednesday night. It was just what it should be.
>
> <div align="right">('Match of the Day', 3 November 1987)</div>

From our perspective this seems to say more about the significance of the

event, local identity and club rivalry than the significance of particular histor-
ical periods in mapping the development of racism in football. For the first
twenty-five minutes of the second game the Everton supporters, referring to
John Barnes, took up the racial taunting where they had left off the previous
Wednesday night, but after this point the taunts were not invoked again
throughout the remainder of the match, despite Barnes' continued presence
on the field.

It seems unlikely that the changing pattern of Everton supporters' inter-
ventions during this match was due to any recognition that their previous
actions were not those of true 'Evertonians' (as was suggested by the Club
Chairman in the local newspapers) or due to some newly found enlighten-
ment into the benefits of a multi-cultural society. It is more likely that the
arrival of John Barnes at Liverpool (the first black player to play for one of
the city's professional clubs since Howard Gayle five years previously) and the
particular occasion of a Merseyside derby provided a unique platform for the
celebration of an exclusively white Scouse identity through an association
with Everton FC which could be played out at the expense of the Liverpool
supporters.

The gradual winding down of the taunts was a reflection of their declining
originality in the context of a second derby game in the space of four days.
Changes in behaviour then can be the product of a host of different factors
which may change from day to day just as readily as decade to decade. It was
precisely the fact that John Barnes was making his *first* appearance in a
Merseyside derby that encouraged the response he received in the initial
game. At any moment the potential was there for the abuse to resurface
during the second game but the universal, communal statement was no longer
necessary, as 'a marker' had already been laid.

'I'd rather be a Paki than a Scouse': racism, collective identity and regional antagonisms

Alongside this very sudden change in behaviour, a decade later, we have
found forms of racialised expression which are generically mobilised against
fans from Merseyside with the intention of offending the Scouse regional
identity and its associated perceived racial preferences. The chant of 'I'd rather
be a Paki than a Scouse' is used by fans of a number of clubs and reinforces
the sense that we need to move beyond seeing the fan culture of individual
clubs as merely the product of particular local conditions, to considering
patterns of cultural interchange and syncretism within fan culture nationally.
Indeed, its use during Euro 96 against the Scottish team and fans mentioned
earlier emphasises the degree to which such songs can be adapted and
elements substituted in different contexts while retaining the same racialised
structure.

These forms of racialisation pose a series of difficult and theoretical prob-

lems with regard to how racism is defined within the context of football. The complexity of this pattern of culture cannot be easily understood either within policy frameworks or the academic literature. Are 'I'd rather be . . . ' and 'Everton are white' racist chants? and if so why are they principally directed at white supporters? In order to grapple with these complexities we need to develop an understanding of how particular aspects of fan culture are racialised, which necessitates a movement beyond crude definitions of particular clubs as racist.

We observed the song 'I'd rather be . . . ' being sung frequently during Millwall games in the 1995–6 season where the opposition was from Merseyside but also by Manchester City fans in games against Liverpool. In contrast to the chanting of 'Everton are white', where the notion of race is central to the celebration of the Scouse identity, this song is racialised only in the sense that it involves a racialised category – 'Paki' – as a means to express contempt for that same emblematic regional identity. But in both cases the efficacy of the insults is premised on the notion of a shared abhorrence of the racialised categories 'Paki' and 'nigger'.

In order for these insults to work it is necessary for there to be an implicit ideal or normative structure of collective identity. In the case of the chant 'Everton are White' this normative structure is confined to two main components, i.e. a reference to the club and a notion of race. However, in the case of 'I'd rather be . . . ', the central component becomes region. It is this shift which allows the song to be freely expressed despite the general decline in racialised chanting and the introduction of legislation under the Football Offences Act (1991) aimed at curbing this type of fan song.

In this formulation the club and regional components are quite straight forward but the third component is only racialised by a discourse of whiteness that structures the terms of these identities whilst the content remains explicitly absent. Here, white ethnicity is implicitly present but explicitly absent. The result is that whiteness is equated with normality and as such it is not in need of definition. Thus 'being normal' is colonised by the idea of 'being white' (Dyer 1997). The result is that two parallel sets of identity hierarchies are invoked as the norm (see Table 4.1).

Whiteness is the defining principle of this collective identity but it is not exclusively white. In keeping with the kinds of negotiation that take place

Table 4.1 Normative structure of club–race identity

	Everton	Millwall
Football fan	Everton/Scouser/white	Millwall/Londoner/white
Other	'Paki'	'Paki'

between black and white young people within football culture it becomes possible for 'black Londoners' to be included as *contingent insiders* (Back 1991; 1996). This inclusion is always established from the position where 'white' is defined as normal, but requires the normative structure outlined (Table 4.1) to be altered (Table 4.2).

Black Londoners can be legitimately included within the local dimension of this structure. Such forms of inclusion are always contingent upon the absence of a specifically anti-black racism within the fan culture. The black–white notion of regional inclusion not only changes the patina of the 'us' category, but it also widens the scope of the insulted 'them' to include black and white Scousers alike. These fraught inclusions mirror the same processes that operate with regard to black players. In both cases racism stands on the 'side-lines' as a potential resource to be used strategically to exclude or undermine the belonging and legitimacy of black fans and players. Just as the Everton fans mobilised race against the inclusion of John Barnes in the Liverpool team playing with the instability of his embracement by the Liverpool fans, 'black Londoners' can be assimilated within the Millwall fan collective, but depending on circumstances and context they can be transformed into vilified 'black bastards'.

It has to be said though that the black figures within Millwall fan culture become almost totally assimilated. They almost become majesty figures within the symbolic dominion of the fan collective. This, however, does not preclude the same figures being targeted by opposing fans in a racialised fashion. Equally, white peers and even friends can indulge in the mirror opposite forms of racialisation when directed towards black fans who support Millwall's rivals.

What is established is a racialised hierarchy. In order to understand this process it is important to cross the analysis of racialised identities with an understanding of how these intersect with gender relations and masculinity. It may be that commensurable, class-inflected ideals about black and white masculinity provide a common ground within black-white peer groups.

Where young white men are forming alliances and friendships with black peers it is important to question the constructions of blackness they may be finding attractive. For young white men this may be located around racialised

Table 4.2 Normative structure of club–race identity, incorporating black supporters

	Everton	Millwall
Football fan	Everton/Scouser/white Everton/black Scouser	Millwall/Londoner/white Millwall/black Londoner
Other	'Paki'	'Paki'

definitions of masculinity. In this sense the image of black masculinity as invulnerable, 'hard' and 'terrace tough' is alarmingly similar to racist notions of dangerous/violent 'black muggers'. At the moment when racist ideas are most vulnerable, in situations where there is intimate contact between black and white men, stereotypical ideas can be reproduced as positive characteristics to be emulated. Thus the internal configurations and contradictions found in white working-class masculinities police the determinants of racial exclusion. Within these white constructions, black men are simultaneously feared and desired, while 'Pakis' are vilified as soft and effeminate.

It is only by understanding these underlying structures that the venom of the 'I'd rather be a Paki than a Scouse' chant can be understood. The chant works as an insult because this normative structure is parodied in play. Its status as a 'play insult' is crucial. Through playing, a negotiated alteration of meaning takes place which dislocates practice from what it 'stands for' in wider usage.

Through singing 'I'd rather be . . . ' Millwall fans are playfully re-ordering the racialised hierarchy outlined above, as in Table 4.3.

The venom of the insult, and its contrast with the more direct racial taunting associated with the Everton chants, is in the way that the hierarchy of most desirable identities is re-ordered. While the insult indexes a whole range of socially available identity categories and social formulations, the particular meaning and fit of these formulations only make sense within the play context. In this sense the preference for the category 'Paki' over 'Scouse', is as much about the choice of an effective insult within the fictional play context.

The song is directed at the white Everton fans and ridicules their celebration of a white Scouse identity. It uses the Everton supporters' history of association with racist sentiments and turns it against them, drawing on the rich cultural traditions of their rivals without resorting to the explicitly racist taunts of previous eras. To profess a desire 'to be' a despised minority over the

Table 4.3 The racialised hierarchy re-ordered to incorporate the 'play insult'

	Identity hierarchy	
	normative	*play*
Desired identity	Millwall/Londoner/white	Millwall/Londoner/white
	Millwall/black Londoners	Millwall/black Londoners
	Everton/Scouser/white	'Paki'
	Everton/black Scousers	
Despised identity	'Paki'	Everton/Scouser/white
		Everton/black Scousers

alternative prospect of being an Everton fan – who is by implication white, or at best black and white – takes on added malice.

However, this is all taking place within a context where racial meanings do not 'stand for' what they would outside the context of the game and the stands. What is important here is that racialised meanings are referenced through the implicit discourse of whiteness and explicit invocation of racist epithets. The key to understanding the cultural politics of 'I'd rather be . . . ' with regard to racism lies in its normative structure that is replete with stigmatised racist categories and a racially exclusive notion of who a 'normal' fan is and what s/he looks like. Once again we see a banality, a taken for granted nature to this form of implicit collective identity.

What 'I'd rather be . . . ' shows very clearly is the way in which these types of racialised hierarchy and exclusion are normalised within fan culture. It also demonstrates how the cultural traditions and associations of particular clubs with racism provide a certain continuity within the development of racism in the game, which can themselves be invoked in new forms of abuse which are less explicit in their rendering of racist notions.

Summarising new perspectives on racism in football

We are concerned not to settle for the established caricatures of what racism looks like in the context of football culture. Our research is based on the premise that racism in football operates in complex and often contradictory ways and a number of themes are emerging from our work which add weight to this perspective.

What is striking about the manifestations of racism in football grounds is their apparent banality. From the games where we have conducted observation we have identified a variety of patterns which suggest simultaneous processes of continuity and change. Racist abuse in grounds occurs in an intermittent fashion, racist epithets and slogans are invoked in specific contexts and serve particular functions such that a series of fixtures may pass without any racist activity whilst a fixture with a heightened atmosphere or the appropriate circumstances can produce an explosion of racist activity. We have found that the perpetrators of racist activity are drawn from all age ranges and that racist activity is unevenly developed within the ground as a whole. Even racialised verbal abuse itself takes a variety of forms in different contexts, including the use of humour, individual slurs, proactive intimidatory abuse and the use of collective songs using racial meanings to express club identities.

Whilst the overall frequency of racist activity has declined there is a discontinuity in relation to the development of patterns of racist practice, both in terms of time and the contextual platforms provided by different arenas, football clubs, players, reputations and traditions. It has become clear that just

as racism is unevenly developed within the game so any improvement or change needs to be understood as similarly uneven.

To summarise our argument we want to return to some of the implications that the dominant understandings of racism in football have for the practical politics of anti-racism. All the evidence from our research suggests that any sophisticated approach to understanding the culture of racism in football must reject the simplistic notion of the racist folk demon and the tendency to label particular clubs as uniformly racist. Up until now the pervasiveness of the racist–hooligan couplet has meant that the complexities which we are concerned with have either been ignored or inflated.

Thus ambiguous and contradictory expressions of racist practice get ignored because their perpetrators don't accept them as racism. A man in his seventies who shouts abusive racial epithets at a black player doesn't comply to the image of what the racist is supposed to look like. Thus such name-calling can be explained away and rationalised: 'Well everyone gets abused – if you've got ginger hair, or fat you'll get grief as well. It's not racism – they are only winding them up.' In order for 'racism to count' within this logic the exponent has to be a fully paid up card carrying Nazi. In reality, such fans are pretty thin on the ground.

Our research has found that it is the nature of the deed and not the uniformity of the doer's racism that matters. A complex racialised chant like 'I'd rather be . . . ' works precisely because it is underscored by a cultural matrix that is shot through with racist formulations. In this sense the racist/hooligan couplet makes it possible for racist practices to be made legitimate and rhetorically denied: 'It's not racist he's only winding him up.' The reasoning behind this argument is simple: 'they are just ordinary blokes not hooligan Nazis'. The other dimension of this process is that from outside – within media and antiracist discourses – these banal forms of racism are inflated so that they constitute neo-Nazi behaviour. The result is a kind of mutual form of misrecognition.

Such a syndrome does not only apply to fan culture. It is equally relevant to the institutions of football. Within the game the racist–hooligan can be vilified and condemned at all levels from the FA, to the football clubs and players. The advantage of this with regard to organising alliances is that there can be some common form of agreement. This is in many ways why there has been almost complete support for the 'Let's Kick Racism Out of Football' campaign (Back et al. 1996). Yet, at the same time there is a reluctance on the part of football's institutions to discuss the issues associated with our work that would widen the scope of their activity. The inference is that you can speak about racism in the football stands but you can't talk about it in the board rooms.

The campaign against racism in football is occurring at precisely a time when the orthodoxies of such moral approaches to anti-racism are being questioned within other areas of British life. Such an approach is doomed to

limited success because it relies on a moralism that does little to understand the social configurations of racism. Yet the starting point for any effective attempt to deal with racism must tackle the issues of silencing and denial that are widespread within the institutions of football. The crude labelling of racists as 'moral degenerates' will do little to identify and tackle the forms of banal racism which still haunt our national game both within its institutions and amongst it loyal fans.

Note

1 This paper is a product of a project funded during 1995–7 by the Economic and Social Research Council on *The Cultures of Racism in Football* (R000 23 5639). We are grateful to the ESRC for their support for this project and to the Centre for Urban and Community Research at Goldsmiths College for providing us with a congenial base.

Bibliography

Back, L. (1991) 'Social context and racist name calling: an ethnographic perspective on racist talk within a south London adolescent community', *European Journal of Intercultural Studies* 1, 3: 19–39.

—— (1996) *New Ethnicities and Urban Culture: Racisms and Multiculture in Young Lives*, London: University College Press.

Back, L., Crabbe, T. and Solomos, J. (1996) *Alive and Still Kicking*, London: AGARI.

Duke, V. (1991) 'The sociology of football: a research agenda for the 1990s', *Sociological Review* 39, 3: 627–45.

Dyer, R. (1997) *White*, London: Routledge.

Giulianotti, R. (1994) 'Social identity and public order: political and academic discourses on football violence', in R. Giulianotti, N. Bonney and M. Hepworth (eds) *Football, Violence and Social Identity*, London: Routledge.

Haynes, R. (1995) *The Football Imagination: The Rise of Football Fanzine Culture*, Aldershot: Arena.

Hill, D. (1989) *Out of His Skin: The John Barnes Phenomenon*, London: Faber and Faber.

Holland, B. (1992a) 'Burnden's burden – summary of findings from a survey of residents living in Burnden, Bolton, on their experiences of racial harassment from football fans attending Bolton Wanderers Football Club matches', unpublished working paper, University of Bradford.

—— (1992b) 'Racial harassment in football', in *Tackling Back: Racism in Scottish Football*, Report of Conference Proceedings, University of Stirling, 30 June, Stirling: Stirling District Council.

—— (1995) '"Kicking racism out of football": an assessment of racial harassment in and around football grounds', *New Community* 21, 4: 567–86.

'Match of the Day' (1987) BBC1, 3 November, London: BBC.

Redhead, S. (1991) *Football with Attitude*, Manchester: Wordsmith.

—— (1993) *The Passion and the Fashion: Football Fandom in the New Europe*, Aldershot: Avebury.

Terrill, C. (1996) 'High Noon', *Soho Stories*, BBC2, 11 November, London: BBC.

Turner, R. (1990) *In Your Blood: Football Culture in the Late 1980s and Early 1990s*, London: Working Press.

Williams, J. (1992) *Lick My Boots – Racism in English Football*, Department of Sociology, Leicester: University of Leicester

——— (1994) '"Rangers is a black club": race, identity and local football in England', in R. Giulianotti and J. Williams (eds) *Game Without Frontiers*, Aldershot: Avebury.

5

THE *ULTRÀS*, RACISM AND FOOTBALL CULTURE IN ITALY[1]

Carlo Podaliri and Carlo Balestri

Here in Italy the situation is becoming very hard. I am fed up with hearing insults from our rivals every Sunday and, as time goes by, the situation worsens.

(Abedì Pelé, *La Republica* 12 April 1996)

Introduction

Facing the problem of racism in Italian stadiums means looking at the history of *curve* support (or *ultrà* support, traditionally located at the end, or *curva*, of grounds) and therefore understanding both the dynamics that enabled racism and right-wing extremism to spread and the intervention strategies that at present are able to help stem this phenomenon.

We will start our report with a small semantic remark: the Italian term *ultrà* is commonly translated to the English term 'hooligan' and this is an easy convention which many Italian journalists, together with many foreign observers, like. However, if we check the meaning of the two terms we will soon realise that they do not correspond. The term 'hooligan' comes from the name of a gang which was active in the late 1800 in England, famous because of its aggressiveness and this term equates these supporters directly as thugs. The term *ultrà*, however, is more all-embracing and it will be used throughout this report: it comes directly from the world of politics (the supporters of the French kings, or post-1968 left-wing groups), and refers to the category of political extremism. This difference, which is not merely semantic, is the necessary starting point for our discussion about the history of *ultrà* support in Italy.

English football hooliganism contributed to the formation of groups of young people expressing support in new and more aggressive ways in all European contexts. Yet, in different national situations, this phenomenon has interacted with some autochthonous cultural, social and political elements and

these determined the different times and nature of the adoption of the English model.

In particular, in Italy the *ultrà* phenomenon demonstrated such a degree of autonomy compared to the original English paradigm that, during the 1980s, it has in turn become an example and a model for other European countries (in particular Mediterranean countries such as Spain, Greece, the Republics of former Yugoslavia, southern France and some of the Baltic States). In Italy the birth of *ultrà* groups took place in an anomalous political context that we should outline briefly.

Phase one

From the end of the Second World War and the end of the 1970s, Italy displayed a special characteristic in its society, namely that political conflict involved all social fields. Therefore, public life, sports and cultural events were given a political meaning deriving from the opposition between a clerical-conservative vision of the world (that in some particular cases could be considered almost pro-Fascism) and a vision linked to the Communist left. This political conflict was also evident in football, to such an extent that it is possible to outline differences in the teams on the basis of the social status of their supporters and of the geographical areas where the different political ideas were more or less strong. In Milan, AC Milan represented the team of the working class (the railway workers in particular), and was considered left-wing, whereas Internazionale was the team of the middle class of Milan and its suburbs and was considered closer to conservative ideas. Further, the dominant political tendency of a region used to have an automatic influence on the most important teams – in Communist Emilia for example, the Bologna team inevitably had left-wing supporters, while the Verona team was the emblem of conservative Veneto.

This general rule even applied to the first supporters groups which were organised by the team managers in the early 1960s for the purpose of dealing with the sale of the tickets, the organisation of support and travel to away matches. Thus, several Inter supporters clubs which were organised by Servello, a representative of the Italian Social Movement and team manager, were so close to conservative ideas that the first *ultrà* group of Inter, the 'Boys', was born out of the splitting up of a group of young supporters belonging to the Italian Social Movement; and some Torino supporters clubs did not conceal their left-wing sympathies, sometimes exhibiting banners bearing political slogans and often starting fights when they encountered fascist meetings.[2]

In a highly politicised context, the advent of young rebels in the second half of the 1960s and the consequent birth of the *ultrà* groups are not only the expression of a social and cultural form of behaviour, but they are also deeply related to the political situation. In England, the street subcultures connected

to popular music contributed to the birth and development of the rule system which formed the basis of hooliganism (strong ties to territory, tight access rules, defence against intruders, and aggressive behaviour). These rules then spread to other European countries through different channels. Notably, in Italy, some young juvenile styles gained importance and strength during the years of the students' protest and of the great factory workers' fights (1968–9) and they were strongly influenced by them – in Italy the protest movement was not linked exclusively to students, but included large numbers of young blue-collar workers. On the basis of this movement's experience, many young people met in groups, sometimes also in small political parties, and sometimes organised along Leninist ideas. These groups occupied the Italian squares and streets, confronting the police and organised right-wing groups. They controlled the meeting places where the new subcultures were flourishing and new street styles and political concerns started to mix in such groups. Also, on the sidelines of these groups, the new youth subcultures imported from England combined with a rebelliousness typical of the young, including anti-establishment ideas. This was where the *ultrà* groups were born.

The first *ultrà* group was called 'La Fossa dei Leoni' (The Lions' Den) and was formed in 1968 at AC Milan. Subsequently, the 'Inter Boys' and the 'Red and Blue Commandos' of Bologna were born, together with other groups which borrowed their names directly from the political language – with '*ultrà*' first used by Sampdoria supporters in 1971, and then 'Tupamaros', 'Fedayn', 'Folgore' and 'Vigilantes'.

All these groups were clearly fascinated by the English hooligan model and when young English and Italian supporters met for a match, they began to make comparisons: the first Italian *ultrà* began to identify themselves with a certain kind of clothes and a specific area of the stadium which consequently became off-limits for other supporters. These groups also supported their team with endless choruses during the whole match and behaved violently towards the rival supporters. However, Italian *ultrà* members were also inspired by the small, politically extremist groups occupying the streets and the squares and representing a very visible model of militancy, clannishness and toughness. Therefore, it is clear that besides the non-occasional contiguity between *curve* supporters and people taking part in the demonstrations, the *ultrà* groups tended to conform to the style of these groups, adopting their organisational and structural characteristics together with some countercultural features. The influence of this model even had repercussions in terms of the allegiance of some *ultrà* to extreme left-wing groups, although the latter never carried out systematic recruitment campaigns in the stadiums.

The examples of *ultrà* groups formed by extreme right-wing leaders was different and happened at Inter, Lazio and Verona. In these cases it seems that the Italian Social Movement, banned from the streets and squares, tried to make instrumental use of a certain rebelliousness in young football supporters, usually to be found in the stadiums' *curva*, and tried to influence their

behaviour. Thus, in Milan leading members of the young people's section of the Italian Social Movement were the founders of the 'Inter Boys' and in Rome there was a very high number of extreme right-wing middle-age militants among the Lazio *ultrà* (Paese Sera dtd. 6 November 1975).

It was a combination between a football culture which was less dependent on the working class supporters and the link with the political groups that determined the peculiar feature of the *ultrà* movement. Thus it was not exclusively based on a working class community (unlike, perhaps, in England), but represented different social classes. The *ultrà* movement was made up, therefore, both of 'people having experimented with mass violence in the political field' (proletarians, lower middle class and middle class fans, and from both left and right) as well as by 'people having experimented with violence in the fulfilment of everyday needs [in local gangs]' (Marchi Valerio (ed.) *Ultrà, Roma Koinè*: 187).

It is now necessary to examine in more detail some specific features differentiating the Italian groups from other European ones in this period. We will see that the mixture of football support and political forms was absorbed by the *ultrà* groups, and was evident in their behaviour patterns and in their organisational structures.

Although the *ultrà* groups were prone to violence just like their English cousins, and they followed traditional alliances or rivalries between the various teams, the *political* tendency of a team soon influenced these alliances or rivalries. For example: the leftist *ultrà* group at Bologna became hostile to the Verona rightist *ultrà* group, while becoming 'twinned' with the Milan *ultrà* group who shared their left-wing tendency. Moreover, *ultrà* members directly adopted the same clothes of political street groups: green parkas, camouflage combat jackets bearing team badges, blue jeans and balaclava caps or neckerchief on the face, all of which made the *ultrà* look like a metropolitan *guerrillero*. Furthermore, in Italian stadiums supporters started to play tin-plate drums borrowed from the blue-collar workers' political demonstrations, using them to accompany choruses. The slogans that football supporters endlessly chanted were also borrowed from politics as were banners, enormous flags and marches typical of political demonstrations.

The *ultrà* group was also much more open toward the outside world than other hooligan groups: because of their countercultural tendency, the *ultrà* groups accepted a fairly remarkable number of women (absent in most other European groups) and carried out direct membership activities, as with political organisations. All these characteristics highlight a substantial organisational difference between these groups in Italy and the English model. While English and other European supporters mainly performed spontaneous activities (such as choruses and choreographies using scarves), Italian supporters felt that the activities borrowed from politics and aimed at socialising and increasing *curve* support participation were a real priority. These activities entailed an organisation that went beyond the Sunday match and involved

midweek meetings where supporters worked at the creation and staging of spectacular choreographies, aimed at involving all the other *curva* supporters and at the production of various materials to self-finance the group.

To complete the overall picture, some other features need to be underlined. The *ultrà* members were similar to the first English hooligans in that they felt themselves deeply tied to the colours of their team and were strongly connected to the popular supporter culture. Therefore, they occupied the cheap seats, watched the match without ever sitting down, and constantly drew inspiration from tradition. For example, fans at Napoli revitalised the Naples custom to use petards, smoke bombs and firecrackers when the teams entered the stadium, resulting in spectacular choreographies. Napoli *ultrà* also brought back the tradition of staging the rivals' funeral, marching as in a funeral procession and following a coffin covered by the rival team flag.

The retrieval of some popular supporting traditions, together with other characteristics of the *ultrà* support, made the groups very attractive to young fans and they became a powerful instrument of identification. Such activities made it easier to achieve the continuous attempt to control, in an hegemonic way, the whole *curva*, an aim which was constantly pursued by these groups and which was also borrowed from the political sphere.

These are the features that characterised the *ultrà* movement which was born in the 1970s, a movement which was constantly developing hand in hand with a considerable increase in the clashes between rival supporters. However, it was only in 1975 (precisely on 21 December) that the *ultrà* phenomenon was officially recognised as having laid deep roots among the supporters of the major clubs, when the Italian Soccer Federation decided to call for a 'friendship day' against the violent *commandos*, on the wake of violent clashes that had taken place during the 1974–5 National League Championship.

Phase two

The second phase of the *ultrà* movement was from 1977 to 1983. During this period in other European countries there was an increase in violence, there was a greater military specialisation of hooligan groups and a greater planning of clashes, due to strengthened safety measures, better policing, and the birth of new youth subcultures in the second half of the 1970s. Above all, the skinhead style became predominant in North European stadiums and, because of an increasing tendency towards xenophobia and racism, this style made right-wing positions attractive to hooligan groups. Such a development was concomitant with attempts at manipulation of, and recruitment in, hooligan groups by extreme right-wing organisations in England and Germany.

In Italy the dynamics were partially different from those that developed in other European contexts. It is true that the *ultrà* groups traditionally controlled by the right strengthened their position, however, the leisure time

and the 'world of imagination' was still completely controlled by the left and groups which were strongly leftist were not threatened by any kind of penetration from the right.

Although the adoption of the skinhead style in Italy was delayed for some years and was confined to particular situations, violence did increase. However, it is necessary to refer this rise to the decline of political movements of the 1970s. This decline had been characterised by violence and feelings of isolation and it led to a fierce and violent explosion in 1977 as well as to an embitterment of clashes with police, right-wing groups and even between left-wing groups themselves. Thus, as had happened in town squares during demonstrations, the stadiums saw an increase in the use of illegitimate weapons, knives, iron bars and rocket launchers. The names of the new groups were still influenced by the political situation of those years: many groups defined themselves 'Brigades', referring to the terrorist groups active in that period and several symbols belonging to left-wing terrorism appeared (e.g. the five-pointed star of the Red Brigade) and to right-wing terrorism (the two-edged axe which was the emblem of 'Ordine Nuovo' or 'New Order'). It also became more and more common for the ultrà groups to stage clashes outside the stadiums, in order to avoid police control.

The increase in violence became tragically evident with the death of a Lazio supporter in 1979 before the beginning of the Roma–Lazio derby. That day other violent clashes occurred leaving many injured in Ascoli, Milan and Brescia. However, in this period, the large ultrà groups had practically gained complete control of all the curve. Although the bellicose character was stronger and the level of the clashes higher, the behavioural pattern activating violence followed the rule of 'violence as an instrument' borrowed from politics. Before entering the elite of the group, rather than in the group in general, the inexperienced members had to pass a series of tests and to demonstrate that they were reliable not only from a military point of view, but also from that of organisation and general behaviour. The exertion of violence occurred only during matches between teams whose supporters were historically hostile to each other and with large ultrà groups, therefore, recourse to violence was controlled. If someone demonstrated that they were unable to move effectively or ignored the oldest members endangering the safety of the group, he was expelled and sent away. In the same period, however, ultrà numbers increased and this strengthened their organisational structures.

These years saw the birth of the first 'Directorates', based on extreme left-wing political parties, helping to co-ordinate the ever-increasing activities of the ultrà groups. At this stage, these activities corresponded to those typical of any organised supporters' club and were particularly devoted to organising travel to away matches, managing ticket distribution, and building a stronger relationship with team management. To give an example of the various activities inside ultrà' groups at the end of the 1970s we will quote an interview given by an Torino ultrà leader:

The leaders are eight including me . . . each one of us has his own tasks. Women mainly deal with the financial aspects and they are almost totally responsible for the assembling of flags and drums. We deal more with relationships with the team management. . . . There are specific tasks: organising away matches, asking for prices, timetables and renting of buses, dealing with materials, for example mending flags, buy flag poles, drums and so on, buying stationery, stickers or T-shirts, organising support and being responsible for confetti and torches, going to the team management for the tickets and keeping in touch with the team and also keeping relationships with other clubs. . . . Concerning the funds, once we used to take general collections not only among ourselves, and to sell our material: T-shirts, stickers and scarves bearing '*ultrà*' on them. But then the Torino team management decided that this was not very elegant, told us to document our expenses and then refunds us.

(Roversi 1992: 53–4)

Phase three

Between 1983 and 1989 the *ultrà* movement even reached the stadiums of provincial towns and teams playing in lower divisions, involving young people coming from all social classes (Roversi 1992: 143–61). Participating in an *ultrà* group did not result directly from a situation of social uneasiness or impoverishment: on the contrary, involved in these groups were people with good jobs, good education (degree, diploma) and people from well-off families, including married men with a stable life. Often it was precisely in the small rich provincial towns that the toughest and most radical groups could be found, for example in Ascoli, Cesena, Verona and Udine.

In these towns the interaction between the *ultrà* culture logic and the traditional rivalries between towns and regions emerged clearly and in its most original way. During this period the *ultrà* world became largely dominated by local and parochial pride, an element granting a strong identity. Before this it had always been possible to connect the recourse to violence against intruders (such as rival supporters or the police) to the defence of the *ultrà* territory (the *curva* and ideally the town and the team colours); yet it was also connected to an atmosphere, a political tension that could supply a surplus of identity, cohesion and aggression, based not only on the traditional friend–foe logic. On the other hand, in the 1980s, with the ebbing of political movements, the situation was no longer the same. Thus, in these years, the main trend inside the *ultrà* movements was that more importance was attached to regional or local identity and parochialism, to regional and local rivalries and to historical hostilities in determining which *ultrà* groups were to be considered enemies. Their logic of the *curva* as a liberated space is

replaced by that of the *curva* as a small 'mother country', which produced a clannishness, a cult of toughness and paramilitary organisation. This link to the small 'mother country', which is very close to extreme right-wing values, facilitated racist and xenophobic behavioural patterns inside the stadia.

At the same time, there was a period of crisis in the traditionally large *ultrà* groups, with them having to face the strengthening of safety measures inside the stadia, controls on groups travelling to away matches and controls on the movements of key *ultrà*. Moreover, the first generational change took place among the *ultrà* hierarchies with some charismatic leaders, also active in the political world, leaving the various *curve*, often because of the numerous repressive measures taken against them (because of events within both football and politics). Also, some other members left the groups or lost their influence there because of drug addiction problems. In the meantime, the Italian *curve* saw the birth of new groups, made up of very young boys (from 14 to 16 years), often disliked by the official groups but succeeding in occupying their own area in their *curva* behind their own banner. Their very names highlighted their different inspirations compared to the groups which had formed during the 1970s: in this period the new groups chose names such as 'Wild Kaos', 'The Sconvolts' (rough translation: 'Wild People'), 'Verona Alcohol', 'Nuclei Sconvolti'. Such groups were mainly interested in fighting and belonged to the hedonistic 'freak-out' culture whose model was not the metropolitan street *guerrillero*, but Alex, the young super-thug in *Clockwork Orange*, whose effigy started to appear in various *curve*, replacing the 'Che Guevara' portrait. The new groups were the result of a period in which civil society was dominated by hedonism, exhibitionism, and disaffection for political and social commitment. The stylistic paradigm adopted by many new *ultrà* members, often chauvinist, violent and intolerant, was that of the *paninaro* – a youth style similar to the 'casuals' in Britain.

All these groups were formed between 1983 and 1985, demonstrating that they were more skilful in escaping repressive police strategies and that they could easily baffle controls by removing or abandoning any identifying marks (club colours etc.). They also did not care about existing alliances, breaking them or creating crises because of their uncontrolled behaviour and systematic use of knives. Having these characteristics, a lot of these groups attacked the principle of 'violence monopoly': that is to say, up to that moment, violence had been resorted to only in specific cases and according to precise rules, whereas the philosophy of these new groups was 'pure violence', forceful action for its own sake, to be carried out always and in any way possible. Therefore, they became an alternative magnet for fans giving priority to military actions inside the *ultrà* group.

However, while in other European countries the increasing trend towards specialisation of the toughest and most aggressive groups led them to a progressive split from other supporters, in Italy this did not happen. The

Italian *ultrà* members felt part of a movement based on a strong and aggregating culture that kept together very different groups and subjects. Therefore, the new groups and the historic group did not question their membership of the *ultrà* world. Consequently, the conflict dynamics were governed by the internal rules of the *ultrà* world and often all the groups, old and new, competed against each other in trying to win control of the *curve*. This fight is still going on inside the co-ordinates of the tradition of Italian *ultrà* culture and the new groups have not only competed against the older ones in a military way but in many cases the confrontation has also taken place on an organisational level and from the point of view of their visibility in the *curva*. Choreographies have become more and more complex and, therefore, more expensive and the result of this conflict has often ended up in a deadlock. In various stadiums where *curva* had previously been controlled by leftist leaderships and groups, and because of the mainly rightist tendency of the new groups, now supporters ambiguously claim their political neutrality. In the name of their faith in their team or for the sake of *curva* unity, various groups accept a solution that actually favours strategies applied by the extreme right-wing groups, aimed at the penetration, rather than replacement, of existing *ultrà* groups.

These strategies were further helped by the increase of intolerance in Italian society towards new immigrants coming from poorer countries. From the end of the 1980s, simultaneous to the rise of political movements overtly including a xenophobic component such as the Northern League, and together with the growth of skinhead and extreme rightist movements, stadia saw the exponential growth of racist choruses, the exhibition of Nazi or fascist symbols and of openly anti-Semitic banners. Outside the stadia the increasingly systematic involvement of *ultrà* groups in actions characterised by racial or political intolerance could be detected (beatings of black people and leftist militants, fire attacks against hostels for foreigners or social centres etc.).

Therefore, in this period the racist and xenophobic tendencies that had long been latent in the civil society started to explode and to became more visible. The part of the *ultrà* movement that had foreseen and anticipated these trends, began to politicise and radicalise more and more their adhesion to a xenophobic vision of life. This happened in the *curve* of certain stadia of Northern Italy, where the growth of an anti-Southern feeling in stadia preceded and accompanied the birth and development of an openly xenophobic and separatist movement such as the Northern League, also acting as booster in the strengthening of identity based on ethnic differences: 'Bergamo is a Nation, all the rest is South' was a common chant of the Atalanta *ultrà* members and 'Bossi save us, Brescia to the people from Brescia' was a banner exhibited in 1991, before the local elections to be held in Brescia (northern Italy).

In Italian *curve*, this local racism coexists with classical racism against those who are considered strangers who do not belong to the national community (immigrants, gypsies). Insults against people from the South are not chanted exclusively by groups supporting the Northern League; on the contrary, they

are also systematically adopted by the Northern supporters of the nationalistic (as opposed to separatist) tendency, such as Verona, Inter, Piacenza and so on.

The emergency, however, does not confine itself to the presence of neo-fascist groups in *curve*, but is characterised by the depth of the adhesion to a reactionary and xenophobic vision of politics, lending support from many of the youngest *ultrà* members to the institutionalised right-wing parties, National Alliance, the Lombard League and the neo-fascist Tricolour Flame. While in northern Europe hooligan groups have often supplied uncivil and uncontrollable underlings, or 'foot soldiers', to the neo-fascist parties, in Italy an increasingly systematic recruitment campaign of young militants and effective political activists has been noticed. The demonstration of the evident mixture between right-wing politics and football comes from the numerous career opportunities offered to some *ultrà* leaders because of their ability to supply votes and gaining a consensus among young people. There are, for example, Parliamentary Members belonging to National Alliance who come from the Verona *curva* supporters. But it is above all inside the local governments that the presence of subjects connected to xenophobic and racist movements is observed. In Rome, for example, during the administrative elections of November 1993, a total of thirteen elected representatives belonging to right-wing lists came from the Roma and Lazio *curva* supporters.

More recently, the extreme right-wing *curve* groups have also been ready to bypass the traditional football rivalries and have started to collaborate in order to pursue a political objective. Thus, on 29 November 1994, on the occasion of the Brescia–Roma match, a pre-planned attack against the police and the Brescia *ultrà* group was organised. This attack was carried out using axes, knives and other weapons and involved neo-fascist superhooligan groups supporting Roma and Lazio as well as neo-fascist *ultrà* members from Bologna and other Italian cities.

Phase four

The history of the *ultrà* movement entered a new phase as a result of the events which took place in Genoa on 29 January 1995. Before the Genoa–Milan match, a small group of superhooligans supporting Milan, led by a young professional accountant who was a strong supporter of the extreme right, planned an act of aggression outside the Marassi stadium. The group was equipped with knives and reached Genoa by a train on regular service, concealing anything that could tie them to football supporters, and reached the stadium following a pre-planned itinerary. In front of the stadium the group attacked some Genoa *ultrà* members and during the fight one of them, Vincenzo 'Claudio' Spagnolo, 24 years of age, was stabbed to death.

The *ultrà* world, which was fiercely attacked by the mass-media, was upset and for the first time a meeting among the representatives of the main groups was organised. The result was a declaration condemning the use of knives

during clashes and hoping for the restoration of old rules and behavioural codes typical of the traditional groups ('Stop the knives, stop the rascals'). Until the end of the 1994–5 Championship a type of undeclared truce was complied with, leading to a considerable decrease in violence and clashes.

However, the truce did not lead to the actual disarmament of the most aggressive groups and these superhooligans did not lose their military power, demonstrated by the fact that from the beginning of the 1995–6 Championship, a considerable renewal of violent behaviour was observed (guerrilla fighting during the Fiorentina–Atalanta Italian Cup Final; extremely violent clashes in Campania between two *ultrà* groups supporting Third Division teams; violence against players in Foggia). Also, racism was back again, illustrated by the shameful behaviour of some *ultrà* supporting Cremonese against Paul Ince (then of Inter), and the ferocious challenge mounted by *ultrà* groups from Verona and Padova sparked by the news that a black player had been signed for the next season. One of the most serious expressions of racism took place in Bologna in June 1996, when a group of extreme-right Bolognese superhooligans ('The Mods'), along with a few Roma *ultrà* attacked eight black immigrants in the course of the celebrations for Bologna's promotion to Serie A. In the wake of the incident, the Bolognese *ultrà* world split: the historic group of the two *curve*, the 'Forever Ultras', issued a press release condemning the attack and expressing solidarity with the victims.

The sharp division which took place among Bologna's *ultrà* bears witness to the fact that the 'unity at all costs' of the *ultrà* world is at risk: the cement represented by a common culture seems no longer to be enough to hold groups together. On the one hand there are groups that offer a strong identity to their members on the basis of a series of initiatives and activities (including even the social field, carrying out collections of second-hand clothes for war victims and fund raising for children's charities) and, on the other, there are groups which are mainly oriented towards a military confrontation.

The number of incidents during the 1996–7 season was slightly reduced, although incidents have tended to occur in lower divisions (one of the highest risk games that season was that between Pisa and Livorno, a Serie C match), and the number of extreme and gratuitously violent incidents has increased, often caused by small groups alien to the traditional *ultrà* groups. Precisely for these reasons, some traditional groups are currently considering methods for reducing violent behaviour on their *curve*.

Moreover, recently there has been the development of a debate, involving *ultrà* from many parts of Italy, on two main issues: the fact that the *ultrà*, as football fans, are treated as second-class citizens and are under strong (and frequently unjustified) pressure from public order forces; and on the other, the implications that modern football's new economic cycle has for the organised supporter culture (television's immense power, the commercialisation of football, the revolutionising of football shows and the increased ticket prices are

all key issues). Furthermore, some small groups and individuals are trying to develop strategies aimed at depriving racist and xenophobic groups of the control they now exert on the stadiums.

The presence of these conditions has also helped the creation and birth of *Progetto Ultrà*. The aim of the Project (which began in December 1995) is to stem intolerance and racism in the stadium *curve*, creating an intervention structure on the basis of the German Fan-project,[3] but adapting it to the Italian situation. In Italy, contrary to what has happened in Germany, it is not possible to set up structures for fans adopting a top-down approach and following a social-pedagogical philosophy. Indeed, in Italy an intervention which is social by nature but has not been negotiated by actors from within the *curve* will not succeed since it will be considered institutional by *ultrà* members who will therefore oppose it. This is why the *Progetto Ultrà* has been set up in such a way as to provide for full collaboration from the *ultrà* during each and every one of the phases of the construction of the intervention structure aimed at them.

The strategy which has been followed up to now has therefore been extremely gradual: an important step has been the setting up of an Archive (*Archivio*) on football support in Europe, bringing together books, essays, and articles on the subject, as well as fanzines, video tapes and choreographic material. The *Archivio*, as well as having become the main observatory of the Italian football fan world, has by now become a point of reference for many researchers and fans throughout Europe, and is also a meeting place for all of those within the *ultrà* world who wish to oppose the growing waves of racism and intolerance. At the same time, the *Archivio* has enabled us to act as a catalyst for the participation of the *ultrà* and to create, in some initiatives, collaborative work with different groups on the *curve*. The task of rooting ourselves within the *ultrà* world is currently progressing well and will enable us to inaugurate the first interventionist structure in Bologna in the first few months of 1998.

Notes

1 This chapter is a development of a paper presented to '*Fanatics!*' Conference by Carlo Podaliri and Carlo Balestri (Archivio sul tifo calcistico in Europa – Progetto Ultrà – Comitato Regionale Uisp Emilia Romagna, Bologna, Italy). Our Project receives financial assistance from the Regione Emilia Romagna and the European Commission, D.G. 5, Cities' Anti-Racist Project.

2 For example in 1964, the *Fedelissimi Club* supporting the Torino team fought against the participants in a fascist rally in Bergamo. Gianfranco Calligarich, *Vie Nuove*, 15 April 1965.

3 The German Fan-Projects are social work structures built on a local basis, financed by institutional actors such as municipal governments or football teams and aimed at football fans. The objective of such structures is to decrease the incidence of violent behaviour, working within the specific framework of fan culture. The *Sozialarbeiter* (social workers) involved in the Fan-Project must have a deep

knowledge of the day-to-day life of the football fan, go on the terraces, go to away games, get into contact with the most violent groups, spark off the participation of fans by supplying the space for aggregation and socialising and for creating opportunities for communal work and discussions on violence.

Bibliography

Archivio sul Tifo calcistico in Europa (1996) 'Italy's racist *Ultrà* groups', *Searchlight* 252.

Balestri, C. and Podaliri, C. (1994) 'Italien: Kurze Geschichte der 'Ultrà' Fankultur und Ihre Beziehung zur Politik', *Der Übersteiger*, 9–10.

—— (1995a) 'Dalla Germania i Fanprojekt', *Il Manifesto*, 7 February.

—— (1995b) 'Progetto Ultrà', Project presented at the European Commission, 15 October.

—— (1996a) 'Relazione per l'incontro con gli operatori del Baden Württenberg del 9 Maggio 1996', unpublished paper.

—— (eds) (1996b) *'Ultrà'*, monographic issue of *Areauisp Review*, 1–6 (December).

Balestrini, N. (1994) *I Furiosi*, Milano: Bompiani.

Bromberger, C. (1995) *Le match de football: ethnologie d'une passion partisane à Marseille, Naples et Turin*, Paris: Editions de la Maison des Sciences de l'homme.

Broussard, P. (1990) *Generation Supporter*, Paris: Laffont.

Cavalli, A. and de Lillo, A. (eds) (1993) *'Giovani anni '90: terzo rapporto Iard sulla condizione giovanile in Italia'*, Bologna: Il Mulino.

Colombo D. and De Luca, D. (1997) *Fanatici: voci, documenti e materiali del movimento ultrà*, introduction by V. Marchi, ed. by C. Balestri, C. Podaliri and M. Grimaldi, Rome: Castelvecchi.

Dal Lago, A. (1990) *Descrizione di una battaglia: i rituali del calcio*, Bologna: Il Mulino.

Dal Lago, A. and Moscati, R. (1992) *Regalateci un sogno: miti e realtà del tifo calcistico in Italia,* Milano: Bompiani.

Dionesalvi, C. (1997) *Comunicazione e potere nello spettacolo calcistico.* Cosenza: Satem.

Giulianotti, R. (1994) 'Calcio e violenza in Europa: le differenze tra Nord e Sud', *Il Discobolo*, November–December.

Grozio, R. (ed.) (1990) *Catenaccio e contropiede: materiali e immaginari del football italiano*, Roma: Antonio Pellicani Editore.

Marchi, V. (ed.) (1994) *Ultrà: le sottoculture giovanili negli stadi d'Europa*, Roma: Koiné.

Matthesius, B. (1992) *Anti-Sozial Front: von Fußballfan zum Hooligan*, Opladen: Leske and Budrich.

Roversi, A. (1990) 'Calcio e violenza in Italia', in A. Roversi (ed.) *Calcio e violenza in Europa*, Bologna: Il Mulino.

—— (1992) *Calcio, tifo e violenza: il teppismo calcistico in Italia*, Bologna: Il Mulino.

Segre, D. (1979) *Ragazzi di stadio*, Milano: Mazzotta.

Smargiasse, A. (1993) 'Calcio, ultrà e ideologia', *Critica marxista* 1–2.

Triani, G. (1990) *Mal di Stadio: storia del tifo e della passione per il calcio*, Roma: Edizioni Associate.

—— (ed.) (1994) *Tifo e Supertifo: la passione, la malattia, al violenza*, Napoli: ESI.

Usvardi, G. (1986) *La violenza delegata,* Roma: AICS.

Verein Jugend und Sport (ed.) (1993) *Der zwölfte Mann . . . : Soziale Arbeit mit Fußballfans in Hamburg*, Hamburg: Verein Jugend und Sport.

6

'FOOTBALL'S COMING HOME' BUT WHOSE HOME? AND DO WE WANT IT?

Nation, football and the politics of exclusion

Ben Carrington

Racism manifests itself in plural and complex forms. In this situation the logic of racism needs to be appraised in what we shall call *metonymic elaborations*. This means that racisms may be expressed through a variety of coded signifiers. . . . Contemporary racisms have evolved and adapted to new circumstances. *The crucial property of these elaborations is that they can produce a racist effect while denying that this effect is the result of racism.*

(Solomos and Back 1996: 27, emphasis added)

Introduction

This chapter argues that the dominant discourse that surrounded Euro 96 (the 1996 European Football Championships) drew on, and reinforced, a form of cultural racism that currently appears to be pervasive. It is argued that the national 'imagined community' (Anderson 1991) that was re-constructed was one that actively worked to exclude certain categories of people – being both gendered and racially exclusive. Seeking to understand the underlying cultural processes that generated this discourse, I show the connections between other cultural spheres, notably pop music, and argue that these cultural expressions are part of a wider reassertion of a narrow and closed white male English identity which has become coded as the so-called 'New Lad' phenomenon. The chapter surveys some of the contemporary characteristics of popular culture before locating the pivotal role of comedians David Baddiel and Frank Skinner in generating the Euro 96 anthem, 'Three Lions' with its 'football's coming home' chorus, and outlines why this song and related themes became so popular within both the public and political imagination.

Imagining England

It is well acknowledged that sport provides one of the key symbolic sites for the production and reproduction of social identities. Eric Hobsbawm's dictum that the identity of a nation of millions 'seems more real as a team of eleven named people' (1990: 43) is a pertinent reminder that sport, and by that it is normally meant, elite-level male competitive sports, is still seen in many countries as being central in symbolising a nation's identity.[1] In relation to English identity Chas Critcher has argued that, it 'is difficult to specify anything, other than war and royalty, which articulates national identity quite so powerfully as the England team competing in the latter stages of a World Cup competition' (1991: 81) – to which we should now add the latter stages of a European football championship.

The symbolism of national sporting sides, and sport itself, has therefore acquired huge political significance, especially for the political right, in trying to foster certain narrow notions of what Britain's/England's (the two are often confused within these discourses) cultural identity should look like. The continuing questioning of the 'loyalty' of black Britons, as spectators and players, demonstrates both the importance of national sports teams to nationalistic projects and the powerful effect that the presence of black athletes can have in challenging the assertion that 'there ain't no black in the Union Jack': Norman Tebbit's 'cricket test', and, more recently, the article in *Wisden Cricket Monthly*, arguing for the replacement of 'Negroes' and other 'foreigners' from the English Test team by 'unequivocal Englishmen' as they supposedly lacked commitment to the national cause (Henderson 1995), is testament to this.[2]

Although racially coded in a way in which previous invocations of sport and national identity had not been, John Major's 1993 St George's Day speech deliberately tried to invoke a mythical, nostalgic, and implicitly white, notion of England as, essentially, a rural country full of 'invincible green suburbs', warm beers, and 'old maids cycling to Holy Communion through the morning mist' to the distant sounds of cricket being played at county grounds. Such portrayals of Englishness were important in trying to construct a national identity – a nation at ease with itself – which inevitably precluded a vision of a multi-cultural, urban and modern Britain, at a time of crisis for the Conservative Party both from without (economically and politically from Europe) and within (in relation to growing social problems and the party's own internal divisions). Sport, and in this instance cricket, thus assumes a heightened political status in standing *in for* a particular image of the nation. As Mike Marqusee accurately pointed out:

> As the British economy wrestled with the demands of a global market, Major offered the governing party shelter in the cosy old England of county cricket. This was an England that did not exist, except, powerfully, in people's heads. Major's real audience was in the

suburbs. . . . Here 'the county ground' and the traditions of county life, including cricket, were ideological mantras to ward off the demons encroaching ever more menacingly from the crime-ridden, multi-racial, dispossessed inner cities.

(Marqusee 1994: 10)

We can see here how the cultural sphere has become the key modality through which racist expressions are articulated. Increasingly notions of 'race' and ethnicity are conflated with national identity thereby working to exclude, by definition, blacks from Britain. Surveying this shift towards what some have labelled a 'new' racism (Barker 1981), Gilroy argues:

We increasingly face a racism which avoids being recognised as such because it is able to link 'race' with nationhood, patriotism and nationalism, a racism which has taken a necessary distance from crude ideas of biological inferiority and superiority and now seeks to present an imaginary definition of the nation as a unified *cultural* community. It constructs and defends an image of national culture – homogenous in its whiteness yet precarious and perpetually vulnerable to attack from enemies within and without. . . . This is a racism that answers the social and political turbulence of crisis and crisis management by the recovery of national greatness *in the imagination*. Its dreamlike construction of our sceptred isle as an ethnically purified one provides a special comfort against the ravages of decline. It has been a key component in the ideological and political processes which have put the 'Great' back into Britain.

(Gilroy 1992: 53)

Thus, far from the processes of imagining the national community being incompatible with racist discourses, as Anderson (1991: ch. 8) seems to suggest, nationalism is now often central to racist ideologies and discourses. These 'dreamlike constructions' of earlier 'golden ages', so central to John Major's speech, are increasingly used as a way to manage contemporary political, economic and social problems by recourse to an invented past of imperial greatness when 'Britain' was supposedly at ease with herself. More importantly, we can see here the way in which certain expressions can come to have racial connotations within particular semantic fields, even as their protagonists deny that there is a 'racial element' to their pronouncements.

Britpop and the new 'British' renaissance?

One of the effects of these attempts to put the 'Great' back into Britain has been a growth in the idea that British popular culture is experiencing a form of renaissance. This can be seen most clearly in the attempt, by some, to herald

the arrival of 'Britpop' as the saviour of the British music scene. In fact, the most culturally significant musical form of recent times has, for me, undoubtedly been the emergence, in the inner-cities of the British metropolis, of Jungle music and its cultural correlates within contemporary Asian dance music culture (Sharma *et al.* 1997). Jungle, or 'drum and bass', has announced the arrival of black Britons into the diasporic black Atlantic world, and is characterised by its denouncement of closed ethnic, racial and national categories, embracing and extending notions of cultural hybridity and offering a powerful critique of the 'overground', commercialised, music industry, all of which has gone largely unremarked on by the mainstream music press. Jungle's 'dark' connotations, 'faceless stars' and its refusal to conform to the commercial formats of the established music industry have made it largely unacceptable for the Sunday spreadsheets and the tabloid 'exclusives', except for occasional excursions 'into the jungle' by ill-informed journalists.

Jungle, itself a derivative of the late 1980s' 'rave' scene, is clearly far more important as a means of gauging the nature of cultural politics in Britain today, telling us who we are, and what we are likely to become, than Britpop could ever be.[3] However given the wider political climate in which 'the past', always selectively defined, is currently being invoked as a time when Britain was once proud (and white) it is not surprising that the media, and, as shall be shown later, politicians, have latched so strongly onto the largely white, guitar-based, indie tunes more commonly known as 'Britpop'. At a time when dance music in general, with all its variants from trip-hop, through to Jungle and more recently 'speed garage', is exploring new dimensions in musical and cultural identity it is the insular and parochial sounds of Britpop that have dominated the media's attentions and which has fit so easily into the cultural and political climate of late 1990s Britain. As Simon Reynolds (1997) has argued:

> For Britpopsters, the Sixties figure as a 'lost golden age' in a way that's alarmingly analogous to the mythic stature of the Empire *vis-à-vis* football hooligans and the BNP. Even more than the insularity of Britpop's quintessentially English canon (Kinks, Jam, Small Faces, Buzzcocks, Beatles, Smiths, Madness), it's the sheer WHITENESS of its sound that is staggering . . . Damon Albarn's pseudo-yob accent testifies to a nostalgia for a lost white ethnicity, one that's fast eroding under the triple attrition of America, Europe and this nation's indigenous non-white population. . . . Thanks to rave, the most vital sectors of '90s UK subculture are all about mixing it up: socially, racially, and musically (DJ cut'n'mix, remixology's deconstructive assault on the song). Returning to the 3 minute pop tune that the milkman can whistle, re-invoking a parochial England with no black people, Britpop has turned its back defiantly to the future.
>
> (Reynolds 1997)

The profoundly conservative underlying ideology of Britpop was demonstrated by the fact that leading up to the 1997 British General Election both sides of the, increasingly contracting, political spectrum were so willing to link their own party's political agendas with that of Britpop. For instance, the right-wing reactionary Conservative MP John Redwood tried to lay claim to the Britpop mantle as an example of all that was best, in his views, in 'British' culture – i.e. white, largely male and rarely counter-hegemonic (Redwood 1996).[4]

Indeed the Labour Party went further in trying to associate itself with Britpop with the Autumn 1996 edition of *New Labour New Britain* ('The Magazine for Labour Party Members') having none other than Noel Gallagher of Oasis on their front cover. In the centre-fold feature (interestingly co-written by Labour's chief election strategist Alastair Campbell) entitled 'New Labour, New Britpop', Britpop is praised for having shown that British bands have transcended the musical influences of (black) America and have found their own distinctive voice. In an insightful analysis of this article and the wider implications of New Labour's desire to attach itself with 'Britpopism' Jeremy Gilbert states:

> Let's not be coy. The implications are clear. Britpop is being *praised* in this article for supplanting Black American music with White British sounds. This process is presented as in both cases being deeply connected with the welcome onset of a period of Labour government. The story being told is this: Black American dance music dominates British youth culture; Authentic Native White guitar pop supplants it at the same time as a Labour government is elected; this constitutes a moment of national renewal. So in our case, Britpop = Blairism = the triumph of native white culture over mid-Atlantic Black culture.
>
> (Gilbert 1997: 2)

As both Reynolds and Gilbert highlight, the promotion of Britpop serves to reinvent a racially exclusive version of British cultural history, both ignoring, or down-playing, the musical debts to black culture of British pop music from the late 1950s onwards and denying the cultural diversity of contemporary Britain – it was not Jungle music that Redwood applauded but Britpop, largely white boys having fun.

Thus what we see here is an attempt to promote a fixed, closed and racially homogenous sense of national cultural identity that actively excludes black representations from the national imaginary. This form of cultural exclusion is not just manifest within popular culture. *The Sunday Times*, on the eve of the European football tournament, heralded a new movement in British arts signalling the 'rebirth' of British cultural identity (see *The Sunday Times*, 'Rebirth of a nation', 19 May 1996). *The Sunday Times* proudly exclaimed,

'Yes, we got it. We had it for some time, but now people are taking notice. We have the makings of a cultural renaissance, based on a new generation of young talent that is being recognised both nationally and internationally.' Significantly, the curious list of creative artists who were supposedly reshaping notions of 'Britishness' were all white, ranging from Britpoppers the Gallagher brothers and Damon Albarn, through artists Damien Hirst, Emma Thompson and Kate Winslet to Sir Simon Rattle. No mention was made of Jungle as constituting a new British musical form, or the truly innovative creations of artists like Diran Adebayo, Meera Syal, Isaac Julien, Sonia Boyce, Grooverider or Talvin Singh, to name but a few.

New Lads, new racism

It is against this cultural backdrop that we can best understand the recent emergence of the so-called 'New Lad'.[5] What is often missing from the discussions about this phenomenon, if it deserves that title at all, is that the expression of New Laddism was, and is, essentially about trying to redefine the limits of white English masculinity even though it is rarely labelled as such. What is interesting is the way in which the New Lad phenomenon has come to signify a supposedly post-feminist, non-racist white English masculinity that is somehow already 'politically correct', and therefore does not have to be. Its cheeky sexist and coded-racist remarks are (in true post-modern fashion) ironic; they are not meant to be taken seriously, and anyone who attempts to critique what is expressed is simply dismissed as not having got the joke.

As Stephen Wagg (1995: 197) has pointed out the comedy duo of Frank Skinner and David Baddiel are important signifiers in locating the recent changes and convergences within popular culture between the media, pop music and sport. Skinner and Baddiel have a long running, and seemingly popular, television show 'Fantasy Football' where they, quite literally, sit on a couch, drink beer, talk about football, and tell jokes about women etc., but circumvent any simple charges of this show being a typical male-only and sexist space as they also invite on guests such as comedienne Jo Brand – so how can they be sexist? In this respect they have, however much they would reject the term, become central icons of New Laddism – their diverse class backgrounds becoming largely irrelevant for this re-imagined class-less English masculinity (see Figure 6.1).

I want to focus here on one of the widely publicised 'Fantasy Football' comedy sketches, as it highlights the complex ways in which contemporary racisms manifest themselves, and some of the problems with the notion that 'New Laddism' is, essentially, a harmless manifestation of 'boys just having fun'. The sketch that attracted most attention was one where the former Nottingham Forest footballer Jason Lee was subject to a series-long 'joke' that seemed to catch the (white) public's imagination. After having earlier

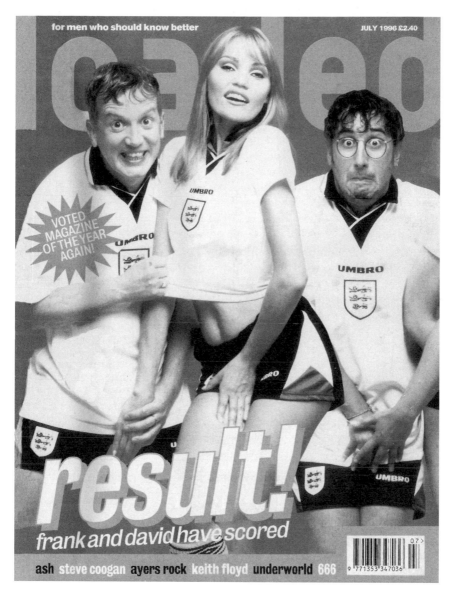

Figure 6.1 Baddiel and Skinner on the front cover of the 'New Lad' magazine *Loaded* ('For men who should know better'), on the eve of Euro 96 in a 'cheeky' pose with a model

Source: Reproduced courtesy of *Loaded* magazine.

ridiculed Jason Lee's footballing ability they then had a sketch whereby David Baddiel 'blackened up' (evoking the barely-coded racist imagery of the minstrel shows), with a pineapple on his head, out of which Jason Lee's dread-locks were growing – the 'joke' being that Jason Lee's dread's resembled a fruit on top of his head. This joke was then carried, with increasing frequency for the rest of the series, with young children sending in drawings of Jason Lee adorned with various fruit on his head. The pineapple joke was taken up by football fans in the terraces who chanted songs about Jason Lee's hair, and significantly transcended the normally insular world of football fandom, and entered into the public domain as both a descriptive term, and a form of ridicule, for any black person with dreadlocks tied back.

Much has been said about this but I want to briefly mention a couple of points as the episode demonstrates well the way in which contemporary racisms are often subtly coded and how such racisms will deny that their motivations are racist even as their effects are. Kobena Mercer has remarked how hairstyle has become an important part of black expressive cultures marking them out from the (white) mainstream and signalling a form of black cultural resistance to racial oppression. Hair in particular functions as a key 'ethnic signifier', its very malleability making it an important and sensitive area of expression. Mercer notes:

> The patterns and practices of aesthetic stylisation developed by black cultures in the West may be seen as modalities of cultural struggle *inscribed* in critical engagement with the dominant white culture and at the same time *expressive* of a neo-African approach to the pleasures of beauty at the level of everyday life.
>
> (Mercer 1994: 114)

Dreadlocks have long since come to signify the most politically assertive form of black resistance – the enunciation of 'dread' or 'rasta' acting as a form of acknowledgement and respect between black peoples. Mercer suggests that dreadlocks, at the symbolic and semiotic level, were vital in 'marking a liber-ating rupture, or "epistemological break", with the dominance of white-bias' (1994: 104). Thus, it could be argued that such hairstyles, '*counter*politicized the signifier of ethnic and racial devalorization, redefining blackness as a desirable attribute' (1994: 104). I would suggest that the specific targeting of Jason Lee's 'locks for ridicule, the degree to which it was taken up by (white) fans and the public at large, and the length and extent to which the 'joke' was carried, suggests that it was far more than 'just another joke' that just happened to be directed at yet another black footballer. Rather it constituted a public chal-lenge to one of the most powerfully symbolic forms of black cultural resistance to white supremacy by trying to belittle and therefore undermine such expressions.

There is not the time here for a content analysis of the wider media reac-

tion to this episode, which grew especially when the Nottingham Forest manager singled out Baddiel and Skinner for wrecking the confidence of Jason Lee, and described them as 'middle-class wide boys'. I will, however, briefly mention the BBC's cultural review show, the 'Late Review', presented by Mark Lawson, which debated the issue, in the run up to Euro 96, of whether such satirical criticism had overstepped the mark in this case. Interestingly, Suzanne Moore had no interest in the issue as it was football-related and thought the whole matter was therefore trivial. Jim White (at the time a journalist on the *Independent*, now with the *Guardian*) however, argued that Jason Lee had simply been too sensitive about the joke, a point that was supported by Lawson. Lawson also suggested that being able to take a joke was an inherent feature of British identity – something which Jason Lee obviously lacked. White then went as far as to say that if Jason Lee was so upset by the remarks he should have had his dreadlocks cut off, which would have then endeared him to the (white) audience.

JIM WHITE: When he was first pilloried on 'Fantasy Football' he should have gone into the studio the next week and shaved his hair off and he would have become a national hero.

MARK LAWSON: Yes, because the great British virtue is being able to take a joke . . .

JIM WHITE: He has a distinctive haircut, now he's making a statement with that. If he's prepared to make a statement that I am different from all the other footballers around with their shaven heads then he should be big enough to accept the flak.

Against this the poet and critic Tom Paulin suggested that the treatment of Jason Lee had been deplorable and the whole episode clearly had racist undertones:

TOM PAULIN: Jason Lee has been treated with great cruelty. . . . The charge of racism is a very feasible one – the *Sun* had him portrayed as having bananas growing out of his head! It doesn't take very much to realise what that's saying.

Unable to see the continuity between the tabloid depiction of the episode and his own analysis, Jim White replied, 'Oh well that was the *Sun*, Baddiel and Skinner never suggested bananas' – no, only pineapples! This hardly needs much critical analysis Jason Lee is portrayed as being outside of English working-class sporting culture because he cannot take a joke (like a man) and in some way had asked for the abuse by daring to deviate from the (white) norm of what a footballer should look like. The argument runs that he is too sensitive (and presumably has a chip on his shoulder if he cannot take a simple joke), and if he wants to fit (read 'assimilate') into English footballing culture

all he has to do is to shave off his dreadlocks, which are seen as being somehow alien to the culture of English football anyway.

The following season, no doubt to the delight of Lawson, White and the terraces, and due to the pressure put upon him, Jason Lee shaved off his dreadlocks. There was, of course, no evidence that this had now 'endeared' him to fans of English football.

Fantasy nation

During the build up to Euro 96 the distinctions between the separate cultural fields of Britpop music and football began to disappear. What Steve Redhead (1991: 153) has referred to as the 'holy trinity', at least for young men, of fashion, pop music and football began to converge in ways unknown before. Footballers appeared on front-covers of indie music magazines, comedians became singers and appeared on New Lad magazines, such as *Loaded*,[6] and pop stars were falling over themselves to be involved in celebrity football matches (Smith 1996) – pop, footie, and New Lads had finally fused into one indistinguishable cultural form in order to promote English nationalism (see Figure 6.2).

Given the climate, it was hardly surprising then when the English FA announced, no doubt to the approval of Blair and Redwood, that Skinner and Baddiel had been chosen to write the official England song for Euro 96, together with Ian Broudie of the Lightning Seeds, a Britpop group! The song itself was entitled 'Three Lions' referring to the England team's emblem, though it was the chorus's deceptively catchy hook, 'football's coming home', that most people came to know the song by.

The basic theme of the song is an attempt to connect English football's finest moment in 1966, when England won its, to date, only major football championship, the World Cup, to the present. The opening lines, which on the record are said over the voice of a football commentator dismissing England's chances, are meant to be a rebuff to those who would put England's chances down – 'they just know, they're so sure/that England's going to throw it away' – which is then met with the assertion that this time it could be different if the memory of 1966 could be invoked again. The intervening thirty years are described as 'thirty years of hurt' when jokes about England's footballing inadequacies were too much to bear, but now is a chance to reclaim those glorious moments.

> It's coming home, it's coming home,
> It's coming,
> Football's coming home.
>
> Everyone seems to know the score,
> They've seen it all before,

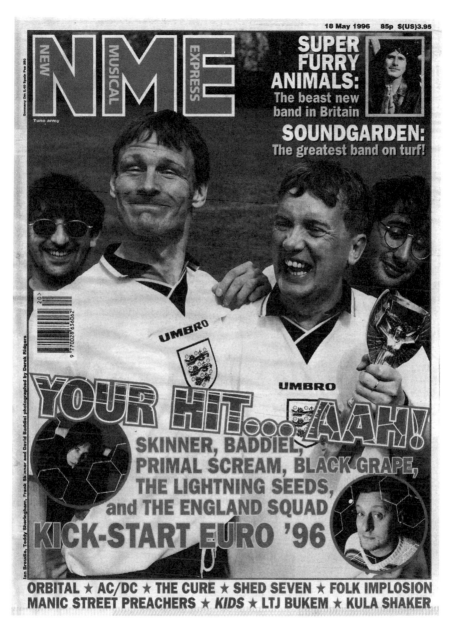

Figure 6.2 The cultural fusion is complete as Baddiel and Skinner join the England striker Teddy Sheringham and the lead singer of the Lightning Seeds, Ian Broudie, on the front cover of the indie music magazine *New Musical Express* before Euro 96

Source: Reproduced courtesy of *New Musical Express*, IPC Magazines.

111

They just know, they're so sure
That England's going to throw it away,
Going to blow it away,
But I know they can play,
Cos I remember.

Three Lions on a shirt,
Jules Rimet still gleaming,
Thirty years of hurt,
Never stopped me dreaming.

So many jokes, so many sneers,
But all those oh so nears wear you down through the years,
But I still see that tackle by Moore,
And when Lineker scored,
Bobby belting the ball,
And Nobby dancing.

I know that was then but it could be again.

It's coming home, it's coming home
It's coming,
Football's coming home (Repeat)

('Three Lions', music by Ian Broudie,
lyrics by Frank Skinner and David Baddiel
© 1996 Chrysalis Music Ltd. Used by permission.)

In interviews at the time the song's writers denied that the song was overtly nationalistic and argued that it was merely meant to be a reply to 'people who knock England'. But whilst Baddiel and Skinner would no doubt distance themselves from any associations with the extreme right, such views do sit uncomfortably close to the constant cry of the right which bemoans the fact that 'British history' is not taught in schools anymore and that English identity is being drowned under a flood of other cultures. It was, after all, the ex-Conservative MP Michael Portillo who talked about 'one of the greatest threats that has ever confronted the British nation', namely, 'the New British Disease – the self-destructive sickness of national cynicism' (1994: 30). This line of thinking argues that it is the trendy 'politically correct' (never defined of course) and the influx of 'foreign cultures' which are, apparently, the source for Britain's social decline and crisis of identity. Prescriptions to reverse this situation range from educationalists arguing for a reassertion of a stronger British identity based on the 'majority culture' to 'revisionist historians' arguing for the merits of Britain's colonial record, and in some cases even calling for a new wave of British imperialism, to some mainstream right-wing commentators actually arguing for the repatriation of blacks.[7]

The song's repeated use of the chorus 'football's coming home' fits neatly

into this wider political discourse and reinforces the ethnocentric notion that football is returning to its rightful place, back into the national psyche of England. The song's chorus became the tournament's theme, virtually usurping the national anthem, and stayed in the top ten throughout most of the summer – seemingly striking a chord with more than just the football watching population. Mirroring the discourse of British colonialism, 'football's coming home' works by seeing England 'educating' the world through sport. Unfortunately for this narrative, England lost its way, and its world position, but now, after 'thirty years of hurt', it is coming back to its rightful place, back home, where football belongs.

The ethnocentric arrogance of these accounts can be traced back to 1904 when FIFA was set up without English support because foreigners could not be involved in jointly running what was thought to be, by rights, an English game (Tomlinson 1986). And, of course, no England team took part in the World Cup finals until 1950, when they were eliminated by the USA, as the tournament was seen as an infringement of English sovereignty over the game. Indeed, suspicion of foreign footballing sides was such that English sides, playing in Europe between the wars, often against the wishes of the Football League, would take their own balls with them to prevent ball-tampering by foreign teams (Andrews 1996). 'Football's coming home' is, then, essentially about trying to reconstruct an imperial Britain, with the assumption that, no matter what others may say about football being a world game, England somehow has inalienable rights to the game on the spurious basis that its codification originated in England a hundred years ago, and therefore football is essentially *our game*.

As Dyer (1993) has argued, representation is not merely about aesthetics but is often deeply implicated in producing and reproducing social relations and inequalities – that is images are inherently political. The music video for 'Three Lions' itself proved instructive in showing which 'eleven people' were deemed English enough to represent the national community. The video, following the format of the recorded song, opens with Baddiel and Skinner at home, watching previous England games on television, listening to the commentator deriding England's chances, and then cuts to the two of them, and Ian Broudie, dreaming nostalgically of previous great moments from English footballing history. The boys are then seen watching football on the TV in a pub, surrounded by other 'lads', cheering on England, as stills of England players past are flashed across the screen, before being magically transported to join members of England's current squad, signifying the link between the fans and the players. Yet from watching the video it is amazing how black faces, be they on the pitch or off, be they supporters in the pub or the children shown emulating their heroes, are *completely* absent. The current England players chosen to reconstruct those 'golden moments' of English footballing history are all white: Robbie Fowler takes the place of Gary Lineker, Steve Stone of Nobby Stiles, Stuart Pearce of Bobby Moore, and

Teddy Sheringham of Bobby Charlton, almost as if ensuring the white male continuity of footballing glories. The nostalgic national community being (re)presented in the video is definitely 'homogenous in its whiteness' – and it should be added, almost entirely male.[8] Indeed, the only black faces that do, momentarily, appear in the video – Pelé and Jairzinho – are shown only to be thwarted by Gordon Banks and Bobby Moore.

If ever there was a sport which represents, to some degree, Britain's multi-cultural history, football is it. The first black professional was Arthur Wharton who turned professional over a century ago in 1889, and there was a number of black players who played for various British clubs, at differing levels, during the inter-war years and immediately afterwards, mainly from the Caribbean but with a few from Asia and Africa as well (Cashmore 1982; Sir Norman Chester Centre for Football Research). Black players have played for England since the late 1970s, there has been a black England captain (Paul Ince), and it is now not unheard of to find some professional clubs, such as Leeds during the 1996–7 season, starting with more black players than white. At the recreational level too, football is the most popular team sport with Asian and black youngsters. Yet this entire history, which is inherently part of *the* wider history of English football, was nowhere invoked in the video, with even the current reality distorted so as to deny the existence of even a contemporary black presence in England.

1966 and all that

The notion of a 'return to 1966' reached ecstatic heights during Euro 96 as the angst of 'thirty years of hurt', as Baddiel and Skinner termed it, came pouring out. The 'myth of 1966', with its main elements being 'those of nostalgic nationalism, an unequivocal masculinity and a submerged reference to class' (Critcher 1994: 86), was replayed for all it was worth. This 'myth' is neatly captured in Dave Hill's (1996) book *England's Glory (1966 and all that)*. The sleeve cover informs us that, 'The 1966 World Cup is still celebrated as a time of unassailable national glory. The image of glamorous cockney captain Bobby Moore holding the trophy aloft remains strikingly recognisable to millions. The contribution of Bobby Charlton is remembered as demonstrating English football at its most pure and free, uncontaminated by dishonesty and deceit.' It is interesting, and significant, how notions of purity and contamination (which have a biological resonance that invokes racial meanings) only come into play during the 1970s, the same time as we witness the first significant increases in black professional players; a period which now gets recast as a time of dishonesty and deceit, compared to the pure and innocent times of the 1960s, epitomised, of course, by the blond Bobby Moore.

However, this longing for a return to past national greatness transcended more than just a desire to reclaim past sporting glories. There was a deliberate

attempt to link the wider cultural and political context of the 1960s to the current situation. Thus part of the 1960s was recast (even by right-wing politicians unable to resist paddling in the wave of nostalgic sporting glory from that year) as a lost golden era linking, sometimes quite literally, the music, sport and political climate of the 1960s to the 1990s (see Figure 6.3). However, the theme of football coming home became coded as arguing for a particular view of Britain in the 1960s, and British economic and political confidence, returning home too.[9]

However, what was left out of these 'back to 1966' narratives was the position of Asian and black people in Britain. As the Political and Economic Planning Report, published a year after England's greatest sporting moment (as some have hailed it) showed, black Britons faced unparalleled levels of racial prejudice, discrimination and violence (Daniels 1968). This was the period when the Conservative MP Peter Griffiths could openly campaign using the slogan, 'If you want a nigger for a neighbour, vote Labour', and still win, and of course the era of Powellism. If this is the Britain which many commentators want to rekindle it is not surprising that so many black people had more than a little apprehension about what exactly was supposed to be returning. '1966 and all that' for many is characterised not as a period of unabashed national glory and confidence but rather as a period painfully marked by struggles for recognition against a backdrop of increased (white) public persecution, both in terms of discriminatory immigration laws (Solomos 1993) and acts of racial violence (Whitte 1996).

England reached nationalistic fervour during the 1996 championships and English nationalism, much to the delight of the right, and many on the left, reared its head again, but this time it was supposedly an inclusive, non-xenophobic, sense of Englishness. However, the reality gave a lie to the propaganda. The *Daily Mirror* half apologised for its use of Second World War imagery when England played Germany and in true fashion said their images had only been a joke anyway. The reaction generally was that the *Daily Mirror* had gone too far and was out of step with the rest of the tournament's media coverage. But the images, and associated nationalistic rhetoric, of England and her competitors used by many sections of the media were remarkably similar to the *Daily Mirror's* deliberate use of war time imagery and national stereotyping (Garland and Rowe 1996; Whannel 1998; Blain and O'Donnell 1998). The images and representations that dominated the television screens, street posters and even commemorative stamps during the tournament barely acknowledged the presence of black people in Britain, or were able to come up with a forward-looking notion of what English identity might be like without recourse to war-time imagery. For example, ITV's tournament coverage used the strains of 'Jerusalem' over shot with the white cliffs of Dover which symbolised more Britain's war time efforts to keep out foreign invaders from our sceptred shores than the idea that England was welcoming and staging an international football tournament.

Figure 6.3 *The Sunday Times Magazine.* Action Replay: The Beatles and Oasis, Charlton and Gascoigne, Wilson and Blair – are the Sixties back?

Source: Reproduced courtesy of *The Sunday Times Magazine* and Allsport.

Interestingly, the images used by ITV, and others, were embarrassingly similar to those used by the British National Party during their election broadcast in the run-up to the 1997 British election. The only difference was that when the BNP's broadcast switched from the very same white cliffs it represented the decline of Britain by using images of black people walking in

the streets of London whereas ITV portrayed an England of footballers complete in their whiteness. Gilroy (1997) has drawn attention to the importance and power of mass-mediated spectacles to nationalistic projects, and his analysis applies as forcefully to the BNP's attempts to re-present the nation as it does to the official images of Euro 96:

> The ultra-nationalist and fascist movements of the twentieth century have developed elaborate technological resources in order to generate spectacles of identity, capable of unifying and co-ordinating an inevitable and untidy diversity into an ideal and unnatural symmetry. This synthetic, manufactured version of national or ethnic identity looks most seductive where all difference has been banished or erased.
>
> (Gilroy 1997: 305–6)

It is easy to see through the far-right's attempts to construct a racially pure, and ethnically homogenous, sense of England as their manufactured versions of national identity are usually so crude. Yet I would argue that the ideological work of the dominant Euro 96 images produced an effect of cultural and racial exclusion from the constructed national community that was inadvertently more powerful than anything the BNP could have achieved.

Oh what a success?

What was most worrying during this display of English nationalism was the absence of any critical reflection on the part of most commentators. The desire to present the championship as a success seemed to negate dispassionate appraisals of the games themselves, the tournament's organisation and their wider implications, for fear of being labelled a 'traitor', or worse, to the English cause, especially when it emerged that England were bidding for the 2006 World Cup.[10]

The BBC's 'When Football Came Home' provided an excellent example of the way the tournament was hailed as an unequivocal success, both on and off the pitch, with embarrassing incidents like the tabloid's xenophobic coverage put down to exceptional over-exuberance. The rioting that took place around central London, and other parts of the country, after England's loss to Germany, and the serious attacks on anyone who was not English and white went largely unreported in the mainstream press and where it was covered it was given minimal space so as not to distract from the 'overall success'. The message seemed to be that a few foreigners and/or blacks fighting for their lives after being attacked by 'England supporters' was not enough for any serious questions to be raised.[11]

Interestingly, it was another BBC programme, 'Soho Stories', shown on BBC2, which neatly exposed the cosy narrative of the success of Euro 96.

Shot, by coincidence, at the same time as the championships it showed terri-fied people trying to escape rampaging 'England supporters' as they wrecked London's West End and fought with the police, singing loudly as they did so, 'football's coming home . . . '. The fact that the majority of the black popula-tion living in England had either a large degree of ambivalence towards England or openly supported 'anyone but England' underscores the points being made that the form of national identity produced failed to be inclusive and actually alienated large sections of the nation.[12]

The extent to which the 'football's coming home' discourse was a deeply conservative ideology was further shown when, after the tournament, both sides of the mainstream political spectrum, fighting desperately over the so-called 'middle-ground', tried to associate themselves with the coming home theme. Tony Blair, in his final conference speech before the 1997 General Election, argued that 'Labour was coming home, after seventeen years of hurt . . . ' (October 1996). A few weeks later at Prime Minister's Question Time (12 November 1996), in response to an attack by Blair, John Major, replied, not quite grasping the logic of the metaphor, that in fact it was the Conservatives who would be 'coming home' at the next election.[13]

Conclusion

It would be tempting to think that the coded racist imagery and messages of Euro 96 could now be put behind us as we attempt to construct a new notion of English identity that is not predicated on either subsuming itself within a British identity, which inevitably means excluding the voices of the other nations within the British Isles, or basing itself on war-time imagery. The need to redefine an inclusive and forward-looking national identity is as urgent as ever for *all* of England's, and Britain's, residents. Here I would concur with Gilroy in arguing that such critiques, as I have tried to advance here, should not be read as suggesting the necessity for:

> the abandonment of any idea of Englishness or Britishness. We are all, no doubt, fond of things which appear unique to our national culture. . . . What must be sacrificed is the language of British nationalism which is stained with the memory of imperial greatness. What must be challenged is the way that these apparently unique customs and practices are understood as expressions of a pure and homogenous nationality.
>
> (Gilroy 1987: 69)

However, the chances of this happening do not look good. For one, as has been suggested, there has been precious little *critical* analysis of Euro 96, even from normally astute and perceptive commentators, beyond proclaiming it as the greatest sporting tournament ever staged anywhere in the world. The

arguments that followed the tournament between the football associations of Germany and England over who was to stage the 2006 World Cup only serve to reinforce this pessimistic reading. The nationalistic arrogance of the press in assuming that England automatically had a right to stage the finals after the Euro 96 'success' was only matched by the Eurocentrism of assuming that it was simply a matter of deciding *which* European country should have the finals – forgetting, of course, that this was the World Cup and that other countries/continents, such as South Africa, might have a greater claim! However, should the English FA somehow manage to secure the finals, which looks increasingly unlikely, we can only hope that the cultural identity projected and the messages produced are radically different to what Euro 96 had to offer. For many the thought of having to endure listening to the national mourning of *forty years* of hurt would be too much to bear.

Notes

1 My use of the signification of sport in this chapter is slightly loose as there is not the space here to analyse the complex semiotic relationship between sport and society, and the degree to which sport stands as a mirror, extension, substitute or parody of society – an interesting analysis of these questions can be found in Blain and O'Donnell (1998), see also Krawczyk (1996).

2 In 1990 the former Conservative MP Norman Tebbit argued that Asians and blacks who continued to support the cricket nations from where they had migrated were disloyal British subjects and proposed that a test of their citizenship should be whether they supported England in Test matches – for a brilliant analysis of the 'Tebbit test' and cultural racism in cricket see Marqusee (1994). The author of the *Wisden Cricket Monthly* article, Robert Henderson, later argued that the numbers of blacks playing for England should be kept to a minimum so as to avoid the problems which would inevitably arise due to the incompatibility of different 'racial cultures': 'If you've got, say, three blacks and eight whites in an England side you're going to be getting two basic groups. If you have one black and ten whites it probably doesn't matter, but I think if you get more than one, certainly if you get three, you're going to get two separate cliques' (Marqusee 1996). The absurd essentialist racism of such arguments is a common feature of 'cultural racism' which posits the inherent incompatibility of black and English cultural identities

3 Let me make clear here that I am not, necessarily, suggesting that Jungle is *better* than Britpop, 'merely' that it is more culturally significant – I am thus side-stepping somewhat the more vexed question that cultural studies is accused of avoiding, i.e. that of cultural *value*.

4 One letter to Redwood's article, which appeared in the *Guardian*, replied: 'John Redwood's lauding of Britpop as reflecting the vitality and distinctiveness of British (or English?) cultural identity is at best naïve, at worst pernicious. The likes of Blur and Oasis do not advance an expansive and contemporary notion of cultural identity. Britpop is, for the most part, retrospective, appealing to a by-gone age of The Beatles, The Rolling Stones and The Small Faces. One suspects that this is exactly its appeal to Redwood, for whom the village cricket green and pretty brick buildings encapsulate what was and continues to be central to our identity as a nation. This rather simple minded view of British culture has little

bearing on contemporary realties' (*Guardian*, Letters, 21 March 1996, p. 28) – see also Jonathan King's dismissal of Britpop on much the same grounds (King 1997).

5 'New Lads' were supposed to be a reaction against the 1980s creation of the caring, sharing and socially reformed man – the so-called 'New Man' who fully respected the rights of women to be his equal, and even superior, and did not mind adopting previously considered 'feminine' roles such as child-rearing and house-keeping (it should be pointed out that very few people actually saw a 'New Man' before he became extinct). The New Lad then was a partial reversion back to the traditional 'laddish' masculinity of old, although the *New* Lad was now supposed to have accepted the basic claims of feminism and so any behaviour, gestures or actions that appeared to be sexist were now deliberately ironic and not meant to be taken literally.

6 Recent years has seen a phenomenal increase in the number and volume of magazines aimed primarily at 'young men'/New Lads from 'general interest magazines' such as *Loaded* to a number of new football and sport magazines, to 'health and fitness' magazines (Cosgrove 1995; White 1995). Despite the claims made by the publishers, most of the men's magazines stick to a format of sport, usually football, fashion and women, preferably naked. *Loaded* is often accused of having shifted the content of the 'serious' men's style magazines 'downwards' to the extent that it is increasingly difficult to distinguish such magazines from so-called 'girlie magazines' (i.e. soft porn publications). As Katherine Viner (1997: 4) observed in the *Guardian*, 'Oh yes, we're all post-feminist now. So of course it would be ridiculous to be offended by the latest spread-leg cover of *Loaded*. Or this month's nude on *GQ*. Or the femme in the tiny bikini on the launch issue of *XL*. Or the soap star in her lingerie on *FHM*. . . . It's all to do with nineties irony, we know that. It's not sexism by the back door, it's not porn dressed up as general interest, it's not men feeling threatened and looking at pictures of bare women to make themselves feel powerful, it's just *ironic* fun. Don't forget!'

7 The government's chief curriculum advisor, Nick Tate, has repeatedly called for the promotion of 'British culture' in schools in order to foster a greater sense of British identity amongst what he has termed the 'majority culture'. Underlying his argument is the suggestion, that 'non-white' cultures are undermining traditional British values and traditions – see 'TEACH THEM TO BE BRITISH: School chief calls for children to have sense of national identity' *Daily Mail*, 18 August 1995, p. 1, and also 'Respect is lost for heroes of British history', *The Sunday Times*, 17 September 1995, p.1. Numerous articles have argued that British imperialism was essentially benevolent (for example see R. James 'Now that the sun has gone down', in *The Times*, 3 June 1995), and more recently there have been calls for a second-wave of British imperialism – for example see B. Fenton 'Is it time for Africa plc?', in the *Daily Telegraph*, 28 September 1996, p. 7. and N. Stone 'Why the Empire must strike back', in the *Observer*, 18 August 1996, p. 22. The right-wing commentator Paul Johnson has consistently called for black repatriation in a number of mainstream publications as 'the cultural gap between blacks and the other races of western democracy is too great to make assimilation likely' (1995: 20) – see for example 'The logical end of black racism is a return to Africa', in *The Spectator*, 30 December 1995, p. 20.

8 The video is a good example of the way in which whiteness becomes normalised and therefore 'disappears' – it has an 'everything and nothing' quality, as Dyer puts it (1993: 142), see also Dyer (1997). Thus, the effect of the video is that Englishness *becomes* whiteness, the correlate being that blackness and Englishness are then produced as mutually exclusive categories.

9 Gilbert (1997: 2) suggests that the 1960s is also an important period within New Lad and Britpop culture: 'It's no accident that 1966 is the moment which Britpop and much of "New Lad" culture looks back on as [a] Golden age. The era of Alfie and the dolly bird, of silent wide-eyed girls on the back of bikes and scooters, is remembered with an unproblematic affection by the readers of *Loaded* and *Melody Maker* alike. It's not just that England won the World Cup; the moment immediately before Women's Liberation, the black civil rights' movement and Gay Pride shook the self-confidence of normative white male heterosexuality is an obvious point of reference for this group who no longer occupy quite the privileged place they once did. The anxiety being suffered by a generation of young men no longer sure of their place in the scheme of things is well documented and *Loaded* and Oasis are symptomatic of this malaise. . . . If Britpop makes concessions to liberal feminism in allowing a couple of woman-fronted bands to join its second or third ranks, it's only on condition that singers like Justine Frishmann and Louise Wiener adopt an identity forged from an almost impossibly unthreatening alloy of sex-appeal and androgyny.'

10 The anti-fascist magazine *Searchlight* provided a notable exception when its front cover provocatively asked 'Football's Coming Home: To what?' and argued that the footballing authorities, and others, had missed a great opportunity to promote a different version of the tournament and football fandom within the 'increasingly nationalistic and xenophobic political climate' (1996: 2). See also Mark Perryman who, in the build up to Euro 96, similarly argued that although there had been significant, and welcome, changes in football fandom in recent years much of this had failed to be reflected in the dominant images of Euro 96. 'Euro 96, in its marketing and presentation, goes with the grain of petty-minded Englishness, rather than celebrating England's coming of age as part of Europe. The marketing slogan says it all: "Football Comes Home". Let's reassert all that history, those far-off days when we invented every game known to mankind, then taught Johnny Foreigner how to play it. The banners draped over all eight host-cities portray the game as a solely English product, and the portraits used pass off our sport's history as a white thing too' (1996: 24). For a rare balanced assessment of the footballing side of Euro 96 see McIlvanney (1996).

11 Garland and Rowe (1996: 1) report that following England's defeat by Germany in the semi-finals 'German-made cars were attacked and other property identified as German was targeted. It was reported that a Russian man was seriously assaulted by an English crowd who, not minded to distinguish between foreigners, mistook him for a German.' Other less well-reported incidents concerned an attack in the East End of London on two Asian brothers, an Asian woman and a young black man by 'football supporters' following the England–Switzerland match on 9 June which resulted in the two brothers being hospitalised with serious injuries (see London Update Monitoring Racism in London, 'Euro 96 violence', Institute of Race Relations, No. 2, Summer 1996).

12 A survey by the black newspaper, *The Voice*, found that the majority of black British football supporters did not support either England or Scotland as they felt uneasy with the form of nationalism expressed during the tournament which was seen as largely xenophobic – Garner (1996), see also Sewell (1996).

13 To paraphrase Gilroy (1987: 57), I am not suggesting that the differences between New Labour and Conservative languages of nation and patriotism are insignificant but rather that these languages, particularly in relation to the cultural discourses outlined in this chapter, significantly overlap. Indeed, with Labour's use of the 'British bulldog' during the 1997 general election campaign it could be argued that there is now a disturbing degree of overlap with the far-right too.

Bibliography

Anderson, B. (1991) *Imagined Communities: Reflections on the Origins and Spread of Nationalism*, rev. edn, London: Verso.

Andrews, C. (1996) 'Secrets of our national game', in the *Guardian Higher*, 26 November, pp. 2–3.

Barker, M. (1981) *The New Racism: Conservatives and the Ideology of the Tribe*, London: Junction Books.

BBC Television (1996) 'When Football Came Home', BBC1 December.

—— (1996) 'Late Review', BBC2, 23 May.

—— (1996) 'Soho Stories' (series), BBC2 November.

Blain, N. and O'Donnell, H. (1998) 'European sports journalism and its readers during Euro 96: "Living without the Sun"', in M. Roche (ed.) *Sport, Popular Culture and Identity*, Aachen: Meyer and Meyer Verlag.

Cashmore, E. (1982) *Black Sportsmen*, London: Routledge and Kegan Paul.

Cosgrove, S. (1995) 'The neo-blokes call the tune', in the *Guardian 2*, 14 August, pp. 14–15.

Critcher, C. (1991) 'Putting on the style: aspects of recent English football', in J. Williams and S. Wagg (eds) *British Football and Social Change: Getting into Europe*, Leicester: Leicester University Press.

—— (1994) 'England and the World Cup: World Cup willies, English football and the myth of 1966', in J. Sugden and A. Tomlinson (eds) *Hosts and Champions: Soccer Cultures, National Identities and the USA World Cup*, Aldershot: Arena.

Daniels, W. (1968) *Racial Discrimination in England*, Harmondsworth: Penguin Books.

Dyer, R. (1993) *The Matter of Images: Essays on Representations*, London: Routledge.

—— (1997) *White*, London: Routledge.

Garland, J. and Rowe, M. (1996) *War Minus the Shooting? Jingoism, the English Press and Euro 96*, Studies in Crime, Order and Policing, Research Paper No. 7, Leicester: Scarman Centre.

Garner, C. (1996) 'Jingoism spoiled Euro 96 for blacks', in the *Independent*, 1 July, p. 4.

Gilbert, J. (1997) 'New Labour's blurred vision', *Signs of the Times* Discussion Paper, London.

Gilroy, P. (1987) *There Ain't No Black in the Union Jack: The Cultural Politics of Race and Nation*, London: Hutchinson.

—— (1992) 'The end of anti-racism', in J. Donald and A. Rattansi (eds) *'Race', Culture and Difference*, London: Sage.

—— (1997) 'Diaspora and the detours of identity', in K. Woodward (ed.) *Identity and Difference*, London: Sage.

Henderson, R. (1995) 'Is it in the blood?', in *Wisden Cricket Monthly* 17, 2: 9–10.

Hill, D. (1996) *England's Glory (1966 and all that)*, London: Pan Books.

Hobsbawm, E. (1990) *Nations and Nationalism Since 1780: Programme, Myth, Reality*, Cambridge: Cambridge University Press.

King, J. and Robb, J. (1997) 'So farewell Britpop', in the *Guardian Weekend*, 8 March, p. 4.

Krawczyk, Z. (1996) 'Sport as symbol', *International Review for the Sociology of Sport* 31, 4: 429–35.

Marqusee, M. (1994) *Anyone But England: Cricket and the National Malaise*, London: Verso.

—— (1996) 'Gower's Cricket Weekly', BBC Radio 5, 6 June.

McIlvanney, H. (1996) 'Getting high on decent stuff', in *McIlvanney on Football*, Edinburgh: Mainstream Publishing.

Mercer, K. (1994) *Welcome to the Jungle: New Positions in Black Cultural Studies*, London: Routledge.

Perryman, M. (1996) 'Football', *New Statesman and Society* 24 May, p. 25.

Portillo, M. (1994) 'Clear blue water: a compendium of speeches and interviews given by the Rt Hon. Michael Portillo MP', London: Conservative Way Forward; quoted in S. Lee (1996) 'A corner of a foreign field: football violence and English national identity', paper presented to 'Fanatics! Football and popular culture in Europe', Manchester: Manchester Institute for Popular Culture, 12 June 1996.

Redhead, S. (1991) 'An era of the end, or the end of an era? Football and youth culture in Britain', in J. Williams and S. Wagg (eds) *British Football and Social Change: Getting into Europe*, Leicester: Leicester University Press.

Redwood, J. (1996) 'There's always England', in the *Guardian* 20 March, p. 18.

Reynolds, S. (1997) *Britpop*, at Simon Reynold's and Joy Press' website, http://members.aol.com/blissout

Searchlight: The International Anti-Fascist Monthly (1996) 'Euro 96 another missed opportunity', 15 June, No. 252, p. 12.

Sewell, T. (1996) 'Patriot games', *The Voice* 2 July, p. 13.

Sharma, S., Hutnyk, J. and Sharma, A. (eds) (1997) *Dis-Orienting Rhythms: The Politics of the New Asian Dance Music*, London: Zed Books.

Sir Norman Chester Centre for Football Research (N.D.) *Black Footballers in Britain*, Factsheet No. 4.

Smith, A. (1996) 'Top of the Britpoppers pitch in', *The Sunday Times: Culture*, 5 May, pp. 8–9.

Solomos, J. (1993) *Race and Racism in Britain*, London: Macmillan.

Solomos, J. and Back, L. (1996) *Racism and Society*, London: Macmillan.

Tomlinson, A. (1986) 'Going global: the FIFA story', in A. Tomlinson and G. Whannel (eds) *Off the Ball: The Football World Cup*, London: Pluto.

Viner, K. (1997) 'Side lines', in the *Guardian 2*, Woman, 15 April, p. 4.

Wagg, S. (1995) *Giving the Game Away: Football, Politics and Culture on Five Continents*, London: Leicester University Press.

Whannel, G. (1998) 'Individual stars and collective identities in media sport', in M. Roche (ed.) *Sport, Popular Culture and Identity*, Aachen: Meyer and Meyer Verlag.

White, J. (1995) 'Leery, laddish and loud – won't the fans just love 'em?', in the *Independent* section 2, 15 August, p. 17.

Whitte, R. (1996) *Racist Violence and the State: A Comparative Analysis of Britain, France and The Netherlands*, London: Longman.

7

SCOTTISH RACISM, SCOTTISH IDENTITIES

The case of Partick Thistle

Paul Dimeo and Gerry P.T. Finn

Introduction

Racism is complex, much more complicated than most previous attempts at explanation (see, for example, Billig *et al.* 1988; Billig 1989; Dovidio and Gaertner 1986). Now it is increasingly recognised that the role of racism around football requires a much more subtle analysis (Back *et al.* 1996 and this volume; Finn 1994a and b). Back *et al.* (this volume) demonstrate how the discussion of racism in football has focused on the notion of racist hooligans: the stereotype of the racist thug has served to obscure the reality of the more common, usually ignored, subtle forms of racism which exist in the 'common-sense' of British society and British sport.

Nor should the subtlety, and the situated importance, of the use of ethnic distinctions within racism be disregarded. Specific ethnic stereotypes can be used to create hierarchies of racialised ethnicity and to redraw contrasted group boundaries (Brah 1996; Back *et al.* this volume), revealing further elements of the complexity of racism. And just as the nature and content of racism has evolved to more subtle forms, so can the content of stereotypes. Some myths about Afro-Caribbean British footballers have been replaced by others (Cashmore 1982): beliefs in physical weakness or an inevitable lack of courage have been discarded by even the most prejudiced. Nonetheless, similarly crude 'biological' beliefs can now colour majority perspectives on British 'Asian' participation in football, but co-exist alongside more 'subtle' beliefs, such as an 'Asian' cultural incompatibility with football-playing (Bains with Patel 1996).[1]

Variants of this latter, banal racism framed much of the discussion, and certainly most of the media coverage, of the proposed take-over of the Glasgow club Partick Thistle by a supposed 'consortium of Asian businessmen' in August 1995. The study indicates how 'Asian' identities are imagined by

powerful institutions of the majority, and how this affects identity construction. Identity constructions depend on a complex dynamic of inter-group exchanges and power struggles, which inevitably retain a local dimension and flavour. Racist discourses in Scotland are interdependent, informed by different forms of racism, and the myth that Scotland has no racism, but has 'sectarianism' instead.

The historic racialisation of the Catholic Irish by significant sections of the dominant Scottish Protestant population is usually disguised when discussing Scottish society and football, discursively masked by the use of 'sectarianism' and the implicit failure to recognise inequalities of power between majority and minority groups (Finn 1991a, 1991b, 1994a, 1994b). When Murray, in a very revealing quote, unusually does unmask some of the myth of sectarianism, it is to sustain the other myth that racism is absent from Scotland: 'however, much we may dislike it, anti-Catholicism is part of Scotland's history and can be understood in these terms. Racism is totally odious and foreign to all that Scotland stands for' (1988: 175). So, 'anti-Catholicism' is to be seen as essentially Scottish, part of what it means to be Scottish, but Scots are not racist: in an ill-judged choice of word, racism is 'foreign' to Scotland.

Myths can be useful: they can be used to legitimise efforts to achieve a new social reality – a Scotland opposed to racism – but the interpenetration of these myths makes this impossible. The avoidance of the issue of anti-Irish racism often presupposes an acceptance of the racist essentialism that 'races', itself a racist construction, come colour-coded. One of the values of analysing anti-Irish racism is the challenge that poses to the racist frame that renders black and white as 'races' (Miles 1982; Finn 1987). So it is disappointing that in his useful analyses of racism and football in Scotland, Horne (1995) skirted around this issue, leaving this black-and-white 'common sense' unchallenged.[2] But, as the Partick Thistle study shows, the commonly accepted Scottish model of 'sectarianism' as a minority group's responsibility could be explicitly invoked as a probable outcome of a successful 'Asian' take-over. It is especially ironic that this direct comparison is drawn for the purposes of further instruction in the myth of Catholic Irish responsibility for 'sectarianism', extended to predict that the creation of an 'Asian' club would create racism, and then used to buttress the myth that racism is not already evident in Scotland.

Despite the racism directed at non-white players by spectators, this variant of Scottish racism has been largely ignored within Scottish football. The Scottish Football Association (SFA) lent no significant support to the Commission for Racial Equality's anti-racist campaign and clubs generally gave only passive support, claiming that there was no real problem in Scotland. Yet there is a consistent pattern in Scotland of this form of racist behaviour. In Paisley, in 1983, Ruud Gullit played for Feyenoord against St Mirren in the UEFA Cup. He reports: 'The Scots booed me because of my colour. It started at the warm-up and went on when I scored. I was even spat on. It was the saddest night of my life' (MacDonald 1994: 117). Soon after

Rangers' Mark Walters had *repeatedly* experienced episodes of banana-throwing, Paul Elliot joined Celtic. He summarised his Scottish experience: 'The racial abuse I've suffered in Scotland is far worse than anything I had to put up with in England or Italy' (MacDonald 1994: 117). Hibernian's Kevin Harper has received racist abuse from fans and opposition players (*Scotland on Sunday* 29 October 1996).

Examples of racist abuse go further back too. Paul Wilson, the Indian-Scot, played for Celtic under Stein, was capped by Scotland, but received substantial abuse from opposition fans. Indeed, Stein was judged 'at his best when encouraging Paul Wilson to withstand the racist abuse to which he was subjected' (Crampsey 1986: 185). Gil Heron, father of jazz musician Gil Scott-Heron and a Jamaican internationalist, was a favourite with both Celtic and Third Lanark in the very early 1950s, but still clearly experienced racism. Now in Detroit, he 'still enjoys ridiculing his black friends with the word "darkie", which he relishes saying in a pantomime Scots accent' (Cosgrove 1991: 130). As Cosgrove observes, the myth that Scotland is devoid of racism is powerful: 'One of the great delusions of Scottish society is the widespread belief that Scotland is a tolerant and welcoming country and racism is a problem confined to England's green and unpleasant land' (Cosgrove 1991: 128).

The myth informs decisions to ignore racism and equally allows racism to remain unchallenged. Explanations of its power are uncertain, but one suggestion is the absence of obvious ultra-right, racists to act as 'folk devils' (Dunlop 1993; Back *et al*. this volume). Other suggestions explore the role of England and the English, either as alternative targets (Horne 1995; Miles 1993) or because racism is believed to be a 'foreign' English disease, which suits contemporary anti-English sentiments (see Finn and Giulianotti, this volume) or, in a more subtle development of this anti-English rhetoric, that Scots can, because of their own history, empathise with the oppressed – an account endorsed in a recent history of the 'Asian' community in Scotland. Maan claimed:

> there is a lot of truth in the belief that Scottish people in general are more tolerant and accommodating than their English cousins . . . [this] could be due to the mixed make-up of Scottish society or to their sympathies being with the other underdogs, considering that they themselves have been underdogs to the English for a long time.
>
> (Maan 1992: 205)

Powerful myths of Scottish tolerance clearly exert a strong effect on all Scots. Commenting on the proposed take-over of Thistle, Ian Archer wrote: 'The Asians . . . have been assimilated like the Irish, the Italians, and the Poles before them, adding a density to the Glasgow experience' (*Herald* 28 August 1995). In Archer's tolerant Scotland even 'sectarianism' disappears, yet the use

of 'assimilation' reveals the limits to this Scottish tolerance, as has the real lived experience of these minorities. However, the myth of tolerance, especially a Scotland free from racism, persists, regardless of the wealth of evidence to the contrary (Armstrong 1989; Bell 1991; Finn 1987; Miles 1993; Horne 1995). The proposed take-over of Thistle brought these various Scottish myths to the discursive fore.

A story of the bid

The affair of the take-over was significantly played out in the newspapers. Media coverage is not simply an 'add-on' to the events, media discourses construct the events, offering them to the public in specific ways, interpreting what is important and stylising the presentation. Other research continues to go beyond and behind the media coverage, but media discourses are real and themselves productive, and not simply reflective, of reality (Blain *et al.* 1993). They are also produced by, and productive of, relations of power – allowing an examination of their content not for traces of a 'reality' now past, but for the workings of power, strategies of domination and resistance, that construct events and identities in discourse (Foucault 1980).

Media attention followed the announcement made to the annual dinner of the Scottish Asian Sports Association by George Galloway, Labour MP for Glasgow Hillhead: 'I have been in discussions with a number of Asians who have been successful in business about the idea of taking a stake in the club. There are willing buyers and I believe there may also be a willing seller' (*Daily Express* 24 August 1995). Much was then written and many 'Asian' names suggested as members of the secret consortium, on whose behalf Galloway claimed to be negotiating. One was Charan Gill, a Glasgow businessman who owns, among other things, a chain of restaurants. A statement by Thistle chairman, Jim Oliver, several days after Galloway's public announcement, significantly influenced events. He said Galloway was misleading the group and only sought to win 'Asian' votes, that the club had been hijacked, that he had received no offer, that he would not sell 'simply to satisfy the wishes of some Indian with a curry shop'. When pressed in a television interview to consider the possibility that this last comment was racist, he replied:

> As I understand it he is an Indian, and he owns a curry shop. If he is not an Indian with a curry shop then I'll apologise. . . . I don't care whether they are Asians, Eskimos or one-eyed black lesbian saxophone players, if they have the money we will talk to them.
>
> (*Herald* 29 August 1995)

The reaction to all this was varied. Galloway removed himself from the bid, claiming that his group were dismayed; Gill, though, said he did not feel insulted. The Partick Thistle fans criticised their chairman, claiming that his

statements were the antithesis of what the club stood for. Discursive space was given over to defending Jim Oliver and allowing him to attack Galloway and his dealings with the club and the media. Some journalists also chose to argue that 'Asians' would bring an unwanted 'ethnic' or 'non-Scottish' element to football, and compared the scenario with 'sectarianism'. These debates in particular expressed some of the beliefs about racism and social identities prevalent in Scottish society, and offer the chance to reflect upon the relations of power which can construct and marginalise racialised groups, simultaneously constructing meanings of 'Scottishness'.

Media discourses

By focusing upon the media coverage of the take-over, rather than the 'reality' of the events it is possible to explore issues relating to racism in Scottish football: notably, how prevalent and influential the myth of tolerance is, how Scottish 'Asians' are differentiated from true Scots, how a narrow and exclusive form of Scottish national identity is reproduced, and how the myth of tolerance is defended through a silencing of anti-racist voices, the omission of the 'Asian' perspective, and a sterling defence of the accused racist.

The story first made the newspapers on Thursday 24 August. George Galloway was helping a 'group of wealthy Asian businessmen' (the *Sun* 24 August 1995) organise a bid for Partick Thistle. The group supposedly included 'restaurateur' Charan Gill, who was quoted as saying that the purchase would 'give something back to the community and promote racial harmony in the city' (*Daily Express* 25 August 1995); the club was 'not disliked by anybody' and was 'non-sectarian', which was 'important' (*Herald* 25 August 1995). Galloway agreed: 'Partick Thistle is a beacon for good community relations and anti-racist feelings' (*The Scotsman* 24 August 1995). Already we have the elements of the emerging drama: the bid is characterised as 'Asian'; Partick Thistle are venerated as an anti-racist club; Gill is usually identified as a restaurant owner rather than more accurately as a businessman; the deal is in its early stages; Galloway's role is uncertain – sometimes he is a 'go-between', acting on behalf of the group: sometimes he has brought the group together.

The positioning of Thistle as an anti-racist club requires some explanation. Historically, Glaswegian football has been dominated by Rangers and Celtic, leaving a handful of small clubs struggling to compete for attention. The successful rivalry of the 'Old Firm' is often bemoaned as 'sectarian' bigotry, allowing Thistle to be perceived as standing apart, appealing to those disenfranchised by 'sectarianism', but their paltry attendances show most fans prefer 'sectarian' bigotry. Thistle have never actively promoted anti-racism in any form, yet they receive acclaim for a principled stance. A claim for the moral high ground from a position of studied inactivity speaks volumes on racism and Scottish football.

The potential 'Asian' involvement in Scottish football intrigued the print-media. Supposed humour was used to demonstrate difference: a cartoon showed two Thistle players, one saying, 'Does this mean we'll huv tae play wur hame games in India?' (*Evening Times* 25 August 1995). On Friday 25 August the *Daily Record* ran a full page by their sports editor Bill Leckie entitled 'For it's a nan old team to play for . . .'. Although Leckie writes, 'The syndicate are banking on gates going through the roof by turning Thistle into Scotland's *first multi-racial club* – and all power to them for that' (emphasis added), he employs a host of stereotypes to describe what this move would mean. For instance, 'the new strip has to be yellow and red stripes with big curry stains'. Humour was used in such ways as inventing new songs ('Singh When You're Winning', 'Come and Have a Goa If You Think You're Hard Enough') and new players ('Pakora Bonner, Hindustan Collymore, Chickpea Charnley'). The theme of subcontinent cuisine was widely employed to 'cook up some fun'. Tom Cowan wrote: 'The supporters are going daft, getting wired into curried pies, bridie Madras, even tandoori-style Wagon Wheels' (*Evening Times* 26 August 1995). The proposal was a 'takeaway rather than a take-over' (*Scottish Sunday Express* 27 August 1995). In short, the idea of an 'Asian' take-over, even the prospect of 'Scotland's first multi-racial club', was reduced to a joke and 'Asian' culture was reduced to curries.

Support from the Thistle fans was voiced: they wanted a new source of money. The general secretary of the supporters federation, Morag McHaffie was quoted: 'The fans would be delighted to see new money coming in. The people who are in control have kept their word by building a new stand, but they can't invest in the team. We hope Mr Oliver would listen to the consortium and give their offer careful consideration' (*Daily Record* 25 August 1995). Many of the club's fans were disillusioned by the lack of capital available for players, the chairman had been the target for expressions of this frustration for a number of months leading up to the bid. Yet some fans supported Oliver (*Daily Record* 30 and 31 August 1995). Only £1 million was suggested for the purchase of players (*Independent* 28 August 1995). Several newspapers indicated that the consortium's bid might not satisfy the demands of the board, who valued the club at £2.4m.[3] George Galloway's conception of the relationship between 'Asian' community and the club was outlined: 'There are thousands of Pakistani and Indian families in the Maryhill area and the businessmen wanted to become involved with Thistle because it has always been seen as a non-racist and non-bigoted football club. The Asian business community would support the club financially and the money generated from that would be used to strengthen the team. The current board have done well in improving the stadium, but they cannot find any more money to strengthen the team' (*Daily Record* 25 August 1995).

The following day brought intensified speculation. It was noted that there had been meetings of the consortium, that they had employed the services of a 'football analyst', and that a bid should be made within a week. They also

quoted Galloway's continuing arguments in favour: 'we can provide a shot in the arm, Asian capital, Asian entrepreneurship, and Asian interest in sport, including through the gates' (*Herald* 26 August 1995).

Jim Oliver then used the club's Jagsline service to respond. His views were reported in the newspapers of Monday 28 August:

> Partick Thistle has been HIJACKED by Galloway. His actions are designed to win the votes of the Asian community. It is cynical self interest on his part hidden by a smokescreen of pretence. If anyone thinks we're going to give away a company, which we have built up over six years, at a personal loss to satisfy the wishes of some Indian with a curry shop then they better get real. I will not be meeting with Mr Galloway again. Someone should tell the Galloways of this world that not everyone views a group of fifty Asian businessmen as *non-sectarian*. The only person to benefit from this is Mr Galloway, who is getting publicity. It has done Partick Thistle a disservice and a great deal of harm. If there is a group of Asian businessmen and they can demonstrate to me they have funds to do a better job then we will be the first to applaud them. The board won't stand in the way of any move which will benefit the club. They should come and speak to me in a proper business forum – not through the Press.
>
> (*Daily Record* 28 August 1995, emphasis added)

When it was suggested on a television interview with Mr Oliver that his comments could be seen as racist he offered his Eskimos and black lesbians riposte. On the same day Oliver implied that 'Asian's' expected special treatment: 'We are a non-Sectarian club, but being Asian doesn't entitle you to a rebate when purchasing a club' (*The Times* 29 August 1995).

It is instructive to consider how these comments were framed and how they were received by the press. Oliver's first salvo at Galloway made 'Asians' appear detached, distant, unknowingly manipulated in the MP's pursuit of power; the attack on Charan Gill has to be considered as racist; the relationship between 'Asians' and 'sectarianism' is asserted and was then continued by various journalists; criticisms of Oliver were expressed through the fans' use of Thistle's 'non-racist' reputation. In newspaper reports, which included some sympathetic defences of Oliver, the voice of those attacked – the 'Asian' community – was marginalised. If an 'Asian' spoke it was to deflect attention from racism, rather than to raise it as an issue. Suggestions of racism were framed in the context of Thistle fans' discontent at the slur on their reputation, or at Oliver's general stewardship of the club; or are framed as part of the Galloway versus Oliver dispute.

Denying racism

Outright defence of Oliver occured. Ken Smith argued that Oliver simply lacked a sense of diplomacy:

> like many ambitious people, Jim Oliver speaks his mind, seeing no need to ponder over the nuances of every word. Almost all chairmen of companies are the same; the difference being that most of them keep an army of public relations personnel to ensure their thoughts are kept safely away from the public.
>
> (*Herald* 29 August 1995)

So, Oliver was not to be criticised: he was merely an ambitious businessman. Yet, if 'all chairmen . . . are the same', then all chairmen would be equally accused of racism. Which is no defence. Alan Davidson even saw fit to laud Oliver for his wit: 'As dismissive lines go, the Partick Thistle chairman's withering description of the take-over bid for his club gets close to the class of Dorothy Parker.' And, as for the suggestion of racism, Davidson is at pains to retain the good reputation of Scottish football: 'Oliver's current resistance to a take-over should not be seen as racist despite the fact there are obvious overtones' (*Evening Times* 29 August 1995). And on that same day, the Scotsman's report simply concluded: 'Mr Oliver denies he was being racist and insists that his description of one of the investors as being Indian and owning a curry shop was accurate.'

Framing the 'racist' accusation

Other writers avoided defending Oliver, seeing something unworthy in his stance. However, they themselves avoided making any accusation of racism: it was the Thistle fans, assuming the mantle of 'non-racists', who were most quoted in this respect. For example, one fans' representative is quoted as claiming Oliver's position was the 'antithesis of everything Partick Thistle stand for' (*Scotsman* 29 August 1995). And Gordon Peden, a fanzine editor, stated: 'We live in a multi-cultural society and we would support a multi-cultural football team' (*Daily Record* 29 August 1995). Interestingly, Peden indirectly acknowledges the present mono-culturalism of Thistle, making their occupancy of the moral high ground seem untenable, little more than a space of inaction in an actively racist environment – hardly a convincing anti-racist strategy.

Galloway's criticisms of Oliver were presented in more explicit terms, but his claims – and his criticisms of the media – were disempowered by being contextualised within the frame of his supposedly personal dispute with Jim Oliver. So his 'racist' accusation was merely represented as part of the 'verbal battle between the Labour politician and the chairman'. The report continued:

Galloway blamed Oliver and the Press for his decision to pull out of the deal.

He said: 'Mr Oliver's description of a group of businessmen employing many hundreds of people is a disgraceful slur. . . . I also have to say the Scottish press has not covered itself in glory. Their coverage has offended, hurt and bewildered many people.'

(*Daily Record* 29 August 1995)

Yet the strength of these comments was reduced by their location. Earlier in the same article Gill denied being offended by Oliver. Instead he blamed Galloway:

> Gill hinted he was unhappy with the manner in which Hillhead MP George Galloway had handled the negotiations with Oliver. . . . Responding to Oliver's scathing attack, Gill said: 'I just feel that a man in Jim Oliver's position should have chosen his words more carefully. I'm not hurt in any way'.

Another 'Asian' voice was heard to counter the charge of racism. Lawyer Dilip Deb attacked Gill and, in supporting the mythology of Partick Thistle, he attacked the bid itself:

> This has been a total public relations disaster for Mr Gill. He should have bid for the club as the head of a consortium of millionaire entrepreneurs, not as an Asian whose main interest, as stated in the press, was to develop the talent of Asian footballers. There are ample opportunities already for any footballer of any colour or creed to shine within the present framework of Partick Thistle, which is a non-racist and non-Sectarian club.
>
> (*Daily Record* 29 August 1995)

The complex discursive strategies used manage to avoid the conclusion that racism is a genuine concern in the Scottish game. Not only does Deb underline this dominant perspective, the use of his quote in the report implies disharmony – not diversity – in the minority community itself.

Problematising 'Asian' involvement

The bid was intended to remedy the current absence of any 'Asian' involvement at a high level in Scottish football. It was intended to assist and represent 'Asian' participation in Scottish sport and to support anti-racist strategies. There are parallels with the early Irish-Scottish community and, in another parallel, there was a tendency for commentators to view this take-over as introducing another form of 'sectarianism'. This line of thought is damaging

and pernicious to Irish-Scots and Asians: it problematises the concept of *any* 'Asian' involvement (and reflects an understanding of 'Asians' as being different, alien, non-Scottish). For instance, Alan Davidson wrote:

> in this case he [Galloway] has shown a lack of judgement because whatever Partick Thistle may be they are intrinsically, definitively, and eccentrically Scottish. They don't enjoy a lot of success but they are a welcome and valued buffer to the prejudices that attach themselves to football and life in the West of Scotland.
>
> (*Evening Times* 29 August 1995)

And in a similar stylisation Hugh Keevins noted: 'After 107 years of religious intolerance between the supporters of Celtic and Rangers, Glasgow has suddenly discovered another theatre of holy war, this time involving the Asian community' (*Scotsman* 29 August 1995).

These discursive strategies allow the structured omission of the reality of racism: writers bend over backwards to avoid acknowledging its existence. 'Asian' voices are called upon only to support this omission. Accusations are deflected by reference to other, disputed, variants. The true extent of racism is only revealed when we focus upon the discourses considered legitimate: that Oliver can and should be defended, that Galloway should accept blame for the bid's collapse, and that 'Asian' participation will lead to a 'holy war'. These discursive structures are driven by historical notions of Scottish tolerance, by the ideas of 'Asians' as outsiders, and by powerful and historical racist beliefs that the sacred field of football will be tarnished by 'outside', unScottish influences.

Dilemmas

Racism is an influential phenomenon in Scottish football: it is subtle and complex, drawing upon decades of racist discourse of one form or another. It frames the potential involvement of 'Asians' in football and Scottish society. This dominant framework poses dilemmas even for 'sympathetic' commentators faced with an 'Asian' entrance into football, as exemplified in the comments of the *Herald* journalist Ian Archer, the Scotsman's John Penman, and George Galloway himself. Each displays 'ideological dilemmas' (Billig *et al.* 1988) in their social thinking, which are instructive of the complexities of racism.

Archer gives evidence of an inability to place the group termed 'Asian'. Although they are 'from the Asian community in Glasgow', their interest in Thistle 'just goes to show they must be as daft in Delhi as we are around this place' (*Herald* 28 August 1995). Archer also indulges in a series of stereotypes, arguably positive, maybe 'strategic essentialisms' (Brah 1996: 127): 'Any schoolteacher will tell you that his or her heart rises in front of ranks of Asian

kids in class. They will be quiet, polite, and keen to learn, unlike some sections of our own proletariat.' So not only are 'Asians' docile and obedient, but they are not 'our own'. But, paradoxically, to 'prove' the assimilation and demonstrate the positive character of 'Asians', Archer tells two similar stories, both instructive of what 'Asians' are and how he feels they can become accepted in and acceptable to Scottish society:

> A few years ago, Pakistan came to play cricket against Scotland at Titwood. It rained. The cosseted players stayed in the pavilion and would not sign autographs. Through the crowd came an Asian gentleman to deliver his opinion of such arrogance. 'Yous,' he said, 'are nothing but a bunch of nig-nogs.' Except there was added the adjective which always brings perfect symmetry to Glasgow invective.
>
> (*Herald* 28 August 1995)

By being racist, and by swearing, and by abusing 'real' Asians, the 'Asian gentleman' endeared himself as sufficiently Scottish to Archer. His second example is similar:

> Then there was Rocky, a waiter in my favourite Indian restaurant. He said one night that he would be away for a while because of some family reunion in Delhi and this did not impress him, because he would miss his five-a-sides and his beloved Rangers. 'The place sounds like a hell hole,' he said, adding the adjective which brings a perfect symmetry to Glasgow invective. Three weeks later he was back, entranced. 'Magic place. Never seen so many five-a-side pitches. It's all wrong, but they've got better facilities than Glasgow, the home of football.'
>
> (*Herald* 28 August 1995)

Rocky's acceptability is demonstrated: he loves football, swears, thinks of India as a 'hell-hole'. His Scottishness is further enhanced when he redefines India by its football facilities and proclaims Glasgow to be the home of football. Archer implies contempt for the subcontinent, and argues for a traditional model of integration, in which minority groups come to accept the xenophobic and racist majority view-point.

Archer describes opposition to racism in the form of the Race Relations Board as oppressive, and on behalf of Thistle supporters and other 'detesters of bigotry' takes the radical step of making a racist joke:

> The world seems full of people like the Race Relations Board, stress councillors [sic], anti-smoking campaigners, and even those who think there isn't enough meat in a Big Mac, who are determined that

we should not speak our minds. On behalf of that bunch of non-conformists, happy bohemians, detesters of bigotry, the simple plain barmy, and the very proper ones from the Bearsden and Milngavie outstation who make up Firhill's faithful, I will cheerfully break the taboo. 'Away the Jags, the Harry Wraggs, the Paki Thistle.'

(*Herald* 28 August 1995)

Yet Archer's dilemmatic thinking is displayed in an article intended to support the bid. His discussions of 'Asian' acceptability are designed to enhance the bid's credibility with the 'Scottish' public. Paradoxically, he states the bid 'would add a new dimension to Scottish football'.

John Penman wrote, as Archer did, as journalist and Thistle fan. He almost attacked Oliver for racism, but in an attempt to address issues of inclusion and separation, the intention of increasing 'Asian' participation is presented as a form of separation with 'sectarianism' as its historical antecedent.

I was proud to be a Jags fan because Thistle were above all that [sectarianism], even though our fans are no angels. But no-one felt excluded from Firhill because of race or religion and, in Glasgow, that's important. Galloway hijacked that good name by his actions. I don't want them to become a club which is a focal point for anyone other than true football fans. As for Thistle chairman Jim Oliver, his remarks left a sour taste. They were crass, ill-advised and, in my opinion, racially insensitive. Oliver's words are the currency of racism and other supporters should not stoop so low. . . . Thistle fans appreciate quality, dignity and football. I am not claiming Thistle are unique, but in Glasgow, where the vast majority of the football is riven with hate, it is worth holding on to their traditions lest the bigotry takes over completely. The sadness is that, after the events of the past week, our grip may have begun to weaken.

(*Scotsman* 1 September 1995)

Penman illustrates the contradictions in Thistle's 'non-racist' position. Even though the chairman is criticised for using 'racially insensitive' terminology, Penman still fears 'outside' influences. 'Asian' involvement would bring a situation similar to 'sectarianism'. So the reputed tolerance and openness of Thistle is to be preserved by discouraging 'Asian' participation, a stance which of course easily translates into a form of racism. Here, the ideological dilemmas underlying and restricting the notion of tolerance (Billig *et al.* 1988) are made crystal clear.

Galloway's own difficulties arise from his desire to promote the 'Asian community'. To do this he relied upon stereotypical descriptions: 'The driving entrepreneurship of Scotland's Asian business community is legendary. With control at Firhill, the 6,000 Asian businesses in West Central Scotland

(employing more than 100,000) could begin to fill the empty corporate space in the Firhill basin' (*Scotland on Sunday* 3 September 1995). But in dealing with the issue of parallels with 'sectarianism', Galloway meets the challenge head on. He accepts a direct comparison with the Scots of Irish descent, but suggests a new 'sect' as a third way forward:

> In the 1950s a Partick Thistle chairman remarked at an annual meeting that the only way Thistle could compete in Glasgow against Celtic and Rangers would be if a third religion were invented. Glasgow's Hindus, Sikhs, Muslims and Jains ARE that third religion.
>
> (*Scotland on Sunday* 3 September 1995)

On the issue of national identity, Galloway struggles for consistency. Responding to Alan Davidson's complaint that the bid was ill-judged because Thistle are 'intrinsically Scottish' Galloway retorted: 'Well, excuse me. Most of the Asians I know were born here, speak with a Scottish accent, and are walking around under the impression they are Scottish' (*Scottish Asian Voice* 3 September 1995). And reacting to the many stereotypical jokes in circulation at the time Galloway tried to adapt the implied 'corner shop' analogy to his advantage:

> About the only good joke cracked during a week of clichés was the one on Radio Scotland which said that, after the take-over, Firhill would now be open from 7.00 in the morning to 11.00 at night. Quite so. And earning money . . . to spend on players.
>
> (*Scottish Asian Voice* 3 September 1995)

Galloway's comments are replete with examples of both ideological and strategic dilemmas (Billig *et al.* 1988). The bid's major promoter vacillates over the significance of cultural difference: if it exists, how is it to be interpreted or represented? Identity labels are also dilemmatic: Asian signifies difference for a group that is also to be seen as Scottish, but for whom Scottish appears to be insufficiently descriptive. And though advocating the inclusion of the 'Asian community' in football, Galloway maps for them positions of distinction, difference and exclusion by using entrepreneurship, religions or long, hard work as defining features. Galloway promotes stereotypes as long as they serve the cause, for some an acceptable use of 'strategic essentialisms', but one which risks endorsing one of the most prominent features of racialised discourse (Brah 1996: 127).

Conclusions

The take-over affair is vital for studies of racism not only because it is a narrative of ideological complexities but because, as Stuart Hall notes 'we should

think . . . of identity as a "production", which is never complete, always in process, and always constituted within, not outside, representation' (Hall 1990: 222). 'Asian' identities are constructed within the context of majority representations which position them as outsiders in Scotland, as surprisingly also does Alan Bairner when he writes that the 'Asian community' does not 'belong to a football culture' (Bairner 1994: 21). Once 'Asians' are positioned outside, various racist discourses can be employed: the curry-related humour, the defence of racism, the framing of 'racist' accusations within other contexts, the problematising by the use of 'sectarianism'. Inequalities of power went unrecognised; easily done when the racism is so banal and everyday, and when the myth of Scottish tolerance continues. As Back *et al.* show, populist thinking requires an obvious example of a 'racist' before the issue of racism can be addressed. Not only was most of this racism so taken-for-granted as to seem subtle, and largely pass unnoticed, but the dilemmatic thinking even from those supposedly in support of the bid, or of 'tolerance', demonstrates the scale of the task faced in going beyond the image of the 'racist thug' to unmask the complexity of racism. And that scale measures the inadequacies of of the challenge to racism in Scottish football and society.

Notes

1 As this chapter shows, communal names pose problems and reflect power relationships (see Gaine 1987; Brah 1996). Recent research shows adolescents strongly dislike Asian or Asian-Scot and prefer specific bi-cultural referents such as Scottish-Pakistani (Saeed *et al.* 1996). Yet in the proposed take-over it was a group of wider geographical ancestry, categorised as Asian that was topicalised. So, 'Asian' will be used in this chapter.

2 Another indication of the lack of seriousness with which racism *within* Scotland is treated, is that it was Finn's (1994b) attempt to develop further the inter-relationships between anti-Irish racism and other variants of racism in Scotland that was, without the author's agreement, removed to reduce the chapter's length: further poor editing ensured that relevant references remain!

3 Thistle's debts became public knowledge in 1997 when the club faced bankruptcy. The club appears safe after a fan-led rescue campaign and creditors' willingness to accept 40p in the pound.

Bibliography

Armstrong, B. (ed.) (1989) *A People Without Prejudice: The Experience of Racism in Scotland*, London: Runnymede Trust.

Back, L., Crabbe, T. and Solomos, J. (1996) *Alive and Still Kicking*, London: AGARI.

Bains, J. with Patel, R. (1996) *Asians Can't Play Football*, Solihull: ASDAL.

Bairner, A. (1994) 'Football and the idea of Scotland' in G. Jarvie and G. Walker (eds) *Ninety Minute Patriots? Scottish Sport in the Making of the Nation*, Leicester: Leicester University Press.

Bell, A. (ed.) (1991) *Aspects of Racism in Scotland – Information and Sources*, Edinburgh: Moray House College.

Billig, M. (1989) *Banal Nationalism*, London: Sage.

—— (1991) *Ideology and Opinions: Studies in Rhetorical Psychology*, London: Sage.

Billig, M., Condor, S., Edwards, D., Gane, M., Middleton, D. and Radley, A.R. (1988) *Ideological Dilemmas: A Social Psychology of Everyday Thinking*, London: Sage.

Blain, N., Boyle, R. and O'Donnell, H. (1993) *Sport and National Identity in the European Media*, Leicester: Leicester University Press.

Brah, A. (1996) *Cartographies of Diaspora: Contesting Identities*, London: Routledge.

Cashmore, E. (1982) *Black Sportsmen*, London: Routledge, Kegan and Paul.

Cosgrove, S. (1991) *Hampden Babylon: Sex and Scandal in Scottish Football*, Edinburgh: Canongate.

Crampsey, B. (1986) *Mr Stein: A Biography of Jock Stein C.B.E. 1922–85*, Edinburgh: Mainstream.

Dovidio, J.F. and Gaertner, S.L. (eds) (1986) *Prejudice, Discrimination, and Racism*, Orlando: Academic Press.

Dunlop, A. (1993) 'A united front? Anti-racist political mobilisation in Scotland', *Scottish Affairs* 3, Spring: 89–101.

Finn, G.P.T. (1987) 'Multicultural antiracism and Scottish education', *Scottish Educational Review* 19, 39–49.

—— (1991a) 'Racism, religion and social prejudice: Irish Catholic clubs, soccer and Scottish society. I – The historical roots of prejudice', *International Journal of the History of Sport* 8, 1: 70–93.

—— (1991b) 'Racism, religion and social prejudice: Irish Catholic clubs, soccer and Scottish society. II – Social identities and conspiracy theories', *International Journal of the History of Sport* 8, 3: 370–9.

—— (1994a) 'Sporting symbols, sporting identities: soccer and inter-group conflict in Scotland and Northern Ireland', in I.S. Wood (ed.) *Scotland and Ulster*, Edinburgh: Mercat.

—— (1994b) 'Faith, hope and bigotry: case-studies in anti-Catholic prejudice in Scottish soccer and society', in G. Jarvie and G. Walker (eds) *Ninety Minute Patriots? Scottish Sport in the Making of the Nation*, Leicester: Leicester University Press.

Foucault, M. (1980) *Power/Knowledge: Selected Interviews and Other Writings 1972–1977*, ed. and trans. C. Gordon, Brighton: Harvester.

Gaine, M. (1987) *No Problem Here*, London: Hutchinson.

Hall, S. (1990) 'Cultural identity and diaspora', in J. Rutherford (ed.) *Identity: Community, Culture, Difference*, London: Lawrence and Wishart.

Horne, J. (1995) 'Racism, sectarianism and football in Scotland', *Scottish Affairs* 12, Summer: 27–51.

MacDonald, K. (1994) *Scottish Football Quotations*, Edinburgh: Mainstream.

Maan, B. (1992) *The New Scots: The Story of Asians in Scotland*, Edinburgh: John Donald.

Miles, R. (1982) *Racism and Migrant Labour*, London: Routledge and Kegan Paul.

—— (1993) *Racism After 'Race Relations'*, London: Routledge.

Murray, B. (1988) *Glasgow's Giants: 100 Years of the Old Firm*, Edinburgh: John Donald.

Saeed, A., Blain, N. and Forbes, D. (1996) *Social Identities of Scottish Pakistani Teenagers*, paper presented to the British Psychological Society's Annual Social Psychology Conference, University of Strathclyde, Glasgow.

Part III

FOOTBALL NORTH TO SOUTH

Continental identities

8

FOOTBALL FANS IN
SCANDINAVIA: 1900–97

Torbjörn Andersson and Aage Radmann

This chapter will treat the Scandinavian football spectators from an historical perspective. Emphasis is given to the earliest and the latest developments, that is to say approximately the periods between 1900–30 and 1970–97. Sweden, and to a lesser extent Denmark, will be the centrepiece, justified by their position as the biggest and most successful football nations in Scandinavia.

1900–30

Among the Scandinavian countries, British football first came to Denmark where the game was already well-established before the turn of the century. The breakthrough in Sweden came a few years after 1900, and a further few years elapsed before the game gained a footing in Norway. Danish football was therefore the spearhead of Scandinavian developments. During the first two decades the best football was played in Copenhagen, and it was here that the crowds were biggest and (according to subjective opinions) best. From a Swedish perspective Danish football was considered to represent real culture – indeed, this was the very word used by the media of the time – both on the field and in the stands, whereas native football was considered to reflect only the primitive skill of the beginner. In fact, this viewpoint also reflected the mutual opinions of the two countries for each other. Denmark was the ancient, contented land of culture while Sweden was seen as a dynamic and thrusting upstart.

What was the basis for an idealised football culture in Denmark? The Scottish amateur team Queens Park had made a strong impression during a pioneering visit to Copenhagen in 1898. This taught the Danes elegant play based on short passes, and it also founded a tradition of distinguished spectators attending matches, including representatives from the Danish royal family. Indeed, early Danish football culture had considerable similarities with British amateur football, with the game concentrated at a few, relatively distinguished clubs in Copenhagen. Before the First World War, the peak of the season came

with the international matches that the leading Copenhagen clubs arranged with British professional clubs. For the Danes these matches had enormous prestige and public excitement was rampant. The spectators kept their enthusiasm within what was considered acceptable. The crowd was given praise for being knowledgeable, gentlemanly and fair. Interestingly, a considerable number of women seem to have attended, at least at the big matches. In only a few cases did sentiments exceed what was approved. In 1910, the referee was attacked after a Liverpool victory (*Idraetten* (1910) 22: 233) and in the same year Manchester City had unpleasant experiences at the hands of a Copenhagen crowd:

> All our players have changed their opinions of the sportsmanship of the Danish team and spectators, especially the latter. . . . When anyone of us got injured the spectators laughed and applauded, and when one of the home side went down, they hooted and jeered at us.
>
> (*Manchester Evening Chronicle* 24 May 1910)

These events fall somewhat into another perspective when considering how the secretary of the Scottish club Hearts expressed his opinion that all comments about rough play, poor refereeing and a prejudiced public – complaints regularly made by British teams after Continental tours – had no relevance for Denmark:

> Whatever may have happened in the Southern states of Germany, in Austria-Hungary, or in Spain, rough play cannot be placed to the discredit of Denmark. A finer sportsman than the Dane it would be difficult to conceive, and the same may be said of the Norwegians and the Swedes. . . . Their spirit might be copied with profit nearer home. The law-abiding nature of the Dane permits of no doubt. Policemen are not engaged, nor are they required for even 20,000 crowds. The small boy finds his way to the pay-box, scorning the idea of surreptitious entry. Betting is unknown. It is the latter evil with its contingent results that casts a blight on the game elsewhere in Europe.
>
> (*Daily Record and Mail* 30 June 1914)

It seems that in Britain attitudes about a good and a bad European football culture were founded around 1910. The attitudes of the British and those of Scandinavians represented the good, while those of central and southern Europe were to be abhorred (a dichotomy that was to have a long life, and which made the shock of the appearance of native British hooliganism all the starker when it erupted in the 1960s). This definitive opinion was mirrored in Scandinavia. The British and native supporters were usually praised, whereas innumerable examples of spectator hooliganism in continental football (and

later also in South America) were published in the sporting press during the 1910s, 1920s and 1930s.

The ideal of behaviour of the 'British gentleman' was to Scandinavians more than a mere example; it became almost an obsession. This took such expressions as the Danish committee of referees that enjoined the Copenhagen clubs to post notices warning the public against excesses of behaviour (*Idraetten* (1918) 29: 262). The cause of this seems to have been nothing worse than persistent, verbal abuse of referees and players. This zealousness of the referees' cadre was commented upon in the leading sports newspaper, which reprinted a piece by a British journalist on the Danish football crowd:

> But when was heard the roar of the spectators? Where were those flashes that, even during a poor match in England, give a break in the monotony? Where was the nervous tension that during ninety minutes links spectator to player and player to spectator?
>
> (*Idraetten* (1918) 33: 296)

The newspaper continued by stating that it was against the spirit of the game to try to forbid the shouts of fans. A later article on the same theme pointed out that jokes and heckling from the cheap stands were part of the true charm of a football match (*Idraetten* (1918) 38: 362). To all intents and purposes there were no spectator disturbances in Danish football, but rather the opposite in that both the crowd and the Danish style of playing were considered to represent true spirituality. The only real exception during the first decades of this century, at bigger matches at least, occurred when some spectators attacked players of Glasgow Rangers in Copenhagen in 1922 (Gandil 1939).

What could be the reasons behind the generally calm behaviour of Danish spectators? A significant factor seems to have been the inner structure of Danish club football. The game was dominated for a long time, indeed even into the 1950s, by traditional Copenhagen clubs whose social and local bases seem to have been so similar that any nourishment of spectator rivalry was weak. Indeed, relationships between the top clubs seem to have always been good. Together they defended their privileged position against the younger, smaller, poorer and altogether more working-class clubs that were challenging their hegemony. The big clubs frequently fielded combined teams against foreign opponents, and these matches became the focus of Danish football, both as a game and spectator sport. The early successes of the Danish national team, which reached the Olympic finals against England in both 1908 and 1912, gave even more emphasis to the international scene. Then, when the Danish team became weaker during the First World War, the matches against an ambitious and aspiring Swedish national team came to be the high point of the Scandinavian football year. These were the matches which, above all others, captured public attention in both nations.

Sweden was a country that at the turn of the century was experiencing a period of rapid change. Swedish industrialisation and urbanisation at this time was characterised by more pronounced social and class conflicts than the quieter development occurring in Denmark. It was not until the 1930s, when the Social Democrats began their long period of government, that the Swedish social climate was to experience greater stability (Bull 1922; Korpi 1978; Larsson 1994). In general, football culture seems to have followed this Swedish pattern. Certainly, the 1940s was characterised by a new-found discipline on the football terraces. This means that the situation with regard to the football public was more complex in Sweden than in Denmark during the first decades of the century.

One decisive difference was the greater local and regional rivalries that characterised Sweden, in contrast to Denmark. In Sweden the composition of the national team was, for a long time, a controversial issue. Three major centres of football fought to be represented in the national team. These were at first Stockholm and Gothenburg, soon to be followed by the region of Scania (mainly Helsingborg and Malmö). For a long time there was considerable uneasiness within the national football leadership concerning the extent to which the public identified themselves with their home towns rather than with the national team. The national concept had its real breakthrough in 1919, when a team of eleven Gothenburg players beat Denmark in Stockholm, with the unreserved support of the crowd (*Nordisk Idrottslif* (1919) 47: 370–4). It was natural that this unstable situation for the national team only mirrored the conflicts that characterised the situation at club level.

Just as in Denmark (and Norway), Swedish football was originally dominated by a few middle-class clubs in the larger coastal towns. Unlike the Danish situation, these clubs were strongly challenged in the first two decades of the twentieth century by teams with more marked working-class origins (this difference was noticeable in terms of members of the leading committee, players and spectators), and this led to the establishment of a series of local rivalries. In Gothenburg the exclusive Örgryte IS was challenged by IFK Gothenburg; in Malmö, IFK Malmö by Malmö FF; in Norrköping, IFK Norrköping by Sleipner, and in Eskilstuna, IFK Eskilstuna by several different clubs. In this respect Stockholm diverged from the rest of the country as the big clubs AIK and Djurgården both had a more complex mixed class composition.

The special interest around these prestige-filled, class-based matches was the fact that social distinctions between the clubs were matched not only by the players, but also by the spectators. The division of the spectators at the grounds was frequently obvious, with the supporters of the more exclusive club occupying the relatively few seats while the cheaper standing areas were filled by their rivals.

It was natural that, as football emerged as a true spectator sport at the beginning of the century, with gates in the thousands instead of hundreds, so

144

it received more attention. Decent behaviour on the part of the supporters was considered essential if the game, which was still strongly criticised by many influential figures in society, was to be guaranteed continued expansion. Respectability was particularly important in order that investments would be made that were necessary for the construction of football grounds. The press therefore expressed concern that the crowd were, in their opinion, too noisy and too prejudiced. This was particularly the case for the local derbies and matches between teams from neighbouring communities. The ideal seemed to swing back and forth between a virtually silent crowd and one which impartially applauded every skilful manoeuvre on the field. As late as 1914 the leading sports newspaper questioned the right of the fans to 'sympathise with one of the teams and give verbal expression of its sympathy and enthusiasm?' (*Nordisk Idrottslif* (1914) 59: 488; see also Bale, this volume). Their own answer, which was in fact a defence of the younger supporters' enthusiastic behaviour in contrast to the boring inactivity of an elder generation, nonetheless seems today to demand a considerable degree of self-control. The conclusion was:

> the spectators may applaud and with every method encourage their favourites, but this applause should be honest, be given at suitable moments and bear the stamp of both insight and good taste. The spectators should in no way irritate and insult the antagonists on the field of play – perhaps with the exception of a player guilty of some particularly ugly trick.
>
> (*Nordisk Idrottslif* (1914) 59: 488)

From such a viewpoint, it was natural that the press should react strongly against incidents that today we would call hooliganism. A number of such episodes were reported in the two decades after 1910. Usually this involved attacks, such as pitch invasions, stone-throwing, and other threatening behaviour, against referees or players. There is no record that rival supporters attacked each other. However, it is clear that some of the incidents had directly political origins, such as when a 'scab' (blackleg) appeared in a team. The matches that experienced upheavals were always between teams from the same or neighbouring towns, or else prestigious matches against foreign opponents. Gothenburg and the industrialised towns and communities of central Sweden were particularly notorious in this respect.

There are a number of points worth noting from the press reports of these so-called football scandals. The opinion was unanimous that it was events occurring on the playing field – mainly poor refereeing or rough play (which was often considered an effect of poor refereeing) – that incensed the spectators. It is also clear that it was usually the fans in the standing areas who lost their self-control, and that the younger cadres (frequently mere teenagers) were invariably the instigators. The general opinion was that these difficulties with spectators could be solved and several measures were taken. Some clubs

were required to erect a barrier around the playing field, and in a few instances matches were prohibited in particularly notorious arenas. There was even a case in which some Gothenburg players were fined by a civil court because their fight on the field had inflamed the public (*Nordisk Idrottslif* (1913) 49: 395). Furthermore, the competence of referees was to be increased by a series of courses. Interestingly the press did not go free from criticism, such as when the Gothenburg newspapers were accused of inciting the public through their obvious sympathies for specific clubs (*Nordisk Idrottslif* (1916) 77: 626). According to this point of view they had failed in their educational mission.

Clearly, Swedish spectators were, in comparison with their Danish counterparts, more noisy, prejudiced and less respectable. The leading sporting newspaper in Denmark wrote that English players had said that they refused to play in Sweden because of their bad reception from clubs and spectators alike (*Idraetten* (1913) 24: 271). In actual fact a number of British clubs played in Sweden quite a lot, but it seems that they did generally consider the Swedish crowd to be more problematical than the Danish. Nonetheless, most of the time the Swedes also received high praise for their gentlemanly behaviour.

A particularly interesting aspect of Swedish spectator culture is that it was created to a large extent by influences from above: from the football authorities, match organisers and the press. One of the most exotic happenings during the Olympic Games of 1912 in Stockholm was the American students' cheer section, whose slogan of 'Ra-ra-ray, U–S–A' was a direct inspiration for Swedish football culture. A Swedish cheer slogan was created expressly for the first international match against Denmark in Stockholm 1913 and the best suggestion came from the nation's most well-known athletics trainer. His 'Heja grabbar, friskt humör, Det är det som susen gör! Sverige, Sverige, Sverige!' (in English: 'Come on boys, show some spirit, That will cheer us on to win it! Sweden, Sweden, Sweden!') was soon well-known (*Nordisk Familjeboks Sportlexikon* (1949) 7: 743–4). From that point onwards, most significant football matches in Sweden were characterised by cheer squads. Frequently, the match organisers recruited a well-known musical artist or an actor to be the cheer leader. Indeed, even the strong man of the Football Association, its secretary Anton Johanson, could occasionally be seen distributing paper megaphones to the spectators in order to heighten their spirits. A singsong before the kick-off was also a frequent part of the programme to create atmosphere. The role of cheer leader could also be taken up spontaneously by someone from the crowd. The slogans used belonged to a standard repertoire that was embellished and enlarged for individual matches. This gave an excellent platform for the quick-witted amongst fans to make up new slogans, which, if appreciated, could quickly be heard to roll out from the stands. This cheer squad culture was specific for Sweden, and even if

it later spread to the other Scandinavian countries, it often evoked surprise abroad. A Swedish sports encyclopedia wrote in 1949 as follows:

> In the majority of other countries there is no organised cheering although spontaneous singing may occur. Outside the Nordic countries there are some places in which Nordic cheering initially gives rise to laughter and curiosity, and then later unpleasantness; the cheers are considered to be evidence of 'organised expressions of feeling', that is to say, the very opposite of spontaneous expressions.
>
> (*Nordisk Familjeboks Sportlexikon* (1949) 7: 745)

The peak of spectator excitement during the season was generally to be found at the international matches between Sweden and Denmark. When Sweden played away in Copenhagen, thousands of fans were present that had come by train from Gothenburg and Stockholm, and by boat from the Scanian coastal towns. On the stands the Swedish cheer squads and the Danish 'Fast Painters' (supporters who, in an instant, could paint an effective slogan on big banners – see Figure 8.1) tried to surpass each other. A carnival-like feeling completely dominated the arena. The press, however, complained about drunkenness that occurred on the train journeys to Denmark. It was not surprising that such a custom of insobriety arose. The rise of Swedish football as a spectator sport occurred after the introduction of an alcohol policy that regulated consumption in beer halls and restaurants. Therefore the tradition never arose of visiting such places in connection with matches. Instead, drinking was concentrated on special trains that took supporters to the important away matches. In contrast, in Denmark, football became merely an extension of an urban drinking tradition based on the use of public premises.

The attendance figures for the internationals between Sweden and Denmark show clearly how interest in the game accelerated. The debut matches in Copenhagen and Stockholm in 1913 were seen by respectively 8,000 and 6,000 spectators, in 1916 the figure was 20,000 in both cities, and after this the figures increased along with the expansion of arenas. In 1960 and 1961 there were 50,000 spectators in Gothenburg and in Copenhagen. Thereafter interest declined rapidly in Sweden as Denmark's position as a feared opponent diminished. (*Nordisk Familjeboks Sportlexikon* (1940) 3: 212–23; *Strömbergs Årets Fotboll* 1970, pp. 73–80).

No other Scandinavian matches achieved the status of the Danish-Swedish meetings. Games between Norway and the other Scandinavian countries were only really popular in Oslo. There the crowd was so enthusiastic that guests frequently remarked that they had never experienced such a noise at home. This was scarcely to be wondered at, as after the dissolution of the union between Norway and Sweden in 1905, sport came to have a special position

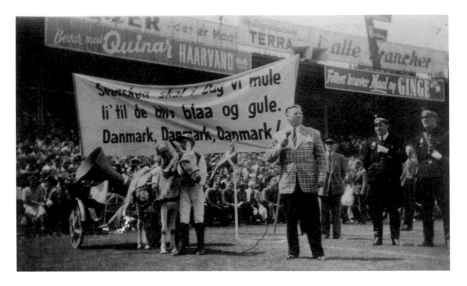

Figure 8.1 A Danish 'Fast Painter' in action – denigrating the Swedes – before the Denmark versus Sweden match in Copenhagen, 1946

Source: Reproduced by permission of the author.

in reinforcing Norwegian national identity. A victory over Sweden would naturally have special value in such a context.

The situation of club football was in stark contrast to that at the international level. Tickets for international matches were relatively expensive, which certainly raised the class level of spectators in relation to that at club matches. Ticket prices were in general a controversial issue, to which many letters in the press bore witness. Of course, ticket prices could exert an absolute influence on the character of a local football culture. The remarkably low attendance figures for the industrial city of Malmö during the 1920s could be explained by high ticket prices, that effectively excluded a large segment of the general public (*Idrottsbladet* (1924) 92: 6). Sometimes, of course, ticket prices were used in a calculated strategy. The distinguished Örgryte club tried an experiment with high ticket prices to deliberately exclude potential troublemakers. Protests, which included a spectator strike in Gothenburg, against high prices yielded results. A number of games were played in, for example, Malmö and Copenhagen, with lower, so-called 'popular' prices, which resulted in larger attendance figures. An even greater problem in Sweden, particularly in small communities, were the large numbers of spectators that managed to get in free. At least into the 1930s there were complaints that the non-paying public could be as large as those who paid, owing to poor fences and ineffective guards around the grounds.

In spite of the fact that football quickly came to be regarded as a working-

class game, it is quite clear that the price of entry was an important factor preventing an even greater spread of its popularity. In fact, it was not until the 1930s that attendances became relatively impressive in Sweden, with an average for the highest league of about 7,000. A real increase only came after the Second World War, when Swedish football entered its golden age. Attendances from 1946 to 1970 were, on average, about 10,000 per match, with a maximum of 13,000 during the season after the World Cup in Sweden in 1958 (Persson 1988: 439). After this figures decreased rapidly, a phenomenon that also afflicted Denmark (*Strömbergs Årets Fotboll* 1971).

The catastrophic decrease in attendances occurring in the 1970s had a strong influence on the atmosphere in arenas where some matches were played in an almost ghost-like silence. The Swedish cheer squad tradition could not be grafted onto another period. Instead, influences from English football once again became more pronounced – English games were in fact transmitted live on television from the end of the 1960s. Soon afterwards, during the autumn of 1970, a new fan culture – with English style singing and colourfulness – was noticeable at Hammarby's games in Stockholm. 'The Ends' had arrived in Swedish football.

1970–97

Norway has always been something of the little brother in Scandinavian football, overshadowed by Sweden and Denmark. The breakthrough for Norwegian football at international level came in 1918, when the national side beat both Sweden and Denmark. International successes since then are, however, easy to count. In the Berlin Olympics of 1936, the team reached the semi-finals and this 'bronze team' still ranks highest among Norwegian football results. Two years later, Norway qualified for the World Cup but were knocked out in the first round. (Larsen 1977; Goksöyr 1994). Fifty-six years were then to elapse before Norway again qualified for a World Cup. This achievement created a football hysteria that the country had never previously experienced. The team players were christened *Drillos*, after the magically successful trainer Egil *Drillo* Olsen. After the sporting, cultural and organisational successes of the Winter Olympic games in 1994 at Lillehammer, in a period of unprecedentedly low unemployment and sound state finances, nationalism knew no bounds. The Norwegian Prime Minister, (Ms.) Gro Harlem Brundtland, said without a trace of false modesty, 'We are the best in the world', a statement that has since become legendary. Although the final result was a sporting disappointment, the 1994 World Cup certainly put Norway on the world football map. International criticism from several fronts, claiming that the *Drillos* played an uninspired 'cement' football, did not dampen the enthusiasm.

The discussions and criticism directed against the Norwegian national team for its dull, destructive type of football during recent years had, in fact,

been present at club level in Sweden during the 1970s. The English trainers Bob Houghton and Roy Hodgson revolutionised Swedish tactics and introduced a new football *field* – and a negative style of football according to critics (Bourdieu 1991; Peterson 1993). In Sweden this discussion finally came to an end with the reformed, more positive, playing style of IFK Gothenburg, which was to be successful in Europe. Sweden's exciting performance in the 1994 World Cup was even more satisfying to everyone. The third place won in the USA came as a saving grace which put Sweden back into a more normal position relative to its Scandinavian football brothers.

In Denmark, the national team has had a series of remarkable successes since 1980, with the victory in the European Championship in 1992 as its best result. It is, however, not only the players that have been praised for excellence, but also their supporters, christened *Roligans* (or 'Cooligans') by the media. The *Roligans*, who were first recognised as a phenomenon in 1984, are unique amongst supporters and have been presented as the antithesis of the typical English hooligan. *Roligans* have been praised from every quarter, not least by the tabloid press. When English hooligans were stigmatised, and described as animals, the Danish *Roligans* were met with respect and other positive attitudes. While English hooligans bathed in the negative glory of media coverage about violence and uninhibited drunken orgies, the Danish media paid attention to the *Roligan* values of anti-violence, partying and a carnival atmosphere.

> The Danish popular press were an active force in support of the Danish *Roligans* and the fantastic reputation that they have achieved in the international press already during the 1984 European Championships in France. Ekstrabladet and BT became mirrors in which the Danish *Roligans*, and indeed all football-lovers of both sexes, could see and recognise themselves. In this way the Danish popular press came to have a similar role to that played by the English popular press for the hooligans, but with reversed polarity. While the Danish press supported recognisable positive trends encompassing companionship, fantasy, humour and pride, the English press helped to intensify and refine violence among English spectators by consciously focusing on and exaggerating the violence and the shame.
>
> (Peitersen and Holm Skov 1991)

A comparative study carried out among Danish and English supporters during the 1988 European Championships in West Germany revealed several clear differences, not least at the socio-economic level. The nucleus of the *Roligan* movement was recruited among skilled workers and civil servants, while the majority of the English supporters, at least at this Championship, consisted of unskilled workers and a large number of unemployed. The

average age of the Danish fans was 31 years, compared to 23 for the English supporters. The Danish *Roligans* spent an average of 6,000–12,000 crowns whereas the English fans spent only half as much. Fifteen per cent of the *Roligans* were women, as opposed to only 2 per cent of the English fans (Peitersen and Holm Skov 1991).

The fans that appear on the international scene in Scandinavia have hardly ever been characterised as troublemakers or hooligans. The Norwegian fans and Danish *Roligans* have both developed a strong tradition of song, music, colour and carnival. The Swedish 'Blue-Yellows' have been more restrained, apart from the massive celebration and carnival after the 1994 World Cup third place. And this is not to forget what all Scandinavian fans have in common when travelling abroad – an interest in serious drinking!

At the level of club football, there are considerable differences between supporter cultures in the three countries. In brief, hooliganism is to be found in Sweden and Denmark, but not in Norway. Some researchers claim that the origins of modern hooliganism in Sweden can be traced to 1969. That year over-enthusiastic IFK Gothenburg fans invaded the pitch several times at Jönköping as they celebrated winning the title. Finally, a battle began between supporters and police. Another big incident occurred a year later. This time it consisted of fighting between players, an invasion of the pitch by over 1,000 people and several battles (Persson 1993). An interesting feature of this event was that several of the Gothenburg players had encouraged their supporters to interfere in the hopes of achieving a replay and thereby avoiding relegation. At that time the terms 'hooligan' and 'hooliganism' were not used in the Swedish debate. This debate concentrated on the events themselves and made no attempt to put the phenomenon into a wider social perspective.

During the 1990s (and also in Sweden in the 1970s and 1980s) both Sweden and Denmark have experienced serious outbreaks of violence in connection with club matches. Norway has been free of this type of problem, with the exception of the Oslo club Vålerenga, whose supporters, nicknamed the 'Ape Mountain', have been the focus of both the police and the media. Still, it would be wrong to characterise the minor troubles connected with them as 'hooliganism'. The Norwegian supporter who has received most publicity in the course of history from the football press was the young man who climbed onto the roof of a beer tent during the 1992 European Championships in Malmö. He was later accused of starting the worst riot of the Championships and thereby 'ruining' them. Follow-up research, and interviews with the Norwegian, showed that the tabloid press coverage contained several direct errors of fact. Further, the behaviour of the evening papers was found to deviate substantially from the ethical rules formulated by the press. An analysis of the tabloid press before, during and after the 1992 European Championships showed that the sports pages generally painted a more

differentiated picture of the Championships than the news and cultural pages (Radmann 1994).

Swedish club football has experienced several 'tumults' between fans, most of them concentrated in Stockholm and its home clubs, AIK, Djurgården and Hammarby. Their supporter clubs, which are respectively the 'Black Army', the 'Blue Saints' and 'Bajen Fans', are nearly always involved when a riot occurs at a football game in Sweden. Together the Stockholm fans make up nearly half of the 18,000–20,000 members of supporter clubs in Sweden's top two divisions.

The only public investigation into hooliganism in Sweden was carried out in 1985 by the National Council for Crime Prevention. The question to be resolved was formulated without nuances: 'Was it professional troublemakers or ordinary 'lads' that were responsible for arena violence and hooliganism?' The investigation came to an unambiguous conclusion. Whenever serious disturbances occurred in the stands, a high proportion of those arrested were so-called 'troublemakers'. As many as 60 per cent of those arrested for arena violence had criminal records; the majority sentenced for crimes of violence. Of the 40 per cent arrested who had no criminal records, half were in contact with the social services (BRÅ 1986). However, this report can be criticised on several counts: selection methods, sample size, the simplistic questions posed and the near absence of any theoretical basis. In addition to this report, there have been others during the 1990s. One example is the project 'Better Supporter Culture', which started in 1991 with the goal of improving supporter life, the arrangements at matches and the relationships between clubs and their fans. It also intended to oppose violence, vandalism, racism and accidents connected with football, bandy and ice-hockey matches (*Projekt Supporterkultur* 1995).

The general increase in violence in Swedish society is reflected by a dramatic increase in the number of assaults. Whereas ten years ago 18–20 year-olds were the group that appeared most frequently in the statistics, it is suspected that nowadays 15–17 year-olds are those most frequently involved in acts of violence. Furthermore this violence is mainly directed against other youths and young men. The increase in registered acts of violence by 74 per cent in the period between 1984–94 illustrates an alarming trend (Lindström and Olsson 1995). That this should also involve the football crowd, with its large proportion of young men, is self-evident. During the 1995 season, there were 25–30 serious incidents – on average one at every seventh game. 'Serious' in this context is defined as any one of the following situations: groups of supporters in direct conflict with each other or the police or guards; attempts by supporter groups to carry out any of the above acts but which have been prevented by the police; and attacks or attempted attacks by spectators on players or officials.

Today there is a network of special supporter police in towns with first division teams and these have been given an important role in the preventa-

tive arrangements surrounding football matches. The supporter police have built up intelligence about different supporter group cultures and even information about the individuals involved. Interviews with the responsible police officers in Norway and Sweden show considerable differences between the two countries. According to the Norwegian police, there is no hooliganism in that country and the only matches given a high-risk classification are those when the English national team is visiting. They also maintain that it is attitudes expressed by the press that strongly contribute to moral panic concerning the English. Norwegian police stress the role of positive feedback in their contacts with supporters. They also never appear in large groups, or go armed with helmets and weapons when on duty at club matches. Finally, they have absolute responsibility before, during and after all matches. From this point of view they behave quite differently from the Swedish police, whose strategy has been to lay responsibility for events within the stadia with the clubs and mainly concern themselves with events outside the grounds. In Sweden most of the local derbies, and the matches between big clubs, are characterised as high-risk matches. In such cases it is usual to have a large force of police, some of whom, often in plain clothes, make video films of the fans while the rest are equipped with shields, helmets, visors and weapons (Radmann 1994).

In Denmark the fully professional clubs Bröndby and FC Copenhagen, both from the capital, are the leading teams. Bröndby is the club which has the largest number of organised supporters in Scandinavia, with about 10,000 members and was the first club with full-time professionals in the Nordic countries. The third professional club in Denmark is Odense Boldklubb. The only fully-professional club in Sweden, Malmö FF, has recently chosen to abandon this strategy and return to semi-professionalism, a form of organisation that is characteristic for both Sweden and Norway. Public interest has increased strongly in Denmark with the introduction of a Super League, and in fact the country is experiencing its biggest football boom for a long time. Some incidents have marred the otherwise positive picture, particularly when local derbies are played in Copenhagen.

It is a characteristic of Scandinavian football fans that they have deep ties to the game itself. Studies of the Danish fans have shown that between 80–5 per cent of Roligans and club supporters play, or have played, football for at least one club. This figure is very high from an international perspective. One conclusion is therefore that a large number of Scandinavian fans are socialised within a structure and context intimately connected with the football experience itself (Peitersen et al. 1991).

The hooliganism that exists in Scandinavia occurs almost exclusively at club level and not at international matches. Sweden, which has had the greatest problems with hooliganism amongst the Scandinavian countries, made considerable efforts before the start of the 1996 season to counteract them because the 1995 season ended in several serious incidents. In one of

these a referee was knocked down by a 'Blue Saints' supporter. For this Djurgården were fined 200,000 crowns. The club tried to solve hooliganism in many different ways, including contracting a private security company to keep order (*Svenska Dagbladet* 28 March 1996). They also registered and investigated all 3,000 members of the fan club, the 'Blue Saints'. The result of this investigation showed that about thirty of them were prepared to start a fight, a further twenty would be prepared to join in a fight and the remaining 2,950 were mainly interested in the football (*Arbetet* 29 March 1996).

The twenty-two-point programme that was the basis for changes prior to the 1996 season makes it absolutely clear that it is the clubs themselves that are responsible for events happening within the grounds during matches. This was necessary in order to avoid legal problems, including the fact that the police do not have the right to search spectators on their way into the arena (in sharp contrast to England: see Osborn and Greenfield, this volume) although club officials can do this. From the beginning of the 1996 season it has also been agreed that every club has to take complete responsibility for its members and any incidents in which they may be involved, at both home and away matches. An initiative banning slogans which insult the opposition, or contain racist or religious prejudices, was tried out, although the idea was rejected by the fans. Supporter clubs discussed the matter in their fanzines and came to the conclusion that it was a paper-construction that never would never work in real life. Still, the cooperation between clubs, supporters and police has, on the whole, been very successful. Some of the clubs, like AIK and Djurgården, have also started cooperation with social workers in their part of the city. This, together with the fact that both Hammarby and Djurgården are not playing in the highest division, resulted in a 1997 season which appeared to be the most peaceful one for a very long time in Sweden.

It is interesting to speculate on the causes of the ups and downs in football violence at club level in Sweden and Denmark. In Denmark the problem is recent: as late as 1991 a research report explained why hooliganism did not exist in Denmark (Peitersen *et al.* 1991). However, even if the problem is relatively marginal in Danish football, it does exist today and there are several incidents showing that violence associated with football games is on the increase. In Sweden the problems have been greater, not least because of the continual escalation of mass media coverage. Nordic criminologists have warned about the great power of media propaganda to influence thoughts and create opinions against various social evils that have frequently been conjured up by the same mass medium. This power can be used to induce a fear amongst ordinary people of criminal acts and to maintain such a fear that is out of all proportion to the actual risk (Wiklund 1990). Still, it cannot be said that the mass media are to be blamed for hooliganism in Sweden, but they do certainly exert a strong influence on the programmes that are adopted.

It would be unfair to Scandinavian football supporters to focus on hooliganism as if it were a massive problem. It certainly exists, but the comments of

a supporter policeman of IFK Gothenburgs 'Änglarna' (or 'Angels') – one of Sweden's largest supporter clubs – puts the matter into perspective:

> I'm fed up with all this talk about hooligans. I don't like the word. If you were to count the real troublemakers, those whom one can really call 'hooligans', then you would find three all told in Gothenburg.
>
> (Jacobsson and Gustafsson 1996)

The Scandinavian supporter culture is predominantly positive in its nature. In Sweden, Bajen Fans, the supporters' club of Hammarby, were those that started the carnival atmosphere in 1970, and ever since they have had the most dedicated fans. It is also clear that various supporter clubs have carried out successful programmes to change the club and its supporters in positive directions. 'The Angels' have induced IFK Gothenburg to abandon the Great Ullevi stadium and return to the more intimate Old Ullevi, and there are forces at work to encourage Malmö FF to make the same sort of change. If this should occur then the two stadiums that were built expressly for the 1958 World Championships will have largely lost their usefulness for club football.

In Denmark it is Bröndby that have, during recent years, come to represent the same tendencies of carnival, partying, colour and fireworks. In Norway the supporter clubs are less influenced by what is happening in the capital than by events in the provinces, with the Trondheim team Rosenborg BK taking first place. This is the team with the biggest gates and the greatest sporting successes in the 1990s. There is a strong tradition associated with the Cup Final in Norway, and 1995 was no exception: when Rosenborg met their arch-rivals, Brann from Bergen, the two supporter-clubs vied with each other in songs, dress, beer-drinking and parties – and there was absolutely no trouble. An RBK supporter who had his three month-old daughter on his arm was asked if he was not afraid that there might be fighting during the Cup Final. He replied that he had not even considered the possibility.

The future looks bright. Scandinavian fans influenced by the carnival spirit of the football cultures of England and Italy are currently creating an atmosphere never before experienced here. Fan activities, including phenomena such as fanzines, internet chatting, the wearing of club colours and 'tifo' spectacles are certainly here to stay.

Bibliography

Andersson, T. (1996) 'Svensk Fotboll 1900–1920'. En studie av fotbollsreferatet i Nordiskt Idrottslif (A Study of the Football Match Reports in Nordic Sports Life (*Nordiskt Idrottslif*) 1900–1920), Unpublished essay: Institute of History, Lunds University.

Bourdieu, P. (1991) *Kultur och kritik* (Culture and Critique), Gothenburg: Daidalos.

Bull, E. (1922, reprint from the original) *Arbetarrörelsens utveckling i de tre nordiska länderna 1914–1920* (The Development of the Working Class Movement in the Three Nordic Countries 1914–1920), Arkiv Förlag.

BRÅ (1986) 'Violence in the stands. Causes and efforts', Stockholm: Allmånna förlaget.

Daily Record and Mail (1914) Glasgow, 30 June.

Gandil, J. (ed.) (1939) *Dansk Fotbold* (Danish Football), Copenhagen: Nörrebros Centraltryckeri.

Goksöyr, M. (1994) 'Norway and the world cup: cultural diffusion, sportification and sport as a vehicle for nationalism', in J. Sugden and A. Tomlinson (eds) *Hosts and Champions: Soccer Cultures, National Identities and the USA World Cup*, Aldershot: Arena.

Idraetten (1905–19) Copenhagen.

Idrottsbladet (1920–49) Stockholm.

Jacobsson, I. and Gustafsson Ö. (1996) 'Grabbarna på läktaren måste tro på mig i Sporten eller livet', *En antologi om huliganism*, kroppsfixering och idrottsliga ideal ('The lads on the stands must believe me', in *Sport or Life*, in *An Anthology on Hooliganism*, Fixation with the Body and Sports Ideal), Stockholm: Heatwave Förlag.

Korpi, W. (1978) *Arbetarklassen i välfärdskapitalismen – Arbete, fackförening och politik i Sverige* (The Working Class in Welfare Capitalism – Work, Unions and Politics in Sweden), Bokförlaget Prisma in co-operation with the Institute of Social Research, Stockholm: Kristianstads Boktryckeri AB.

Larsen, P. (1977) *75 norske fotballår, Norges Fotballforbund 1902–1977* (Seventy-five Norwegian Football Years), Oslo: Norwegian Football Association.

Larsson, J. (1994) *Hemmet vi ärvde: Om folkhemmet, identiteten och den gemensamma framtiden* (The Home We Inherited: About the People's Home, Identity and the Common Future), Stockholm: Arena Förlag.

Lindström, P. and Olsson, M. (1995) *Det obegripliga våldet* (The Incomprehensible Violence), Stockholm: Forskningsrådsnämnden.

Manchester Evening Chronicle (1910) 24 October.

Nordisk Familjeboks Sportlexicon (The Nordic Family Book Encyclopedia of Sports) (1938–49) vols 1–7, Stockholm: Nordisk Familjeboks Förlags AB.

Nordiskt Idrottslif (1900–20) Stockholm.

Peitersen, B. and Holm Skov, B. (1991) *Herlige Tider, Historien om de danske Roligans* (Great Times, The History of Danish *Roligans*), Copenhagen: Komma Sport.

Peitersen, B., Toft, J., Langberg, H., Saarup, J.H. (1991) *Det er svært at være fotboldfan i Danmark* (It is Hard to be a Football Fan in Denmark), The Danish State Institute of Physical Education.

Persson, G. (ed.) (1988) *Allsvenskan genom tiderna* (Swedish First Division through the Ages), Stockholm: Strömbergs/Brunnhages Förlag.

Persson, L.K. (1993) *De blåvita invasionerna 1969–70. Den moderna huliganismens första framträdande i Sverige* (The Blue and White Invasions 1969–70. The First Occasions of Modern Hooliganism in Sweden), in the 1993 Yearbook, Göteborg: Sports Museum of Göteborg.

Peterson, T. (1993) 'Svensk fotboll i omvandling under efterkrigstiden' (Swedish Football's Post-war Transitions), in *Den svengelska modellen*.

Projekt Supporterkultur (1995) Rapport från fotbollssäsongen 1995 (Report from the Football Season of 1995), draft from the Sports Council of Stockholm.

Radmann, A. (1994) *Fotball EM-92. En studie av kveldspressen* (Football European Cup '92, A Study of the Tabloid Press), Lund: I SVEBI's yearbook.

Strömbergs Årets Fotboll, 1970 (Strömberg's Football Year 1970) (1970) Stockholm: Strömbergs idrottsböcker AB.

Strömbergs Årets Fotboll, 1971 (Strömberg's Football Year 1971) (1971) Stockholm: Strömbergs idrottsböcker AB.

Wiklund, G. (1990) *Nordiska kriminologer om 90-talets kriminalpolitik* (Nordic Criminologists on '90s Political Crime), (red.) Stockholm: Brottsförebyggande rådet, Sober Förlag.

9

'ON THE BORDER'

Some notes on football and national identity in Portugal

João Nuno Coelho[1]

> All societies that maintain armies maintain the belief that some things are more Valuable than life itself. Just what is so valued varies.
>
> (Michael Billig 1995)

> The imagined community of millions seems more real as a team of eleven named people.
>
> (Eric Hobsbawm 1992)

Introduction

Recently I watched a television programme in which the Romanian international Petrescu said: 'The national football team is the only thing that Romanians can be proud of . . .'. On the same programme the Bulgarian Ivanov stated: 'All over Europe the other countries produce more cars, computers, everything, but we beat them in football . . . we just can't let people down.'

In recent matches of the Portuguese national team when a player scores a goal he immediately runs to the team bench and kisses a national flag held by the team's coach. Recently I wrote the following in a participant observation report:

> The national anthem. I would never sing it if there was no football. We all are a bit nationalist in certain situations. This game drives me through these doubtful ways. . . . Moreover, the Portuguese anthem is really hard to sing. My deep belief is that no one can sing it perfectly, not even Pavarotti. It must be the composers' fault. And the lyrics, well, it is even better not to talk about it, so shameful they are, so nationalistic and belligerent. Nevertheless, it sounds great, magnificent, when you're in the middle of a crowd, at the stadium, anxious

as ever, waiting for the match to get started. Among the turbulence of voices, including mine, desperately singing it word by word, it is beautiful as always.

Being a football fan who mixes pleasure with work (football is my chosen sociological subject as well as pastime) I am now particularly interested in the symbolic construction of national identity related to the game. This text puts together my first notes and initial thoughts on the issue.

Football and identity

Football, as we all know, is a powerful catalyst for social identities. Football teams and matches are usually a primary motivating factor and place for assertion and celebration of various identities whether they be local, religious, ethnic, professional, or whatever. It is fascinating, even though some times frightening, how a football team performance gains vast and complex social signification and symbolism which overtake the simple outcome of a sporting competition.

As Christian Bromberger (1993) argues, football condenses, like the best drama plays, the main themes of our times. These dramatic qualities make football the most popular of all sports and spectacles. It concentrates the main values and themes of modern societies: supposed meritocracy, success and failure, solidarity, competition, balance between individualism and team work, the role of luck in our destiny. Football shows in a symbolical way that basically the misfortune of some is the condition of happiness for others. Football is about the alternation of victories and defeats, good luck and bad luck, justice and injustice which decides the destiny of the good (we) against the bad (them). The enormous popular exaltation around football teams is not then surprising. They always represent something, some identity, some positive identification, in opposition to many others, in an extremely expressive way.

Football and national identity

From all forms of social identification, national identity is the most developed identity in modernity. It can be argued, as does Boaventura Santos (1993), that the imposition of the national identity over other kinds of social bonds – religious, ethnic, etc. – is a feature of a bigger social-political-cultural project: the project of modernity. Today, nationality is a kind of shadow of each one of us, an inseparable and definite shadow. Someone who does not have a nationality is usually stigmatised. The idea of nationality is everywhere, our world is a 'world of nations'. But of most interest is the way people can not forget their nationality and are prepared to die and kill in its name. 'Fatherland or death', the revolutionary's (!) dramatic appeal, is a good example of this.

At this point, it is crucial to draw attention to the ideological consciousness of nationhood that is at work on – and permanently shapes – our societies. Nevertheless, the symbolic reproduction of the nation state is not a deeply and well studied process.

Following Anderson (1983), nation states are based on imagined communities, constructions of a supposed shared identity, institutionalised by a sovereignty, used as a form of social homogenisation beyond different types of social inequalities of class, gender, race, etc. In sociological terms, the questions we have to answer are the following: how is a national community imagined? How is it symbolically reproduced every day? As Billig (1995) puts it, national identity and pride are built day after day in everyday activities, through taken for granted forms and practices.

> It embraces a complex set of themes about 'us', 'our homeland', 'nations' ('ours' and 'theirs'), the 'world', as well as the morality of national duty and honour. Moreover, these themes are widely diffused as common sense. It is not the common sense of a particular nation, but this common sense is international, to be found in the nations of the so called world order.
>
> (Billig 1995: 4)

The language habits, the national flags in the public institutions, for instance, are expressions of this banal nationalism. Nevertheless, it is usual to define and situate nationalism in the periphery, involving dictators and bloodshed. The media but also many academic discourses reproduce these kind of ideas. The banal expressions of nationalism do not look dangerous or dramatic because they are embodied habits of social life. But they are reminders, elements of a broader socialisation process which produces (proud) soldiers to defend the fatherland when there is a war.

'Having a national identity involves being situated physically, legally, socially, as well as emotionally' (Billig 1995: 7) by ideological narratives based on a selection of myths and traditions – roots – which are considered as essential, natural, to a country. The question is why are some roots chosen and other forgotten? I want to argue that studying football as a social phenomenon can help us analyse this banal construction of national identity, namely, because football involves a set of activities deeply connected to emotions and feelings, which are socially determined. If national identity is the most 'developed' identity of modernity, football is its most popular sport/spectacle.

Modern football and nationalism are somehow sons of the same century, the nineteenth century, when modern football was born and the nation building process was consolidated. Using a metaphor, the older son – nationalism – has been, since then, exploring and sometimes colonising the younger – football – and we don't need to remember extreme examples, like the

'Football War' between Honduras and Salvador, nor the Italian, Argentinean, Brazilian or even the Portuguese dictatorships where this has happened. Further, each one of us can be a little bit nationalist when our national team is playing. Sometimes football can even unify what seemed impossible to unify: the multi-ethnic or multi-national states like Belgium or Spain, where strong support for the national teams seems to overlap, momentarily, with the nationalist claims so many times catalysed by football (of which FC Barcelona is a paradigmatic case (Crolley and Duke 1996)). A football match allows the fulfilment of banal nationalism's crucial objective, the affirmation and celebration of a difference and its superiority through sporting victories. Football can easily be seen as war by other means.

Naturally, in a 'world of nations' a form of global culture like football which promotes the competition between nations is a privileged arena for the production and 'essentialisation' of images and discourses based in the ideas of success, triumph, honour or glory, always dealing with heroes, villains and characters, applied to the national dimension. Therefore, in a country like Portugal where it's impossible to turn on the television or go out without hearing something about football, it is perfectly reasonable to think that the way we watch and feel this game must say a lot about ourselves, about our society, and in this case about our national and cultural identity. Portugal's national sport and passion, the most usual topic of conversation, the top selling theme in the press and television (there are three daily sports newspapers, dealing almost exclusively with football, which are the top selling papers in the country) football is a subject that does not leave anyone indifferent.

The social representations of national identity

Hall and Du Gay (1996: 4) consider that identities are mainly connected to the way people use historical, discursive and cultural resources. So, attention must be invested in the social representations of identity, the 'narrativisation of the self'. The fictional character of this process does not affect its political and discursive effectiveness. Identities are produced in the discourse and it is important to understand this production in different historical and institutional contexts.

To achieve that objective I propose the introduction of the concept of social representation which allows the rejection of some essentialist concepts such as national psychology or character, in the study of national identity. Obviously, the social representations – discourses, images, metaphors – are only constructions, narratives about the way a group represents itself and the way they want to show themselves. But within these representations we can find the most significant features of a self-established identity. Moreover, these representations, not being 'real', have a powerful ability to structure what they say. Only a set of social representations about the things that join people as a

group – the past and the future to come – can explain the sense of sharing and communion that we can find in the people of a nation.

I believe the knowledge about the dominant social representations of Portuguese football can help us in the study of the way national identity is constructed and the imagined community of the Portuguese nation is reproduced.

Semiperipheral representations and border culture

How can we define, in a broad sense, the Portuguese self representations as a nation? Santos (1994) defends an analytical perspective in which the concept of semiperiphery is not confined to the field of social structures and positions in the world system but is also applied to the study of social representations. That is to say that maybe the 'semiperipheral' position of Portugal – on the southern edge of Europe, with a long history as a colonial power and strong links with the 'Third World' regions of southern Africa and South America – is more than political or economic and can characterise the representations of our identity construction. Portugal's semiperipheral condition in the world system involves not only an intermediate position but also an intermediary role, being a bridge – but also a wall – between the central and the peripheral countries (Santos 1994). In the Portuguese case, this condition was related to colonial power; Portugal was the last European country that gave up their colonies, after existing for decades as a developing country and a coloniser at the same time. The end of this situation didn't change the Portuguese semiperipheral condition, because it was already embodied in the nation's structures and mentalities (Santos 1994).

The Portuguese tend to always see themselves in the middle position. The discourses of nationhood, in Portugal, show the idea of a national character which is perfectly unique, a blend of positive and negative features that produce an ambiguous result. This narrative materialises what I define as the 'culture of the more or less'. There are two trends that affect representations of national identity, and still following Santos (1993), I would call them 'centre imagination' and 'periphery trauma'. They can be illustrated with two very common sayings in Portugal: first, 'we [Portuguese people] are as good or even better than the others [the foreigners]'; second, 'we are a Third World country'. The same person can use these two ideas in different moments depending on the situation or the mood.

Centre imagination is a concept that arose with European Community integration and can be illustrated with the idea that Portugal is a European country like any other. We are part of the centre, and we have to prove it, sharing the centre characteristics, statistics and even problems. Complementary to this, the periphery trauma is the fear of being peripheral, out of Europe, out of the occident.

This set of semiperipheral social representations shapes a kind of cultural

identity which Santos (1993) calls 'border culture'. Santos thinks that Portuguese cultural identity is mainly formal; it is the result of a culture without contents; it just has a form and that form is the border, the borderline zone. We know that national cultures, as substance, are a nineteenth century creation, the historical product of a tension between universalism and localism managed by the state. In that management the state has two functions: first, to differentiate the culture of the national territory towards the exterior, and second to promote cultural homogeneity inside the national territory. In Portugal this double process only happened partly due to state inefficiency, because Portuguese culture was never easy to differentiate from the others and at the same time it never showed a huge internal unity. This may be seen both as a good and a bad thing. Therefore, Portugal has experienced a deficit of identity in the national time and space frame, although in the local and the trans-national frame Portugal's identities are strong.

> In terms of national identity Portugal was never similar to the positive cultural identifications which were the case for other European cultures, and neither was different enough from the negative cultural identification which were the case for the others, the non-Europeans.
>
> (Santos 1993: 32)

During recent centuries, the Portuguese were the only Europeans who saw their colonial subjects as savages who were both primitive and exotic, yet at same time were being seen by other Europeans in a similar way. Therefore, Portugal saw itself in both mirrors, the civilised and the barbarian, the colonist and the colonised (especially by the English). One Portuguese writer, António José Saraiva, refers to a promiscuity between the 'me' and the 'other', a certain lack of cultural preconceptions, and a lack of a superiority complex which defines the occidental culture, in the Portuguese mentality (Santos 1993). Portuguese culture has that capacity to move between the local and the trans-national without stopping or locating in the national level and consequently the different cultural localisms say more about our culture than it does the so called national culture. The greater importance given to club football in Portugal in comparison to that given to the national team is a good example of this idea.

As I have mentioned, and as Santos argues (1993), the border culture is not a content but a form. It is not the American sense of border – the frontier, beyond which we can only imagine the vacuum – but instead a border where the vacuum is on our side. It is a hybrid zone where we are the European and the exotic, the centre and the periphery, the rich and the poor. This is a form that recreates itself easily, because it is a cosmopolitan one.

Cultural elements of 'border football'

As previously mentioned, some social representations that materialise as national identity assume a visible form in a particular way of playing, seeing and feeling football. In the Portuguese case this form can be analysed in reference to the concept of 'border culture'. So, what can be said about Portuguese imagery around the national team that can help us to develop our knowledge in terms of Portuguese national identity representations? The following categories are based on Christian Bromberger's works (1993; 1994), whose texts have always helped orientate and inspire my football research.

Meanings of history and tradition

Football has everything to do with winning and losing, being fulfilled or disappointed, and that is to say that our team, like us, is sometimes up and sometimes down. The way that fans perceive these moments are very important because the performance of the team is perceived as a representation of the value and relative position of the collective self image, as a brief look at the Portuguese national team will illustrate.

From the beginning the national team had great difficulties both in terms of organisation – playing the first match of its history before the existence of any league or cup in Portugal – and conflicts between the clubs in the selection of players. It was not surprising that Portugal lost its first match – against Spain in 1921 (3–1). In the early days, during the 1920s, Portugal played with Spain several times and lost most of them (the best result was a draw in 1928) which greatly disappointed the enthusiastic Portuguese fans, not least because Spain is Portugal's only neighbour and the country's great rival. It was a poor team with great support that took almost four years to win a single match (1–0, against Italy, in 1925).

During the 1930s, the Portuguese fans became even more accustomed to losing. Social instability influenced the national team organisation and the problems between club directors (especially between Porto and Lisbon) continued. As a result of this, Portugal only played eighteen matches in this decade, including the most humiliating defeat one can imagine: 9–0 to Spain in the 1934 World Cup qualification rounds. That produced a feeling of shame that entered the national imagination, songs and plays. However, at the same time it showed that something should be done to change the situation of Portuguese football and acted as a catalyst for the creation of the Portuguese National League competition in 1934–5.

Portugal eventually beat Spain in 1947, twenty years and sixteen matches after the first match between the two countries. That victory had a tremendous impact in Portugal and made people forget the past humiliations: for the first time people really felt proud of the national team. However, the worst was still to come: an incredible home defeat by England (10–0!), in the

recently inaugurated National Stadium in front of a crowd of 60,000 (including all of Salazar's fascist government) who watched astonished as the 'masters of football' (as the Portuguese press called the English) trashed the 'poor' Portuguese. Folklore says that Salazar ordered a secret police investigation to know if the Portuguese players showed a lack of commitment due to conflicts with the Portuguese Association in order to get higher match prizes.

The lack of confidence in the team continued in the 1950s as a consequence of bad performances and results. Until the end of this decade the history of the Portuguese national team was easy to summarise: one hundred and four matches, thirty-one victories, nineteen draws, fifty-eight defeats and Portugal had never qualified for a World Cup. That, of course, didn't help encourage support and attendance fell at the national team's matches, although the number of matches played increased a lot. However, disasters were always present: for example, in the qualification for the 1954 World Cup Portugal were defeated in Vienna, 9–1.

Benfica's success in the early 1960s – including a double European Champions Cup victory, and a brilliant group of players like Eusébio and Coluna – helped to radically change this state of affairs. It was a national squad developed around the Benfica team which participated very successfully in the 1966 World Cup (the first time Portugal qualified), finishing third, and only beaten by the English in the semi-finals. En route, the team beat Pelé's Brazil (3–1) and North Korea (5–3, after being 0–3 down) in the quarter finals. The latter of these two created a legend – Eusébio – and is still seen as the most brilliant moment of Portuguese football and its main national landmark. That 1966 team impressed the world and helped a dying Salazar's dictatorship to survive some more years leading to the Portuguese colonial wars in Angola and Mozambique. For the average Portuguese it was a kind of rare moment of glory and pride. The truth is that for the first time after a decade of poor results, Portugal had a positive outcome (Figure 9.1).

The hangover was terrible. The final years of the 1960s and all through the 1970s it was confirmed that 1966 had been an exception, and Eusébio had been an exceptional player. Portugal still won more than they lost but they failed to qualify for any major international tournament. The Portuguese Football Association and the national team organisation were very poor and conflicts in management didn't help. At the same time, the Portuguese Revolution (in 1974) created a deep chaos and redefinition of the country. Portuguese football became more and more based on club football and club interests were always considered more important than the national side – a priority shared by the supporters.

That situation continued in the 1980s, although Portugal reached the final stages of the 1984 European Championship in France and the 1986 World Cup in Mexico. But once again the chaotic organisation hampered success. In 1984, the final third place left a bitter taste because in the semi-final against France, Portugal were leading the French with just six minutes to go at end of

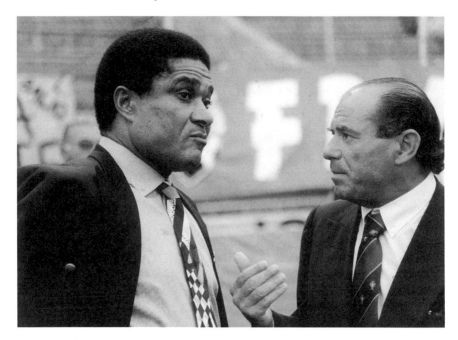

Figure 9.1 The first 'golden generation' of Portuguese internationals: Eusébio (left) and Antonio Simoes – two of the great stars of Portugal's team which came third in the World Cup in England in 1966

Source: Cristina Pinto.

extra-time, yet were defeated. In 1986, the players rose in rebellion against the Portuguese Football Federation complaining about the level of match bonuses. Such demands were considered intolerable by many Portuguese and the national team lost some of its support for many years.

More recent years have brought some fundamental changes to aspects of Portuguese football. Portugal raised a group of brilliant young players that won two Under-20 World Cups, with players like Rui Costa, Paulo Sousa, Vítor Baía, Fernando Couto, and Figo, all of whom are now playing abroad and are well known by fans all over Europe. Such players have a different mentality and have created great expectations amongst Portugal's fans, playing attractively, although the dominant club focus of football fandom in Portugal remained. As many sport journalists say in Portugal, the current national team deserves better support in several senses.

Table 9.1 shows the performance of the Portuguese national team. This rather poor national record, which includes few qualifications for major competitions – only twice for the World Cup finals and twice for the European Championships – has not helped to stimulate national support.

Table 9.1 Performance of the Portuguese national team

	Matches			
	Played	*Won*	*Drawn*	*Lost*
1921–30	25	7	5	13
1931–40	18	6	2	10
1941–50	21	7	6	12
1951–60	40	11	6	23
1961–70	55	24	10	21
1971–80	56	27	14	15
1981–90	73	32	16	25
1990–6	47	23	15	9
Total	339	137	74	128

Source: Sousa 1997.

Note: Does not include the Euro 96 event where Portugal were eliminated by the Czech
Republic in the Quarter-Finals

Furthermore, it is even more disappointing when one considers that the
perspective of Portuguese club football is much more positive and successful:
Benfica have been European Cup finalists eight times and even FC Porto –
1987 European and World Club Champions – and Sporting Lisbon have
enjoyed European success. Statistically, Portugal has three clubs in the
European top twenty.

Experience shows that fans like to watch their team playing in the greatest
European tournaments but they have become accustomed to choosing an
alternative national team to support in the final rounds of the big competi-
tions. As mentioned above, in football and in other areas of life, the
Portuguese suffer from a 'centre imagination' and a 'periphery trauma'.
Football victories over central or major (in football terms) European teams
have 'fed' the centre imagination. Defeats like the one against Morocco in the
1986 World Cup reflect the periphery trauma in all its colour. Moreover, in
this latter instance, Morocco qualified for the final rounds of this global
competition and Portugal went home.

We all know that a football match or competition can have a strong effect
on national self image (as has happened in England in recent years);
Portuguese history tells us that usually national team performances *kill* the
centre imagination and give the periphery trauma a new life. When that

happens fans tend to return to the safer (and winning) hands of FC Porto or Benfica.

The playing style

Football supporters identify themselves so intensely with their national football team and their club teams because that team is perceived, namely through its playing style, as a symbol of a specific mode of collective existence. The skills and tactics of football can be understood as lasting cultural traditions: they are not only sporting definitions, but also cultural ones (Archetti 1994). The cultural plasticity of football depends on this variety in the way the game is played and lived in different parts of the world.

Football playing styles in national terms are often seen as being connected to the so called 'national character' rather than other characteristics. So, playing style is seen as unique and essential to the country concerned. Often this is the way that fans and players like to be seen and to win is to impose a style – a way of life – on others and to prove one's superiority. We can say that a style is imagined in the same way that national identity is imagined, by the cultural and journalistic elite, through forms of banal nationalism. The style is the way we like to represent ourselves and to be seen by the relevant others. It is a sort of story we tell about the way we live together.

It is not surprising that the emergence of these football playing styles occurred in the thirties, the historical era of the nationalisation of the masses – the British style, the central European style and so on. I can remember growing up listening to people saying that Portuguese football was very nice, skilful, elegant, beautiful, cool, soft and gentle – you name it – but Portugal couldn't score and struggled to win. This inefficiency and incapacity to score, to make the final cut, has always been considered to be the reason for failure. There have been infinite discussions in the sports media about this and people still say Portuguese players are 'brinca na areia' or 'the ones who play football on the beach'.

The truth is that things are not so simple as the last few years have brought some changes in this matter. I would prefer to call the Portuguese football playing style 'border style', a mixture of talent and skill typical from Latin football – South American and European – with the creativity and improvisation of African football, although this does not always result in a successful crossing of styles!

In recent years the European influence has been growing (with more work on team formations, physical condition and defensive roles) and there have been some good results. This complex mixture can only be the result of a border culture, in the intersection of different cultures and styles, namely the African and Brazilian cultures, both historically deeply connected with Portugal. Some of the best ever Portuguese players were from Africa, such as Eusébio and Coluna (from Mozambique) or even today with Oceano, Helder

and Dimas. The blend of European and Atlantic styles could yet make Portugal not only an attractive playing side but also a very effective one, if organisational and structural problems were solved.

The players

Players represent an important part of the identity expressed by national teams because, as in other nations, in a country where almost all kids grow up playing football there is a great feeling of admiration towards those who reach the international level.

> If the team as a whole offers, across its style and composition, an expressive support to the affirmation of a collective identity, each player gains more or less favour amongst the public according to the specific qualities he brings to the game.
>
> (Bromberger 1993: 124)

I have already classified the Portuguese playing style as a border style based on players' different characteristics and cultural origins: some stand out for their creativity and talent, others for their physical energy and winning mentality. However, it is difficult to find a player that crosses all these qualities and only one player has reached immortality in Portuguese football: Eusébio. After him only Paulo Futre was in a similar mould, but he failed to make the same impact. Due to the characteristics of the current team, filled with very skilful players who form a brilliant mid-field, the Portuguese fans are still waiting for a special 'king of players', a real striker, as Eusébio was. The desire for something that is not present is known as a typical feature of Portuguese culture and it forms part of a national myth: the return of the saviour hero which we call 'Sebastianismo'. King Sebastião disappeared mysteriously after a battle against the Moors in the sixteenth century and legend has it that he is not dead but hiding or imprisoned and he can come back any day to save Portugal from their problems, and I must add, from the periphery.

Finally, the Portuguese players in international competitions sometimes suffer from both centre imagination and periphery trauma. These two 'illnesses' put too much pressure on the players and failures at the most important moments are common.

The supporters

Just as owners take on the characteristics of their pet dogs, football supporters can take on the characteristics of their teams. Brazilian teams can produce much of the most beautiful football and also have the most beautiful fans; Portuguese fans reflect the poor performance of their national team with a

pessimism which is also something of a national characteristic. As such, popular support for the national team was very low in the 1970s and 1980s.

The Under-20 team victories and the development of the new Portuguese national team have completely changed this scenario. The emergence of some great young players helped to create a different attitude amongst the fans. Confidence had been rising and the crucial match against the Irish Republic – when Portugal qualified for the Euro 96 Championship – was the greatest proof and can be seen as a turning point. Eighty thousand fans braved torrential rain, on 17 November 1995 and celebrated their qualification to Euro 96 – it felt really good for many Portuguese fans (Figure 9.2).

However, of one thing you can be sure: if you ask any committed football fan in Portugal (and the question is whether this is true elsewhere) which is their favourite team, the national or the club one, 99 per cent would laugh in your face.

Final remarks

This chapter represents work in progress and it is only the beginning of a reflection on national identity-construction in the case of Portuguese football. To ask how the imagined community is imagined, in everyday activities and subjects, is to ask about the symbolical reproduction of national identity. My aim is to do that in close relation to football.

Nevertheless, one knows that studying social identity-construction can be very problematic. We must be aware that identities are not rigid or permanent, they do change a lot, they are not something we possess and carry with us all the time. Being created and recreated continually, they are cultural mixtures, with ideological and political features, in transitory processes. The way state loyalty has been imposed over other social bonds since the last century is a very good example of this social construction of identities. Nation states are a product, a construction of the modernity project and the roots that are presented as foundations of an identity are selected from a vast range of possibilities. The question is always: why are some roots selected instead of others?

Today, globalisation of social life brings the emergence of new identities and cultural forms which were formerly submerged by national loyalty and I think Portuguese football is a good example of this. Just as the playing style of Portuguese football can be successful if well balanced in its different cultural features, the cultural border identity has great opportunities because it stands in a passage zone, a cosmopolitan and multicultural area where the constant and different fluidities are more intense. An open door on the border?

Portugal as a society must run away from the dangerous centre imagination – only concerned with constructing nationalist images – and must take advantage of our semiperipheral position and its multicultural possibilities, in life as in football.

Figure 9.2 The second 'golden generation' of Portuguese football: many of this young team who qualified for Euro 96 – pictured here before the qualifier against the Republic of Ireland – were members of the two–times Under–20 World Cup winning team

Source: Cristina Pinto.

Note: Top row, left to right: Vítor Baía (25), Fernando Couto (26), Oceano (32), Jorge Costa (23), Paulo Sousa (25), Rui Costa (23). Front row, left to right: Secretario (25), Paulinho Santos (24), Domingos (26), Folha (24), Figo (23).

Note

1 I would like to thank Adam and Sarah (in England) and Ricardo, Nuno and Berta (in Portugal) for all their help and friendship.

Bibliography

Anderson, B. (1983) *Imagined Communities*, London: Verso.

Archetti, E. (1994) 'Argentina and the World Cup: in search of national identity', in J. Sugden and A. Tomlinson (eds) *Hosts and Champions: Soccer Cultures, National Identities and the USA World Cup*, Aldershot: Arena/Ashgate.

Billig, M. (1995) *Banal Nationalism*, London: Sage.

Bromberger, C. (1993) 'Allez O.M., Forza Juve: The passion for football in Marseille and Turin', in S. Redhead (ed.) *The Passion and the Fashion*, Aldershot: Avebury.

—— (1994) 'Football passion and the World Cup: why so much sound and fury?', in J. Sugden and A. Tomlinson (eds) *Hosts and Champions: Soccer Cultures, National Identities and the USA World Cup*, Aldershot: Arena/Ashgate.

Crolley, L. and Duke, V. (1996) *Football, Nationality and the State*, London: Addison Wesley Longman.

Hall, S. and Du Gay, P. (eds) (1996) *Questions of Cultural Identity*, London: Sage.

Hobsbawm, E. (1992) *Nations and Nationalism Since 1780: Programme, Myth, Reality*, Cambridge: Cambridge University Press.

Santos, B.S. (1993) 'Modernidade, Identidade e a Cultura de Fronteira', *Revista Crítica de Ciências Sociais* 38: 11–37.

—— (1994) *Pela Mão de Alice, O Social e o Político na Pós-Modernidade*, Porto: Afrontamento.

Sousa, M. (1997) *História do Futebol, Origens, Nomes, Números e Factos*, Mem–Martins: Sporpress.

10

NATIONAL OBSESSIONS AND IDENTITIES IN FOOTBALL MATCH REPORTS

Liz Crolley, David Hand and Ralf Jeutter

Football match reports are one of the mainstays of the sports pages of both 'tabloids' and 'quality' newspapers across Europe. The present study constitutes the first attempts to analyse match reports in French, German and Spanish 'quality' dailies with a view to extracting themes which reflect national obsessions and identities. Some of these themes may be common to all three countries with, perhaps, some differences of perspective, while others may well be country-specific. The data were collected over a five month period, namely July–November 1995. It is envisaged that this study will form part of a larger piece of research investigating styles of football match reports.

The newspapers analysed were *Le Monde* and *Libération* in France, *Süddeustche Zeitung* in Germany and *El País* in Spain. *Le Monde*, founded in 1944, is a quality newspaper read generally by an educated élite, politically to the left of centre while *Libération* is a slightly more popular daily (although quite unlike the tabloid style of English popular press) born of the 1968 ideology of resistance. *El País* is a tabloid-sized quality daily Spanish newspaper, politically, traditionally to the left of centre and generally considered to bias Spain's PSOE socialist government which held power from 1982–96. The German newspaper examined is in political outlook a liberal to left-wing daily, comparable in England to the *Guardian*. It is, therefore, no surprise that the match reports are rife with political vocabulary originating in the 1960s. The tone of the reportage is consistently ironic and detached. It seems that in Germany football cannot yet be made part of a serious intellectual discourse. From the space which is given to match reports, it is clear that football is an important issue but nevertheless the writing is in the *as if* mode – as if football is not important – although it can safely be assumed that neither for the writers nor for the readers is football the least important matter in their life.

Blain and O'Donnell (1997) have noted the unique nature of the tabloid press in Britain, and especially in England, and suggest that the 'quality' dailies

of continental Europe fall into a different category. However, is this division between Europe and the UK so clear-cut? Is it not possible that football in France, Germany and Spain is presented as being an extension of society? By analysing how national obsessions and identities are reflected in the metaphors and imagery used in French, German and Spanish football match reports, we might discover that football is more than self-referent and more than a sign of society. The way in which football reports are constructed in the newspapers under consideration tells us something about society and this is true in all three countries studied here. Could it be, then, that the real differences between the UK and continental Europe regarding the relationship between football and society are rather ones of style and degree?

It is this very relationship between football and society which becomes clear when analysing the use of imagery and metaphor in match reports. In the broadest sense, imagery may be seen as a linguistic device which suggests mental pictures through vivid descriptions while a metaphor, itself an image, implies an analogy or close comparison between two objects that are not normally treated as if they had anything in common. Obvious, clichéd metaphors have been largely avoided in the analysis and for the purposes of this research more imaginative metaphors and imagery are examined. It is important to emphasise that it is the researchers' own reading and interpretation of reports that is outlined. The readings are, therefore, unashamedly subjective and open to further comment and interpretation. It is difficult to make clear links between football writing and fandom, but there appear to be several occasions where cultural or political references apparent in the data are reflected in the behaviour of football fans in the countries concerned. These connections are highlighted later on.

Taking a thematic approach, topics such as war, money/business and religion are to be found in football match reports in all countries, although interestingly they can be employed in a slightly different way in each and thus reflect the way in which these themes are perceived in each country. The countries' individual national identities or obsessions are also mirrored in the choice and variety of images such as health (in France), political vocabulary of the 1960s (in Germany) and bullfighting (in Spain).

Among the most central themes in many match reports is that of war. Images of war can be as clichéd as the midfield 'pocket battleship' but not as extreme as some of the reports which appeared in the English tabloids during Euro 96, typified by the *Daily Mirror*'s headline 'Achtung! Surrender' (24 June 1996) whose obvious and vivid metaphor received widespread criticism. One of France's national obsessions is its military past and France has had, of course, a long history of military victories and defeats, perhaps the longest of all European nations dating, as it does, back to the ninth century. The imagery of warfare in football match reports is probably most apparent when French teams play foreign ones either in club or international competitions. The French are still haunted, for instance, by their defeat in May 1940 at the hands

of the Germans, the obsession being with the strength of the German 'Blitzkrieg', its efficiency, and, above all, its sheer speed, characteristics which might be considered part of a wider German identity as perceived by the French. Interestingly, then, when Bordeaux played the German outfit Karlsruhe on their way to the 1996 UEFA Cup Final, the military imagery of the match report centred on the Germans' qualities in occupying key areas of the battlefield and 'the frightening speed' of their attacks (*Libération* 9 August 1995).

Similarly, the last time Great Britain and France were at war (with each other, that is) was Waterloo in 1815 marking the end of the Napoleonic wars which were, of course, wars still fought with canon and muskets. This very imagery of early nineteenth century warfare crept into the match report of the 1995 UEFA Cup match between the future double winners of that season, Auxerre, and England's Nottingham Forest. This match was described by the journalist as a real battle in which one could 'smell the powder' and see 'the canon fire' (*Libération* 18 October 1995).

Again, when the French national team beat Romania in a Euro 96 qualifier away in Bucharest, the line-up was described in the match report as 'closed ranks' resisting the Romanian attacks led by their star 'swordsman' Hagi in a successful attempt to defend their 'fort'. At the very end of the game, leading 1–2, victory was assured, we note, when 'the French guard had no need to retreat' but, on the contrary, advanced to score a third goal (*Libération* 12 October 1995).

As a final example, we may quote the remarkably subtle and finely tuned military imagery used to describe the encounter between France and Poland in another Euro 96 qualifying match. In a military sense, the Poles are remembered historically in France as being great cavalrymen in the early nineteenth century. This imagery from the French collective unconscious resurfaced in the report of the match in question in which there are references to 'the attacks of the light horsemen' and 'the sabre strikes' of the Polish forwards (*Libération* 17 August 1995).

In common with the French (and English) match reports, military imagery has a strong presence in Spanish football writing. Unlike in France, the images and metaphors are frequently less specific and more general in nature, although they do have some characteristics particular to Spain. Many are almost clichés in nature: 'Oviedo used all their ammunition' (*El País* 27 November 1995); 'Atlético de Madrid have the spirit of a warrior' (*El País* 2 October 1995); 'Sevilla bombed the area' (*El País* 27 November 1995); 'Real Sociedad lacked the imagination necessary to kill off a wounded side' (*El País* 2 October 1995).

It is indeed startling to note the number of references to 'reconquests' (seventeen in this period alone) compared to the relatively few references to 'conquests' (just three). Many writers refer to a fight-back as a 'reconquest'. The reconquest of the territory of Spain by the Christians from the Moors in

the fifteenth century is, of course, one of the most important aspects of Spain's history and the unity of Spain as an administrative and political entity dates back to this period. It is not surprising, therefore, in a forum which seems to reflect national identities to encounter images and metaphors relating to this period: 'The Atlético reconquest began . . . and de la Peña was injured' (*El País* 27 November 1995).

As well as these rather obvious images and metaphors, others can be imaginative and highly developed. After a dirty match in which six players were booked in midfield, one writer reported that, 'Sevilla and Atlético de Madrid decided to fight in unoccupied territory [i.e. in midfield] and the match ended up without a victor. The result was a battle with many injured [booked] but surprisingly no fatalities [sendings-off]' (*El País* 2 October 1995). Another journalist continues the elaborate metaphor throughout the report:

> A brave team turned up. Betis took risks but Tenerife escaped bare-chested [with little with which to defend themselves]. They didn't notice the fact that Alfonso was secretly stalking them. He took on Llorente with all his ammunition and then all that was needed was a cross towards the unprotected stakes . . . Felipe managed to clear to a trouble-free zone and from there began to organise the ranks . . . Pizzi meanwhile loaded his arms and released the gunpowder shortly afterwards.
>
> (*El País* 6 November 1995)

The notion of an army needing direction and leadership is a recurring theme in Spanish match reports. In this respect the Spanish football reports are unique in the collection. Unlike in France, Germany and England where football teams are more likely to be compared to an army when they are organised and disciplined, in Spain teams are consistently referred to in militaristic terms when they are disorganised or lack leadership. This might appear surprising given the common association between army and strict organisation/discipline, but it serves to provide an insight into the Spanish perception of their armed forces, 60 per cent of which are youths (usually reluctantly) carrying out their military service. It reflects too the legacy of the Spanish Civil War in which both sides, the defeated Republicans and the victorious Nationalists, consisted of volunteers with little or no experience. Anyone who has seen the film *Land and Freedom* directed by Ken Loach or has read George Orwell's *Homage to Catalonia* can imagine how poorly organised these troops were. The following passage serves to illustrate how these perceptions of 'an army' remain today. In the report of a match between Mérida and Real Sociedad:

The manager opted to simulate a Revolution . . . , he made many changes and ended up with a disorganised army with no intelligence service and with too many troops. The battle was a formality [at this point the metaphor switches], a collision between two steam-trains chugging along a track [it then switches back to the war imagery]. In two aerial attacks Mérida conquered Real Sociedad.

(*El País* 16 October 1995)

So unlike the militaristic characteristics of football writing in France, Spain's national obsession with war is more specifically related (although never directly referred to as such) to the Spanish Civil War.

To move on to the second theme, politics, specific references are very common in German match reports. Political metaphors relevant to the 1960s noted in the sample include reference to the 'long march' (*Süddeustche Zeitung* 27 November 1995), clearly a reference to the long march of the Communist Revolution in China, but also an allusion to the political strategy of those who became disillusioned with direct political action and who did not want to go the way of the terrorists. The football world in Germany can be divided into left-wing and right-wing. The Hamburg team St Pauli, for example, is perceived to be a left-wing team. Its left-wing/anarchist image has been adopted by its fans and this is reflected both in Fan Projects and in the fanzines of St Pauli fans. The St Pauli manager himself is on record as saying, 'I don't think German society offers a very fertile soil for a revolution at the moment' (*Süddeustche Zeitung* 27 November 1995). On the other hand, Hansa Rostsock (former GDR) is seen to have strong right-wing support.

A difference can be made between the ideological fundamentalists and the pragmatists like in the debates within the Green Party. A crisis meeting of the Bayern Munich presidial committee, for instance, is compared to a 1960s commune (*Süddeustche Zeitung* 27 November 1995) whereby the main points of discussion are who will do the washing up, who the cleaning, etc. The range of tactics employed in the Bundesliga is conveyed using a famous formula, 'The new confusion' (*Süddeustche Zeitung* 20 November 1995), coined by the most eminent post-Adorno sociologist and philosopher Jürgen Habermast, who applied this catch-phrase to the confusing range of ideologies available in the post modern philosophical shops. One journalist detects 'cultural pessimism' (*Süddeustche Zeitung* 27 November 1995) in the statement of one of the managers, a turn of phrase which invokes an intellectual debate dating back to early nineteenth century Germany and which became virulent again in the 1960s. Those who were accused of 'cultural pessimism' were those politically suspect people who did not share the revolutionary optimism of so many of the students' generation.

The question has to be posed why German football match reports are so steeped in this kind of vocabulary, a marriage which is slightly mismatched it would seem at first glance. In the more cynical 1980s and less ideological

1990s, this sort of serious political discourse has lost a lot of its credibility. If at all, it can only be used tongue in cheek or with distancing devices like irony and since intellectual German writing cannot bring itself to write seriously about football, the employment of this sort of vocabulary is not an ineffective way of showing a little haughtiness, while at the same time allowing journalists to invest football with the ingredients of (although only mock) political discourse, reminiscent of the 'transcontextualisation' of football and political terminology found in Italy (Duke and Crolley 1996). Again, the political discourse is sometimes transferred into the behaviour and symbolism within football fan culture, a culture in which political allegiances and identification with a football club can coexist and one cannot always be considered to the exclusion of the other.

From the political vocabulary of the 1960s in Germany, we come right up to date with a look at the vocabulary of the 1990s in France. The Thatcher revolution successfully crossed the English Channel in the mid 1980s with the result that, in France now as in many other countries, whereas business used to be a part of life, life – and football with it – is now a business. It comes as no surprise, then, to read French football match reports in which the activities of the players on the pitch are described using commercial language and discourse. Possession of the ball, for instance, can be seen as 'a monopoly' (*Libération* 30 August 1995). Similarly, one team quickly becomes 'the boss on the park' (*Libération* 28 October 1995) (although this is such a widely used phrase in English and, probably, in French as to qualify as a cliché). A whole team in French match reports is often described as 'enterprising' (*Le Monde* 4 November 1995) or 'workmanlike' (ibid.). The players involved may be 'trainees' (*Le Monde* 2 November 1995) or, on the other hand, 'a consortium' (*Le Monde* 20 October 1995) while a key element of business transactions, the contract, is a constantly recurring item in the lexis of French football match reports: to quote a single example, when France beat Israel to clinch a place in the finals of Euro 96, the report stated that 'the contract [had been] duly fulfilled' (*Le Monde* 17 November 1995).

Again, failure on the pitch is often conveyed in the French press by the vocabulary of failure in business as demonstrated by the example of France's 1–1 'defeat' against Poland in a Euro 96 qualifier being described as 'bankruptcy' (*Le Monde* 18 August 1995). Finally, a French team doing well in Europe, Lens (but ultimately not quite as well as Paris Saint Germain who went on to win the 1996 Cup Winners' Cup) was said in one match report to be 'pursuing its European career' (*Le Monde* 3 November 1995). It is possible that the practice of leaving business cards by some fans, such as Paris Saint Germain, in the late 1980s (Broussard 1990: 171) could be interpreted as an extension of this business theme into football fandom, although it is more probable that this custom was an imitation of English football fan culture and the habit of hooligan groups leaving 'calling cards' with their victims. In time, it will be interesting to see whether or not the number of references to the

business world increases given the continued rise in commercialism of football in France and indeed across Europe.

As with France, when we talk about national obsessions in Germany, surely one of the main topics will always be matters relating to money, because Germany shaped its post-war identity on the basis of economic strength. On the other hand, the Germans do have a very strong idealistic streak in their character, as displayed in their history and cultural and philosophical endeavours. Immediately after 1945, football became an area where this brand of idealism could find expression. All those values which were corrupted under Nazi rule could now, albeit only temporarily, find a home in the football arena. Unselfishness, cooperation, service to the nation, were then concepts very much in vogue, conveniently disguising the opposite impulses in German society and also underplaying the political implications of such 'disinterested love' for football. The endemic employment of metaphors stemming from the world of business suggests great disappointment and consequently a cynical approach to the game.

One of the most repeated topics in the football match reports of the *Süddeutsche Zeitung* is the way individual footballers use their skills purely for self-marketing purposes. It is no surprise, then, that so many metaphors can be found relating to the business world. The football club is a 'firm', the footballers the 'employees' or the 'salaried employees' and the manager the 'head of department' or a 'leading employee'. A lost away game is a 'sad company outing'; a footballer can be a 'kicking entrepreneur'; 'damages' are part of 'the salary'; a manager or player can suffer from what the Germans call *Betriebsblindheit*, being blind to the shortcomings of one's own company. A football match is a 'Saturday shift' which takes place on a 'working day'. Success in sport is a 'lubricant for successful business transactions'. The audience is the 'customer', either angry or happy, depending on the quality of the match. One journalist talks about the 'green economic miracle lawns', referring back to the 1950s and early 1960s when Germany's rise to economic superstardom started. The whole of the football experience is summed up in the words 'football adventure park' and a player, when injured or sick, has to hand in what the Germans so beautifully call a '*Arbeitsunfahigkeits-bescheinigung*', a sick-note, like any other employee in the world of business. (*Süddeustche Zeitung* 13 November 1995; 25 September 1995; and 6 November 1995)

In Spain too, the football world is described in terms of the world of work. Football clubs have become businesses (literally as well as metaphorically – in 1992 all Spain's professional football clubs became *Sociedades Anónimas*, or public limited companies). Hence, the labelling of a club as a 'company' and its supporters as 'shareholders' is no longer, strictly speaking, solely metaphorical. Nevertheless, in the last few years in particular there has been a rise in the use of metaphors which describe footballers as 'workers', and refer to their 'earning a living'. No longer are they idols who play football to represent the

people. They do it for money and are described in these terms. However, the Spanish case differs from the French and German in its specificity. When Spanish footballers circulate in the world of work they are civil servants ('*funcionarios*'). It is when they are performing without passion that these images are portrayed. This theme is intensely Spanish. Spanish society is riddled with bureaucracy and the legacy lingers of the image of the de-motivated civil servant whose position, secure for life, was obtained as a reward for services to the Franco Regime.

Teams or players who are accused of going through the motions, playing without passion, for the money, are, then, often compared to '*funcionarios*'.

> Spain formalised their documentation to go to England [for the 1996 European Championships]. It was a task performed without passion, carried out in a civil servant-like style which was, of course, poor because of absenteeism [another accusation customarily directed at civil servants relevant here as players were being accused of preferring to play for their club and pulling out of the national team].
>
> (*El País* 22 October 1996)

On a more personal level, individual players are accused: 'Julén Guerrero passes the ball with the deference of a post office worker [a civil servant in Spain]: he wraps the parcel, ties it, seals it and sends it with the vacant expression of a bureaucrat' (*El País* 2 November 1995).

Next, an example of a field of metaphor specific to one country observed in the data is that of the cult of the leader, or even messianic vocabulary which, for obvious reasons one might think, is either very much in use or totally absent in Germany's football reportage. The Germans, it seems, cannot get rid of their obsession with leader figures. German footballers are not just geniuses on the field, role models for youngsters or cultural icons, they are equipped with more power than that: They are called 'the Emperor' (Kaiser Franz), and the leading literary critic 'the Pope'. The *Süddeutsche Zeitung* follows this pattern but, as always, ironically.

Another important field of metaphors is, therefore, the messianic one, where the cult of the leader merges with religious under – or even overtones. About Matthäus, for instance, one journalist writes that 'media disciples gathered in feverish expectation in order to give birth to the new Messiah out of their sweaty, steaming midst' (*Süddeustche Zeitung* 20 November 1995). He is, then, seen as the 'redeemer and Saviour'. Other less religiously-imbued metaphors are linked with the leader figure, be it that a football team is compared to an 'orchestra without a conductor' or that there are no 'chiefs around, only Indians' (*Süddeustche Zeitung* 25 September 1995). Finally, another journalist reminds the readers that 'one needs a pilot to fly a plane – flight attendants alone are not enough' (*Süddeustche Zeitung* 25 September 1995).

180

Of course, it is neither unusual nor imaginative for match reports to contain references to idolatry; players are 'idolised' or 'worshipped' everywhere. What is interesting is the way in which it is exploited in each country. The importance of religious metaphor is by no means unique to any one country but it seems to have a particularly heavy presence in Spain, a traditionally Catholic country. Importantly, it is not just religious metaphor, but more specifically Catholic imagery that is portrayed (via reference, for example, to candles, saints, purgatory). Liverpool striker Robbie Fowler's nickname of 'God' found a parallel when Bebeto of Deportivo La Coruña scored five goals in one game against Albacete: 'Five goals in one game sanctify a player for a long time' (*El País* 2 October 1995).

One or two examples will suffice to illustrate how religious imagery and metaphor go beyond the cliché in Spanish match reports. After Espanyol failed to score in four consecutive home games, the writer takes the religious theme to its ultimate conclusion. 'The older fans maintained the blind faith of the enlightened . . . the crowd unafraid, in communion with their team. Then the goal arrived, and with it ecstasy [the state of the soul when in mystical communion with God]' (*El País* 2 October 1995). Mixing religious and literary metaphors, 'From his pulpit Cruyff watched a sketch from his latest great masterpiece' (*El País* 6 November 1995).

Significantly in Spanish football match reports, not all religious metaphors conjure positive images. 'The eighteenth league fixture saw Atlético de Madrid return to the top of the table and two innocent victims sent to purgatory' (*El País* 27 November 1995). It is important to note that this fixture took place in November, hence the two teams concerned were only relegated to purgatory and not to hell – there is still time for them to get out after they have suffered for a while!

Again, religious metaphors are used to depict a team in difficulty: 'Sevilla's mission was to run and run . . . with their cross on their back . . . but they played flowery football. They lit a candle for Unzúe [Sevilla's goalkeeper] who kept it burning' (*El País* 16 September 1995). The image of the candle burning, a tradition of the Catholic church, is an unexpectedly frequent one in football match reports in Spain. Such heavy reliance on religious imagery serves to perpetuate the national stereotype of Spain as a strongly Catholic country.

Turning to France, one of the big issues which is reflected in the match reports is that of health care. France, as a nation, spends twice as much of its GDP on health care than Great Britain – a country with a similar population and economy – and the average French household spends seven times as much of its disposable income on health care than the average British one (INSEE 1992). The importance of health and social security to the French people was also underlined for all to see when they took to the streets in their hundreds of thousands in November and December 1995 to protest against proposed government reforms to the system.

According to our theory of national obsessions translating into journalists' reports on the national game, there are many examples of health and body imagery at work in the French reports studied. Teams not performing well, for instance, are often described using the word '*fébrile*', that is, 'nervous' or 'feverish' (*Libération* 16 October 1995). Similarly, the act of key players leaving a club leading to a downturn in performance on the field is described in one report as 'a haemorrhage' (*Le Monde* 2 November 1995): the outpouring of vital body fluid. Again, Nantes were French champions in 1995 but they made a bad start to the 1995–6 season which led to the team being described (retrospectively) in one report as 'apparently dead, deprived of its vital organs following the departures of Christian Karembeu and Patrice Loko', two key French internationals (*Le Monde* 24 November 1995). When their performances improved, though, Nantes were portrayed as a team which had 'finished its convalescence and been cured' (*Le Monde* 20 October 1995). Conversely, a team whose poor performance had ultimately cost them their place in the first division, Guegnon, was often portrayed as 'sick' (*Libération* 6 November 1995) while a team with absolutely no hope at all of survival in the top flight who will, to spare their blushes, remain anonymous, was described as just plain 'dead' (*Le Monde* 24 November 1995), an absence of success on the field being conveyed in terms of a total absence of good health.

Continuing with the themes common in France, the French awareness of their country being a nation of artistic expression, music and literature is probably just as strong today as it has been through the centuries. If football is truly to be seen in France as a sign of society or even as an extension of society (Blain and O'Donnell 1997), then the vocabulary used in match reports will surely reflect this particular national obsession. To take literature as the first example, on numerous occasions images of and references to literature are employed. Goal scorers are often referred to as 'authors' as was the case with Bancarel ('*auteur des deux buts*'), the Bordeaux striker whose two goals knocked the Macedonians Skopje out of the UEFA Cup, while their team-mates at the other end of the pitch, the goalkeepers, frequently become 'authors of great saves' as did, in the same report, Bordeaux's Huard against Volgograd (*Libération* 1 November 1995). Similarly, an entire team's efforts, good or bad, may be conveyed in literary terms as the example of Paris Saint Germain's disappointing showing in the league against En Avant de Guingamp demonstrates: their futile attempts to score were 'an anthology of missed opportunities' (*Le Monde* 28 July 1995).

A slightly different mechanism is at work in those match reports employing literary and artistic references rather than metaphors to describe activities on the field of play which, of course, raises interesting questions concerning the nature of the readership of such reports. A large part of the readership of *Le Monde*, for instance, is drawn from the teaching profession and student body which contrasts sharply with the perceived readership of some of the English tabloids. Two examples of references appealing to the

educated elite in France will suffice. First, the national team's coach, Aimé Jacquet, once had his attempts to control his players' performances compared with Mary Shelley's best-know literary character via the following simile: 'Like Doctor Frankenstein and his creation, the coach knows he is not in total control of the machine he has worked so hard to build' (*Le Monde* 17 November 1995). The other example refers not to nineteenth century English literature but to nineteenth century French art: The Nantes players who held on so desperately to earn a 2–2 away draw in the Champions' League against Panathanaikos of Greece were described as heroic sailors, cast adrift in terrible circumstances, whose team spirit saw them through to survival just like '*les rescapés de la Méduse*' (*Le Monde* 24 November 1995), the survivors of the shipwrecked vessel, the Medusa, who lived on a makeshift raft for weeks before being rescued and whose torment was immortalised in Géricault's 1824 painting 'The Raft of the Medusa' now on display in the Louvre.

There are also themes specific to Spain which reflect interests, identity or obsessions; indeed some of these help to create or at least perpetuate the national stereotype. Teams playing in a lethargic manner are customarily accused of having a '*siesta*'. The atmosphere in grounds too during hot weather is described as siesta time. 'Too hot, too sunny. It was a good siesta. Sevilla and Atlético de Madrid made a toast to the sun during the second half. In fact, there was no bull' (*El País* 9 October 1995).

This last example makes reference to that other symbol of Spain, bull-fighting. Borrowing of metaphors and imagery is frequent and invariably in the direction from bullfighting to football. An article in *El País* (23 June 1988) made the point that there are few metaphors taken in the opposite direction. The match is commonly referred to as *la corrida* (the bullfight) and in the above example where the players were so lethargic in the sun, 'there was no bull', that is, there was no match at all. A player who scores the winning goal is the *matador* (the one who eventually kills the bull). The one producing an outstanding performance might be called a *torero* (a bullfighter). This metaphor is reflected in the behaviour of football fans in Spain. It is not unusual for fans in a football ground to chant *torero* to a player who has just demonstrated exceptional skills as they would to a bullfighter carrying off a particularly impressive move. Similarly, they might wave white handkerchiefs as an expression of deep emotion.

Other images and metaphors reflect the identities of the regions or nations that make up the politico-administrative unit of Spain. León Solís (1996) examined the ways in which several Spanish newspapers reported on their national team in the 1994 World Cup Finals. He illustrates how football is reported as 'an allegory of centre-periphery tensions and the team manager, the players and even the national anthem can often become metaphors for social, political and cultural cleavage'. Unsurprisingly, different patterns emerged within the coverage of each newspaper according to their political

leanings. *El País*, the daily chosen for the purposes of this analysis, displayed what León Solís refers to as '*discurso diferencial*', that is, a style of discourse that highlights the differences between nations/regions within the Spanish politico-administrative territory rather than the unitary or disjunctive (separatist) styles of discourse reflected in other newspapers (namely *ABC* representing the former and *Deia/Avui*, Basque and Catalan dailies respectively representing the latter).

The images and metaphors conjured up in *El País* follow in the vein of León Solís' study in that they tend to reflect the regional/national stereotypes. Catalans are traditionally considered to be a hard-working population. FC Barcelona is a 'machine' which keeps going. Sevilla are described in terms of flowers – they play 'flowery football'. The stereotype of Andalucía, of which Sevilla is the capital, is one of flowers, colour and vibrancy. It is no surprise, therefore, that their team is described with such metaphors. Football is thus reported in terms which reflect it as being an extension of society.

To conclude, we have seen that the imagery and metaphors used in our sample of French, German and Spanish football match reports are diverse, inventive and imaginative. Some of the themes evoked by them are common to all three of the countries concerned (war, business) but, perhaps, with differences of tone or referent while others are clearly country-specific (health in France, Messianism in Germany, geopolitics in Spain). In all cases, though, we contend that our initial findings suggest that football may, in mainland Europe, be more than simply a sign of society; football is reflected by the French, German and Spanish match reports studied as an extension of society in that so many of the images and metaphors used to describe it derive from French, German and Spanish constructions of collective identity. Clearly, the vocabulary and style (not to mention the readers) of our continental match reports cannot be said to be comparable to those employed by British tabloids reporting on football. However, we would stress that this difference between British tabloids, on the one hand, and French, German and Spanish quality dailies on the other is primarily one of style and, perhaps, degree but not necessarily one of typology in terms of the relationship between football and society as mediated by the press. In short, when we read a football match report in *Le Monde*, *Libération*, *Süddeutsche Zietung*, or *El País*, we are highly likely to encounter imaginative and adventurous (re)constructions of French, German and Spanish obsessions which, themselves, are rooted in French, German or Spanish perceptions of their own collective national identity.

Bibliography

Blain, N. and O'Donnell, H. (1997) 'Living without the sun: European sports journalism and its readers', in M. Roche (ed.) *Sport, Popular Culture and Identity*, Aachen: Meyer and Meyer.

Broussard, P. (1990) *Génération Supporter*, Paris: Laffont.

Duke, V. and Crolley, L. (1996) *Football, Nationality and the State*, London: Addison Wesley Longman.

INSEE (1992), *Tableaux de l'économie française*, Paris: INSEE.

León Solís, F. (1996) 'El Juego de las nacionalidades', in *International Journal of Iberian Studies* 9, 1: 28–45.

Part IV

FOOTBALL IN BRITAIN –
THE 'NATIONAL' SPORT?

11

SCOTTISH FANS, NOT ENGLISH HOOLIGANS!

Scots, Scottishness and Scottish football[1]

Gerry P.T. Finn and Richard Giulianotti

Scotland, England and football

Scotland has one of the world's oldest footballing traditions. This sporting history owes much to Scotland's complex relationship to England, whether in Unionist fraternity, cultural rivalry or nationalist animosity. Imitation of England was behind the early organisation of Scottish football and the administration of its affairs (Rafferty 1975), in a process that was then thought to strengthen the British nation and the union. For a nation of only five million inhabitants, Scotland still exercises a disproportionate power within football, through officials like UEFA's Technical Director (Andy Roxburgh), the Vice President of FIFA (David Will), and the Chairman of UEFA's Stadium Committee (Ernie Walker). Scotland also has one of eight seats on the International Football Association Board, a legacy of its links with England and the British role in the early evolution of football.[2]

On the park, Scottish players have shown a greater sense of their cultural subsidiarity. They instructed English neighbours in the aesthetics and benefits of the 'passing' game, and helped export and teach the game overseas (Forsyth 1990). Scotland is the only nation to compete and qualify for the World Cup Finals on five consecutive occasions (1974–90). In the European Championships Scotland has been much less successful, having previously qualified only for the 1992 finals in Sweden. Qualification for Euro 96 was achieved only through the tournament's expansion to accommodate sixteen rather than eight teams. Euro 96 also provided several other new departures for Scottish football. It was the first time Scotland had participated in a major international tournament held in England. Although Scotland also played Holland and Switzerland (in Birmingham) as part of its Group D matches, Scottish supporters were mainly focused on the match at Wembley against England, the first against the 'Auld Enemy' since 1989. According to the

189

traditions of Scotland's football culture, the match against England furnishes players and supporters alike with the greatest anticipation and highest levels of adrenaline. The curious ambivalence, sometimes downright hostility, of Scotland towards England is so culturally and historically embedded as to lend credence to the argument that this truly represents world football's most intense 'derby match' at any level – civic, national or international.

Fan styles: social identities and culture

Recently, international football identities have been located in heavily contrasting styles: the 'carnival' and 'hooligan' styles of support. 'Carnival' supporters display sociable, indeed gregarious, behaviour that is best described as boisterous. Although carnival behaviour is strongly associated with alcohol use, it remains decidedly non-violent. Qualifiers for Euro 96 with supporter groups falling into this category included Scotland's 'Tartan Army', the Dutch 'Oranji', and the Danish 'Roligans' (Giulianotti 1991; 1995a; Peitersen 1991; cf. van den Brug 1994; Andersson and Radmann, this volume). 'Hooligan' supporters engage in competitive violence with other fan groups. Usually a 'moral code' is claimed by these supporters, who say they target their violence only on similar groups of opposing fans (Allan 1989: 23; Finn 1994b: 114). Germany, Holland and Scotland each have a hooligan contingent that can appear among their fans, particularly when opposing teams are thought to possess a comparable grouping.

The carnival and hooligan categories have heuristic and self-identifying value. They are important analytical categories for examining the cultural structures of the Scottish fans' activities. The carnival–hooligan differentiation also provides a consciously nurtured resource through which these supporters develop and publicly sustain their distinctive social identities. The appearance of Scotland and Holland in both carnival and hooligan categories indicates how this binary opposition of fan categories can be crudely manufactured. For example, previous research with the Tartan Army has shown that in certain circumstances the apparently opposed categories of carnival and hooligan can be submerged within a common Scottish social identity (Giulianotti 1991; 1995a).

Social identities are complex, incorporating multiple dimensions. Different facets of an individual's social identity can be made more or less salient as a result of different forms of social exchange, and this can produce quite different forms of behaviour. In some instances the identity may remain at the personal level and not be group oriented, so inter-group behaviour would not be expected. However, if the inter-group dimension is made situationally dominant, the ensuing exchange will involve participants' respective social identities.

The social dynamics of an inter-group exchange are strongly influenced by the pre-existing relationship between the social identities involved. Even when social actors have mutually opposed categories of social identity, antago-

nistic inter-group behaviour does not have to take place. The 'opposing' groups may, for example, share another social identity. Clearly, the behaviour that then ensues will strongly depend on which aspect of inter-group differentiation is made most salient. In the case of Scotland's supporters, rival club identities are largely submerged within a crossed and common Scottish identity, which adopts a carnivalesque pattern of behaviour as its group norm. However, the social identity of Scottish fans is complicated by the existence of other, earlier variants of Scotland fan behaviour (which are more easily associated with 'hooligan' behaviour). The interpretation and evaluation of Scottish fan behaviour is given greater complexity by the continuing uncertainty over how they should respond, and how they will respond, when they are confronted by 'hooligan' international fans, particularly those from England. For some years this uncertainty has provided an undercurrent of unease that occasionally appears in statements from Scottish officials or the Scottish media.

To understand the enactment and interplay of Scottish supporter identities, it is necessary to look in greater detail at how the carnival and hooligan identities are engendered by Scottish fans. Carnival fans are typically presented by the media and football authorities as 'ambassadors' for the game. Their public persona of gregariousness and friendliness represents good publicity for tournament organisers and football as a sport. The Scottish 'Tartan Army' has acquired an international reputation as carnival fans *par excellence*. In part, this fan identity has a long cultural history in Scotland, being rooted in the popular Scottish working-class carnival that has surrounded events such as seaside holiday outings or Hogmanay gatherings. Behaviourally, carnivals are characterised by an abandonment to hedonistic excesses, and the psycho-social *jouissance* of eating, drinking, singing, joking, swearing, wearing of stylised attire and costumes, engaging in elaborate social interplay, enjoying sexual activity, etc. (Hall 1993: 6, on Bakhtin). Modern carnival tends to be comparatively circumscribed, in being permitted to occur only within specific times and places (Eco 1984: 6). However, since by definition the carnivalesque involves the turning upside-down of hierarchical orders, in which bourgeois senses of propriety may be symbolically or physically assaulted, there is always the danger for those in authority that the carnival might become unruly or 'get out of hand'.

Like Irish fans, through the extension of this carnivalesque to football, Scotland's Tartan Army have self-consciously developed and presented a positive Scottish persona when abroad (see Giulianotti 1996a; 1996b). At Italia '90, over 20,000 Scots attended the three group matches in Genoa and Turin, and developed a 'mutual appreciation society' with the local Italians. In Genoa, Scotland fans broke the Ferraris Stadium's decibel record at the match against Sweden. Even more remarkably, while on the park the Scottish team behaved very aggressively to the Swedes, off the park Scottish and Swedish fans behaved like reunited long lost friends (Finn 1994b; Giulianotti 1991). At

Euro '92, 5,000 Scottish fans were awarded the 'Fair Play Award' for their behaviour by UEFA (Giulianotti 1994a; 1995a).

The Swedish campaign was a key moment in the image-reconstruction of Scottish football supporters. The Tartan Army have made deliberate efforts to 'behave' at fixtures outside Britain since 1981. A positive impression is manufactured by the fans for other nationalities, through social rituals with a truly Goffmanesque form. A degree of 'self-policing' now occurs: supporters who become abusive or aggressive towards others tend to be 'quietened' through the intervention of fellow Scots, acting by persuasion or by force. For 'self-policing' to occur, the Tartan Army needs to have already generated a sense of shared identity within its ranks. Like any other supporter group, Scottish fans are separated by the sociological 'facts' of class, age and ethnic stratification, and regional divisions.[3] More seriously, there are fundamental cleavages within Scottish football culture, in particular those relating to club affiliation and, in some cases, club fan identities tied to ethnic divisions overlaid with religious sentiments (like those found to quite varying degrees around the 'Protestant' Rangers or Hearts, and the 'Catholic' Celtic or Hibernian (Finn 1991a; 1991b; 1994a; 1994c)). But as Cohen (1993: 129) points out, carnival can 'bring together in amity people from different classes and ethnic and religious groupings'. To achieve this unity, there is an informal 'ban' throughout the Tartan Army on the wearing of potentially divisive Scottish club colours. Special sensitivity is reserved for the wearing of Rangers motifs; as well as dominating Scottish football, the club culture of Rangers is often perceived by rivals to be intolerant, arrogant and rather dismissive of the national team.[4] It has to be noted that the vast majority of Rangers fans who attend Scotland fixtures overseas adhere to the ban on club colours; they also generally avoid voicing the anti-Catholic and anti-Irish epithets which are commonly heard at Rangers' club matches. After overcoming the domestic divisions within the support, the Tartan Army then merges its sense of collective identity with the belief that being a Scottish supporter means entering into positive and exuberantly friendly exchanges with opposing supporters and the local 'host' population.

Underpinning the Tartan Army's repertoire is a collective anti-Englishness, strongly associated with the popular typification of English fans as 'hooligans' (Giulianotti 1991: 509). This anti-Englishness possesses both a practical and cultural dimension. Scottish supporters deliberately project an image of themselves as being Scottish-not-English, and the stereotype of English fan hooliganism has proved highly efficacious in generating a rapport with the local hosts when they are overseas. The hosts and other fans often make the mistake of confusing Scotland with England, or at least a shared 'British' football identity, which means there is an expectation that the Scots may be violent fans. The easiest method through which the Scots may explain their cultural and historical differences from the English, for the benefit of the uninformed, is to stigmatise the English as hooligans and express their contempt for such nationally-defined hooligan behaviour.

Yet there are forms of Scottish identity which are receptive to a shared sense of Britishness with the English. Most germanely, Glasgow Rangers again represent a complicating factor through their Unionism towards England and the UK generally – something blithely ignored by some sociologists (e.g. Moorhouse) and tabloid journalists alike. Ambiguities still remain on the modernisation of Rangers' traditional intolerance towards Catholics. Catholic players signed in recent years have been advised by Rangers not to bless themselves when taking the field. Meanwhile, English internationalists have shown their assimilation into Rangers' club culture, by anti-Irish ranting while with the England team (Terry Butcher), conducting Ibrox fans in these Orange hymns during an Old Firm game (Graeme Roberts), or 'playing the flute' in true Orange Order style after scoring (Paul Gascoigne) (Finn 1997).

Within a wider setting, the relationship between Scottish sport and Scottish nationalism is quite perplexing (Jarvie and Walker 1994). Scottish football has been the subject of vexed perorations by cultural nationalists and intellectuals. It is thought that the obsession with football provides the Scots with a 'stubborn national neurosis' (McIlvanney 1991: 70), a distraction from the development of a modern nationalist consciousness which should translate into an institutionally autonomous nationhood. The leading Scottish nation-alist politician, Jim Sillars, complained that 'we have got too many 90-minute patriots in this country' (*Scotsman* 24 April 1992). The critical theorist, Tom Nairn (1981), has argued that Scottish popular culture (including football) fosters a peculiar 'sub-nationalism' among the Scottish people, which is politi-cally schizophrenic and ultimately self-destructive. Even Scotland's footballing tradition, in snatching defeat from the jaws of victory, is read as a metaphor for its political impotence. (Euro 96 offered further nourishment for this view, as the Scots failed *again* to go beyond the first round of a major international tournament).

These arguments have an historical and ideological appeal. But, they assume that nationalism within popular culture can only deter rather than promote a potentially political sense of Scottishness. Notwithstanding the culturally and nationally unifying features of 'Unionist' football in the UK, there are broader and deeper political fissures between Scotland and England. Support for 'home rule' was vindicated by the 1997 referendum, in which Scots voted for a Scottish parliament with tax-varying powers. Popular culture *does* reflect some of these emotions. The Scottish National Party has claimed the film *Braveheart* as an inspiration for Scottish political independence.[5] Scotland's football manager claimed the film to be an inspiration for the national team and its supporters in Euro 96. Coach-loads of Scottish supporters watched the epic on video as they travelled south to matches in England. On the eve of the Wembley match, some of the Tartan Army's hard core paid a ceremonial visit to the London site of Wallace's execution by the English in 1304. More commonly, during the long drinking sessions before and after matches, it was a regular sight for a tartan-clad Scot to emerge

waving a small-but-life-size cardboard cut-out of Mel Gibson as William Wallace. Mischievous shouts of the battle cry 'Freedom!' would be echoed in full by the laughing on-lookers, in an atmosphere more burlesque than bellicose.

More traditionally, the match against England resumed the world's oldest international fixture, and with it a return to the Scottish Wembley 'tradition'. Since the 1920s, thousands of Scottish fans have enjoyed the carnival excesses of their 'Wembley Weekends' (Holt 1989: 260). Mostly, Scottish fans were seen as amiable, if inebriated visitors. But, from the late 1970s, these biennial 'northern invasions' had started to attract increasing political and media criticism in which it was the Scottish, not the English, supporter who was typified as 'hooligan'.

Violence and Scottish fans

In 1977, after defeating England 2–1 at Wembley, Scotland supporters invaded the pitch, tore down the goal-posts and dug up the grass, to take home as souvenirs of an epic victory. In 1979, after some genuinely violent incidents, the Scots brought the London Underground to a standstill as its workers walked out on strike, rather than transport the visiting fans around the capital. In 1981, the English FA attempted to impose a ticket ban on Scottish supporters, but failed dismally. In 1983, the match was switched to a Wednesday evening, and thus lost much of its sparkle. Nevertheless, in 1985, only days after the Heysel disaster involving Liverpool fans, the Prime Minister Margaret Thatcher insisted that the scheduled Wembley match be transferred to Hampden Park in Glasgow, to stop the 'hooliganism' of Scottish fans in London. The switch ignored the change in English fans' relationship to the fixture. Until then, the Scottish fans' tradition had been to greatly outnumber the English, at Hampden (as a matter of course) and at Wembley (as a matter of pride). After Heysel, English clubs were banned from playing overseas, entailing the near total absence of any hooligan competition at international fixtures in the UK. Matches against Scotland (particularly in Glasgow) provided one of the last tests of English fan 'hardness', against even more celebrated opposition. Accordingly, Scotland–England matches between 1985–9 resulted in serious disorder, with over 240 fans arrested at the final fixture in Glasgow. Afterwards, the English and Scottish FAs bowed to police and political pressure by calling off the annual fixture, claiming in the process that this would permit better preparation matches for international tournaments.

Fear of disorder ensured no more meetings occurred. At Italia '90 and Euro '92, the two sides were kept apart in the group draws, while local police and the National Football Intelligence Unit (NFIU) introduced heavy security to prevent the rival fans meeting in transit. In Sweden, the SFA's security advisor had been pessimistic about the Scots' willingness to respond peaceably to any

English provocation. Prior to Euro 96, UEFA's President, Lennart Johansson, had considered keeping the two sides deliberately apart in the group draws, while comparing their rivalry to the Balkan situation! But an open draw resulted in the two countries meeting for the first time in seven years.

Since the early 1980s, Scottish hooligan violence at club fixtures has been dominated by the 'soccer casuals'. The soccer casual style represents a departure from the traditional violence associated with Scottish club fans, and is a special departure from the ethnic violence associated with Rangers and Celtic. It combines football fandom with youth subcultural style (Redhead and McLaughlin 1985; Giulianotti 1993; 1995b); and is thus distinguished by the casuals' almost complete avoidance of club colours in favour of fashionable menswear. The leading casual rivalry involves Aberdeen and Hibernian (also known as Hibs, from Edinburgh); other major casual groups include those who follow the Dundee clubs and Glasgow Rangers. Intriguingly, some casuals attend Scotland matches abroad, but, unlike their English counterparts, they have not transferred their hooligan *club* identity onto the international stage. Instead, their casual identity is usually submerged by full participation in the Scottish carnivalesque.

Nonetheless, some signs of a common *Scottish* casual identity have appeared. For the first time since Hampden 1989, and for the first time ever abroad in modern times, Scotland's friendly match away to The Netherlands in May 1994 led to *mass* arrests of Scottish fans. After some considerable negotiation, an uneasy 'alliance' of Hibs, Aberdeen and Dundee casuals had been put together, and totalled approximately 140. Some disorder occurred outside the stadium in Utrecht, police moved in and forty-seven were arrested. At a preliminary meeting of some 'top boys' associated with each group, a similar alliance was prepared for Euro 96.

Scotland fans at Euro 96

In the event, the Scottish 'invasion' passed off relatively peacefully. Scottish fans in Birmingham for the fixtures against Holland and Switzerland encountered little trouble. Neither opposing side appeared to have brought a hooligan following (the Dutch being conspicuously absent), while the publicised English assault failed to materialise. Before the first game, a minor skirmish at the campsite involving locals and Scottish fans was turned into a 'danger signal' by the Scottish media, partially because a tabloid journalist (and hard core Scottish fan) camping there had chanced upon this newsworthy incident. The pedestrianised city centre was heavily policed, with squad vans and cars habitually parked outside pubs and nightclubs housing Scots drinkers. Supporters staying over in England soon located friendly drinking spots, including those offering the requisite 'lock-in', to circumvent uncivilised licensing laws. Small groups of Scottish casuals appeared in Birmingham, neither looking for nor expecting violence; they mixed in with

the mainstream Tartan Army, reactivating old friendships with some of the hard core, and discussing freely the issue of violence at the Wembley fixture. Even those Scottish CID officers monitoring the fans in Birmingham expected little action, with some from Aberdeen turning their attentions instead to late-night drinking and local women.

The Birmingham authorities had sought to entertain visiting fans (especially overseas ones), by hiring street theatre artists. Purer moments of the carnivalesque were more appreciated by the Scots when *they* initiated the action; in doing so, they sometimes found themselves near the receiving end of social control. Prior to the Swiss game, a large group of drinking fans were packed into a pedestrianised street, when a light ball was thrown up into the air by a young local. To the accompaniment of constant cheering, the fans kept it aloft by any means possible, with no obstacle too precious, in what passed for a throwback to folk football, in a street lined with 'olde worlde' bars. This spontaneous revelry was too much for the attendant police, who insisted that the ball's owner reclaim his property. When, to huge cheers, he threw the returned ball back into play, the police pulled him round the street corner. But a pursuing pack of Scottish fans persuaded them of their humourless indiscretion, the youth was released, and the game continued.

For the Wembley game, the London–Scottish social club had organised some entertainment for compatriots. One bar in Kentish Town doubled as a 'flop house' for those without accommodation, while a special 'ball' was arranged in Shepherd's Bush. On the morning of the game, Scottish casuals joined the Tartan Army at Trafalgar Square, the Scots' traditional meeting place for Wembley fixtures. In total, around 250 Scottish casuals made the trip south.[6] They soon demonstrated their pursuit of a separate agenda, when a group of over 100, broke off to attack a bar beside Leicester Square containing English hooligans (cf. Brimson and Brimson 1997: 151). En route to Wembley, some coaches filled with Scottish fans had their windows smashed while driving past mobs of England fans in central London. Outside the ground, the Scots gathered at the turnstiles to their ground section, which was absurdly small due to the organisers' unjust distribution of tickets. Inside, security was surprisingly lax, as rival fans mingled with one another freely. Yet, the dearth of violence was probably attributable to large numbers of England fans being relative newcomers to the now fashionable game. Their remarkable taciturnity also told its own story, as the outnumbered Scots battled hard to sustain their Wembley tradition, and so out-sang them easily. At full-time, with Scotland defeated, many England fans reached across security cordons to congratulate the Scots fans on their support, shaking hands and swapping some regalia. The home fans' graciousness in victory continued outside the ground, while the visitors morosely speculated on how their hosts would have responded to an England defeat.

After the fixture, the events at Trafalgar Square acquired a ritualistic dimension, as the key players in the drama took up positions in concentric circles. At

the epicentre, and controlling the contested space of the square and fountain, were the hard core Tartan Army fans, defiantly drinking and singing their elegies to a beaten team. On the fringes were various groups of Scottish casuals, seeking to move out centrifugally and fight their opposite numbers. Hemming them in was a perimeter of police officers, with batons and shields to the fore, and just as concerned to keep the outer ring of English hooligans on the periphery. The final ring was made up of *de facto* spectators, watching a drama that became London's major tourist attraction for the evening.

While the Scottish media fretted about the incidents, with most newspapers calling for a further ban on the game, it seems likely that the disorder involving the Scottish casuals has done little to affect the image of the Tartan Army abroad. For example, the Italian fan magazine, *Supertifo* (6 August 1996), reported the disorder, but placed the Tartan Army at the top of their league for Euro 96 supporters.

Mediating Scottish identities

The Scottish media participate in identity construction in intriguing ways. Studies of football fans have argued routinely that the mass media 'amplify' football hooliganism: in exaggerating the actual incidence of fan disorder, it is argued, the media promote a climate of fear and intolerance among the authorities and general public towards football fans, while also heightening the expectation of violence among supporters. *Ipso facto*, 'amplification' intensifies the very 'problem' which the mass media had criticised and set out to eradicate (Hall 1978; Marsh *et al.* 1978; Whannel 1979; Armstrong and Harris 1991). In Scotland, the 'amplification' thesis would appear to have been internalised by the media, to the extent that they would now prefer to 'de-amplify' (effectively, to ignore) any disorder involving the Tartan Army at matches overseas. Before the Holland match, the Scottish media typically reported on the 'unblemished record' of the Tartan Army, thus ignoring the arrest of a dozen Aberdeen casuals at an international in Paris in 1989, and those other occasions when the carnivalesque of mainstream fans moved from positive impression management to disorderly excess.

The Scottish media adopt several reporting strategies in promoting the ambassadorial image of the Tartan Army. One basic strategy is to collapse the cognitive distance between team, supporters, media and reader, to enable a form of self-celebration between all four categories. Hence, after 5,000 Scotland fans had been publicly 'awarded' the Fair Play championship for spectators at Euro '92, the Scottish tabloids proclaimed 'We're the finest in Europe' (*Sun* 26 June 1992); and 'WE'RE THE TOPS! – And that's official' (*Daily Record* 26 June 1992). This strategy is buttressed by the attempt of the Scottish media to interpolate a sense of national identity through collective differentiation (by reader and media) from an antithetical other: the English. Images of English fans fighting or being arrested at matches overseas, are

juxtaposed with pictures of Scottish fans overflowing with bonhomie towards their hosts and opposition fans. When routinely condemning the behaviour of English fans overseas, hapless members of past Conservative governments regularly referred to these miscreants as 'British' supporters[7] – provoking the ire of Scottish politicians and editorialists, who countered in populist mode that all football offenders hail from south of the border. In heightening this sense of national identification with the supporters, the Scottish media are also legitimising their difference from English-based British-claiming media, which report on the same political and sporting issues, but which are often seen to give only a token coverage of Scottish-orientated news.

These populist and nationalist discourses in the Scottish media have been counterpoised by reporting pressures that would seem to undermine the 'ambassadorial' presentation of the Tartan Army. From outwith Scotland, there is the relatively recent attempt by some English politicians and football officials to recontextualise (to the extent of de-amplifying) the violent propensities of English supporters. In arguing that English hooliganism is neither unique nor exceptionally violent, favourable comparisons are drawn with police and press reports of disorder involving Scottish and other European supporters (Giulianotti 1994b). Second, within Scotland, the print media has become increasingly competitive in recent years (Meech and Kilborn 1992). Most 'British' newspapers have devolved some editorial and writing power to journalists composing Scottish editions, especially within news and sports sections. Growing pressure is placed on teams of Scottish-based journalists to come up with exclusive reports or new reporting perspectives on particular issues, and the behaviour of Scottish football supporters is no exception. For example, following the disorder in Holland in May 1994, the Scottish newspaper the *Daily Record* and its tabloid rival the *Sun* were involved in an editorial argument surrounding their respective coverage of the story. The *Sun* (30 May 1994) had issued a front page 'exclusive', identifying the 'leader' of the Scottish hooligans (an individual who, in fact, had not even been to the match in Holland!) (Armstrong and Giulianotti 1998). The *Daily Record* (1 June 1994) responded by accusing its rival of reporting hooliganism irresponsibly and unprofessionally. However, only ten months earlier, the two newspapers had adopted completely opposing positions when reporting a police 'dawn raid' in Glasgow.

For Euro 96, the binary opposition between Scottish casuals/hooligans and the Tartan Army/anti-hooligan styles posed problems for the Scottish media. Yet while the Scottish media intermittently reported that the casuals were intending to travel south for violence, the predominant narrative pinpointed English fans *en masse* as the most likely to initiate trouble. This came into some conflict with English media views on hooliganism. Immediately after the group draw, newspaper coverage focused on the England–Scotland match and raised the possibility of fan violence. In discussing this story, the contradictions of

advocating dual nationalisms were quickly realised by the *Sun* (18 December 1995). While its Scottish edition compared England fans most unfavourably with the praiseworthy Scots, the English issue portrayed the latter as the likely instigators of disorder. In response, the *Daily Record* (19 December 1995) accused its rival of bad faith, championing its own claim to be the truly Scottish newspaper. This claim was later symbolically strengthened by the *Record's* announcement of official sponsorship of the Scottish team squad, interpreted as showing that some Scotland players and management 'know that *real* Scots read the Record' (3 February 1996). However, on the same day, this proud boast and advertising catchphrase was subverted by the *Sun*, which reported the loss of *Record* jobs to London under the headline, 'Real Scots sacked by the Record'.

The newspaper circulation war led to continued efforts by tabloids to use Scottish football to position themselves as the newspaper with the truly Scottish identity for a truly Scottish community. Team, fans, newspaper and its readers could be collapsed into one entity, presented as a unity, the *true* Scottish community. For different news purposes different elements of the whole could be topicalised. Yet by the commencement of Euro 96, media reports generally focused at least as much, and arguably more, on the role of Scotland's community of fans as on the players. In the interregnum between the Holland and England fixtures, *Scotland on Sunday*, sister paper to Edinburgh's *Scotsman*, commented:

> This is a crucial time for Scottish football. . . . We hope Scotland wins both matches. If the whole truth be told we hope most of all that Scotland wins at Wembley . . . but most of all we hope that the Tartan Army returns from England with its reputation unblemished. It is far better to lose a football match than to gain reputation on the continent for thuggery and xenophobia. Ask England.
>
> (*Scotland on Sunday* 9 June 1996)

This elevation of the fans above the team also contains within it a gentler expression of anti-English sentiment, and an affirmation of England fans *qua* hooligans (cf. Giulianotti 1995a). But to elaborate our point on the player–fan hierarchy, we may note that Scottish supporters have even come to be used as central representatives of Scottish identity. When the *Daily Record* welcomed the publication of the Home Rule Bill (26 July 1997), the main editorial page was ecstatically titled: 'Yes! Yes!' Immediately underneath this slogan, and by way of illustrating an article headed 'Scottish and proud of it!', there was a photograph which needed no description: it was the Tartan Army *en fête* in London's Trafalgar Square. The image of Scotland's fans had been appropriated to become the definitive representation of being Scottish, and to herald the new Scotland to come.

Football and nation into the millennium

Until now, the limited means for the expression of a Scottish identity has meant that sport, especially the supposed 'people's game' of football, has carried much of the burden of expressing a Scottish identity. Recently in the appropriation of any suitable, available images to portray Scotland, it has been real Scottish people, in the form of Scotland's 'Tartan Army', that have become a significant representation of that identity. If sports teams can give substance to 'imagined communities' (Anderson 1983), then massed supporters can do that as well, or even better – and in the case of Scotland with greater success (Finn 1994b; cf. Hobsbawm 1990). Nonetheless, even the positive carnivalesque Scottish fan identity relies on a binary opposition with English 'hooligans', which is then reflected in media coverage of Scottish supporters. Occasionally, a more insightful media analysis is proposed. As *Scotland on Sunday* (25 February 1995) explained, 'fighting old battles' with England, in sport or politics, is no substitute for becoming 'a modern confident democracy . . . more concerned about planning for a vibrant future'.

Euro 96 was but one of many tests of Scotland and Scottishness, but there was little evidence of real progress towards a less anti-English, more positive Scottish social identity. Scottish supporters' actions have reflected aspects of their nation and its position in the contemporary world: football has been one of the few, and one of the most important, international stages on which the Scottish social identity could be imagined and performed. Both team and supporters, recently especially the supporters, have represented Scotland. The new Scottish parliament may enable other, more significant expressions of Scottishness to be made. A more positive, more inclusive (see Dimeo and Finn, this volume) sense of Scottish identities is required and can easily be imagined, but its performance requires much more traditional invention. Two measures of its successful accomplishment will be when Scottish fans can present a truly *Scottish* and *international* carnivalesque social identity, and when that performance is seen in Scotland as being primarily *sporting* rather than quintessentially *Scottish*.

Notes

1 This article extensively revises and develops ideas first tentatively discussed in a paper which has been published in Italian (Finn and Giulianotti 1998)

2 The eight Board seats are taken by England, Scotland, Wales and Northern Ireland (one seat each); and FIFA (four seats). The Board adjudicates on changes to football's rules; a minimum of three-quarters support from its members is required for changes to be made.

3 Gender divisions are less notable within the support, as attendance of women at Scotland's matches abroad is low relative to other fan groups. For example, while Norway's overseas support is roughly equally divided between males and females, we estimate that women constitute less than 20 per cent of the Scottish supporters who travel abroad. Moreover, the carnival culture of the Scottish supporters is strongly

masculine in content. During its more excessive moments, female fans are left to choose between screening off traditional perceptions of their 'femininity' through participation or, more frequently, by playing a peripheral role in proceedings.

4 At the fixture against Greece in Athens in December 1994, many Scottish fans wore AEK Athens hats, largely in celebration of this side's victory over Rangers in the European Cup four months earlier.

5 The film is rather loosely based on the legend of the eponymous Scottish 'freedom fighter' William Wallace, and his vainglorious battles with the English armies in the late thirteenth and early fourteenth centuries.

6 The Scottish casuals comprised mainly lads from Aberdeen (roughly sixty), Dundee (forty), Rangers (thirty), Falkirk (twenty-five), and small groups following Airdrie, Kilmarnock and Celtic. Around fifteen Hibs travelled through to the centre early in the day; a larger number remained in North London.

7 One culprit was David Mellor, then Minister for National Heritage and now head of the Geovernment Football Task Force in England.

Bibliography

Allan, J. (1989) *Bloody Casuals: Diary of a Football Hooligan*, Glasgow: Famedram.

Anderson, B. (1983) *Imagined Communities – Reflections on the Origin and Spread of Nationalism*, London: Verso.

Armstrong, G. and Giulianotti, R. (1998) 'Ungentlemanly conduct: football hooligans, the media and the construction of notoriety', in R. De Biasi (ed.) *Il Mito del Tifo Inglese*, Milan: SHEKE.

Armstrong, G. and Harris, R. (1991) 'Football hooligans: theory and evidence', *Sociological Review* 39, 3: 427–58.

Brimson, D. and Brimson, E. (1997) *Capital Punishment*, London: Headline.

Brug, H.H. van den (1994) 'Football hooliganism in the Netherlands', in R. Giulianotti, N. Bonney and M. Hepworth (eds) *Football, Violence and Social Identity*, London: Routledge.

Cohen, A. (1993) *Masquerade Politics*, Oxford: Berg.

Eco, U. (1984) 'The frames of comic freedom', in T.A. Sebeok (ed.) *Carnival!*, New York: Mouton.

Finn, G.P.T. (1991a) 'Racism, religion and social prejudice: Irish Catholic clubs, soccer and Scottish society. I – The historical roots of prejudice', *International Journal of the History of Sport* 8, 1: 70–93.

—— (1991b) 'Racism, religion and social prejudice: Irish Catholic clubs, soccer and Scottish society. II – Social identities and conspiracy theories', *International Journal of the History of Sport* 8, 3: 370–97.

—— (1994a) 'Sporting symbols, sporting identities: soccer and intergroup conflict in Scotland and Northern Ireland', in I.S. Wood (ed.) *Scotland and Ulster*, Edinburgh: Mercat Press.

—— (1994b) 'Football Violence: a societal psychological perspective', in R. Giulianotti, N. Bonney and M. Hepworth (eds) *Football, Violence and Social Identity*, London: Routledge.

—— (1994c) 'Faith, Hope and Bigotry: case-studies of anti-Catholic prejudice in Scottish soccer and society', in G. Jarvie and G. Walker (eds) *Sport in the Making of the Nation: Ninety Minute Patriots?*, Leicester: Leicester University Press.

—— (1997) 'Scotland, soccer, society: global perspectives, parochial myopia', paper to the *NASSS Annual Conference: Crossing Boundaries*, University of Toronto, Canada.

Finn, G.P.T. and Giulianotti, R. (1998) 'La Scozia e Euro 96', in R. De Biasi (ed.) *Il Mito del Tifo Inglese*, Milan: SHEKE.

Forsyth, R. (1990) *The Only Game: The Scots and World Football*, Edinburgh: Mainstream.

Giulianotti, R. (1991) 'Scotland's Tartan Army in Italy: the case for the carnivalesque', *Sociological Review* 39, 3: 503–27.

—— (1993) 'Soccer casuals as cultural intermediaries: the politics of Scottish style', in S. Redhead (ed.) *The Passion and the Fashion*, Aldershot: Arena.

—— (1994a) 'Scoring away from home: a statistical study of Scotland football fans at international matches in Romania and Sweden', *International Review for the Sociology of Sport* 29, 2: 171–200.

—— (1994b) 'Social identity and public order: political and academic discourses on football violence', in R. Giulianotti, N. Bonney and M. Hepworth (eds) *Football, Violence and Social Identity*, London: Routledge.

—— (1995a) 'Football and the politics of carnival: an ethnographic study of Scottish fans in Sweden', *International Review for the Sociology of Sport*, 30, 2: 191–224.

—— (1995b) 'Participant observation and research into football hooliganism: reflections on the problems of entrée and everyday risks', *Sociology of Sport Journal* 12, 1: 1–20.

—— (1996a) 'Back to the future: an ethnography of Ireland's football fans at the 1994 World Cup Finals in the USA', *International Review for the Sociology of Sport* 31, 3: 323–48.

—— (1996b) ' "All the Olympians: a thing never known again?" Reflections on Irish football culture and the 1994 World Cup finals', *Irish Journal of Sociology*, 6: 101–26.

Giulianotti, R., Bonney, N. and Hepworth, M. (eds) (1994) *Football, Violence and Social Identity*, London: Routledge.

Hall, S. (1978) 'The treatment of football hooliganism in the press', in R. Ingham (ed.) *Football Hooliganism: The Wider Context*, London: Inter-Action Imprint.

—— (1993) 'For Allon White: metaphors of transformation', in A. White (ed.) *Carnival, Hysteria and Writing*, Oxford: Clarendon.

Hobsbawm, E. (1990) *Nations and Nationalism Since 1780*, Cambridge: Cambridge University Press.

Holt, R. (ed.) (1989) *Sport and the British*, Oxford: Oxford University Press.

Jarvie, G. and Walker, G. (eds) (1994) *Scottish Sport in the Making of the Nation: Ninety Minute Patriots?*, Leicester: Leicester University Press.

Marsh, P., Rosser, E. and Harré, R. (1978) *The Rules of Disorder*, London: Routledge and Kegan Paul.

McIlvanney, W. (1991) *Surviving the Shipwreck*, Edinburgh: Mainstream.

Meech, P. and Kilborn, R. (1992) 'Media and identity in a stateless nation: the case of Scotland', *Media, Culture & Society* 14: 245–59.

Nairn, T. (1981) *The Break-Up of Britain*, 2nd edn, London: NLB.

Peitersen, B. (1991) 'If only Denmark had been there: Danish football spectators at the World Cup finals in Italy', *Report to the Council of Europe*.

Rafferty, J. (1975) *One Hundred Years of Scottish Football*, London: Pan.

Redhead, S. and McLaughlin, E. (1985) 'Soccer's style wars', *New Society*, 16 August.

Whannel, G. (1979) 'Football crowd behaviour and the press', *Media, Culture & Society* 1: 327–42.

12

'WE SHALL NOT BE MOVED'!
MERE SPORT, MERE SONGS?

A tale of Scottish football

Joseph M. Bradley

Introduction

The songs of football supporters are an important part of their diet of communication. In Scotland football is often characterised by songs which convey a set of identities which are indicative of many of the identities and underlying features of society. As well as regular football songs, songs abusing Catholics and the Irish, about the Battle of Bannockburn in 1314, songs of the British Empire, Irish rebel tunes, Scottish rebel tunes, chants about loyalist paramilitaries in Northern Ireland, ditties about secret societies and the Pope, all distinguish football in Scotland.

This work reflects on some of these songs. It particularly focuses on the songs of the supporters of the Old Firm clubs of Glasgow Rangers and Celtic, although reference will be made to other tunes or a similar song set on the part of other fans. Further, using survey evidence collected since 1990, it also shows that rather than simply meaningless songs, these verses represent fundamental aspects of the identities of a significant number of the supporters of football in Scotland. Therefore, they are important to a social and political analysis of Scottish society.

Football as a mass interest sport in Scotland

Although other sports are undoubtedly popular in Scotland and can enjoy both high participation rates and significant audiences, no sport has captured the imagination of the country's population as soccer has. For over a century football has dominated in terms of money, media and crowds. Clubs in Scotland such as Aberdeen, Glasgow Rangers and Celtic, as well as the Scottish international side, have all recorded crowds which are records for European football. Along with the changing nature of sport and society

generally, especially through the influence of television, other manifestations also characterise the game's popularity. So for example, in Scotland, Glasgow Rangers have since the late 1980s averaged season ticket sales of around forty thousand a year. Corresponding to Celtic's stadium reconstruction and its financial rebuilding since 1994, it has increased season ticket sales from seven thousand in 1993–4 to over forty thousand for season 1997–8: the largest season ticket base in Britain.

Possibly one of the greatest modern manifestations of football clubs' popularity is their capacity for selling replica kits. If we consider ability to sell kits on the basis of population to national league and, in relation to the area covered by that league, sales of both Rangers and Celtic outfits surpasses those of any of the top clubs in England, and possibly of any other European club. Indeed, Rangers' appeal means that their kit replica sold 72,000 in its first week of release onto the market in May 1992 (*Herald* 29 October 1991; *Evening Times* 11 May 1992). Such figures give a more accurate indication of the depth of support existing for both sides of the Old Firm. Although reasonably well supported by the standards of clubs in other European countries like Holland and France, but not those of England and Italy, other clubs in Scotland have failed to provide the attraction of Rangers and Celtic. The origins and development of Rangers and Celtic as well as their links to the wider society in Scotland and beyond, gives much of Scottish football a character which rises above the mere mundane of sport in all its simplicity and beauty, and which gives it an intrinsic symbolic value.

Raised on songs and stories

In reference to the SAS Gibraltar killings of three IRA personnel in 1988, a large section of the Motherwell Football Club's fans have regularly chanted to the followers of Celtic, 'SAS, 1, 2, 3 . . . SAS, 1, 2, 3' (or alternatively, 'bang, bang, bang') (for example at Motherwell games on 25 August 1990 and 6 November 1990). Although not characterised by a strong religious or ethnic identity, Aberdeen supporters have in the recent past taunted the Celtic fans with anti-Catholic and anti-Irish songs.

One of the most popular football songs in Scotland is the 'Billy Boys'.

> Hello, hello, we are the Billy Boys.
> Hello, hello, you can tell us by our noise.
> We're up to our knees in Fenian blood, Surrender or you'll die.
> For we are the 'Billy Billy' Boys.[1]

Celtic fans note that this anti-Catholic song is sung (sometimes with a varied wording) by the followers of a significant number of clubs in Scotland (interview with ex-Celtic director Tom Grant; *Glasgow Herald* 23 February 1990). Another popular song among some fans in Scottish football, and one

particularly manifest when the opposition club is Celtic, is 'No Pope of Rome'.

No, no Pope of Rome, No chapels to sadden my eyes.
No nuns and no priests, no rosary beads,
every day is the twelfth of July.[2]

Politics, religion and ethnicity have also traditionally had a bearing on the character of the Scottish international support. Although the predominance of Rangers fans among that support has become less significant during the late 1980s and 1990s,[3] the booing of some Catholic footballers (especially Celtic Catholic players) playing for Scotland remains an aspect of the overall support. This was reflected in a letter in 1990 to the popular Scottish broadsheet, the *Sunday Mail*: 'Wasn't it moving to hear Brian McClair and Roy Aitken [both ex-Celtic players] booed onto the park against Argentina? This must have lifted the team' (*Sunday Mail* 1 April 1990).

Recent research focusing on the fans of the international team reflects that sentiments against Catholic and Irish manifestations in Scotland are not unusual. In discussions with the author, interviewees at an international match in 1994 refused to complete a questionnaire because they felt it asked too many questions which had little to do with football and too much to do with religion and politics. Nonetheless, a short time later the same small group of supporters proceeded to castigate the Celtic club captain who was playing for Scotland, on the basis of his religion, while they sang the following song.

Could you go a chicken supper Bobby Sands
Could you go a chicken supper Bobby Sands
Could you go a chicken supper
You dirty Fenian fucker
Could you go a chicken supper Bobby Sands
 (at Scotland versus Faroe Islands 12 October 1994)

The comment which asked the researcher, 'what's politics and religion got to do with football'?, was ironically answered by the perpetuators of both the question and the song.

The Nazi salute is not an unusual symbol among some football supporters in England and is common among those of the considered far right who follow the national side. This was much in evidence when England visited Dublin to play the Irish national team in February 1995. One of the leaders of the England supporters who rioted that evening boasted afterwards: 'We didn't care if England won or not. The lads were only there for a good fight and to teach the IRA bastards a thing or two, and to try and screw up the so-called peace talks' (*Tiocfaidh Ar La* (Our Day Will Come) (1995) 12: 11 (Celtic fanzine)). The anti-Irish feeling demonstrated at this match is also common at English league matches. Detective Inspector Peter Chapman of the English

Football Intelligence Unit believes that: 'the one thing we do find that runs through football is the violently anti-Irish feeling' (*World in Action*, 'The Nightmare Returns', 29 March 1995).

Clearly the Nazi salute has links to the far right's anti-Irishness as well as anti-black attitudes. Although there is a far right presence among some football fans in Scotland the demonstrating of this salute can be viewed there as more to do with reflecting similar anti-Irishness in addition to negative attitudes towards the small number of black players in the Scottish game. In the main, it has come to represent a particular manifestation of Britishness (which often aligns itself with Scottish identity), which views an important feature of British national identity as being against Catholicism and demonstrations of Irishness in Scotland. A significant number of the supporters of clubs such as Rangers, Motherwell and Hearts frequently display this symbolism in matches against Celtic: the one club in Scotland/Britain which is identifiably Irish and Catholic.

The British national anthem, 'God Save the Queen', is an anthem savoured by the supporters of Glasgow Rangers, emphasising as it does their proclaimed loyalty to 'Crown, Country and Religion'. However, in recent years, and probably influenced by the more right-wing British elements of England's football support, 'Rule Britannia' has also gained popularity. Again this song receives more renditions than is usual when Celtic are the opponents or when the club plays abroad: such times are occasions when Rangers supporters view their British and Protestant identities as deserving of assertion and recognition (Figure 12.1).

This song's popularity may also have developed since the time of the Falklands–Malvinas War in 1982, in which the popular media contained striking images of a powerful British force sailing to Argentina. This was also a period when traditional anti-British army and anti-'imperialist' sentiments, even pro-Argentina ones, were expressed on the terraces of Celtic's stadium. In the 1980s and 1990s clubs such as Aberdeen and Dundee United have developed strong Scottish identities and a common hostility often exists within the fan base of both clubs with regards the British–Scottish–Ulster identities of Glasgow Rangers and the Irish identity of Celtic.

Celtic football fans, whether at a match or social occasion, will be heard to sing supportive chants for their club as well as a collection of songs and anthems which reflect their own and their club's origins in Ireland (Bradley 1995: 34–7). Such roots also means that the supporters continue the legacy of the first decades of the club's existence, a time when Irish immigrants in many countries were often characterised by links with a variety of Irish associations and activity for facets of the Irish nationalist cause then being pursued in the home country. Present day Celtic supporters continue this tradition by demonstrating their desire, through song, for an independent and united Ireland (Figure 12.2).

In the aftermath of the 1988 Scottish Cup Final in which Celtic played

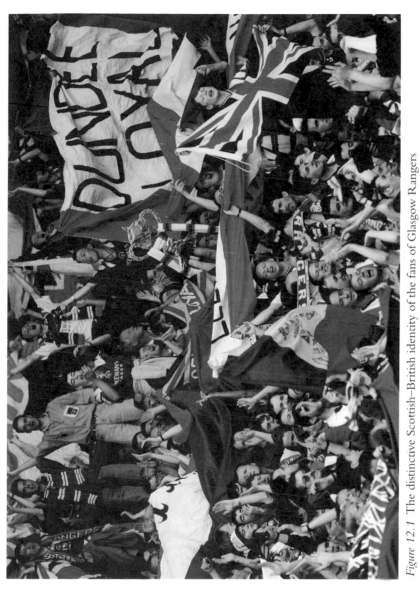

Figure 12.1 The distinctive Scottish–British identity of the fans of Glasgow Rangers

Source: Courtesy Herald/Evening News.

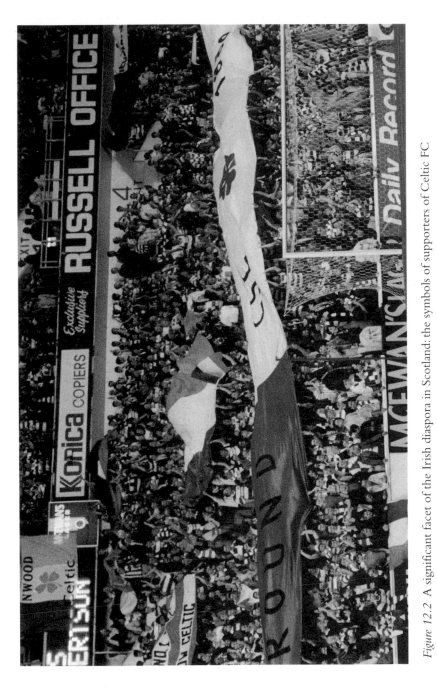

Figure 12.2 A significant facet of the Irish diaspora in Scotland: the symbols of supporters of Celtic FC

Source: Reproduced by permission of *The Celtic View.*

Dundee United, a game witnessed by then Prime Minister, Margaret Thatcher, a national newspaper reported: 'Celtic supporters waved tricolour flags and sang choruses of Irish rebel songs, and there were chants of anti-British slogans from sections of the crowd' (*Sunday Mirror* 15 May 1988). Renditions of Irish folk and rebel songs means that Celtic are unique in British football in terms of the identity of the club and its supporters. Likewise Rangers are unique in terms of the strength of the British–Scottish–Ulster Protestant identity which they (i.e. club and fans) are characterised by, though many other clubs in Scotland have similar or related identities. Many of these songs, as well as their themes and expressions, have opponents within the Scottish game and society generally. Nonetheless, such songs are intrinsic to the nature and identities of both clubs and their respective supporters, as well as to many others in the wider society. One controversy emerged around 1994 when a significant sports media commentator began a campaign to have Celtic fans cease singing and the club to stop playing the Irish ballad, 'The Fields of Athenry'.[4]

> By a lonely prison wall
> I heard a young man calling
> Nothing matters Mary when you're free
> Against the Famine and the Crown
> I rebelled, they cut me down
> Now you must raise our child with dignity
>
> (chorus)
> Low lie the fields of Athenry
> Where once we watched the small free birds fly
> Our love was on the wing
> We had dreams and songs to sing
> It's so lonely round the fields of Athenry.

The song was defended by its author: 'I think it dovetails with the history of the club being founded by Irish immigrants who lived through the Famine'. The Celtic club newspaper also quoted 'Irish historian' Terence O' Fee:

> There is an obvious connection between the potato famine and Celtic. Thousands of immigrants landed in Scotland during the famine years from 1845–50. Those people who fled to Glasgow were in acute hardship . . . had England adopted a more caring attitude to the Irish peasants when the Famine struck, Celtic FC might never had been formed.
>
> (*Celtic View* (1996) No. 1338, 6 March, p. 7)

Using the same tune as that of the 'Fields of Athenry', Glasgow Rangers supporters also sing one of their popular songs.

Remember our fathers brave and tall
Who fought for Ulster's cause in far off lands (fuck Bobby Sands)
Oh my father said to me
You must join the YCV
With a rifle or a pistol in your hand.[5]

Using the example of some of the symbols, opinions, chants and songs which characterise football in Scotland, it is evident that football there reflects a number of features of the wider society. A survey of a sample of the supporters of some the largest clubs in Scottish football demonstrates that these aspects of the game are symptomatic of the political and cultural identities of many football fans in Scotland.

Not merely songs and stories

Although identifying with the Scottish national team is seen by the wider football community (including the media) as inevitable, this is not the view of Celtic fans. A majority of Celtic fans surveyed indicated an 'ambivalence' towards the national side: 54 per cent said that they never attended matches of the Scottish team, 43 per cent went sometimes, whilst only 3 per cent always attended (see Finn and Giulianotti, this volume). All other categories of Scottish football fan were significantly more likely to attend Scotland matches than Celtic fans (Table 12.1). Thus, there are faint ties between a significant symbol of modern Scottish identity (Moorhouse 1987: 189–202) and the Irish club with its home in Scottish football.

A cleavage within Scottish football, and the distinctiveness of Celtic in particular, is clear from the answer to the question: do you support or like 'any other' international football team? (Table 12.2). A majority of clubs supporters indicated no preference for any country other than Scotland.

Celtic fans stood out via their support for the Republic of Ireland: 52 per cent indicating this preference. For a majority of Celtic fans exhibiting such support is an adjunct of 'Celtic culture' itself: indeed, it is a particular manifestation of a distinctive Irish identity amongst the Irish diaspora residing in Scotland. It is also a manifestation and expression of a particular identity which is not clearly reflected in other ways (Bradley 1995).

Scottish football, and particularly occasions which involve the Old Firm of Glasgow Rangers and Celtic, also provide a setting within which cleavage over the Northern Ireland issue is expressed within Scotland. These political and cultural expressions are clear in the responses of the football fans in Scotland to questions concerning Northern Ireland.

Almost three-quarters of Rangers fans surveyed believe Northern Ireland should remain in the UK (Table 12.3). This figure indicates the 'loyalism' of the Rangers fans. As over 90 per cent of Protestants in Northern Ireland support the continuation of the union with Britain, it is apparent that

Table 12.1 Percentages of fans attending Scottish international team games

Group	Always	Sometimes	Never	Row total
Rangers fans	17.0 (15)	63.0 (57)	20.0 (18)	20.0 (90)
Hearts fans	10.0 (4)	65.0 (26)	25.0 (10)	9.0 (40)
Aberdeen fans	12.0 (7)	78.0 (46)	10.0 (6)	13.0 (59)
Kilmarnock fans	14.0 (7)	78.0 (39)	8.0 (4)	11.0 (50)
Celtic fans	3.0 (3)	43.0 (41)	54.0 (52)	22.0 (96)
Motherwell fans	15.0 (5)	72.0 (23)	12.0 (4)	7.0 (32)
Hibernian fans	17.0 (3)	78.0 (14)	6.0 (1)	4.0 (18)
Dundee United fans	4.0 (1)	82.0 (18)	14.0 (3)	5.0 (22)
St Johnstone fans	6.0 (2)	79.0 (27)	15.0 (50)	8.0 (34)
Column total	11.0 (47)	66.0 (291)	24.0 (103)	100.0 (441)

Notes:
All percentages have been rounded to the nearest whole figure
Numbers in parenthesis indicate sample size

Table 12.2 Scottish fans who support 'other' international teams

Group	Ireland Republic	None	Ireland North	England	Holland	Other	Row total
Rangers fans	1.0 (1)	57.0 (48)	6.0 (5)	13.0 (11)	6.0 (5)	17.0 (14)	21.0 (84)
Hearts fans	3.0 (1)	67.0 (22)	3.0 (1)	6.0 (2)	9.0 (3)	12.0 (4)	8.0 (33)
Aberdeen fans		55.0 (28)			16.0 (8)	29.0 (15)	13.0 (51)
Kilmarnock fans		67.0 (32)	2.0 (1)	2.0 (1)	4.0 (2)	24.0 (12)	12.0 (48)
Celtic fans	52.0 (47)	35.0 (32)			2.0 (2)	11.0 (10)	23.0 (91)
Motherwell fans		69.0 (20)	4.0 (1)		7.0 (2)	21.0 (6)	7.0 (29)
Hibernian fans	12.0 (2)	50.0 (8)		6.0 (1)		31.0 (5)	4.0 (16)
Dundee Utd fans	5.0 (1)	75.0 (15)				20.0 (4)	5.0 (20)
St Johnstone fans	3.0 (1)	57.0 (17)	3.0 (1)	7.0 (2)	7.0 (2)	23.0 (70)	7.0 (30)
Column total	13.0 (53)	55.0 (222)	2.0 (9)	4.0 (17)	6.0 (24)	19.0 (77)	100.0 (402)

Notes:
All percentages have been rounded to the nearest whole figure
Numbers in parenthesis indicate sample size

Glasgow Rangers fans share this affinity of political partisanship (Curtice and Gallagher 1990: 183–216). Most Motherwell, Hearts and Kilmarnock fans support the 'keep Northern Ireland British' option: a position which is reflected in some of the vocal opinions of their fans in games. A large number of Aberdeen fans were 'don't knows' with the rest split evenly between supporters of the *status quo* and of a united Ireland.

Although Table 12.3 shows 61 per cent of Hibernian fans and 64 per cent of Dundee United fans favourable to a united Ireland position, the numbers involved are small. Nevertheless, this may indicate the Irish origins of both clubs. Anti-Irish or Catholic songs, common at many other clubs, are not sung by Hibernian fans and rarely heard at Dundee United. Nonetheless, both clubs, are now Scottish in disposition and only limited sections of the Hibernian support give indication of their Irish background.

Significantly, every team apart from Celtic, and to a lesser extent Hibernian and Dundee United, has a much smaller proportion of supporters favouring a united Ireland than are to be found in the wider British population. Curtice and Gallagher assert that: 'British Governments clearly lack widespread public support for Britain's continued association with and involvement in, the province' (ibid.). Although this evidence does not invalidate the findings of Curtice and Gallagher, their conclusion is less accurate when the opinions of Scottish football fans are considered.

Table 12.3 Scottish fans' solution to the Northern Ireland conflict

Group	Remain in UK	Reunify with Ireland	Other answer	Don't know	Row total
Rangers fans	73.0 (65)	11.0 (10)	6.0 (5)	10.0 (9)	20.0 (89)
Hearts fans	42.0 (16)	21.0 (8)	18.0 (7)	18.0 (7)	9.0 (38)
Aberdeen fans	25.0 (14)	29.0 (16)	7.0 (4)	39.0 (22)	13.0 (56)
Kilmarnock fans	47.0 (24)	22.0 (11)	8.0 (4)	23.0 (12)	12.0 (51)
Celtic fans	5.0 (5)	79.0 (77)	6.0 (6)	9.0 (9)	22.0 (97)
Motherwell fans	48.0 (15)	29.0 (9)	10.0 (3)	13.0 (4)	7.0 (31)
Hibernian fans		61.0 (11)	22.0 (4)	17.0 (3)	4.0 (18)
Dundee United fans	9.0 (2)	64.0 (14)	14.0 (3)	14.0 (3)	5.0 (22)
St Johnstone fans	38.0 (13)	41.0 (14)	3.0 (1)	18.0 (6)	7.8 (34)
Column total	35.0 (154)	39.0 (170)	8.0 (37)	17.0 (75)	100.0 (436)

Notes:
All percentages have been rounded to the nearest whole figure
Numbers in parenthesis indicate sample size

Given the extent of support for Rangers, such evidence is an indication of the variation of attitudes towards the Northern Ireland question in Scotland as compared to the rest of Britain. Whereas many people in Britain have become exasperated by the continuing violence associated with the conflict and for this reason wish to end Britain's involvement in this, the evidence here indicates a significant number of people in Scotland have a more partisan view of the problem/solution. The view that: 'all shades of British opinion believe that the best future for Northern Ireland would be for it to be part of a united Ireland' is also be seen as less true in Scotland (ibid.).

Although Celtic fans' repertoire of songs makes us less surprised at these findings, the most striking figures are for the Celtic fans who identify most closely with a united Ireland. Four out of five Celtic followers support a united Ireland, in contrast to the 55 per cent of the general British population who take such a view (ibid.). This result also suggests a strong politico-cultural connection between Celtic fans and Ireland: one which is highly distinctive in terms of the broad spectrum of football fans in Scotland and Britain generally.

Again substantial differentials can be noted in the survey results which focus on the British political affiliations of the respective supporters (Table 12.4).

The Scottish National Party was the most popular preference amongst the fans of Dundee United and Aberdeen in particular. Support for the SNP was

Table 12.4 Scottish fans' political party support

Group	Labour	Conservative	SNP	Other	None	Row total
Rangers fans	33.0 (29)	32.0 (28)	14.0 (12)	8.0 (7)	14.0 (12)	20.0 (88)
Hearts fans	45.0 (18)	12.0 (5)	20.0 (8)	4.0 (2)	17.0 (7)	9.0 (40)
Aberdeen fans	26.0 (15)	17.0 (10)	33.0 (19)	9.0 (5)	14.0 (8)	13.0 (57)
Kilmarnock fans	58.0 (30)	10.0 (5)	21.0 (11)	2.0 (1)	10.0 (5)	12.0 (52)
Celtic fans	85.0 (83)	3.0 (3)	4.0 (4)	3.0 (3)	5.2 (5)	22.0 (98)
Motherwell fans	34.0 (11)	9.0 (3)	37.0 (12)	3.0 (1)	16.0 (5)	7.0 (32)
Hibernian fans	33.0 (6)	11.0 (2)	17.0 (3)		39.0 (7)	4.0 (18)
Dundee United fans	32.0 (7)	4.0 (1)	41.0 (9)		23.0 (5)	5.0 (22)
St Johnstone fans	12.0 (4)	29.0 (10)	23.0 (8)	3.0 (1)	32.0 (11)	8.0 (34)
Column total	46.0 (20)	15.0 (67)	19.0 (83)	4.0 (20)	15.0 (65)	100.0 (441)

Notes:
All percentages have been rounded to the nearest whole figure
Numbers in parenthesis indicate sample size

lowest among the Celtic supporters. This is not surprising considering Celtic supporters lack of affinity with the symbols of Scotland, including the national football team, as well as the fact that Catholics are generally less likely to be SNP supporters.[6]

In terms of the symbols associated with fans of clubs from the north-east of the country, in the late 1980s and 1990s groups of their supporters began to display Scottish flags as opposed to the more common Union Jack flags of other Scottish clubs or the Irish Tricolour adopted by Celtic fans. Even in political terms, SNP symbols are often found to be sported among some fans of Dundee United. Such manifestations reflect a strong Scottish identity among fans of some football clubs, as opposed to the identities of Glasgow Rangers and Celtic.

In terms of British politics, from the 1987, up until the 1997 General Election in Britain, support for the Conservative Party in Scotland has hovered around 14–26 per cent (*Herald*). Significantly, Rangers are well above the Scottish average in this respect. It is Rangers fans' Protestantism which is expressed in a national political setting through a notable degree of support for the most Unionist (and 'nationalist') of the main British political parties. Thus the vocal and symbolic British–Protestant identity projected by Rangers fans, is partly expressed in a high degree of support for the Conservatives.

Although football fanzines may or may not reflect the views of a majority of fans, the most popular Rangers fanzine, *Follow Follow*, has claimed that Glasgow Rangers are, 'a symbol of unionism and Protestantism', while the present Rangers management and directors have affirmed this via personal statements and actions (*Follow Follow* (1989) Issue 8). Apart from the Irish-minded Celtic fans, Rangers supporters also displayed the lowest level of support for the SNP. Overall, the survey found that Conservatism is frequently strong among supporters of football clubs where Protestant identity is significant (and likewise weak among the Catholic Celtic support).

Even so, it is Celtic fans who reveal the clearest pattern. In the General Election of 1987, Labour achieved its best ever Scottish General Election result with 42.4 per cent of the poll. However, 85 per cent of Celtic fans indicate support for the Labour Party. Celtic fans are of course overwhelmingly Catholic and working class and Catholics and the working class tend to support the Labour Party (Bradley 1995: 61–71). Nevertheless, the figure of 85 per cent is a massive one.

Overall, these results confirm that rather than simply a set of meaningless football ditties, religious, cultural, and ethnic identities are an important aspect of Scottish football, particularly with regards to clubs' interaction with Celtic. The outstanding feature of the survey is the distinctiveness of the Celtic support on a wide range of issues and attitudes: including attitudes to Northern Ireland and party political preference. In addition, on the whole, Celtic supporters are not supportive of the Scottish international football team. Indeed, their identity is partly defined by their support for the Republic of Ireland soccer team.

The non-Celtic supporters in the survey do not share social and political attitudes. However, the degree of divergence among them on the questions asked is not so startling or consistent as the distinction between them and Celtic fans. It is at all times Celtic, the overwhelmingly Catholic support, which is distinct. On a number of questions, including ones relating to Northern Ireland, Rangers fans adopt polar opposite views to those of Celtic. Nevertheless, many Rangers fans do share views with the supporters of other clubs, except Celtic. Dundee United and Hibernian fans show the regional variations which exist within this ethno-religious cleavage commented upon. These are the clubs in which the religious identities so prominent in Scottish football generally, are less clear: their more secular labels are also reflected in the low level of religious commitment (i.e. church attendance) of their supporters (Bradley 1995: 62). Significantly, all other clubs in Scotland are less well supported than Rangers and Celtic.

Conclusion

The ethno-religious origins and identities of Rangers and Celtic are the most significant factors in sustaining the vibrancy and financial profitability of Scottish professional football. Matches involving the Old Firm are regularly attended by half or more of the total support recorded at matches during a typical Scottish football Saturday. Rangers and Celtic are representative of widespread sections of the population of Scotland. Whereas almost all other clubs in Scotland are characterised by a provincial support, the Old Firm are deemed more attractive because of the identities that they represent. For many people, both clubs have become important national, religious, cultural, social and political experiences and expressions.

The evidence from the football survey demonstrates that where a resolute Protestant identity remains, and indeed, where Protestant identity is a defining characteristic, Unionism is strong (Curtice and Seawright 1995: 319–42). This is illustrated in the responses of the supporters of some football clubs from the west central belt. Given the extent of the support for Rangers, such evidence is also an indication of the variation of attitudes towards the Northern Ireland question in Scotland as compared to the rest of Britain. Whereas many people in Britain perceive merits in uniting Ireland, the football survey results indicate that a significant number of people in Scotland have another view. This view is further reinforced when we consider the 1993 Mori survey results which showed that only one quarter of people polled in Britain had a unionist perspective on Northern Ireland (*Sunday Observer* 21 November 1993). It is likely also to be the case that despite 'the decline of the empire and the contraction of Britain's military role' and that 'there is every reason to believe that some of the traditional pillars of unionism' have been losing their emotive power (Curtice and Seawright 1995: 319–42), Northern Ireland retains a symbolic role for many Scottish Protestants. Football, and the

relationship between football and Protestantism, demonstrates the view that 'all shades of British opinion believe that the best future for Northern Ireland would be for it to be part of a united Ireland' is also less true in Scotland (Curtice and Gallagher 1990: 183–216).

Not all Catholics in Scotland are of Irish origin. Some thousands of Catholics have migrated from Italy as well as Poland and Lithuania during the course of this century. Also, a small number of Scots remained Catholic after the Reformation. Inter-marriage, secularisation and the growth of mass and popular cultures also obscure and influence identity. Such things affect our capacity to talk rigidly of social, cultural and political categories. Nevertheless, the vast majority of Catholics in Scotland originate from Ireland and a strong bond exists between many of those Catholics and Celtic Football Club: an institution conceived and constructed from within, and sustained by, that immigrant community.[7]

To many Catholics in Scotland, and in similar fashion to Jay Raynot's description of Barcelona Football Club's Catalonian identity, Celtic have been appropriated over the years as something of a metaphor for the whole Irish and Catholic tradition (*Independent on Sunday* 28 June 1992). For the Catholic/Irish community, Celtic is the greatest, single 'ethno–cultural focus', because it provides the social setting and process through which that community's sense of its own identity is sustained, in and through a set of symbolic processes and representations. Certain dimensions of Scottish anti-Catholicism have evolved within Scottish football in response to this social, cultural and political reality.

The songs and symbols of football in Scotland are significant comments on the wider society. As Moorhouse notes: 'Scottish football, at a number of levels, reveals how sport can represent and enliven all kinds of divisions pertinent in society' (Moorhouse 1986: 284–315). Also strengthened by these findings is Blain and Boyle's idea that: 'the complex nature of collective identity formations associated with Scottish sport parallels the complexity of Scotland as a political entity' (Blain *et al.* 1993: 125–41).

Notes

1 The 'Fenians' was the name of the mid-nineteenth century Irishmen who engaged in military struggle against Britain. Today in west-central Scotland and Northern Ireland it is often derogatorily used to describe Roman Catholics. The 'Billy Boys' is the name which approximates to anyone of a Protestant religious label identifying themselves as followers or supporters of Northern Irish and Scottish loyalism.

2 The 12 July being the celebratory date for the Battle of the Boyne of the 1 July 1690 (old calendar).

3 This has generally been seen as a consequence of Rangers' increasing European status and involvement, as a result of discord between Rangers former manager Graeme Souness and the Scotland management as well as between the latter and a

number of contemporary Rangers players. Also, because of the general poor quality of the Scotland team in the late 1980s and early 1990s.

4 See the *Sunday Mail*, Gerry McNee, 23 October 1994, p. 71. This sentiment has been repeated by McNee on both radio and television at least until early 1997, a time also characterised by that commentator's personal campaign to have Celtic remove the Irish flag from above their stadium and for Celtic supporters to cease displaying the same (Radio Clyde, 13 January 1996). In March 1996 the Club defended the playing of the song on match days and their fans for singing the song stressing it was not a sectarian ballad and in fact its words were reflective of the origins of both the club and their supporters' presence in Scotland (*Celtic View* (1996) 6 March, No. 1338, p. 7).

5 YCV is a section of the Ulster Volunteer Force (UVF). The term also relates to many of the Protestant Ulstermen who volunteered to fight in the First World War (many were members of the original UVF).

6 (Brand 1978). However, more recently Brand *et al.* have also argued that Catholics' lack of affinity for the SNP is diminishing (Brand *et al.* 1994: 616–29).

7 Community is of course a highly debated and contested term. In this context it is deemed appropriate due to the coming together of a variety of social and political features within the Catholic section of the population of Scotland. So for example many members of this community share a common heritage, ethnic background, religion, Irish names, similar sporting expressions, Catholic schooling, common political sentiments in Scotland and in terms of Ireland, etc.

Bibliography

Allison, L. (1986) *The Politics of Sport*, Manchester: Manchester University Press.

Blain, N., Boyle, R. and O'Donnell, H. (1993) *Sport and National Identity in the European Media*, Leicester: Leicester University Press.

Bradley, J.M. (1995) *Ethnic and Religious Identity in Modern Scotland*, Aldershot: Avebury.

—— (1996a) 'Profile of a Roman Catholic parish in Scotland', *Scottish Affairs* 14 (Winter): 123–139.

—— (1996b) 'Identity, politics and culture: Orangeism in Scotland', *Scottish Affairs* 16 (Summer): 104–128.

Brand, J. (1978) *The National Movement in Scotland,* London: Routledge and Kegan Paul.

Brand, J., Mitchell, J. and Surridge, S. (1994) 'Social constituency and ideological profile: Scottish nationalism in the 1990s', *Political Studies* 42: 616–29

Campbell, T. and Woods, P. (1986) *The Glory and The Dream, The History of Celtic FC, 1887–1986*, Edinburgh: Mainstream Publishing.

Curtice, J. and Gallagher, T. (1990) in R. Jowell, S. Witherspoon and L. Brook (eds) *British Social Attitudes; The 7th report:* Social and Community Planning Research, Gower Publishing.

Curtice, J. and Seawright, D. (1995) 'The decline of the Scottish Conservative and Unionist Party 1950–1992. religion, ideology or economics?', *Journal of Contemporary British History* 9, 2 (Autumn): 319–42.

Devine, T.M. (ed.) (1991) *Irish Immigrants and Scottish Society in the Nineteenth and Twentieth Centuries; Proceedings of the Scottish Historical Studies Seminar*, University of Strathclyde, 1989–90, Edinburgh: John Donald Publishers Ltd.

Finn, G.P.T. (1991a) 'Racism, religion and social prejudice: Irish Catholic clubs, soccer and Scottish society. I – The historical roots of prejudice', *International Journal of the History of Sport* 8, 1: 70–93.

—— (1991b) 'Racism, religion and social prejudice: Irish Catholic clubs, soccer and Scottish society. II – Social identities and conspiracy theories', *International Journal of the History of Sport* 8, 3: 370–97.

—— (1994a) 'Faith, hope and bigotry: case-studies of anti-Catholic prejudice in Scottish soccer and society', in G. Jarvie and G. Walker (eds) *Sport in the Making of the Nation: Ninety Minute Patriots?*, Leicester: Leicester University Press.

—— (1994b) 'Sporting symbols, sporting identities: soccer and intergroup conflict in Scotland and Northern Ireland', in I.S. Wood (ed.) *Scotland and Ulster*, Edinburgh: Mercat Press, pp. 33–55.

Gallagher, T. (1987) *Glasgow The Uneasy Peace*, Manchester: Manchester University Press.

—— (1991) 'The Catholic Irish in Scotland: in search of identity, in T.M. Devine (ed.) *Irish Immigrants and Scottish Society in the Nineteenth and Twentieth Centuries*, Edinburgh: John Donald.

Hill, D. (1989) *Out Of His Skin: The John Barnes Phenomenon*, London: Faber and Faber.

Hoberman, J. (1984) *Sport and Political Ideology*, London: Heinemann.

Jarvie, G. and Walker, G. (1994) *Scottish Sport in the Making of the Nation; Ninety Minute Patriots*, Leicester: Leicester University Press.

Kendrick, S. (1989) 'Scotland, social change and politics', in D. McCrone, D. Kendrick and P. Straw (eds) *The Making of Scotland: Nation, Culture and Social Change*, Edinburgh: Edinburgh University Press.

Miller, W.L. (1981) *The End of British Politics? Scottish and English Political Behaviour in the Seventies*, Oxford: Clarendon Press.

Mitchell, J. (1992) 'Religion and politics in Scotland', Unpublished paper presented to Seminar on Religion and Scottish Politics, University of Edinburgh.

Moorhouse H.F. (1986) 'Repressed nationalism and professional football: Scotland versus England', in J. Mangan and R. Small (eds) *Sport, Culture, Society* London: E and FN Spon., pp. 52–9.

—— (1987) 'Scotland versus England; football and popular culture', *International Journal of Sport* 4: 189–202.

Rawnsley, A. (1993) 'At worst, an heroic failure', *Sunday Observer* 21 November.

Sugden, J and Bairner, A. (1986) 'Northern Ireland; sport in a divided society', in, L. Allison, *The Politics Of Sport*, Manchester: Manchester University Press, pp. 90–117.

Walker, G. and Gallagher, T. (1990) *Sermons and Battle Hymns; Protestant Popular Culture in Modern Scotland*, Edinburgh: Edinburgh University Press.

13

'ANGELS' WITH
DRUNKEN FACES?

Travelling Republic of Ireland supporters and the construction of Irish migrant identity in England

Marcus Free

Introduction

24 June 1994: The Dubliner, an 'Irish theme pub' in Digbeth, Birmingham. Ireland's televised second first-round match against Mexico in the US '94 World Cup attracts a full house. This is Ireland's second consecutive appearance in World Cup finals and marks the maturity of a period of unprecedented success for the Republic since ex-England player Jack Charlton's managerial appointment in 1986, the highlight of which was a World Cup quarter-final defeat by Italy in 1990. An estimated half a million people lined the streets of Dublin to greet the team's return in 1990 (Dunphy 1994: 6), and there were parallel Irish celebrations around the world. Back in The Dubliner, Ireland have won their first match against Italy in US '94 1–0 and expectations among the Irish community for a second win are running high. The transmission of American television pictures is mediated by the context of a Radio Telefis Eireann (RTE) programme taken by satellite from Ireland. Setanta Sports transmits a range of RTE sports broadcasts to Irish pubs and clubs throughout Britain, irrespective of their availability on British terrestrial television.

As numbers increase the landlord, an ex-Irish super heavyweight boxing champion, makes a pre-match surgical strike on a self-made 'character' who bursts into song – 'he was pissing on the seats – I warned him'. In a bizarre parallel with the heat and humidity of Orlando (water bags will be thrown to players throughout the match) evaporated sweat condenses and drips from the ceiling. The abundance of youthful English accents signifies the presence of locally bred 'second generation' Irish fans: two are unhappily distracted from the screen and the singing of the national anthem by the slurred speech and

red eyed stare of a middle-aged acquaintance. An argument breaks out about whether opening the curtains will allow more air to circulate or whitewash the video screen. A fiftyish women in tight shorts – 'old enough to know better' – is bouncing her inflated tricolour hammer off the cranium of any man under forty. In a tense match, Ireland play badly and are 2–0 down twenty minutes into the second half. The match is temporarily eclipsed on screen by the touchline delay of substitute John Aldridge's entrance in a protracted argument with an official. The Irish commentator's irritation at the officials' 'peaked caps and self importance' is drowned by 'fuck offs' and 'wankers', echoes of Aldridge's easily lip read anger. Chants of 'Come on Aldo' seem to will this 'third generation' Irish Liverpudlian to score. Aldo, who claimed to have seen 'shamrocks, not pound signs', when asked to play for the Republic – 'embarrassing as shite, that was, ammunition to the anti-plastics brigade' – duly obliges. As the final whistle announces a 2–1 defeat, the hammer-woman announces that 'at least we got through', a remark possibly attributable to the Mexicans' playing in green.

The doors are opened and face painted fans spill onto the pavement singing 'you'll never beat the Irish'. Tricolours are waved at passing traffic who honk replies. An elderly man sits, crying with head in hand. I accidentally tread on a discarded tricolour lighter. Outside the police station opposite two officers gaze passively across. I'm nudged in the ribs by Graham who remarks that, were we face painted England fans we'd be surrounded by police watching our every move. 'Second generation' himself he revels in the incongruity of Irish flags and colours in an English city scarred by the IRA pub bombings of 1974: 'they're thinking, "what provo'd [i.e. Provisional IRA] be mad enough to do this in the middle of Birmingham?"' Three hours later and pavement drinking is still in full swing, the strains of The Pogues' 'Sally MacLenane' is emanating from within. Now on the number 50 bus, having been down to Moseley for an obligatory post-drinking Balti I hear a black boy behind me scoff 'fucking Paddies'.

To some extent this story, and the ongoing ethnography of Republic football fans in Birmingham and London of which it is part, echoes the current proliferation of claims for the Republic's success in football as a symbol of paradoxically post-nationalistic national identity in Ireland and throughout its 'diaspora' (Giulianotti 1996). It is argued that, for a European country with a unique history of emigration, largely to Britain since the 1950s (NESC 1991), the presence of second or third generation Irish players in the team forces acknowledgement of a permeability to national and supposedly exclusive *territorial* boundaries. The supporter's (committed and casual) investment of time, money, speculation, self – physically and wherever he/she may be – in the fortunes of the team is a way of rethinking migration as 'diaspora', the spillage of genetically bonded seeds from the nation (Humphries 1994; Bolger 1992). There is a post-colonial dimension, too. The promiscuity and profanity of a football fan *culture* founded on a sport not only of 'foreign' but also of British

imperial origin and manifest in a 'carnivalesque' culture of heavy drinking is easily counter-pointed to a supposedly virginal and sacred 'national culture' blind to the contradictions of its own birth (Doyle 1994; Jones 1995; Dunphy 1994; Cronin 1994).

Undoubtedly Ireland's successes in football have highlighted the 'imagined' dimension to the 'community' (Anderson 1983) of the nation. But do they allow Irish people to see and ponder the contradictions of their national identity or merely reproduce them unconsciously? Do they facilitate the imagination of place-specific variations on the 'diaspora' experience, and the fissures within these variations? How central or incidental *is* football and being a fan to the processes of national identity and introspection that appear to surround it? In post-colonial theorist, Fanon's terms (1967: 175), is it an uncritical acceptance of the most plastic manifestation of national culture in order to escape the 'swamp [of contradictions] that may suck . . . [one] down'? Or is it a way of avoiding both this and his alternative, that is to float terrifyingly above the 'swamp' – 'without an anchor, without a horizon, colourless, stateless, rootless – a race of angels' – by learning to know and live with 'contradictions which run the risk of becoming insurmountable'? This would be akin to em*bod*ying the contradictions but with the territorial freedom of the 'angel', able now to imagine different identities, to see their comparability or their interconnectedness, not least that which lies between both kinds of post-colonial/imperial subject: English and Irish, being Irish ('first' or 'second' generation) in England. This chapter draws on the words and experiences of 'second generation' Irish fans in Birmingham and London to begin to address these questions.

'Second generation Irish' or first generation 'plastic'?

Is the shamrock-struck 'Aldo' a 'plastic paddy' – a term of abuse used by Irish-born fans to indict the nominally 'second generation' with simulating an identity which is incompatible with theirs because it is expressed through cultural forms unconnected with their place of origin (Rowan 1994)? I quizzed one London Irish fan about his 'real' thoughts on Michael Robinson, the extreme case of a player who qualified only because his mother first acquired Irish citizenship via her grandmother. Robinson had told him personally of his son's Irish flag above his bed, yet publicly proclaimed his renewed English identity on retirement. 'There's supposed to be some pride in pulling on the green shirt and all that. I think it's total cobblers. Pride is within someone else's motivation. They're professionals.' The symbol which helps to legitimate Birmingham/London Irish identities is surrendered to a special status immune from critical discussion of players' 'real' national identities because it's a commodified form. It can't be exhausted in one place or torn apart through its contradictions. Like plastic, its internal elements and the nature of their bonds are externally invisible. Whatever the temporary

No

appropriation of segments of inner-city Birmingham, travelling fans have no such protection, and the accusations which emerge on trips indict either supposed irrational caprice or a calculated, patronising form of 'English' post-imperial presumptuousness.

A recent report (Hickman and Walter 1997: 20) which 'corrects' the 1991 British census by multiplying the number of Irish-born by three to account for the 'second generation' is problematic for two reasons in this respect: the inability of statistical correction to impact upon embedded perceptions of ethnic difference purely on the basis of colour or accent; and the voluntarism of 'second generation' Irish identity in Britain given the paucity of institutional cultural frameworks and 'ethnic markers' (Chance 1987). The nominally 'second generation' is placed in a highly ambivalent relationship to Irish identity by a society which considers them non-existent as such. Friction with Irish born fans may simply be a symptom of ineradicably binary national distinction, especially given the colonial past.

Such accusations are facilitated by the plasticity of the commodified form in which the football comes readily packaged, a bone of contention for those who consider themselves to be 'serious' fans. Consider these scenes from the climax to Ireland's Euro 96 qualifying campaign against Portugal (November 1995). The majority of an estimated 20,000 fans went on package holidays to the Algarve rather than direct and solely to Lisbon. Many of the group I accompanied spent the night before their departure playing poker in a 'lock-in' pub, delivered to the airport by taxi with a combination of alcoholic anaesthetic and exhaustion such that the experience of travel would be unfelt as an otherwise affecting experience. The holiday resort, Praia da Rocha, is a purposely constructed mass tourist venue calculated to eliminate traces of interference in the idealised corporeal experience it offers. The hotel resolved the problem of local 'difference' by incorporating elements of Moorish architecture into an otherwise undistinguished structure and providing an exclusive provision of northern European 'cuisine': buffets of roast beef and boiled vegetables, pork stews and sausages or cold meat with plain salads. The infrequency of public transport made excursions beyond the five hour coach or train journey to the match in Lisbon a major inconvenience and there was little evidence of local residence outside the hotels and building sites. Thus both travellers and destination were complicit in the 'travel agent' paradox that it acted principally to eliminate many of the features of pleasure-driven travel, if the latter is understood as cultural enlightenment through the recognition and gauging of 'difference'.

The day trip to Lisbon led first to a tour of back street red light district bars, with which one group member was familiar from a previous trip, before encountering other Irish fans on a main pedestrianised thoroughfare. Interaction with locals was hardly 'carnivalesque', thus supporting Giulianotti's (1996) thesis that, by contrast with their Scottish counterparts Irish fans do not feel compelled to dissolve national boundaries in an effort to individuate

themselves from a popular European image of English football hooligans abroad. A young boy busking with an accordion and 'singing' 'olé olé olé' in a calculated parody of an adopted Irish chant was quickly moved on by fans disposing of their change into his Coke can. A group of Portuguese fans approaching from the ferry port unceremoniously pushed an Irish perfor- mance artist from his upturned crate. Mobile 'dealers' attempted to bargain with seated fans over 'orientex' watches and other bogus brand name goods. As the skies darkened and the rain came we took the underground railway to the Stadium of Light, a vast concrete oval sporting a dome of floodlit, wind swept rain.

In all the milling about at its base our group was split up. A small opening between some barriers at the 'Irish' end seemed to have no function other than delaying supporters. Only one entrance gate to the stadium was open so that a dangerous crush developed. The numerous armed police ignored pleas to open another gate or at least widen the gap between barriers. On entry, no tickets were checked and an onerous 'search' of fans yielded the various umbrellas which had been purchased a hundred metres away. The spiral ascent into the terraced stadium was again slowed by funnelling into a single opening, followed by edging past already tightly packed fans to the more open higher reaches where three columns deep of police separated us from the Portuguese fans.

A combination of rain – thousands, myself included, had no more protec- tion than a shirt, and in one place, four fans huddled under a sleeping bag – heavy handed policing, dangerous channelling of fans, irrespective of whether they had tickets (several of our group hadn't and entered free) – and of course the result, a 3–0 defeat, heightened the inherent irony of 'Always look on the Bright Side of Life', which resounded around the stadium as the vanquished team hand-clapped the fans. During the match itself Irish singing was sporadic and moans about particular players – hapless striker Niall Quinn and defender Alan Kernaghan (brought on at 2–0 down!) – were audible at some distance across the terraces. As the police staggered fans' entry to the under- ground, chants of 'Portugal, Portugal' were hard to distinguish from 'Ooh Aah, Paul McGrath': here was the 'legendary' good behaviour of the Irish fans, bolstered by the news, circulated via mobile phones, that Northern Ireland's defeat of Austria had propelled Ireland into the play-off match against Holland.

The plasticity of the experience was surely exemplified by the failure of promiscuous engagement with local culture and the constraints imposed by the rigid policing, thus directly continuous with Praia. Photography, in this respect, was an interesting motif. One of the fans, too slow to raise a drunken grin for a visiting TV crew, had run after them to try again. The same night another was held for four hours for daring to take a photograph of an armed policeman, the otherwise obligatory sign of the 'carnivalesque' in dissolving hierarchical boundaries, though like the professional counterpart a mode of

reification, of deadening by freezing the moment as permanent and engulfing metonymy. But the plastic and homogeneous exterior concealed to the outsider a degree of heterogeneity within, ironically a function of that plasticity, in turn symptomatic of the magnitude of the occasion and the gearing of Portugal to mass tourist arrivals.

Where identical symbols are freely available, bitter struggles for their meaning are more likely. As we stepped onto the Lisbon Metro the theme from 'Eastenders', a popular British soap opera, was being sung. The singers were fans from Dublin, the joke at the expense of London and Birmingham Irish on the train who were taunting Portuguese fans about their defeat by Ireland in Dublin. Their supposedly unwarranted presence was further kept at bay through a form of mimesis – it was followed by 'Dick van Dyke' cockney accents! As Taussig (1992) argues, mimesis is a primitive way of controlling threatening demons by simulating them. The degree of bitterness involved may well indicate the extent to which the self has already been possessed: the demon caged, 'they then asked each other Man[chester] United trivia questions', the irony of which appeared to be lost on them.

The striking absence of direct engagement between factions here is reflected in parallel incidents in Lisbon and Praia. In Lisbon, 'we're in the hotel and this bloke asks us what we're doing here, probably his first time at a match, and so you start off and . . . the usual. I'm coming out of the toilets. It's him, so I go "how're you doing?" – "You're English!"'

After the return to Praia, on the last night the Birmingham group paid to keep a karaoke bar open all night, nominating each other to sing without forewarning. Local Birmingham club rivalries were strongly implicated in the banter which ensued: the only self-nominated repeat performer, for example, was drowned out with chants of 'Ooh Aah Paul McGrath' (then an Irish *and* Aston Villa stalwart); 'Bluenose' was an epithet for all Birmingham City ('Blues') supporters. While this playful articulation of place and national identity was proceeding, however, there was some disgruntlement among Dublin fans in the bar toilets, a focal point of which was the alleged ease with which England-based fans could get match tickets: the forthcoming play-off match would be in Liverpool. This appeared to be a generalised extrapolation from the England–Ireland match of 1991, following which a Dublin travel agent had publicly expressed discontent at the English FA's distribution of tickets to the London Irish supporters club, according to members of the club itself a goodwill gesture to the Irish community in England. It also conflicted directly with the club's repeated indictment of the Football Association of Ireland for distributing tickets through travel agents and its policy, prohibitive to fans in England, of forcing block bookings for home matches including friendlies. Thus the rift between fans was spatialised, stuck in a pattern of projection, of 'plasticity', but without counter-projection because those on whom 'outsider' status is projected have no recourse to legitimated response – to do so overtly

is to confirm that status as patronising *English* fans appropriating this symbolic moment as just another holiday.

'Birmingham/London Irish': a contradiction in terms?

There are two fundamental ironies embedded in these encounters. The first is that such events, for English-born Irish fans, are an extension of their articulation of collective, localised identity via football. For Irish-born and based visitors they are an extension of the *dis*placement of their identity onto a phenomenon rooted in the English football league. But each is attached to a further irony: that local investment in football cannot be articulated to Irish national identity; and that drawing attention to contradictions invisible to Irish-based fans is taken as a mark of aggressive, post-imperial *English* masculinity!

The first was amply visible on the occasion of a pre-season friendly between (Glasgow) Celtic and 'Blues' (Birmingham City) in July 1995. I attended with a group of second generation Irish/ Blues fans and Irish friends visiting from London. All had a casual interest in Celtic as well. From morning opening, Birmingham's 'theme' Irish pubs, clustered in Digbeth and around a kilometre from the stadium in a direct route from the main railway and bus stations, were speedily filled by visiting Celtic fans. Some of the Irish Blues fans were deeply ambivalent in their attitude to Celtic, as signified by our drinking in a back street pub whose long Irish associations were less nakedly visible to the visitors: 'ask them who they'd support if Ireland was playing Scotland and it'll be Scotland, but they'll be singing [Irish] rebel songs up there all day'.

On the other hand being a Blues fan is not unproblematically compatible with being 'Birmingham Irish' since 'Bluenose', linking the club with Celtic's sectarian Glasgow rivals Rangers on the basis of team strip, is a common term of abuse by Birmingham Irish Aston Villa fans, making an imaginary geographical distinction in a city where the Blues' ground is situated close to the main concentration of Irish born migrants. Unbeknown to us, some 'Blues' fans had made an attack on The Dubliner and a minor fight had ensued outside.

En route to the stadium there was a highly visible police presence on each corner. Within, the Celtic fans filled one end with a sea of green and white and the resounding strains of 'Ooh Aah up the Ra [IRA]' and 'Fields of Athenry'. The remainder of spectators were sporadically located with the exception of a cluster of about two hundred Blues fans immediately below us in the main stand. Towards the end of the first half they unfurled a UVF flag, clearly in order to provoke the Celtic end. A row of sideline press photographers spun round and the club chair, Karen Brady emerged to calm things down. The walk back to Digbeth was a hot and sweaty journey through dual

carriageways, roundabouts, under railway viaducts and past empty factories and warehouses. None of the pubs appeared to be open:

— 'it's like Sunday here'
— 'at least Worcester has pubs'
— 'one pub'
— 'one pub in Worcester, there's only one pub in Worcester'
— 'yeah and none in fucking Birmingham!'

It was only through familiarity with a barman that we were able to re-enter, though not together, the pub we had started from, the curtains in which were closed. This was a frustrating day for the Birmingham lads, not least because one of the conversations which ensued concerned *what* they were. Tommy, a Dublin born Londoner insisted that they were straightforwardly Irish but the response was that they were not, that they were 'Birmingham Irish' (Figure 13.1), though this was a verbal assertion which, as the day's events demonstrated, could not be dramatised through a specific cultural form, literally confined to a back street pub. In effect it was a 'double bind' (Bateson 1972): to be 'true' to oneself is to anchor cultural/national identity in the local. In attempting to do so, however, either one or other is destroyed or their polarity is confirmed: silent witness on the 'Blues' stand, combined with invisible and outwardly inaudible arguments refuse the terms of the bind rather than resolving what is in effect a 'power geometry' (Massey 1993) which fixes subjects at various points or forces them to circumvent the pattern entirely.

As to the second irony there is a peculiarly *sexual* dimension to stories of encounters between fans: 'sexual' rather than 'gendered' because of the clustered sub-themes of taboo, morality, corporeal attraction and invasion, and em*bodied* hierarchical power which become 'articulated' to those of colonial invasion. Thus Pat, from Hemel Hempstead, tells of how a possibly apocryphal story of an Irish fan having sex with a local 'in a bar on top of a table' in Denmark – published in the Irish *Sunday World* paper in 1984, with the implication 'that they weren't Irish fans, that they was English' – resurfaced two years later in an argument with a local in Dublin about the right of the 'second generation' to use the label. On using their attendance at the match against Scotland as empirical evidence, his London-born girlfriend was forced into reluctant resignation at the retort, 'don't start telling us you fucking London Irish, I read about you in the *Sunday World*'. National 'difference' is rhetorically marked by the alleged subordination of 'legitimate' partisan competitive motivation and corporeal application to sexual promiscuity, and a conversely metaphorical condensation of national purity and identity into corporeal and sexual purity. 'Diaspora', the literal dispersal of seeds, is only acceptable if neither the seed nor the place of its arrival is corrupted. This 'articulation' (Hall 1996) of the discourses of scandalous promiscuous sexu-

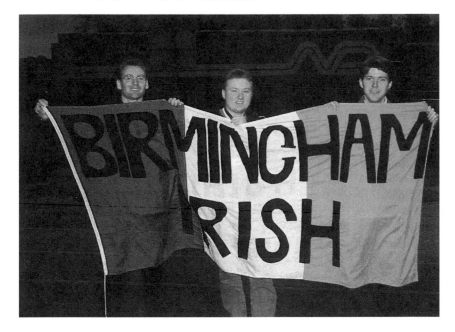

Figure 13.1 Birmingham-based Republic of Ireland fans display their allegiance

Source: Reproduced by permission of the author.

ality, and scandalous tourism through the corruption of place, conjures up a colonial image of conquest as sexual invasion: 'London Irish' signifies the corruption of both the seed and its occasional destinations.

A standard focus of the prior 'corruption' through place in these stories is the acquisition of an English accent, in the tale of sexual encounter it is a frequent guarantee of metaphorical *coitus interruptus* for 'second generation Irish' men. Hence Bob's (Birmingham) tale of ironic tension between the stereotypical embodiment of the diaspora ('looking Irish') and the marker of environmental influence ('accent'):

> in Romania, we're in this bar and these Irish relief workers come up
> to us and say 'well we could see you were Irish lads, just looking at
> you'. You're fine if you don't open your mouth, then it's 'but you're
> English!', and you have to go through the whole story . . . 'well, my
> parents are Irish and . . . ' but you're wasting your time.

Not even recourse to sarcasm will reverse this place-specific corruption: 'it's like "yeah, I've spent hundreds coming to one of the piss-poorest countries in Europe to watch an Ireland match 'cause I'm English!" I'm some fucking tourist, I am!' The sarcastic extension points, by enacting it, to the

tacit implication in the original exclamation, that his inappropriate appearance here is a sign of presumptuous 'English' arrogance whereby Irish identity may be co-opted when convenient and in any setting. Perhaps the implication is not so wildly misplaced as, to the annoyance of this same group of fans, several of their self-avowedly 'English' friends were able to rehearse their Irish 'roots' to strategic effect in pursuit of 'Irish-American' women during the US '94 tournament. Whereas the latter might entertain a diasporic connection, however, the same could not be said of temporary Irish migrants without comparable investment in their destinations.

A minor schism was caused in this extended group of friends when a wedding was scheduled in Birmingham to coincide with the Ireland–Romania match in Dublin in October 1997, with the 'stag weekend' in Dublin two weeks beforehand: 'a bunch of English fucking lager louts, that's what we'll look like, marauding around Temple Bar on the piss'. At root here is a reflexive horror of being mistaken for a stereotypically 'English' form of post-*imperial* aggressive masculinity in a setting where protestations to the contrary were unlikely to be heeded. Perhaps more significant, though, is the disavowal and outward projection of this as a set of 'English' national characteristics. It nonetheless remains in their friends as a ghostly shade waiting to materially colonise themselves, especially given the ritual divestment of childish (and Irish) things through the stag rite of passage.

Masculinity, though, is not a fixed state, but through its contradictory articulation to nationality and national identity a variable quality for these fans. Peadar (Birmingham) describes a disastrous sole relationship with an Irish born woman on a visit to Dublin. Greeted suspiciously by her father as an unwelcome invasive presence, 'on the Sunday morning I said I'd be down at the [local pub] . . . if he wanted to go for a pint. . . . So he never came and when I got back to the house they were all eating their dinner so it was like "well where the hell were you?"' Despite conforming to a customary pre-Sunday dinner drink, a routine among the male members of his Irish family and friends in Birmingham, and common enough in Ireland, he has found himself construed as an arrogant and alien *English* presence first delaying and then interrupting a symbolic family gathering, excluded, but with the blame for exclusion projected onto himself. Yet in another story his alien presence and unfamiliarity with the location – 'before the England–Ireland game in Dublin [1991] . . . we were walking up and down O'Connell Street looking for tickets' – license easy dismissal by 'these two young girls, only that height . . . "what are youse lot doin with your Ireland colours on, you're fuckin' English" . . . They were too young to even bother listening' as they walked away from his explanation. The prior existence of an inviolate 'explanation', the accent as indelible marker of 'difference' makes both the 'possession' of 'English' masculinity by definition an aggressive intrusion *and* a paradoxical form of emasculation when it masks an awaiting but invalidated narrative of familial migration and complex linkage of nationally confined *places*.

In a further twist to this paradoxical narrative, while struggling towards Wembley on crutches for the return leg of this qualifying series (for the 1992 European Championship in Sweden), Peadar was nearly thrown into passing traffic by an acquaintance, a drunken England fan from Birmingham whom he had asked for help: not only are English birth and Irish identity doubly incompatible, but the hierarchical status of one's masculinity is context specific and contradictory. Masculine identity may be subject to 'contingency' (Connolly 1991), but variable only according to structural and historical constraints.

Being in two places at once: the politics of irony

So how do Birmingham or London Irish fans deal creatively with their nominal but immaterial places within the 'diaspora', given that 'plastic' in this context connotes only synthetic construction and manufacture rather than flexibility? A key feature of the way in which these fans discuss themselves is the use of irony and this stems from incongruous *experience*. The term 'master-racer', often used to describe Irish-born fans, is a way of re-placing in the perpetrator those characteristics – of presumptuousness and superiority – projected on themselves as supposedly unproblematically *English* tourists. It highlights the ways in which to them Irish national identity has become an exclusive preserve, a post-colonial defensive fortress rather than a post-nationalistic umbrella. But irony needs to be experienced, and for second generation Irish an aspect of this entails metaphorically walking in their parental footsteps, experiencing for themselves, through leisure rather than migrant labour in a foreign country, the construction of the self in terms framed by another. For this realisation that identity does not possess free-standing, immanent qualities, is the mark of a *post*-colonial consciousness. This may take different forms.

Thus at Praia it was noted that the owners of 'Foley's Bar', advertising itself as an 'Irish pub', were actually English, possessing no Irish connections at all, and that the canvas sign displaying the name 'Paddy's Pub' over another bar had been hastily erected (the bar had at least two other names visible on the front and side): 'but that's typical, you know, you put up a sign like that and all the paddies flock in', Jim said as we walked through the entrance. On a rare collective stroll through the town which revealed that there really was very little other than bars and hotels, a teenage boy working on a building site was waving two fingers at us. Stephen remarked that he was 'either telling us to fuck off back to Ireland or that we're going to get stuffed two–nil'. More proactively at an Ireland–Malta match in Valetta in 1989:

> the Maltese . . . started coming out with bricks . . . throwing stones . . . and you couldn't watch the game 'cause you were forever looking the other way, ducking and diving . . . and then, after about

five or ten minutes the Irish fans all started singing 'we love you Malta, we do' . . . and it took the heat out of the whole situation, you wouldn't believe it.

Now this might be read as an example of Goffman's 'front region' (1967), a collective, calculated 'impression management' in accordance with the supporters' club's explicit instructions to members and tightly policed by members themselves. As Peadar noted of a different occasion, in the Italy World Cup of 1990, a group of younger fans who had taken a long route downhill over the roofs of cars were warned of beatings by their elders. But in this case who is the 'good behaviour' for? This is a form of playing the 'fool', a comedic category in which, by *playing* the innocent he survives and thrives, preserving by reserving integrity which outright innocence would deny. It is a kind of self-'vulnerisation', a self-wounding or submission to potential wounding, made possible and safe because the full implications of the wounding are not *actually* materialised. The blurred boundary between innocence and calculation makes precise designation impossible.

Such cases are ironic, rather than paradoxical in nature, because paradox is a contradiction, obvious meaning coexisting with its inverse, whereas irony more subtly and suggestively suggests the presence of some other, not necessarily opposite, meaning whose affective power to confound lies in the possibility that it may inextricably, organically be part of that more obviously foregrounded meaning (Hutcheon 1994: 62). Thus it is both 'self-protective' through ingratiation but also 'ludic', making the identity and orientation of the originator the objects of a guessing game (Hutcheon 1994: 47–50).

A recurrent theme in many of the interactions (and second-hand accounts of such interactions) with 'local' people that I have witnessed is a delight in failure of communication as a result either of childish mis-recognition of meaning or ambiguity of self-expression. This casts the visitors as some kind of intermediate category between the innocent and the 'fool' who plays the innocent. Witness this story concerning a hangover-marred excursion to Graceland, Memphis during the 1994 World Cup:

> they bring you round in little groups . . . and you don't really ask many questions, you just listen to them doing their job and telling you Elvis lived here at a certain age, and his parents own this and all of this kind of thing and this girl said 'Has anybody got any questions?', and I said to Nick 'Ask em where Elvis' toilet is', so he says 'where's Elvis' toilet 'cause we're absolutely dying?' and everybody's rolling round in stitches.

In this case the humour hinges on the tension between the *possible* innocence of the question and the equal possibilities that it is a kind of star fandom taken to absurd extremity (the desire to see Elvis' ignominious

deathbed) or a send-up of the guide's worshipful tour of the King's intimate details. In another favourite (possibly apocryphal or exaggerated) anecdote from America, Peadar and friends, garbed in Ireland football shirts, were asked if they were the national team by an air stewardess on an internal flight. Following their confirmation the pilot invited a round of applause from passengers and wished them good luck in coming matches. As Peadar wryly noted, 'Looking at the state of us after a week of solid drinking – I mean Brian's in his fifties, maybe they thought he was the manager or something – you know, we were going to need it! [. . .] You'd wonder, like, if it was any other country would she even think of that.' The characteristic delight in their team's (here indirect or implied) dismissal as no-hopers intersects with the irony of their projection as supporters into the team itself and the inability to distinguish among them as first or second generation Irish. In effect, in their projection into the team they have projected themselves into their own parents' shoes, playing them in their absence and preserving the features of their marginalisation, though in such a way that its comic nature also preserves their integrity because the comedy of the fool smudges the boundary between parties in power relations and makes dual the direction of laughter.

Travelling to international football matches certainly risks the heightening of tensions with fans from Ireland and makes stark the anomalous position of the 'second generation' in England. But reclaiming the 'comic Irishman' isn't simply a form of 'plastic paddying' at once desperately defensive and patron-ising of their 'Irishness'. As Waters remarks of the nineteenth century 'stage Irishman', to which these stories and performances are akin, while he was always the 'boy', ultimately contained by relations of authority, permitted to play – but only insofar as he 'confirmed the stereotype of the happy, child-like indolent Celt' (1984: 55) – he could never quite be fixed by the stare or the language of his English 'betters', there was always some excess.

To play the fool is to recapture this romantic account of the colonial Irishman who exceeds both English discursive designations and the insular designation which persists in Ireland, despite its post-colonial pretensions. In doing so, second generation migrants periodically and without being swamped by the contradictions may give body to the 'angel' born of a colonial construction and which continues to haunt themselves via their parents' uneven experiences of being Irish in England. It is a way of metaphorically being in two places at once, imagining by re-enacting the marginality of Irish identity in Britain through its history of migration while technically being British citizens, so realising the ironic nature of that citizenship.

When Bob was ten, he told his father that 'if you don't like it here [Birmingham] you can fuck off back to Ireland'. *En route* to Liverpool in December 1995 for Ireland's play-off against Holland for the Euro 96 finals, his 'Birmingham Irish' flag was flying from the car window: 'this'll show these

English fuckers'. When I pointed out that we were getting nothing but honks of support from passing traffic he muttered 'patronising bastards!'

Bibliography

Anderson, B. (1983) *Imagined Communities: Reflections on the Origins and Spread of Nationalism*, London: Verso.

Bateson, G. (1972) *Steps to an Ecology of Mind*, New York: Ballantine Books.

Bolger, D. (1992) 'In High Germany', in D. Bolger, *A Dublin Quartet*, Harmondsworth: Penguin.

Chance, J. (1987) 'The Irish in London: an exploration of ethnic boundary maintenance', in P. Jackson (ed.) *Race and Racism: Essays in Social Geography*, London: Allen and Unwin.

Connolly, W.E. (1991) *Identity/Difference: Democratic Negotiations of Political Paradox*, Ithaca, NY: Cornell University Press.

Cronin, M. (1994) 'Sport and a sense of Irishness', *Irish Studies Review*, 9: 13–17.

Doyle, R. (1994) 'Republic is a beautiful word', in N. Hornby *My Favourite Year*, London: Gollancz/Witherby.

Dunphy, E. (1994) 'A law unto himself', *Sunday Independent World Cup 1994 Supplement* 12 June: 3–6.

Fanon, F. (1967) *The Wretched of the Earth*, Harmondsworth: Penguin.

Giulianotti, R. (1996) '"All the Olympians: a thing never known again?" Reflections on Irish football culture and the 1994 World Cup Finals', *Irish Journal of Sociology* 6: 101–126.

Goffman, E. (1967) *The Presentation of Self in Everyday Life*, Harmondsworth: Penguin.

Hall, S. (1996) 'On postmodernism and articulation: an interview with Stuart Hall', in D. Morley and K. Chen (eds) *Stuart Hall: Critical Dialogues in Cultural Studies*, London: Routledge.

Hickman, M. and Walter, B. (1997) *Discrimination and the Irish Community in Britain*, London: Commission for Racial Equality.

Humphries, T. (1994) *The Legend of Jack Charlton*, London: Weidenfeld and Nicholson.

Hutcheon, L. (1994) *Irony's Edge*, London: Routledge.

Jones, M. (1995) *A Night in November*, Dublin: New Island Books.

Massey, D. (1993) 'Power-geometry and a progressive sense of place', in J. Bird, B. Curtis, T. Putnam, G. Robertson and L. Tickner (eds) *Mapping the Futures: Local Cultures, Global Change*, London: Routledge.

National Economic and Social Council (NESC) (1991) *The Economic and Social Implications of Emigration*, Dublin: NESC.

Rowan, P. (1994) *The Team that Jack Built*, Edinburgh: Mainstream Publishing.

Taussig, M. (1992) *Mimesis and Alterity: A Particular History of the Senses*, London: Routledge.

Waters, M. (1984) *The Comic Irishman*, Albany, NY: State University of New York.

Part V

FOOTBALL BOUNDARIES
Regulation and the place of fans

14

WHEN THE WRIT
HITS THE FAN

Panic law and football fandom

Steve Greenfield and Guy Osborn

> Take away the fans' freedom of expression and there is not
> much purpose in playing the game as a spectator sport. J.B.
> Priestley's description of a football crowd still applies: ' . . . all
> brothers together for an hour and a half . . . cheering together,
> thumping one another on the shoulders, swapping judgements
> like lords of the earth . . . '. Do that at Old Trafford and you
> might fall foul of Ned's Army; Ned Kelly that is, Manchester
> United's head of security and no laughing matter.
>
> (David Lacey, *Guardian* 27 September 1997)

Football and football supporters have been the subject of a number of legisla-
tive provisions in the past, many of which have been direct responses to tragic
incidents, in particular those resulting from the Taylor Report that followed
the Hillsborough disaster.[1] The introduction of the Criminal Justice and
Public Order Act 1994 (CJA 1994) was controversial for many reasons, not
least the abolition of the accused's right to silence and the introduction of
secure training orders, but perhaps surprisingly there are also a number of
potential ramifications for football supporters that this chapter examines.
There was well publicised dissent from a number of groups such as hunt sabo-
teurs and ravers that had been singled out for treatment by the legislation but
the effect on football fans has perhaps been largely overlooked. In fact, in
terms of football legislation the passing of CJA 1994 is merely the culmina-
tion of a number of provisions that have effected football many of which have
been created during a climate of moral panic.[2] The overall effect of all these
provisions has been to seriously challenge the civil liberties afforded to
supporters wishing to watch the 'beautiful game':

> As means of regulating and controlling the participants of cultural
> industries, the restriction of a person's civil liberties, like censorship, is
> one of the most basic. Football supporters suffer more than most

participants in cultural industries from this form of control . . . [t]his is the day to day reality of being a football supporter. The increase in the last ten years of legislative and security measures that are available to police, clubs and stewards, has been dramatic, reflected by its impact on the civil liberties issue.

(Brown, A. 1994: 2)

The ineffectiveness of some of the previous panic measures suggests that those contained within the CJA 1994 may well, in the long term, prove to be as equally ill conceived. Recent years have seen a steady decline in sporting autonomy at the expense of legal intrusion (Foster 1993) and it is this ideological shift that has also produced state intervention in the game. The post-Heysel/Bradford/Hillsborough landscape has embraced identity cards, specific 'football' legislation, judicial inquiries, and other attempts to tackle 'the hooligan problem' as well as safety issues. It has been observed that the game of football has in fact been subject to state regulation from some of its earliest incarnations (Murray 1994) although it is the Conservative governments of the 1980s and early 1990s that can take the credit for the legal terrain that now pervades football fandom.

The Conservative governments and football regulation

It was primarily the football disasters of the 1980s that led to calls for, and subsequent increased regulation of, the game. Legislation was promoted in a number of distinct areas covering the availability of alcohol at matches, the structure of grounds and the question of membership schemes. The seemingly inexorable rise of the football hooligan culture throughout the 1970s and 1980s was also a strong feature that provoked government action, though it was far from clear how this burgeoning problem could be contained. The late 1970s saw an added political dimension to the hooligan problem with links to groups such as the National Front and the more hard line British Movement, and there is evidence that elements of the far right (such as Combat 18) still have some influence with respect to football hooliganism (see Greenfield and Osborn 1996b).

The political impetus for tackling 'football' was a riot at Luton Town football club involving Millwall supporters which led to Luton Town introducing a home members only scheme for fans which disbarred away fans from attendance (Williams et al. 1989). The government response was to establish a 'war cabinet' on football hooliganism with the question of attendance at matches the central bone of contention. In Popplewell's Interim Report (1993),[3] it was argued that a membership scheme could contribute to the solution:

Experience will no doubt show what in practice is the best scheme to retain the desirable and exclude the undesirable. *I therefore recom-*

mend that urgent consideration be given by football clubs in England and Wales to introducing a membership system so as to exclude visiting fans.

(Popplewell 1985: 6.48)

However, the Government responded to what it perceived as football's other internal problems before even this Interim Report was released. This intervention was to deal with what it saw as the contribution of alcohol to the problem by introducing legislation to make it an offence to be drunk or to possess alcohol on football coaches, on entry to grounds and in most areas of grounds (*Hansard HC* 3 June 1985, Col. 21). Ironically, this particular piece of legislation the Sporting Events (Control of Alcohol etc.) Act 1985 (SEA 1985) was initiated in the light of the events of May 1985 yet at all three of these games no alcohol could be purchased. In fact as was later identified, the major problem was not so much consumption of alcohol *at* the ground but *before* matches, so in many ways it is preferable to allow the supporters into the ground earlier thus avoiding the situation where fans arrive in large numbers close to kick off. The final report of Popplewell (1986) observed that the financial effect on clubs through lost revenue from alcohol was very serious, Manchester United's loss of income from executive boxes for example was projected at over £500,000. The Act was amended through the Public Order Act 1986 (POA 1986) to establish 'a new regime for the sale and possession of alcohol in executive boxes and restaurants'. Commenting on the changes Tom Pendry MP pointed out that the original provisions had not been properly thought out:

> It is no secret that on the Second Reading of the Sporting Events (Control of Alcohol etc.) Act, I said that I felt that both the Government and my front bench had overreacted to the terrible tragedies at Brussels, Birmingham and Luton. . . . Unfortunately the flow of money from executive box holders, which would enable clubs to do all the things that the Prime Minister and the Minister of State wanted, including improving safety standards, was drying up fast.
>
> (*Hansard HC* 30 April 1986)

Whilst the SEA 1985 sought to regulate the link between football and drinking, Taylor (1990) pointed out that drink was not a major factor for the group of 'serious hooligans'. More problematic is the application of the provisions that render it unlawful to enter, or try to enter a designated sports event whilst drunk. If the officer arrests the fan, the officer will be away from their position for some time whilst the fan is processed, and other potentially more serious matter may go 'unpoliced' in their absence. In addition, the provisions themselves have proved problematic and worryingly all-encompassing. The legislation allows the police to arrest supporters in the belief that they are drunk without needing any supplementary proof, such as a breath or blood

test: therefore, theoretically someone who had had beer spilt on them and had not been drinking could be caught under the legislation with little or no chance of appeal against any subsequent action.[4]

The government continued to look at ways of regulating fandom and the deliberations produced the embryonic Football Spectators Act 1989 (FSA 1989) which provided the framework for a national membership scheme under the auspices of the Football Membership Authority. In addition Part I of the Act also established a body, the Football Licensing Authority, to be responsible for licensing grounds. However the Bill was overtaken by the tragic events at Sheffield Wednesday's Hillsborough ground when during an FA Cup semi-final match on 15 April 1989 ninety-five Liverpool fans were crushed to death in the Leppings Lane end of the ground (the subsequent death of Tony Bland took the toll to 96). On 17 April 1989 Douglas Hurd (Secretary of State for the Home Office) announced that Lord Justice Taylor had been asked to chair an inquiry into the disaster 'to inquire into the events at Sheffield Wednesday football ground and to make recommendations about the needs of crowd control and safety at sports grounds'. Hurd posited that notwithstanding Lord Justice Taylor's involvement a wider view needed to be taken embracing a strengthening of the Football Spectators Bill. Many commentators found it both surprising and disturbing that while the Taylor Committee was still hearing evidence, Parliament was debating a Bill that would have a profound effect on some of the very issues that Taylor was examining:

> The events of Hillsborough on that dreadful day in April cast shadows far and wide and into the hearts and minds of the whole nation. To seek to progress this Bill in the midst of such awful, horrific and unbearable tragedy for the bereaved, the injured, the emotionally damaged, the clubs, the players and the cities of Sheffield and Liverpool seems to be to be an act of unspeakable obscenity. To intrude Parliament and Parliamentarians into such enormous, unbearable grief is an exercise of monumental insensitivity. To do so demands an imperative of overriding priority. It demands progress with this Bill at a time when the evidence of what happened on that awful day has still to be gathered, let alone evaluated. It places a priority on speed before all else.
>
> (Lord Graham, *Hansard HL* 16 June 1989)

Such dissent was even seen within the Tory ranks in the Commons but despite this the Bill was passed. However, the whole question of any membership scheme was rendered obsolete by Taylor's Final Report where he noted that:

> I have grave doubts about the feasibility of the national membership scheme and serious misgivings about its likely impact on safety. I also

have grave doubts about the chances of its achieving its purposes and am very anxious about its potential impact on police commitments and control of spectators. For these reasons, I cannot support the implementation of Part I of the FSA.

(Taylor, Lord Justice 1990: para. 424)

Accordingly Part I of the FSA 1989 was not implemented.[5] Taylor was concerned that the technology would not prove adequate which would have serious safety implications. If the government had waited the six months until the Final Report was delivered, this ill thought out provision would not have entered the statute books. Whilst Taylor criticised some aspects of the government's football legislation, he did recommend that racist and obscene chanting should be made a separate offence and The Football (Offences) Act 1991 (FOA 1991) sought to implement this recommendation. His concern was that the Public Order Act 1986 did not adequately cover incidents involving chanting of a racist nature as it required that there be an identifiable victim. However notwithstanding that this was undoubtedly a progressive step, it was still centred upon the potential risk to public order rather than the social unacceptability of racism. Furthermore, this section of the Act was somewhat emasculated by the definition of racist chanting as 'the repeated uttering of any words or sounds in concert with one or more others' (for a fuller discussion of this legislation, see Gardiner, this volume).[6] The FOA also criminalises encroachment onto the field of play and the throwing of missiles onto the pitch, both of which perhaps need to be seen in conjunction with the provisions of the CJA 1994.

Football as deviancy: another folk devil

Many of the provisions of the CJA 1994 have the *potential* to affect football fans in a generalised fashion such as the those relating to right to silence, the taking of samples etc. Other sections have ramifications for football fans *specifically* (ticket touting) or have applications that may impinge upon football fandom more than might have been expected. In particular, the provisions relating to stop and search, intentional harassment and peaceful demonstrations all may effect the way in which fans can 'consume' and enjoy football or protest about the way the game or their club is being run.

Concomitant with the reactions to the apparent crisis in football of the 1980s, there has been an increasing optimism about the current state of the game. Indeed the whole structure of football is, at the highest level, unrecognisable from the low point of the mid-1980s. Attendance figures have continued to rise over recent years and whilst the figures are not high by comparison with post-war attendances (77 million in 1949–50 down to around 20 million in the late 1980s) they must be seen in the light of the shift towards all seater stadia and the consequential decrease in ground capacities. Whilst attendances have

increased, arrest figures have oscillated somewhat. The figure for the total arrests over all four divisions was 3,840 in 1994–5, whilst the figure fell to 3,437 for the following season.[7] However, fears that these arrest figures would escalate in the face of these new provisions have proved to have some limited grounding with the total arrest figures for 1996–7 rising to 3,577, an increase of some 4 per cent on the previous season. It should be noted, however, that this figure represents just 0.016 per cent per match attendance of that season. A crucial element with respect to many of the potential offences at the point of entry to the ground and throughout the game is the replacement of police officers by club stewards. This will clearly contribute to the number of arrests with ejection the preferred (and easier) form of penalty; it may well be the case that with a 'traditional' police presence the number of arrests would be considerably higher. Similarly much will depend on whether the policing that exists is proactive or not, evidence of touting in particular is relatively easy to gather yet may at some matches have a low police priority.

In the area of ticket touting, the National Football Intelligence Unit reported that arrests increased from 47 in 1993–4 to 224 in 1994–5 and it is this, the only football *specific* provision in the CJA 1994, that will be dealt with first. Ticket touting was identified in the aftermath of the Hillsborough disaster to be a serious matter that potentially led to disorder at games (Taylor, Lord Justice 1990, para. 275). A clause was drafted for the Criminal Justice and Public Order Bill to account for the recommendations that Taylor proposed and the scope of the section was heavily debated in both Houses. Foremost in the initial debates was whether the offence should embrace other entertainment events rather than be specific to football.[8] Central to the debate that surrounded the enactment of this clause was whether it was an issue of criminality or purely a safety measure. This was further complicated both by the fact that many corporate hospitality packages may well contain an element of ticket inflation and that the practice of touting is a prime example of the economics of supply and demand, a principle close to the ideological core of the Conservative government. The House of Lords considered the provisions and an attempt was made to make a 'logical extension of the legislation to cover all sporting events at which more than 6,000 tickets are sold' (*Hansard HL* 20 June 1994). The government line continued to be that the section was designed purely to deal with the football/public order problem, a view Lord Donoughue took strong issue with:

> There is much evidence that ticket touting has been taken over by professional criminals in other sports. It does not mean that all other sports are identical to football; we are not saying that it is an identical problem. This problem takes a different form in different sports. But the common element is the criminal element. The sporting bodies have documented the tactics used by touts to get tickets. Their actions regularly include fraud, theft, deception, forgery and intimi-

dation. Those involved are often organised into Mafia-style gangs; and to obtain tickets they steal in the post, they mug ticket holders in the street and steal from the hands of children. . . . Ticket touting is a public order issue, not just in relation to football. There is evidence from the Police Federation that the police are concerned at the growth of criminality, at the extent of public nuisance involved and that under the present law they can do little about it. The answer is not a jumble of self-regulation, growing up in various sports intro- duced by various governing bodies and backed by private security agents. That is not desirable and not effective. . . . There is in my view no logical or practical distinction between the criminals who tout tickets at Wembley and the gangs – so far legal – who tout at Wimbledon, Twickenham, Lords or York Races.

(*Hansard HL* 20 June 1994)

Lord Donoughue's amendment was eventually accepted allowing a provi- sion to be inserted into the Act to provide the Secretary of State with the ability to extend the provisions by statutory instrument to cover other sporting events. Still at issue was the ambiguity concerning who was covered by the provision. Lord Mostyn made the point that if he were to offer a ticket that he had purchased to another member of the Lords in a public house because he was unable to go he would according to the Act be committing an offence, a point that Tom Pendry MP took up during the third reading:

How will [the Minister] protect the ordinary, honest fan from possible prosecution if he buys a ticket for a friend? As the Bill stands the fan who asks a friend to buy him a ticket in advance and then pays for it at face value on the train to a match or in another public place will be asking his friend to commit an offence. I am sure that this is not the Minister's intention, but what direction will he give the police and the courts for such circumstances? These measures are designed to protect genuine sports fans; there should be no possi- bility, therefore, of their suffering as a result of the measures.

(*Hansard HC* 20 October 1994)

Whilst the government responded to this point by saying that the law would not catch people such as those who buy a ticket for a game and who, once finding that they cannot go, pass the ticket to a friend; 'The clause prohibits the unauthorised sale, or offer for sale, of a ticket in a public place, a place to which the public has access to, or in any other place if the sale is in the course of a trade or business. The aim is to prevent the professional ticket tout but not, for instance, to make it illegal for someone to sell on a ticket to a friend or relation' (November 1994 Westminster Strategy Report, Government Media Relations Department). The CJA 1994 s166(1) now

provides that: 'It is an offence for an unauthorised person to sell, or offer or expose for sale, a ticket for a designated football match in any public place to which the public has access or, in the course of a trade or business, in any other place'.

However, since this came into force in November 1994 there have been some overly literal applications of the section. In March 1995 three Birmingham City fans were arrested at Wycombe for attempting to sell a spare ticket at face value outside the away end. One of the fans was a season ticket holder and stood to make no profit from the transaction, yet he was still arrested before the match and held in custody for some eight hours. Even more ludicrously, the *Stoke Evening Sentinel* reported the case of a 10 year old Stoke City fan who won a ticket for their game against Millwall. He was unable to go to the match and tried to sell his ticket (face value £11.00) for £7.00 in a local paper. His father was rung up by a club official and informed that the club would be passing the details on to the police. Whilst the enforcement of the ticket touting provision has caused problems, the ticketing arrangements surrounding Euro 96 proved a Foucauldian nightmare.

Ostensibly the first occasion for thirty years where the British public was to have the chance to see some of the world's greatest players compete, 1.5 million tickets were made available with elaborate safeguards in place to prevent tickets falling into the 'wrong' hands. Applications were limited to four tickets per person per group game, each ticket would bear the name of the purchaser and the tickets would not be sent out until a couple of weeks before the tournament in order to prevent a black market forming. Ticket applications had to be made from a British address with foreign fans expected to apply via their own Football Associations. Whilst it seemed that all sensible precautions had been taken, in the months before the tournament the first seeds of disquiet began to be sown (Corrigan 1996). 'Operation Portent' saw a number of arrests for alleged unauthorised sale of tickets via hospitality pack-ages although it later appeared that FA permission had been given to sell these tickets. In early May it emerged that more tickets were to go on sale for key games and reports began to surface that segregation would in fact be impos-sible notwithstanding the carefully laid plans of the FA. During the tournament this proved not to be a major problem; tolerance and friendship were the byword and fears that the mass migration of tickets in the later stages would force the police to operate CJA 1994 s166 in a draconian fashion were assuaged by England qualifying for the semi-final, coupled with a largely non-interventionist policy on the part of the police. The main problems with respect to tickets were in fact caused by a series of administrative blunders that caused among other things, partially filled stadiums with fans locked outside, tickets not arriving and confusion about how and where to buy tickets. For some games tickets were also widely available on the (saturated) black market at a fraction of the cover price. Since Euro 96, it has been apparent that 'touts'

are still plying their trade at profitable matches, although at times a little further from the ground.

In terms of the CJA 1994, the other provisions which may prove most relevant are those relating to stop and search, trespassory assemblies and intentional harassment. Football fans have long been subject to being searched at football matches, often as a condition of entry. The CJA 1994 s60 now provides that: 'Where a police officer of or above the rank of superintendent reasonably believes that, (a) incidents involving serious violence may take place in any locality in his area, and (b) it is expedient to do so to prevent their occurrence, he may give an authorisation that the powers to stop and search persons and vehicles . . . shall be exercisable at any place within that locality for a period not exceeding twenty four hours.'

Even before the section came into force there was evidence that fans were being arbitrarily stopped and held to prevent them from attending at football games. The new section further creates the risk that the powers will be used disproportionately towards certain groups; Football Fans Against the Criminal Justice Act (FFACJA) argue that football supporters are one of these groups. FFACJA cite for example the case of Cardiff City fans travelling by coach to a game with Plymouth Argyle, who were stopped by a road block on the way to the game, strip searched and taken to three separate police stations and held for seven hours (thus missing the game) before being released without charge. In fact this incident took place before the new section 60 powers came into force, FFACJA feeling that: 'Police already tend to pick on fans unnecessarily and this will give them more powers to harass us . . . no-one likes being stopped and searched and my fear is that people will react badly, even violently' (Brown, M. 1994). Similarly 150 Manchester United fans were detained by the Metropolitan Police for two hours before a match with West Ham in 1995; the police in riot gear took photographs and names and addresses before releasing the fans, with subsequent reports of supporters detained that day being 'recognised' by officers of other forces and questioned.

A similar response can be seen in the provisions relating to aggravated trespass and trespassory assembly contained within sections 68 to 71. These sections were designed to deal with 'deviant' groups such as hunt saboteurs. There has however been criticism of the provisions as they are broad enough to embrace situations not directly intended by the government. For example, under CJA s68 aggravated trespass is committed if a person:

> trespasses on land in the open air and, in relation to any lawful activity which persons are engaging in or are about to engage in on that or adjoining land in the open air, does there anything which is intended by him to have the effect:

(a) of intimidating those persons or any of them so as to deter them or any of them from engaging in that activity,

(b) of obstructing that activity, or

(c) of disrupting that activity.

This in theory could easily catch the type of peaceful demonstrations at football grounds that have been used increasingly frequently in recent years to protest about the Board of Directors or about other issues such as the implementation of a bond scheme (see Brown, this volume). Certainly, as we have argued elsewhere (Greenfield and Osborn 1997), these provisions would have had a marked effect on the successful 'Stop the Seventy Tour' campaign. Finally the CJA 1994 s154 creates a new s4A in the Public Order Act 1986, originally intended as a further tool to combat racial harassment, although the issue of race is surprisingly not included within the statutory provision:

> There is a risk that in one respect [this section] may be inappropriately wide. It covers any kind of threatening or disorderly behaviour or abusive or threatening written words; and it could be a one-off incident because the new clause does not specify that the behaviour has to be repeated.
>
> (Lord Irvine, *Hansard HL* 16 June 1994)

Part of the ritual pleasure of being a football fan is to be able to admonish, criticise, and shout in support of your own side whilst maintaining a degree of abuse and derision for the opposition throughout for the game. The problem encountered by the vagueness of this section is that it does not discriminate between the use of abusive or racist language (already catered for under FOA 1991) and 'mere hyperbole' and comments/actions that may still alarm or distress other parties.

In tandem with such restrictions is the attempted strict adoption by clubs, stewards and police of the 'all seated' requirement in the top two divisions in English football, a rigid enforcement of which has been seen at grounds such as Manchester United's Old Trafford in the 1997–8 season, with forty-one expulsions at the first home game for 'persistently standing'. Similarly there have been attempts to prevent the Sheffield Wednesday 'Owl band' from performing at away games and a number of other instances of heavy handed and ill thought out reactions to football fan culture. Such examples provide further evidence of an attempt to sanitise football through a rigid adoption of legislative provisions coupled with internal regulations that have tried to fundamentally alter football's essence.

Conclusion

Since the implementation of recommendations within the Taylor Report, the game has certainly changed both on and off the field. All seated stadia are the norm with new stands encompassing previously unthought-of facilities for eating, drinking and entertainment. Many of these facilities have far more in common with those found in North American sports stadia than 'traditional' English football grounds. Yet a new set of problems has emerged. Many fans are discontented with the high prices clubs are charging for tickets or the way in which clubs and the game is run, and this has led to the emergence of independent supporters groups (as discussed elsewhere in this volume). Indeed, whilst some of the Taylor recommendations have been rigorously adopted and enforced, others, such as pricing of tickets and the wider involvement of fans in running football, have been ignored. With safety measures unlikely to cause significant controversy it is the attempts to regulate fans' conduct which are more problematic. The political approach has been distinguished by the tendency to ignore the views of the football authorities, let alone fans, and promote a distinctly political agenda. The flaws in the CJA 1994 are a result of a misinterpretation of the situation rather than a panic law solution, as other measures such as increased stewarding and CCTV have reduced the likelihood of disorder inside the stadium. Taylor was reporting at a time when grounds were profoundly different. Now away fans cannot easily congregate in small groups amongst the home supporters through the purchase of illicit tickets and in any event are likely to be ejected at the first sign of their support.

Perhaps more importantly, the CJA raises questions about the applicability of legislation to football. If clubs were to exercise greater control over ticket allocation (one of the demands of the supporters' groups), the problems of touts could be lessened. Football has addressed many of the 'blights' that disfigured the game and is not helped by unnecessary and ill conceived government intervention:

> All these new police powers have come at a time when domestic football has made great strides in self regulation, with a resulting dramatic decrease in incidents of arrest and violence. Better police surveillance and intelligence, the use of club stewards, and the continuing trend of getting the actual supporters involved with stadium policing have helped to make grounds far more welcoming places. The role of the burgeoning fanzine culture and supporters' organisations like the Football Supporters Association have helped articulate the true voice of the terraces, and have gone some way to dispel the stereotypical image of fans as hooligans.
>
> (Slocombe 1995)

The role of fans within football has thrived in spite of legislation which has sought to stigmatise and suffocate their role. With the development of the fanzine culture and the formation of fan groups such as Football Fans Against the Criminal Justice Act (FFACJA) and Libero! (Brick 1997a; 1997b)[9] there is strong evidence of a solid grass roots attempt to build upon the work of the Football Supporters' Association. A constructive dialogue from within all quarters of the game may allow for the legislative excesses to be reversed with a firm emphasis on consensual regulation.

Notes

1 The 1980s saw three significant football tragedies: the fire at Bradford City FC in May 1985 where fifty-six people lost their lives; the tragedy at the Heysel Stadium less than three weeks later involving Liverpool fans where thirty-nine Juventus supporters were killed at the European Cup Final; and the Hillsborough Stadium disaster in April 1989 where ninety-five Liverpool fans were crushed to death. The public nature of all three was emphasised by the live television coverage of all three incidents. (See Taylor, I. 1991.)

2 A key element is the haste in which the government felt compelled to act in response to events in order to demonstrate its authority. Such reactions which extend beyond football and embrace government or legislative reactions to areas that appear to demand a swift response (i.e. the problem of dangerous dogs) are instances of what Redhead (1995) terms 'panic law'.

3 The Popplewell Committee was originally created to investigate two incidents at English grounds that occurred on 11 May 1985. These were the fire at Bradford City's ground in which fifty-six people died and a riot at the Birmingham City versus Leeds United match (described by Popplewell as more like 'the Battle of Agincourt than a football match') in which a 15 year old youth died when a wall collapsed.

4 We are grateful to the editor, Adam Brown, for this point and for his constructive comments generally on this chapter; we would like to blame all errors on him but they remain, of course, our own.

5 Whilst still on the statute book, given Taylor's vehement opposition to the provisions it is highly unlikely that this section will ever be implemented. However voluntary club membership schemes are becoming a more common feature and in some cases a requirement to purchase tickets.

6 'Against that background, it would be a mistake to criminalise a single racialist or indecent remark that might not be widely audible in the ground; to do so would set the threshold for criminal behaviour too low. We wish to prevent group chanting, which is repeated and loud and may spark trouble, and if it occurs, to prosecute and punish the offenders' (Peter Lloyd *Hansard HC* 19 April 1991, Col. 733). The FOA 1991 s3(1) now provides that 'It is an offence to take part at a designated football match in chanting of an indecent or racialist nature'. The Commission for Racial Equality (CRE) in conjunction with the Professional Footballers Association (PFA) initiated the 'Kick Racism out of Football' Campaign which has had a number of elements including disseminating information of the initiative. One of these, Kick It!, contained details of a failed attempt to prosecute for the reasons noted. For a recent analysis of the implementation of the scheme see McArdle and Lewis 1997.

7 Source: National Football Intelligence Unit. We are very grateful to DI Chapman for his help in obtaining material and explaining the work conducted by the NFIU.

8 Tom Pendry put forward an amendment to Clause 137 (as then was) designed to shift the focus of the section from football matches so that it would cover all sporting events.

9 FFACJA website can be found at http://www.urban75.com and Libero! can be contacted at 1 Darwin Road, London N22 6NS.

Bibliography

Brick, C. (1997a) 'Orange jacket required', *90 Minutes* 15 March.

—— (1997b) 'We're not singing anymore', *90 Minutes* 25 April.

Brown, A. (1994) 'Football fans and civil liberties', *Journal of Sport and the Law* 1, 2.

Brown, M. (1994) 'Marching orders', *When Saturday Comes* October: 14.

Corrigan, P. (1996) 'Ticket to ride roughshod over real fans', *Independent on Sunday* 19 May.

Foster, K. (1993) 'Developments in sporting law', in L. Allison (ed.) *The Changing Politics of Sport*, Manchester: Manchester University Press.

Greenfield, S. and Osborn, G. (1996a) 'After the Act? The (re)construction and regulation of football fandom', *Journal of Civil Liberties* 1, 7.

—— (1996b) 'When the whites go marching in? Racism and resistance in English football', *Marquette Sports Law Journal* 6, 2: 315.

—— (1997) 'Enough is enough. Race, cricket and protest in the UK', *Sociological Focus* 30, 4 373–83.

Hansard HC (1985) 3 June, Col. 21, London: Hansard.

—— (1986) 30 April 1986, Col. 1,058, London: Hansard.

—— (1994) 20 October, Col. 514, London: Hansard.

Hansard HL (1989) 16 June, Lord Graham, Col. 1,647, London: Hansard.

—— (1994) 16 June, Col. 1,866, Lord Irvine, London: Hansard.

—— (1994) 20 June, Col. 144, London: Hansard.

Lacey, D. (1997) 'Fans should always be in with a shout', in the *Guardian* 27 September.

McArdle, D. and Lewis, D. (1997) *'Kick Racism Out of Football': A Report on the Implementation of the Commission for Racial Equality's Strategies*, Centre for Research in Industrial and Commercial Law, London: Middlesex University.

Murray, B. (1994) *Football. A History of the World Game*, London: Scolar Press.

Popplewell, Lord Justice (1985) *Committee of Inquiry into Crowd Safety and Control at Sports Grounds*, Interim Report, London: HMSO.

—— (1986) *Committee of Inquiry into Crowd Safety and Control at Sports Grounds*, Final Report, London: HMSO.

Redhead, S. (1995) *Unpopular Cultures*, Manchester: Manchester University Press.

Slocombe, M. (1995) *Football Fans Against the Criminal Justice Bill*, Leaflet.

Taylor, I. (1991) 'English football in the 1990s: taking Hillsborough seriously?' in J. Williams and S. Wagg (eds) *British Football and Social Change: Getting into Europe* Leicester: Leicester University Press.

Taylor, Lord Justice (1990) *The Hillsborough Stadium Disaster (15 April 1989), Inquiry by the Rt Hon. Lord Justice Taylor, Final Report*, Cmd 962, London: HMSO.

Williams, J., Dunning, E. and Murphy, B. (1989) *The Luton Town Members Scheme Final Report*, Sir Norman Chester Centre for Football Research, University of Leicester.

15

THE LAW AND HATE SPEECH

'Ooh Aah Cantona' and the demonisation
of 'the other'[1]

Simon Gardiner

Introduction

This chapter presents a social and legal analysis of the issues that arose out of
the infamous incident on 25 January 1995 at Selhurst Park when Eric
Cantona, the former Manchester United player, 'kung fu kicked' a Crystal
Palace supporter. This action crystallised the interaction between players and
supporters and questioned the role that the law should play. Two main issues
arose. First, the need to provide sports athletes adequate protection from fans
showing their adulation or hatred in oppressive and violent ways and effec-
tively controlling provocative behaviour by spectators. Second, the liability of
players who assault spectators. It is primarily the first issue which will be
examined by this paper. The basis of the verbal attack on Cantona was racial
and this incident reflects the recent debate concerning the more general
occurrence of racist attacks in society. Is legislation the most appropriate way
to stop physical and verbal racism in football and elsewhere or are changes in
societal attitudes most effectively attained through social policies?

However, perhaps a more central area of inquiry is the way that such verbal
attacks on sportsmen and women are a complex amalgam of secular rivalry,
racist xenophobia and general intolerance and fear of 'the other'. The 'other',
in British sport in general and football in particular, has been stereotypically
constructed in terms of colour and ethnicity with Afro-Caribbean and Asian
sports men and women those most often feared. That Cantona should be a
Frenchman, shifts the analysis of regulation of spectator racism and is particu-
larly poignant in a time of political moves to increasing European unification.

This chapter will provide an examination of how Cantona's 'otherness' was
constructed by football commentators and the British media in relation to his
exploits on that cold winter's night and this will be compared with other
constructions of Cantona that have been made during his playing career in
England since 1992. An attempt will be made to evaluate the role that the law

can play in diffusing the fear of 'the other', by the criminalisation of behaviour and speech which is racist and a form of incitement. Certainly legal intervention can help demarcate behaviour that is seen as acceptable from the unacceptable but its role in positively changing social attitudes is more problematic.

We are in 'modern times' (Hall and Jacques 1989): in the context of Britain, this is very much within the supra-nationality of the 'New Europe', where there is an ever growing need for diversity to be accepted. National isolationism and xenophobia, although common, does not match up to this brave new world and sport has a huge potential, perhaps one that does not always materialise, to celebrate diversity. Indeed sport seems to be increasingly used as a mechanism to support greater European unification:[2] but whether it can attain that goal is questionable. The extremes of nationalism and racism are only too often evident and indeed encouraged within the dynamics of sport and the way that the identity of Cantona, the embodiment of difference, a Frenchman in Britain, has been constructed may well tell us something important about how intolerance toward the other can be managed.

Kung fu fighting

The Cantona incident in south London in early 1995 needs careful explanation. He was sent off after kicking out at a Crystal Palace player. He was walking along the touch-line towards the exit to the dressing rooms when Matthew Simmons, a Crystal Palace supporter, ran down to the front of the crowd and 'verbally and digitally' abused Cantona ('Cantona hits fan, faces lengthy ban', *Guardian* 26 January 1995). He was reported as saying the immortal words: 'Fucking, cheating French cunt. Fuck off back to France, you mother fucker' (Ridley 1995: 13). Cantona reacted by leaping over the advertising hoardings with a two-footed kick against Simmons' chest. He struck him a number of times before the two were parted by police, stewards and team officials.

Simmons' version of this outburst was rather different. He told the police after the event that he actually had walked eleven rows down to the front because he wanted to go to the toilet and said: 'Off! Off! Off! Go on, Cantona, have an early shower.' In court he said: 'The crowd was very noisy, everyone was cheering and shouting, everyone was pleased that he [Cantona] had been sent off, me included. Like any normal fan, I joined in with this and was just shouting "Off, off, off" and pointing towards the dressing rooms' ('It was business as normal', says Cantona case accused', *Guardian* 1 May 1996).

Cantona was charged with common assault and pleaded guilty at his trial. He was initially given a two week prison sentence by magistrates, justified at the time largely because 'he is a high profile public figure looked up to by many young people' (*Guardian* 24 March 1995). This was commuted to 120 hours community service teaching school children football skills,[3] and he was also banned from playing for eight months by the English Football

Association.[4] Cantona's own obscure observation concerning the immense public interest in his case was: 'When seagulls follow a trawler, it is because they think sardines will be thrown into the sea' (Ridley 1995: 42).

As Redhead (1997: 26) observes, the incident was 'caught clearly on camera and has been repeatedly shown via the international airwaves almost as many times as the Zapruder film of the JFK assassination in Dallas'. He compares it with the way that an incident involving Paul Ince was dealt with by the football authorities, one that was not clearly mediated by the TV cameras. Ince was charged with assaulting another Crystal Place supporter, Dennis Warren, shortly after the Cantona incident. He was not given any ban before his trial and was acquitted on the charge of assault. Warren had four previous convictions for football violence and drunkenness, belonged to a right-wing fascist group and had been banned from acting as a manager in 1993 by Surrey Football Association for shouting instructions to his players to, 'get the nigger', on the opposing team. The power of the video image and its ability to reify events and actions is well illustrated by the distinctions in the respective censuring of Cantona and Ince.

Simmons, over a year after the incident, was convicted of threatening behaviour ('Cantona tormentor jailed for court kick', *Guardian* 3 May 1996). At his trial he did however turn the tables on Cantona, although not targeting him as the victim: he launched his own drop-kick attack on the prosecuting lawyer, seconds after hearing he had been found guilty of provoking the Manchester United star. He threw himself at Jeffrey McCann, grabbing him around the neck, trying to haul him over a table and appearing to kick him in the chest. McCann had asked magistrates to ban Simmons from all football grounds. Six police officers rushed in to restrain Simmons, who then rushed at the press box shouting: 'I am innocent. I swear on the Bible. You press, you are scum.' Simmons was fined £500 for threatening behaviour, banned from all professional football grounds for 12 months, and sentenced to seven days in prison for contempt of court.[5] During his trial there had been unsubstantiated claims that Simmons was linked with right-wing fascist groups.

This was certainly not the first time a player has responded to supporters' provocation,[6] but the Cantona affair highlighted the vulnerability of sports athletes to attack. Other recent incidents include the stabbing of the tennis player Monica Seles; the stalking of the ice skater Katarina Witt; the assault of the Glasgow Rangers goalkeeper by an Hibernian supporter, from across the sectarian divide in Scottish football; and the former England manager Graham Taylor was spat at by a Sheffield United supporter and unsuccessfully attempted a citizen's arrest (*Guardian*, 24 April 1995). They are all examples of the focus that sports players can provide for spectators' frustrations, phobias and obsessions. The fact that the provocation was of a racist nature in the Cantona incident, led to comments on the high level of control that Afro-Caribbean footballers had shown over the years in the face of extreme racial provocation.

The Cantona incident can be compared with one similar incident involving a leading player from English football's history, Dixie Dean. On leaving the ground at the end of a match at Tottenham Hotspur, a spectator shouted, 'We'll get you yet, you black bastard!' Dean reacted immediately and was reported as saying to an on looking policeman, 'It's all right officer, I'll look after this'. After punching the offender and 'knocking him flying into the crowd', the policeman shook Dean by the hand and stated, 'That was a beauty, but I never saw it, I mean officially or otherwise!' (Walsh 1978: 101). This incident in 1938, perhaps reinforces the historical specificity of the legitimacy of such events and highlights the ambiguous role of the law in relation to supporters.

The life of Eric

Cantona was born in 1966 near Marseilles. As a city that is at the cross-roads of the Mediterranean, his family heralded from Italy on his father's side and Spain on his mother's and whilst his family was poor, his childhood seems 'to have been almost idyllic' (Ridley 1995: 42). He appears to have come from a traditional close-knit working class family, where traditions and identity to the locality are strong. Although not academically gifted, his intelligence was clearly applied on the football field where he excelled as a young boy and he started his professional career at Auxerre when he was fifteen. During the next ten years he played for five other French clubs, Marseilles being the biggest. During his time there his behaviour on the field perhaps epitomised the reason for his 'enfant terrible' image – during a charity match, he responded to jeering from the crowd and kicked the ball at the crowd, hurled his shirt at the referee and stormed off the pitch when he was substituted. He also claimed that he would not play for France again under the current manager at the time, Henri Michel, calling him a 'sacs à merde'. His career in France was never one of continuity and he was loaned out to other clubs a number of times. His stay at his final French club, Nimes, was not a happy one and in late 1991, he disagreed with a refereeing decision and struck the referee with the ball. At the subsequent disciplinary hearing he was given a four match ban, extended to two months after he personally described each official as an 'idiot'. Within a few days he announced he was retiring and his football career was over – in France that is, because he was about to head for England.

Sheffield Wednesday was the English club initially interested in Cantona. He was asked and agreed to come on a week's trial much to Cantona's disgust, and when it was extended for a further week, he decided he had enough, and walked out. The Leeds United manager, Howard Wilkinson, searching for a striker to boost Leeds' First Division Championship hopes, persuaded him to come on loan until the end of the season. Although he only scored three goals during the rest of the season, he was probably a crucial

player in Leeds becoming champions. A love affair was sealed with the Leeds fans and 'Ooh Aah Cantona' became the acclaimed cry. The love affair was mutual: 'I am very happy. Thank you very much. Why I love you, I don't know why, but I love you' (address during Leeds' Championship parade).

But the love affair ended hurtfully as often they do – during the first few months of the next season, the Leeds manager Howard Wilkinson, a dour Yorkshireman, clashed increasingly with the very different temperament of Cantona. There had been a number of doubts about the ability of Cantona's Gaelic temperament in English football and he was transferred to Manchester United in November 1992. The rest is part of English football folklore, with Cantona playing a major role in Manchester United being the champions of the new Premier League in 1993, 1994, 1996 and 1997. His disciplinary record was often criticised however, and he was sent-off five times before the Selhurst Park incident. Cantona's (1994b) own view of his indiscipline was: 'I play with fire. You have to accept that sometimes this fire does harm. I know it does harm. I harm myself. I am aware of it, I am aware of harming others. But I cannot be what I am without those other sides of my character.'

Representation of difference: *vive la différance*?

Cantona has become an icon of British football in the 1990s. Probably more column inches have been written about him than any other footballer although he has given very few interviews (see Cantona 1994b; 1994c; 1997; Ridley 1995; Kurt 1996; White 1997). He has been adept at presenting an image with some ambiguity and in this he has manipulated the press, creating mythology about the 'essential Cantona'. As 'the first existentialist footballer', he cultivates himself as a philosopher king, an outsider, but one who lives life to the full.[7] He lives for football and it is this persona that contributed to the polarisation of opinion as to Cantona's behaviour. It is his visibility that allows him to be constructed as the hero on one hand and the anti-hero on the other. His nationality clearly is major component of this and allows the general British xenophobia to the French to be aired.

However it is not only racial and national distinctions that are able to be highlighted in contemporary life. The fear of 'the other' is an increasing tendency in Britain to fail to tolerate those whose life style is different. As Ian Taylor states:

> There is a widespread fear of 'the other' – specifically of other people(s) who may be encountered in the interactions of everyday life: so far from there being evidence, here, of a society acting in cele brating plurality and difference, there is evidence of a society acting in fear of difference.
>
> (Taylor 1995: 411)

Recent legislation in Britain has criminalised the activities of the lives of rave-party organisers, travellers and road demonstrators, as well, of course, football supporters (see Greenfield and Osborn, this volume). Other social groups – single-mothers, the long-term unemployed, black youth – are increasingly 'demonised'. Amalgamated, the spectre of the underclass is clearly seen (Morris 1994; Gardiner 1995; Morrison 1995). It is his Frenchness and 'difference' that has contributed to the way Cantona has been viewed.

Public opinion was divided as to the legitimacy of Cantona's actions. The initial reaction on the whole was to be censorial, both in the broadsheet press and the popular tabloid press with overtly judgmental views of Cantona's actions. There were statements that he should have been incarcerated, slung out of football and probably deported back to France. The *Daily Mirror* (27 May 1995) talked about the 'Shame of Cantona' and asked questions about his state of mind. Labelling him 'the Marquis de Sade in a Manchester United shirt', it presents a detailed analysis from a 'top sports psychologist'. The *Daily Telegraph* (26 January 1995) claimed 'Cantona guilty of great betrayal'; the *Independent* (26 January 1995) stated 'Shame at Selhurst Park: Cantona brings disgrace to the game'; *The Times*, (27 January 1995) reviewed the paradox of Cantona ('Eric Cantona has been football's poet. Now he is its chief thug'); and the *Sun* (27 January 1995) argued that Cantona should have been arrested, banged in a cell and hauled before a court. Later, after his conviction and the initial custodial sentence, the *Sun* (24 March 1995) celebrated with the chant 'Ooh Aah Prisona' and claimed that this was the 'sentence of sanity' and broadsheets also called for his banning:

> If professional football is to retain any lingering pretensions to be a part of sport, as opposed to a product guided by market forces, then Eric Cantona has surely played his last game for Manchester United.
>
> (David Lacey (1995) *Guardian* 27 January)

Some thought his only salvation was a public apology:

> It is my view, though, that everyone should be given one last chance (call me naive if you like), and if Eric responds with repentance and sincerity he too should have a last opportunity to avoid the almost unprecedented *sine die*.
>
> (Gary Lineker (1995) *Observer* 29 January)

A more reflective justification for his actions emerged in some quarters locating Cantona's actions within a context of trying to understand the extreme provocation that he was subject to and Simmons' unjustifiable acts. *The Sunday Times* (29 January 1995), under the heading, 'The sporting spite' focused on the continuing provocation that players can be subject to on the field:

Retaliation is wrong, but in the context can be understandable. In some circumstances it is morally and even legally condoned. The law on violence against the person is riddled with genuinely difficult arguments about whether such and such a victim was justified in striking back. I repeat that doesn't excuse Cantona. But he was provoked. Can the same be said on behalf of the 'fan'? Was his abuse justifiable in any circumstances whatever?

(*Guardian* 27 January 1995)

The representation of the Cantona affair in the press was interesting in the sense of how his Frenchness was depicted. This was clearly visible in terms of his suspect temperament and the suggested need for psychiatric care. Examination of depictions of the incidents in cartoons are also interesting to examine. They often expose an underlying narrative to the media reporting and were able to show how Cantona's Frenchness could be seen as an issue. One suggests he is a participant in the quintessential French cultural form of the 'Folies Bergere' (*Observer* 28 January 1995), whilst another uses the incident to show John Major as Cantona reacting to anti-European utterances (*Independent On Sunday* 29 January 1995), legitimate concerns in the context of Conservative Party politics at that time. Perhaps the most outrageous was a cartoon from the *Sun* (28 January 1995) depicting Cantona's replacement for Manchester United as a banana-eating gorilla – the stereotype of the black player constructed by racist football spectators over the last quarter of a century.

All these different representations of the Cantona affair and of Cantona himself are complex and ambiguous and clearly the media play an important role in emphasising certain facets of individuals characters. The majority of the initial press rhetoric presented Cantona with the image of the Gaelic madman with uncontrollable psychotic tendencies. The affair was conflated with other issues such as concerns of levels of violence in football and the inadequacies of 'effective policing' by the football authorities. However, they all have the impact on the construction of difference. Where the difference is one of nationality, the stereotypes and prejudices are reinforced. As Theodore Zeldin shows, historically, the British arguably have a paradoxical view of the French:

The British visit France more than any other country; over a third of them have been to France; but only 2% say that they admire the French . . . opinion polls regularly find that the British mistrust the French . . . why is it that the French mystify or irritate so many people?

(Zeldin 1983: 5)

In politics, culture and social life, the English and French seem to be

unable to mutually comprehend each other. The demonisation of Jacques Delors when he was European President is a good example and the French are often seen as arrogant in English eyes. Interestingly, Cantona believes:

> People say the English are arrogant, but I wonder if they do not have good reason. They do everything better and you don't hear them speaking about it. We French always talk about it and believe we revolutionised the world with ideas which date back three centuries.
>
> (Cantona 1993)

> I like the English. On the continent we say that they are cold and reserved, but they are not. The English like to laugh. They like to tell jokes. I've been surprised.
>
> (Cantona 1994c)

The cult of Cantona

It is useful to compare the media representation of Cantona in early 1995 with periods before and after *l'affaire Cantona*. This also allows regional rivalries and identities with his time spent at the two United rivals, Leeds and Manchester, to be conflated with more fundamental national distinctions. The short period that Cantona had as a player at Leeds United during 1992 can help to shed light on the construction of the hero and the anti-hero, the familiar and 'the other'.

Cantona very quickly became a cult player at Leeds. One of the main factors in the development of the cult of Cantona was his natural skill and flair and his skill symbolised what was perceived as the improved quality of the championship side of 1991–2. His nationality confirmed in the fans' eyes that the Leeds team could attract players of international quality. His Frenchness could also be seen as a continuation of the anti-racist initiative within the club. His nationality, however, provided paradoxical reaction. Cantona's rejection of French football and his acclaimed love for the greater intimacy and passion of English football and love for the Leeds fans, allowed those fans to make claims to a long-held English footballing superiority. As Anthony King argues:

> The adoption of Cantona as a cult figure was partly a celebration of anti-racism but it was an ambiguous celebration for it rested on the assumption that England was still superior. Other cultures can be accepted and enjoyed as long as they recognise the manifest superiority of England . . . this paradoxical adoption of the foreign which did nothing but confirm Englishness was best displayed . . . by the fact that many Leeds fans adopted the English parody of Frenchness; fans began to wear onions, berets and striped T-shirts to matches. By

espousing the very parodies of Frenchness which grew out of a belief in English distinctiveness and superiority, fans were, of course, doing nothing else than confirming their traditional Englishness. If they had started discussing their justifications of French peasants to protect their meagre income from imports instead of wearing onions, a very different Englishness would have emerged. Instead the new Englishness which was expressed in the Cantona Cult confirmed a new identity, albeit slightly renegotiated with regard to the issue of foreignness.

(King 1995: 20)

In attempting to provide a theoretical understanding of the emergence of a specific cultural movement, the 'Cantona Cult', King supports a 'historically specific' approach where the construction of the cult by Leeds fans was a product of their own historical position. He sees the fans were prisoners of their past and their subsequent polarisation and abuse towards Cantona on his transfer to Manchester United, Leeds' most intense rivals, or 'The Scum' as they are commonly known, created a feeling of betrayal. In a number of Leeds supporters' fanzines, this betrayal was reinforced by the sexualised relationship that the Leeds fans had with him; they not only lost a player they adored, it was a loss akin to the loss of an intimate lover.

The reaction against Cantona was also very much in terms of who he was. King explains how the earlier ambiguity to his Frenchness, 'was renegotiated to a traditional hatred of difference' (King 1995: 23). 'He's gay, he's French, he's always on the bench' and 'He's French, he's dumb, he'll do fuck all with The Scum', became the new chants. These stereotyped the French and deployed nationalistic notions of race and sexuality. The concept of nationalism is central to this analysis. National distinction, the 'otherness' of Cantona, became much more visible. Cantona was initially supported for his anti-establishment attitudes, his professed love for the values of the traditional English game mirroring the fans' concerns about transformations in contemporary football: the move to all-seater stadiums, and the increased alienation from the owners of clubs. Cantona's difference was an issue of celebration.

His move to Manchester United was accompanied by a more traditional hatred of difference. His nationality became central and was accompanied by heightened notions of nationalism on the part of the Leeds fans. For the Leeds United fans, the image of Cantona also reflects more limited petty rivalries between clubs. Returning to play at Elland Road for Manchester United was bound to be problematic: there were death threats when he played at Elland in the 1993–4 season; and he was fined for allegedly spitting at a Leeds supporter (Ridley 1995: 94).

This period can be compared with the much longer period at Manchester United from November 1992 until June 1997. He is identified as one of the main reasons for the return of the glory days of Charlton, Best and Law in the

late 1960s and stands alongside them in the hero stakes. He has generated a whole sub-industry within the Manchester United's gargantuan marketing machine and became an all-time folk hero with Manchester United fans.

After the incident at Selhurst Park, Cantona continued to be supported by Manchester United fans and many T-shirts celebrated his role as the anti-hero. The club clearly recognised the value of Cantona, giving him a much improved four year contract (*Guardian* 28 April 1995). Sports manufacturers Nike used Cantona and Les Ferdinand in a television advert stating the unacceptability of racial hatred and violence in sport, backed by the Commission of Racial Equality as an appropriate mechanism for changing attitudes.[8] Cantona stated in the advert that 'violence is not acceptable in sport'. On his return to playing football, an advert showing Cantona at an opened barred-gate, proclaims, 'He has been punished for his mistakes. Now it's someone else's turn.'

The period after he had served his ban and returned to play for the team is probably the most significant as far as this analysis is concerned ('Fire but no sardines for the return of the magnificent 7', *Guardian* 29 September 1995). A clear area of concern was that he would be subject to extreme provocation of the kind that Simmons provided, and would be liable to repeat the exploits of the past of violence towards players and spectators. However he came back a changed character, one who recognised the problems of controlling the 'dark side' of his character. This was arguably the most effective period of his footballing career, scoring thirteen winning or equalising goals in the run up to the championship – clearly the most significant player in securing a third championship in four years for Manchester United – and scoring the goal (against Liverpool) which won United's second League and FA Cup 'Double'.

He had found the resolve to control his temper on the pitch. As Jim White concludes:

> He started to cast himself as the peace-maker on the pitch, the wise old head who would lead perplexed colleagues away from the scrap. Just as Tony Adams fights when he goes past a bar, or Paul Merson tightens his resolve when he sees a mirror on a coffee table, so Cantona must have battled to control his urges in those seasons. But he did it privately, apparently changing his character alone, through his own strength of will. That was his achievement, and it was not sufficiently acknowledged in the obituaries to his career.
>
> (White 1997: 52)

The psychotic thug had disappeared. It was now St Eric: demonisation to canonisation.

Criminalisation of hate speech

The Cantona case highlights the issue of control of racist 'hate speech'. Is legislation the answer to the xenophobia of those such as Simmons? He was convicted under public order offences for racial hatred: he could not be charged under Section 3 of the Football Offences Act 1991 for indecent and racist chanting because he fell outside the scope of this legislation due to his actions being solitary. Liability only occurs when 'in a designated football match, words or sounds are chanted in concert with one or more others which are threatening, abusive or threatening to a person by reason of his colour, race, nationality or ethnic or national origins'. The Act has been the second dedicated piece of legislation for the regulation of football stadia the first being the Football Spectators Act 1989 (see Osborn and Greenfield, this volume). The 1991 Act had its origins in the recommendations of the Taylor Report (1990) based on the Hillsborough disaster. The Taylor Report considered that the provisions of the Public Order Act 1986 concerning 'threatening, abusive or insulting words or behaviour', did not adequately cover indecent or racist chanting. This was due to the need to have a clearly identifiable victim as necessary for liability, in that either another person believed 'unlawful violence will be used against him or another',[9] or the chanting was 'within the hearing or sight of a person likely to be caused harassment, alarm or distress'.[10] Under the 1991 Act, no recognisable individual is needed, although the racial abuse will generally be directed at a particular player and invariably one of the visiting team.

The issue that the Simmons–Cantona incident highlighted was the limitation of the 1991 act to 'chanting in concert with one or more others'.[11] During the parliamentary progress of the legislation it had been argued that to criminalise a single racist or indecent remark would have created 'too low' a threshold. After the Cantona incident, again there were calls for the legislation to be extended to include individual acts. However as Papworth argues: 'There is a certain futility in creating statutory offences which are effectively moribund due to difficulties associated with detection' (Papworth 1993: 1016).

Section 3 of the Football Offences Act 1991 has been little used suggesting that it has been used symbolically. As Chambliss and Seidman (1982) argue, the way to identify legal symbolism is to measure the levels of enforcement. If they are low, symbolism is likely. Up until late 1997, there have only been a few prosecutions under this legislation and there seems to be a downward trend: in 1994–5 season there were thirty arrests, in 1996–7 season there were only ten convictions (Greenfield and Osborn 1996). This may suggest that the problem of racist chanting is decreasing. However it is probably more likely to concern the level of policing of this offence even though closed circuit television cameras are used to aid identification of perpetrators during matches. The individualising of the offence would arguably be even harder to enforce with

police and ground stewards finding it difficult to identify the cries of a lone racist. There have been calls for crowds to engage in greater peer policing although this may well put individuals who would want to report the activities of a racist to the authorities, who may well have a general propensity to violence, into an invidious position (Simmons, for example had previous convictions for assault).

There is a strong argument that the use of legislation can be seen as diverting attention and resources from educational and social policy initiatives which might more successfully eliminate the causes of the problem. Football stadia have become one of the most overly regulated public spaces and there is an increasing danger that this regulatory approach to social problems by the use of the law will create increasingly anodyne environments, where freedom of expression and movement is overly suppressed through the law. Panic law is invariably bad law. An alternative approach is the use of campaign and education strategies, such as the Kick Racism Out Of Football Campaign, launched by the Commission for Racial Equality and the Professional Footballers' Association in 1993.[12] This has been periodically re-invented to keep the message in the public eye and these campaigns have been supported by anti-racist marketing adverts such as the Cantona and Ferdinand Nike advert. In addition, many clubs have developed their own policies against racism with the Football in the Community Programme – although the success of these is a matter of debate – and fans have tackled the issue through fanzines.[13]

This debate about the extension and individualising of racist hate speech on the football field, reflects the calls for the creation of a specific offence for racial attacks to penalise more stringently perpetrators of racially motivated assaults which have been on the increase recently (Bindman 1992; Fidgett 1993; Loveland 1994). Official statistics indicate that incidents of racial assaults and abuse have risen from 4,383 in 1988 to 7,734 in 1992 (Home Affairs Committee 1993). However, the British Crime Survey suggests that because of the considerable under-reporting, a more realistic 'dark figure' for racial assaults is more likely to be between 13,000 and 14,000 in 1992 (Home Office 1994). There have been calls from many including the House of Commons Home Affairs Committee and the Commission for Racial Equality (Anti-Racist Alliance 1993), for a dedicated racially motivated violence offence. However proposals during the passage of the Criminal Justice and Public Order Bill 1993 were rejected by the government. The change of government in 1997, has put the creation of such an offence back on the political agenda.

However in the United States, a majority of states have enacted 'hate crimes' legislation based primarily on race and ethnic hostility. This has been done on the basis of either creating a new race hate offence or permitting the enhancement of the penalties available for existing offences in circumstances of racial hatred. In the United States, the major issue has been 'the constitutionality' of such offences in terms of the protection that even racist symbolic

speech may get from the right of 'freedom of speech' (Matsuda 1989; Gellman 1993; Loveland 1994; Walker 1994).

The creation of a new dedicated offence in Britain is premised on the argument that further legislation would 'encourage a welcome realism in the levels of reporting of racial attacks, and could act as a deterrent to possible attackers' (Labour Party 1994). This argument can be applied irrespective of whether it is racism in the sports stadia or in society generally. However, there is a view that a major problem is with the lack of implementation of existing provisions by the police and other enforcement agencies, suggesting a failure in practice of these agencies to take racial violence and abuse seriously. As Peter Francis argues:

> What the evidence does highlight is the overall paucity of political discussion on tackling racial attacks and the absence of any realistic assessment of existing legal and extra-legal provision . . . further legislation will suffer the same problem existing legislation has encountered, and may not even provide symbolic importance. Rather what is needed is a genuine commitment from Government and existing agencies to an imaginative use of existing powers, coupled with the continuing development, monitoring and evaluation of extra-legal provision.
>
> (Francis 1994: 15)

Conclusion: *au revoir* Cantona

Eric Cantona announced his departure from Manchester United and his final retirement from football on 18 May 1997 (*Guardian* 19 May 1997). Many thought that his decision was pre-emptive and he would return to the game at some future point ('Great performers take several curtain calls', *Guardian* 20 May 1997) although no such return has happened to date. As Tom Watt states:

> The secret of vaudeville: always leave them wanting more. Eric Cantona's hour of strutting and fretting on English football's stage may be remembered for moments of instinctive improvisation, moments beautiful and ugly in equal measures. His leaving, though, with the audience still on its feet applauding his and Manchester United's latest triumph, suggests a careful appreciation of the vagaries of hindsight and posterity. Better to depart as a class act than wait for the cheap seats to start tutting that you were one once.
>
> (Watt 1996: 9)

His persona as a proud Frenchman, his turned-up collar, his studied aloofness, has reinforced his difference. True, he has been subjected to the rage of

infuriated fans of opposing teams. But this antagonism needs to be under-
stood in the context of it being an essential part of the regionalist and secular
rivalry found in the British game. Some of this rage, however, has been of the
type Simmons produced on that cold winters night in early 1995 – racist
speech that needs to be unmistakably challenged.

The process of criminalisation of problems such as racist hate speech, can
often be used to deflect political responsibility for them away from it being a
failure of social policy, to be seen primarily as a criminal issue based on indi-
vidual responsibility and wickedness (Lacey 1995: 24; Gardiner 1996: 24).
Legislation has a role to play, but it should not be at the expense of other
non-legal social practices. Within the 'New Europe', stereotypical construc-
tions of national distinctions will need to be increasingly challenged. In his
own way, Eric Cantona has done that – not so much in terms of his single act
of defiance against Matthew Simmons – but the fact that he has arguably
been more influential than any other individual player in epitomising the
rehabilitation and renaissance of British football in the 1990s.

Notes

1 I would like to thank Pierre Lanranchi and Wray Vamplew for their comments on
an earlier draft of this paper. This paper has also been given at a number of confer-
ences: Socio-Legal Studies Association, University of Southampton, April 1996;
'Fanatics! Football and Popular Culture in Europe', MIPC, Manchester
Metropolitan University, June 1996; 'Rediscovering the Crowd', De Montfort
University, July 1996; and British Sociological Association, Sociology of Sport
Study Workshop Group, Chichester College of HE, October 1996. I am grateful
to all those who have offered advice and criticism at these venues.
2 The European Commission have developed an extensive social policy based on
sport and intervention with issues such as the Bosman case likely to have a greater
impact on a clearer identity of European-wide sport, (see Gardiner et al. (1998) for
further analysis).
3 'Fish-quoter Cantona ducks the cells', *Guardian* 1 April 1995, 'Schools bid for
Cantona free transfer after community service substitution' (*Guardian* 1 April
1995).
4 'Cantona banned until October' (*Guardian* 25 February 1995). This eight month
ban was an extension of the voluntary ban imposed by Manchester United until
the end of the 1994–5 season. See 'Exit Cantona as United impose ban' (*Guardian*
28 January 1995).
5 He was subsequently only jailed for one day due to release rules under the
Criminal Justice Act 1982, see 'Cantona's attacker freed from jail after one day'
(*Guardian* 4 May 1996).
6 See *The Times* 12 January 1993, David Speedie cleared of assaulting a spectator. He
was bound over to keep the peace for twelve months. Criticising the matter
coming to court, the judge said: 'the complainant spat at the man (Speedie) and
was surprised he was kicked!'
7 He refers to a number of influences, in low culture, Jim Morrison of The Doors
and Micky Rourke, and in high culture, the poet Arthur Rimbaud and the writer
Albert Camus. There are parallels between Cantona and the central character in
the Camus book *The Outsider*.

8 The narrative of the advert is: the pair ask: 'What do you see?' 'A black man?' wonders Ferdinand. 'A Frenchman?' asks Cantona. 'Is it OK to shout racial abuse at me just because I am on a football pitch? Some people say we have to accept abuse as part of the game. Why?' Cantona adds, 'I know that violence is not acceptable in sport'. Nike were criticised in some quarters by glorifying the violence of the Cantona Affair – see 'Nike cleared of "Cashing in" on the notoriety of Eric Cantona' (*Guardian, 26* June 1995).

9 Section 4 Public Order Act 1986, 'Fear or Provocation of Violence'.

10 Section 5 Public Order Act 1986, 'Harassment, Alarm or Distress'. An additional offence has recently been created with s4A Public Order Act 1986, Intentional Harassment, Alarm or Distress, as substituted by Section 154 Criminal Justice and Public Order Act 1994, again needing an identifiable victim.

11 See 'It takes two to chant, court decides' (*The Times* 23 January 1993).

12 It has been seen as having been effective. As Brendon Batson of the PFA says: 'The CRE's campaign has helped and so has the emergence of high profile black players . . . racial abuse is on the decline and its much easier for young black players. It is being tackled by the game, but it's still there and must be tackled' ('Anti-racist TV advert delayed in aftermath of Cantona case', *Guardian* 24 March 1995).

13 See also Part II of this volume; McArdle and Lewis 1997; Back *et al.* 1996.

Bibliography

Anti-Racist Alliance (1993) *Submission to the Home Affairs Committee: Sub-committee on Racial Attacks and Harassment,* London: ARA.

Back, L., Crabbe, T. and Solomos, J. (1996) *Alive and Still Kicking,* London: AGARI.

Bindman, G. (1992) 'Outlawing hate speech' *Law Society Gazette* 18 April.

Cantona, E (1993) *World Soccer* July.

—— (1994a) *Cantona: My Story,* London: Headline.

—— (1994b) *Eric the King,* Manchester United Video.

—— (1994c) *L'Equipe* magazine, September.

Cantona, E. with Alex, F. (1996) *Cantona on Cantona,* Manchester: Manchester United Publication.

Cantona, E. (1997) *The Complete Cantona,* London: Headline.

Chambliss, W. and Seidman, R. (1982) *Law, Order and Power,* 2nd edn, New York: Addison Wesley.

Fidgett, P. (1993) 'Responding to racial violence', *The Probation Journal.*

Francis, P. (1994) 'Race attacks: do we need new legislation?', *Criminal Justice Matters* 16.

Gardiner, S. (1995) 'Criminal Justice Act 1991: Management of the underclass and the potential of community', in L. Noakes, M. Levi and M. Maguire (eds) *Contemporary Issues in Criminology,* Cardiff: University of Cardiff Press.

—— (1996) 'Ooh Aah Cantona: racism as hate speech', *Criminal Justice Matters* 23: 23–4.

Gardiner, S., Felix, A., James, M., Welch, R. and O'Leary, J. (1998) *Sports Law,* London: Cavendish.

Gellman, S. (1993) 'Hate is not speech: a constitutional defence of penalty enhancement for hate crimes', *Harvard Law Review* 106, 6: 1,314.

Greenfield, S. and Osborn, G. (1996) 'When the whites come marching in? Racism and resistance in English football', *Marquette Sports Law Journal* 6, 2.

Guardian (1995) 'Editorial: the Cantona context', 27 January.

Hall, S. and Jacques, M. (eds) (1989) *New Times: The Changing Face of Politics in the 1990s*, London: Lawrence and Wishart.

Home Affairs Committee (1993) *Racial Attacks and Harassment*, London: Home Office.

Home Office Research and Planning Unit (1994), *Racially Motivated Crime: British Crime Survey Analysis*, Paper No. 82, London: Home Office.

King, A. (1995) 'The problem of identity and the cult of Cantona', *Salford Papers in Sociology*, Manchester: Salford University.

Kurt, R. (1996) *Cantona*, London: Pan Books.

Labour Party (1993) *Racial Attacks: Time to Act*, London: Labour Party.

—— (1994) *The Rising Tide*, London: Labour Party.

Lacey, D. (1997) 'Cantona's flashpoint of no return', *Guardian* 27 January.

Lacey, N. (1995) 'Contingency and criminalisation', in Loveland, I. (ed.) *Frontiers of Criminality*, London: Sweet and Maxwell.

Lineker, G. (1995) 'Be a man, Eric, say sorry', *Observer* 29 January.

Loveland, I. (1994) 'Hate crimes and the First Amendment', *Public Law*.

Matsude, M. (1989) 'Public response to racist hate speech: considering the victims' story', *Michigan Law Review* 87.

McArdle, D. and Lewis, D. (1997) *'Kick Racism Out of Football': A Report on the Implementation of the Commission for Racial Equality's Strategies*, Centre for Research in Industrial and Commercial Law, London: Middlesex University.

Morris, L. (1994) *Dangerous Classes: The Underclass and Social Citizenship*, London: Routledge.

Morrison, W. (1995) *Theoretical Criminology: From Modernity to Post-modernity*, London: Cavendish.

Papworth, N. (1993) 'Football and racism: a legislative solution', *Solicitors Journal* 15 October: 1,016.

Redhead, S. (1997) *Post-Fandom and the Millennial Blues: The Transformation of Soccer Culture* London: Routledge.

Ridley, I. (1995) *Cantona: The Red and the Black*, London: Headline.

Taylor, I. (1995) 'Critical criminology and the free market', in L. Noakes, M. Levi and M. Maguire (eds) *Contemporary Issues in Criminology*, Cardiff: University of Wales.

Taylor, Lord Justice (1990) *The Hillsborough Stadium Disaster (15 April 1989), Inquiry by the Rt Hon. Lord Justice Taylor, Final Report*, Cmd 962, London: HMSO.

Walker, S. (1994) *Hate Speech: The History of an American Controversy*, Lincoln, NB: University of Nebraska Press.

Walsh, N. (1978) *Dixie Dean: The Life of a Goal Scoring Legend*, Newton Abbot: Readers Union.

Watt, T. (1996) *This Passion for the Game: Real Lives in Football*, London: Mainstream.

White, J. (1997) 'My Life After Eric', in S. Kuper, *Perfect Pitch*, London: Review.

Zeldin, T. (1983) *The French*, London: Collins.

16

VIRTUAL FANDOMS

Futurescapes of football

John Bale

The craze for the word 'space'... expresses... not only the themes that haunt the contemporary era... but also the abstraction that corrodes and threatens them.

(Augé 1995)

Introduction

The contributions to a geography of football have steadily increased over the last few decades. The kinds of geographic research undertaken during that period may be categorised into three main groups. These include studies exhibiting what I have termed a fetish for cartography (Bale 1992), essentially concerned with patterns of geographic variation in football phenomena, usually the 'production' and migration of superior players (e.g. Bale 1983). These have been complemented by similar approaches which have explored the geographical diffusion of certain aspects of the game (Bale 1978). A second group of studies has explored the spatial and environmental impact of football events, ranging from major tournaments to individual clubs, on their local communities (Bale 1993). These are basically applications of economic and welfare concepts and have explored both the positive and negative effects of such events.

A third group of studies focus on what I would term the sports landscape. It is in this area that the application of ideas from the 'new cultural geography' have been most apparent though approaches continue to range across a wide spectrum. For example, Raitz's (1995) recent edited collection on *The Theater of Sport* follows a broadly traditional pattern, while Allan Pred's (1995) analysis of the Stockholm arena, 'The Globe' (as part of his unusual exploration of European modernities), adopts a much more adventurous – not to say curious – approach. Though not explicitly applied to football, Pred's work on the politics and poetics of writing and representation, is a model which has much to offer. It is one of the few works which attempts to grapple with the 'crisis of representation' in a sport-place context. My own book, *Landscapes of*

Modern Sport, tries to bring together different 'ways of seeing' the sports land-scape (Bale 1994). Part of this 'landscape' approach includes studies of the micro- and meso-geography of fandoms. The former, building on the work of Christian Bromberger (1992), identify quite significant patterns of fan loca-tion within the stadium. The segmentation of fan groups into relatively homogeneous clusters has been identified for English clubs ranging from Oxford United to Arsenal (see Bale 1992). The more formal, indeed, officially sanctioned, segmentation of fans has been touched on since the Hillsborough disaster which led to recommendations for all-seat stadiums. Inspired by the ideas of Michel Foucault (Bale 1992), this has led some observers to see the stadium as a 'carceral space'.

Despite these studies, debates about a geography of football have hardly been prominent. Some allusions which were made to sports geography by Michael Dear (1988) have, however, sparked off a minor discussion, if not a debate. In a paper responding to the 'postmodern challenge' in human geog-raphy, Dear suggested that some sub-disciplines are less central than others. He argued, for example, that the geography of sport is not central to the structure and explanation of geographical knowledge and that it was not of scholarly centrality in the way that political, social and economic geography are. In a reply to Dear's paper, however, Jamie Scott and Paul Simpson-Housley (1989) noted that, in shifting a geography of sport to the periphery of the 'discipline' Dear failed to recognise that the 'conditions predominating in any given field of study dictate which sub-discipline is more or less fruitful'. It could there-fore be argued that 'the geography of the sport of soccer governs key aspects of the political, social and economic conditions of Rio de Janeiro, rather than vice versa'. Dear's observations also elicited comments from Chris Philo who rejected Dear's desire to 'police' geographic enquiry and locate it in the disci-plinary 'heartland' of economic, social and political geography. Citing Foucault, Philo noted how 'all manner of insights about the workings of human society can best be found . . . from sources which on first glance may seem quite marginal, peripheral, insignificant and often esoteric' – hence a geography of sport may 'open exciting new windows on a host of issues currently high on the agendas of many contemporary social scientists' (Philo 1995).

Such observations, while providing a convincing rationale for a geography of football, do not go very far towards a geographical theory of the sport. This lack of theorisation contrasts, for example, with work in sociology where interpretations of football have been rooted in several theoretical foundations. Most noteworthy has been the applications of Norbert Elias' 'civilising process', primarily associated with the work of the 'Leicester school' (Elias and Dunning 1986) although this is not to deny the importance of Gramsci or Bakhtin, for example (Jarvie and Maguire 1994). The purpose of this chapter is to speculate about a geographic theory of football. This is rooted in Edward Relph's (1976) notion of 'placelessness' or, as Augé (1995) puts it in his more recent rendition, 'non-place'. It is to this that I now turn.

A geographical theory of football

Philosophical discussions about the rationale or basis for a geographical theory of football are few and far between. It is worth noting, however, that in drawing attention to the distinction between sport and recreation or leisure, the cultural geographer Philip Wagner argued that there was nothing natural about sports (by which he meant 'achievement sports') and that as a result they are acted out in 'an entire class of very closely defined conventionalised places' (Wagner 1981). Wagner's little-read paper is important because it basically defined sport (as opposed to recreation or leisure) *from an essentially geographic perspective*. He argues that the sportised body and the sportised landscape are quite different from the bodies and landscapes of recreation, leisure and play, an approach similar to that of the German cultural sociologist, Henning Eichberg (1998). For Eichberg, the difference lies in the ideological or philosophical roots of each of these activities. The locations and landscapes of sportised football are basically the outcome of its achievement orientation – a basic characteristic of all modern sports to which I will return later. Achievement orientation is not central to play or recreation and the landscapes and locations of these activities are therefore different. Hence, the landscape required for playfully kicking a ball is fundamentally different from the serious business of 'playing' professional football.

My model – which might be a better way to present it – has one basic theorem – *that the football landscape ought to be one of placelessness*. Note that this is a model of what 'ought to be'; it is a normative model which, in this case, is founded on the norms of the game itself. These norms provide the logic behind the model. With normative models it would be tilting at windmills to explore whether they fit the real world since the model is based on 'what ought to be' rather than 'what is'. On the other hand, it is possible that the real world (in this case the 'landscape' of football) may be getting closer to the model, indicating that the model has some predictive qualities. If the world does not fit the model, it does not infer that the model is wrong; rather, it is the world that needs correcting in order to meet the norms of the model, assuming that the norms are widely subscribed to. In exploring the landscape of football, I predict that the norms of the game logically encourage a 'placeless' landscape and I conclude that over time there has been a tendency for football places to become increasingly placeless. At the same time, however, I note that there has been a counter-tendency to retain a degree of placefulness. There is, therefore, a tension between place and placelessness.

Because placelessness forms a central feature of the model I will summarise it as the existence of relatively homogeneous and standardised landscapes which diminish the local specificity and variety of places that characterised pre-industrial societies. It is reflected in what is often felt to be a growing 'sameness' in society. The term 'placelessness' is mainly associated with the geographer Edward Relph (1976) but has also been applied in the areas of

architecture and theatre studies (see Bale 1994). In most areas of life where placelessness exists it seems to result from factors *extrinsic* to the activity upon which it is imposed. For example, McDonald's restaurants do not *have* to be the same in order for hamburgers to be produced. Likewise, suburban houses do not *have* to be the same for purposes of residential occupation. High rise buildings do not *have* to be standardised for office work to take place. It may be more efficient and more rational but it is not absolutely necessary. Placelessness in such contexts exists primarily for commercial, planning or design reasons. It is not intrinsic to the activities carried out at the places. In sports, on the other hand, I will argue that placelessness *is* intrinsic to the activity involved. It is part of the norms of sport, a part – often hidden – in its underlying (and sometimes conflicting) ideologies of fair play and achievement orientation.

My basic thesis is that the logic of achievement football seeks to eliminate place (a unique area or peopled space) and replace it with space – or 'non-place' or placelessness. In sport the pressures are not to produce regional inflexions in the landscape (except in a superficial sense) but instead to move steadily towards the elimination of place-to-place differences. Such an assertion is based on the two concepts central to professional football: these are *fair play* and *achievement orientation*. Each of these can be examined in turn.

Fair play

The notion of fair play was established in football in the 1850s with its emergence as a modern mass phenomenon. 'Fair play' included the establishment of common rules, mainly referring to behaviour but also to the space on which football was played. The most basic spatial rule was the imposition of a boundary which marked the field of play and explicitly served to mark a line of segregation between players and spectators. Inside the line, the space was 'purified', being purged of spectators so that they could no longer wander on to an ill-defined playing space and interfere with the players and the progress of the game. It was a form of territorialisation, that of power over people and space (Sack 1986). This was a way of making football a fairer game. No such rules, however, were made in relation to place. There could be grandstands or open fields; spectators could number anything from 100,000 or more to 10 or less. Hence, in football we have rules which clearly specify the spatial dimensions of the 'play' (later, 'work') area but the details of the surrounding landscape ensemble – including the spectators – were left unspecified. If the spaces of football were different from game to game, the outcome might be more laughable and this did, of course, exist in pre-modern, less serious sport-like forms. A non-specialised football landscape was occupied by non-specialised bodies – the presence of the grotesque body was found in the less serious landscapes in which such activities were practised. With the

growing seriousness of the game came the growing seriousness of the land-scape in which it took place.

For most sports the spatial parameters are prescribed very precisely. In the case of football the prescribed spatial extent of the pitch does vary slightly but the geometry and size of segments on the field of play are precisely defined and standardised. Given the limited margins within which the size of the pitch is allowed to vary, team managers have, nevertheless, been known to alter the width and/or length for games against particular opponents. The large 'space' of the Wembley pitch in England is often said to disadvantage certain teams. This seems to contravene the logic of fair play. For the ethos of fair play to be satisfied each space (and, I suggest later, each place) upon which a given sport occurs should logically be the same; otherwise, one participant or team would be unfairly advantaged.

An example of such an unfair advantage – though not often thought of as crossing the boundary of fair play – lies in the case of downhill skiers who live in, say Austria, and compete with those who live in, say, The Netherlands. Obviously, the former are widely thought to have an unfair advantage, but it is one which is tolerated by those who run the sport and many would argue that it is not necessarily unfair. As Roger Gardner (1995) argues, however, this claim 'would at least seem to suggest more analysis: because, at this point in time, such advantages do not seem to be *clearly* fair either'. An analogous foot-ball example would be one in which the topographic nature of fields of play differed. Hence, a club with a pitch possessing an idiosyncratic slope, for example, is often deemed to possess an 'unfair advantage' over its opponents during the playing of home games.

Let me take this argument a little further with another hypothetical example from football. Assume the Football League allowed clubs to play on either natural or synthetic surfaces. Assume also that only two clubs retained natural (grass) surfaces. Would it be 'fair play' when these two clubs played every other club in the league? There seems to be a strong case to say that it would not and that the football authorities should logically prescribe the same surface for all clubs (as happened in England in the late 1980s when synthetic surfaces were outlawed). For fair play to be achieved, therefore, I am initially suggesting that the surface of the playing field should be – literally – even. This view has been explicated forcefully by the philosopher Paul Weiss. Though couched in the context of track and field athletics its general idea applies also to football:

> Ideally a normal set of conditions for a race is one in which there are no turns, no wind, no interference, no interval between signal and start, and no irregularities to the track – in short no deviations from a standard situation
>
> (Weiss 1968)

Replace the word 'race' by 'games' and it seems logical that such a 'standard situation' should also apply in football. Standard situations are almost synonymous with the word 'placelessness'.

Achievement

A crucial characteristic of modern sport which distinguishes it from both its folk-game antecedents and recreation, is its achievement orientation and its associated seeking after records. For records and 'progress' and to be meaningful, each space where a performance may be achieved should be the same – exactly the same or measurement of such progress would be impossible. The 'production' of a record *requires* placelessness.

Here is the sporting analogue of the isotropic plane – the rational solution to the problems of variety and individuality imposed by place. Indeed, although (as noted above) the size of pitches vary, the spatial dimensions of points and segments on football pitches are precisely prescribed; penalty area, centre circles, the penalty spot and the half-way line have all quite precisely quantified dimensions. They must be the same on every football field in the world. Given these spatial regularities, progress in the tactical development of the game can take place. Skills and tactics can be developed which would be much more difficult if the spatial configurations of football fields differed from place to place. In such ways geometry triumphs over space, segmenting it and territorialising it.

Geometry is also seen to triumph over nature and considerable pressure exists to eliminate nature from the sports landscape. Environmental interference in a football match can be unfair. A strong wind blowing only during the second half of a match puts one of the teams at a disadvantage. This, and other kinds of environmental interference can be eliminated by moving sport indoors, a common tendency at the present time in North America and elsewhere. The introduction of prescribed artificial surfaces may lead to further predictability and placelessness. Until then, 'turf science' seeks to provide surfaces which, in effect, differ from each other as little as possible and, at the same time, encourage progress in technical skills.

So far I have suggested that there is a logic and a tendency to eliminate certain environmental factors in order to subscribe to the logic of 'fair play' and the protocols of achievement sport. I believe that there is considerable evidence that the football landscape – at least, the field of 'play' – is becoming more predictable, and hence more placeless, over time. Contributors to football fanzines bemoan the 'container architecture' of their modern stadiums and the sameness of the football environment, and philosophers of sport arrive at a similar prediction for the logical landscape of achievement sport. However, the place-making qualities of football's milieu are difficult to deny – and to resist. Although spectators may have been prevented from encroaching on the field of play with the inscribing of the white line around it in 1882,

they still, literally, present 'noise' with respect to my proposed theory. It is to the fans, therefore, that I now turn.

The 'problem' of spectators

It is now appropriate to return more explicitly to the role of fandom in all this. In the recently published English edition of Marc Augé's *Non-Places*, it is noted that 'a space which cannot be defined as relational, or historical, or concerned with identity will be a non-place' (Augé 1995). According to the norms of sport, football spaces should not be concerned with identity because identification with them would create advantages for the home team. Yet football is widely regarded (including work in this volume) as fostering identity, local and national. Football is a 'representational' sport.

Modern football is highly commodified – something to be bought and sold to consumers. Spectators/consumers at sports events create a problem for my theory of sport as a model of placelessness because, as noted above, in even the most sterile stadium the crowd acts as a form of 'noise', creating a place out of nothing. The modern partisan spectator, in many sports, creates problems for the notion of 'fair play'. Crowds at team sports undeniably influence performance; they contribute greatly to the 'home-field advantage', even in the domed stadium; their Bakhtin-like carnivalism (as Richard Giulianotti has theorised the behaviour of Scottish – though not English – football fans) may contribute more to topophilia (a love of place) than to placelessness (Giulianotti 1991). It is the crowd which produces a 'home field advantage' in the most sterile of environments. This assertion is supported by studies into this form of (unfair?) advantage in the United States. For example, a typical study revealed that the home advantage was most strongly felt in sports such as basketball and ice-hockey – those with the most artificial and 'placeless' playing surfaces – and that it was in the environmentally variable sport of baseball that the home field advantage was least evident (Schwartz and Barsky 1977). It has also been shown that the home advantage is significantly greater in baseball games played in domed-stadiums – those playing environments where the natural environment has been most neutralised (Zeller and Jurkovac 1989). The enhanced home field advantage in such situations was attributed to the closeness and involvement of the crowd.

In the early days of modern sports the fixed boundaries which now exist between spectators and players were absent. The explicit white line separating players from spectators was not introduced in soccer until it was recognised that spectators would walk onto the field of play and interfere with the game. Hence, although the spatial parameters were established in 1863, the insistence on a marked line did not occur until 1882. The boundary *communicates* the notion of territoriality, as outlined by Sack (1986) as the imposition of power over space. Territoriality may therefore be seen as a way of solving the problem of spectator interference in sports. The boundary line did not prevent

aural interference with play, however, which would logically help to favour the home team. For this reason early applause was directed at the visiting team in order to accord with the ethics of fair play. This 'gentlemanly' conduct gradually disappeared with partisanship in the place-focus of many team games. What could have become sports spaces were clearly reclaimed as meaningful places by the crowd. The sports arena was not a space where one discriminatingly attended a 'performance'; it became a meaningful place to support *our* team.

Such crowd interference reveals the spatial boundaries of sport as limen. The liminality of sports space has been addressed by the anthropologist, Bradd Shore (1995), who notes that in many sports the spatial boundaries are constantly (and in some cases, deliberately) being violated. The crowd involvement, which makes the nature of boundaries in sports such a good example of liminal space – neither one thing or the other or a world betwixt and between playing and spectating – is not present in all sports, nor has it always been present in sports where it is currently found. For example, an article in a football programme for a Sheffield United football match in 1907 encouraged polite, non-dialogical behaviour among spectators, carrying the note: 'continued bellowing at the top of your voice . . . gets on people's nerves and takes away a lot of the enjoyment of the game' (Mason 1980). In the case of tennis, however, territorialisation has not only served to confine the crowd as a collective body to a particular segment of the sports place; it has also served to contain noise to particular times of a game. Here the crowd engages in courteous turn-taking, polite applause being reserved for periods when the players are not actually engaged in the game. The referee requests silence when it is the turn of the players to take part in the game. The logic of sport is that, if it is to have spectators, it should assume the model provided by tennis – a model which, it seems, may have once been assumed by football. On the other hand, current tendencies in tennis, badminton and other sports suggest that there is a move towards greater interaction between spectators and players, indicating greater liminality than previously existed. Nor can it be denied that in some cases place-making has been tutored by business and capital.

We may have a synthetic isotropic plane, we may have a territorialised space, but because of the place-making quality of people as sports spectators it might seem that my emphasis on placelessness has been misplaced. What seems to exist instead is a constant tension between place and space in an activity where placelessness would seem to be logically paramount. However, my story does not end here and while placelessness might typify modernity it is the sportsworld of the post-modern, as reflected in the writing of Jean Baudrillard and Paul Virilio, that I now turn.

In *The Transparency of Evil* Baudrillard (1993) devotes several pages to the 1985 Heysel disaster and other aspects of football stadiums. At Heysel, football was perverted into violence. In Baudrillard's words, 'there is always the danger

that this kind of transition may occur, that spectators may cease to be specta-
tors and slip into the role of victims or murderers, that sport may cease to be
sport and be transformed into terrorism: that is why the public must simply
be eliminated, to ensure that the only event occurring is strictly *televisual* in
nature' (Baudrillard 1993). In Baudrillardian sport, however, the expulsion of
spectators from stadiums also serves to 'ensure the *objective conduct of the*
match, . . . in . . . a transparent form of public space from which all the actors
have been withdrawn' (Baudrillard 1993, emphasis added).

The gradual territorialisation of spectators has been progressively enforced
in British stadiums during the course of this century. From relatively open
spaces to enclosed, segregated, all-seat stadiums, the football environment has
become increasingly panopticised, subject to an increasing number of hierar-
chical and disciplinary gazes. Televised sport continues the general trend. The
banning of spectators furthers the domestication and the spatial confinement
of the spectating experience. In an empty stadium, the world could watch on
TV 'a pure form of the event from which all passion as been removed'
(Baudrillard 1993). The shape of the future is recalled by Baudrillard in his
allusion to a football match between Real Madrid and Naples – a European
Cup match in 1987 when the game took place in an empty stadium as a
result of disciplinary measures against Madrid from a previous game. This
'phantom football match' is described by Baudrillard as:

> a world where a 'real' event occurs in a vacuum, stripped of its
> context and visible only from afar, televisually. Here we have a sort of
> surgically accurate prefigurement of the events of our future: events
> so minimal that they might well not need to take place at all – along
> with their maximal enlargement on screens. No one will have
> directly experienced the actual course of such happenings, but
> everyone will have received an image of them. A pure event, in other
> words, devoid of any reference to nature, and readily susceptible to
> replacement by synthetic images.
>
> (Baudrillard 1993)

Television sport produces a sport landscape of sameness. Drawing on the
writing of Virilio (who, in turn, drew on the writing of Marcel Pagnol) we
can note the difference between spectating at a sports event and watching it
on television (Virilio 1991). At a football game no two people see the same
event (because no two people can occupy exactly the same place) whereas the
game on television is exactly what the camera saw. Spectators see this wher-
ever they sit. Television re-places spectators. More significantly, however,
Virilio and Baudrillard draw attention to, and provide the solution to, one of
the problems of the sports landscape already alluded to in this chapter – that
the intrusion of spectators transforms what should be a sports space into a
sporting place – sometimes a sport place of disport. Virilio (1991) notes that

the potential exists for the placelessness of sport to become literal – stadiums can be abolished and live performers be replaced with televisual images that would be shown in a video-stadium without sports players, for consumption to tele-spectators. To some extent this already exists: the presence of jumbo-tron video screens inside stadiums (as at Arsenal's Highbury), which relay slow motion replays and the fine detail of the action, has become the defining reality for many sports fans – a postmodern condition where the image is superior to the reality. It is also uncannily predicted in the recent television advertisement for Adidas, the sports clothing firm, which displays a futurescape of football in which the game is 'played' in a tightly enclosed concrete box with what appear to be simulated spectators, programmed, presumably, to applaud skill but lacking in any partisan sentiments. This also reminds us of the commercial imperatives of modern sports for which sani-tised and safe places, combined with a synthetic environment which, as far as possible, should be 'weatherless', are highly desirable. It would not be totally inappropriate to describe the scenarios I have been outlining as the 'malefac-tion' of football.

The one thing that Baudrillard and Virilio do not recognise (or do not make explicit) is that such scenarios would also satisfy perfectly the norms of achievement sport – the 'surgical' space in which this event takes place provides the placeless environment insisted on by the achievement and fair play norms of sport. Virilio's prescription that the architecture of sports places 'would become no more than the scaffolding for an artificial environment, one whose physical dimensions have become instantaneous opto-electronic information' (Virilio 1991), is a dystopian milieu but one which is predicted by my sport-geographic model.

Three views of the same game and an optimistic conclusion

Paradoxically, however, place can be reclaimed from the flat plane of such a televisual dystopia. Let me illustrate the continued contestation of the ideal, pure-space of the normative sports environment by an empirical allusion to the environments of the 1992 European Championship Final between Denmark and Germany, which was played in the Swedish city of Gothenburg. The game was actually played – and re-(p)layed – in three different places, each of which was a different spectating environment.

The first was the 'real' game, being played in Gothenburg. Many thousands of fans witnessed the live game while under surveillance in their individu-alised and numbered cells at the Nya Ullevi Stadium. Although the stadium is a high-tech concrete bowl, there can be little doubt that a strong sense of place was obtained by the huge Danish contingent which crossed the Oresund from Copenhagen. Who is to say that the huge crowd of 'Vikings' did not influence the performance (in fact, the victory) of the Danish team,

the neutrality of the large number of Swedish spectators being temporarily removed as they supported their Nordic neighbours? Although the space of the stadium was the same as any other, the crowd transformed it into a place of power, passion and of national significance.

The second environment in which the game was (re)played was the homes of the millions of European television-viewers who watched it. For this huge audience television provided a social context, the way of joining a crowd. Adams would regard television as a gathering place; after all, domestically-confined sports fans 'experientially inhabit it and relate to other persons through it or with it'. It undoubtedly constructs meaningful human experiences. It 'draws us in', allows us to cross experiential boundaries. But television audiences are unable (yet) to influence the outcome of the event they are watching. They are also confined in domestic space in which domestic constraints on behaviour are as rigid – if not more so – than those in the stadium at which the game is 'actually' being played. Watching sport in a domestic situation cannot easily be interpreted as a form of resistance – in fact, the exact opposite would seem to be the case. Indeed, as Adams points out, 'throwing a brick through a TV screen has no effect on what is seen on any other screen' (Adams 1992), let alone the course of the game that is being televised. Nor, in a domestic context, would such resistance have any effect outside the domestic cell (although this does not mean that we do not shout at the television when watching our team!).

The third environment in which the game was played was conceptually (and geographically) some way between the stadium and the home. In Copenhagen, near the national football stadium, lies a large area of open space known as Fælled. This area was once common grazing land and was the original locus of Danish football. Today it is a large area of park land, given over to the playing of club-level football. The site has a certain significance to Danes, being the 'home' of their footballing traditions. On the night of the Denmark–Germany game a huge television screen was erected in the open space of the Fælled. This was not domesticated television space in the sense of a small box being in the corner of a living room. It was open, un-enclosed and contained no seats. Nor were there any obvious controls on the sale and consumption of alcohol. A vast crowd attended the game. It was mediated by television but the crowd could, for a night, celebrate in the open space. It was a form of carnival with drunken fans celebrating their small nation's victory over the German 'machine'. Who is to say that the experience of the Fælled was anything but the optimal sporting experience for late modernity – thousands watching in open spaces without being able to influence the game, but standing in opposition to the panopticised confinement which the modern stadium enforces. It was an incongruous juxtapositioning of late-modern and 'folk' traditions. In a way, this kind of situation satisfies the norms of achievement sport and also the desires of the fans. It is not quite placeless. It exemplifies a tension between the apparently logical need for a predictable

environment and the place-making potential of fandom. It also illustrates the tension between the certain world of 'the scientist' and the ambiguous world of 'the human' – or the 'hard' and 'soft' worlds of football.

Bibliography

Adams, P. (1992) 'Television as gathering place', *Annals of the Association of American Geographers* 82, 1: 117–35.

Augé, M. (1995) *Non-Places: Introduction to an Anthology of Modernity*, London:Verso.

Bale, J. (1978) 'Geographical diffusion and the adoption of professionalism in football in England and Wales', *Geography* 63, 2: 188–97.

—— (1983) 'The changing regional origins of an occupation: the case of professional footballers in 1950 and 1980', *Geography* 68, 2: 140–8.

—— (1992) 'Cartographic fetishism to geographical humanism: some central features of a geography of sport', *Innovation in Social Sciences Research* 5, 1: 71–88.

—— (1993) *Sport, Space and the City*, London: Routledge.

—— (1994) *Landscapes of Modern Sport*, Leicester: Leicester University Press.

Baudrillard, J. (1993) *The Transparency of Evil*, London:Verso.

Bromberger, C. (1992) 'Lo spettacolo delle partite di calcio', in P. Lanfranchi (ed.) *Il Calcio e il suo Pubblico*, Naples: Edizioni Scientifiche Italiane.

Dear, M. (1988) 'The postmodern challenge: reconstructing human geography', *Transactions of the Institute of British Geographers*, NS13, 3: 262–94.

Eichberg, H. (1998) *Body Cultures*, ed. J. Bale and C. Philo, London: Routledge.

Elias, N. and Dunning, E. (1986) *Quest for Excitement*, Oxford: Blackwell.

Gardner, R. (1995) 'On performance-enhancing substances and the unfair advantage argument', in W. Morgan and K. Meier (eds) *Philosophic Enquiry in Sport*, Champaign: Human Kinetics, pp. 222–31.

Guilianotti, R. (1991) 'The Tartan Army in Italy: the case of the carnivalesque', *Sociological Review* 39, 9: 503–27.

Jarvie, G. and Maguire, J. (1994) *Sport and Leisure in Social Thought*, London: Routledge.

Mason, T. (1980) *Association Football and English Society, 1863–1915*, Brighton: Harvester Press.

Philo, C. (1995) 'In the same ballpark? Looking in on the new sports geography', in J. Bale (ed.) *Community, Landscape and Identity: Horizons in a Geography of Sport*, Keele, Department of Geography Occasional Paper 20, Keele University, pp. 1–18.

Pred, A. (1995) *Re-cognizing European Modernities*, London: Routledge.

Raitz, K. (ed.) (1995) *The Theater of Sport*, Baltimore, MD: Johns Hopkins University Press.

Relph, E. (1976) *Place and Placelessness*, London: Pion.

Sack, R. (1986) *Human Territoriality*, Cambridge, Cambridge University Press.

Schwartz, B. and Barsky, B. (1977) 'The home advantage', *Social Forces* 55: 641–66.

Scott, J. and Simpson-Housley, P. (1989) 'Relativizing the relativizers: on the postmodern challenge to human geography', *Transactions of the Institute of British Geographers*, NS14, pp. 231–6.

Shore, B. (1995) 'Marginal play: sport at the borderlands of space and time', in O. Weiss and W. Schultz (eds) *Sport in Space and Time*, Vienna: Vienna University Press, pp. 111–25.

Virilio, P. (1991) *The Lost Dimension*, New York: Semiotext(e).

Wagner, P. (1981) 'Sport: culture and geography', in A. Pred (ed.) *Space and Time in Geography*, Lund: Gleerup.

Weiss, P. (1968) *Sport: A Philosophic Enquiry*, Carbondale, IL: University of Southern Illinois Press.

Zeller, R. and Jurkovac, T. (1989) 'A dome stadium: does it help the home team in the National Football League?', *Sport Place* 3, 3: 36–9.

INDEX